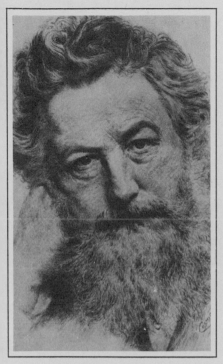

William Morris

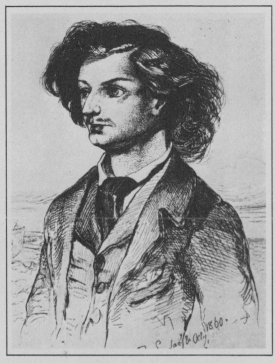

Algernon Charles Swinburne

THE PRE-RAPHAELITE POETS

THE PRE-RAPHAELITE POETS

by Lionel Stevenson

THE UNIVERSITY OF
NORTH CAROLINA PRESS
CHAPEL HILL

Passages from the following works have been reprinted with permission of the publishers:

The Darkling Plain by John Heath-Stubbs. Copyright © 1950 by Eyre & Spottiswood, London (160 words taken from pp. 154–55).

"Pre-Raphaelite Poetry" by W. W. Robson, in Boris Ford (ed.): *The Pelican Guide to English Literature*, Vol. 6: *From Dickens to Hardy*, pp. 358–63. Copyright © Penguin Books, 1958, London.

The Last Romantics by Graham Hough. Copyright © 1949 by Gerald Duckworth & Co. Ltd., London.

The Romantic Imagination by C. M. Bowra. Copyright © 1949 by Harvard University Press, Cambridge, Mass.; copyright © 1949 by Oxford University Press, London.

The House of Life by Dante Gabriel Rossetti, edited by Paull F. Baum. Copyright © 1928 by Harvard University Press, Cambridge, Mass.

"Gabriel Charles Dante Rossetti" by Lord David Cecil, in *The Great Victorians*, edited by H. J. and Hugh Massingham. Copyright © 1932 by Doubleday, Doran & Company.

"Swinburne as Poet," in *Selected Essays, 1917–1932* by T. S. Eliot. Copyright © 1932 by Harcourt, Brace and Co. The portion of the essay reprinted in this book is by permission of Harcourt Brace Jovanovich. Inc.

Manufactured in the United States of America
Printed by Heritage Printers, Inc.
Charlotte, North Carolina
ISBN 0-8078-1196-3
Library of Congress Catalog Card Number 72-78151

CONTENTS

THE PRE-RAPHAELITE POETS

I. INTRODUCTION

The primary significance of the Pre-Raphaelite poets is that they stood at the epicenter of an upheaval that shattered literary placidity in the middle years of the nineteenth century. First of all, they served as the shock troops in the assault on bourgeois complacency. Carlyle, the unrepentant peasant, brandishing the weapons of romantic primitivism, had introduced from German the pejorative sense of the word "philistine," and had condemned every manifestation of middle-class prosperity, commercial vulgarity, materialistic greed. His earliest recruit was Ruskin, who transformed Carlyle's moral austerity into a cult of beauty; and later came Arnold to proclaim the need for disinterested detachment. To some degree, however, both Ruskin and Arnold were of philistine origins themselves, and their aestheticism was uncomfortably yoked with moralistic doctrines.

The Pre-Raphaelites suffered from no such inhibitions. Rossetti, a dissolute foreigner; his sister Christina, a cloistered devotee in an era of rationalistic doubt; Morris, a fugitive from the middle class who dressed like a laborer and swore like a trooper; Swinburne, a renegade aristocrat proclaiming himself a republican and a pagan; Meredith, a sardonic intellectual gadfly—to all these the keenest pleasure in life was *épater les bourgeois*. When they pub-

lished their first major poetry during a few years between 1858 and 1866 the literary landscape was permanently reshaped.

It is not necessary to argue that any one of the Pre-Raphaelite group should be accorded rank among the greatest English poets. The remarkable phenomenon is that jointly they achieved a literary eminence that none of them could have gained alone. In the authentic Romantic model, each was intensely individual, so that no prototype of "the Pre-Raphaelite poet" can be constructed; but it was their diversity that provided their vigor and visibility. The nearest parallel, perhaps, is the Coleridge-Southey-Wordsworth axis that gave direction to the Romantic revolt. A major breakthrough, in defiance of accepted standards, demands more assurance than even the most gifted individual can command by himself; mutual support and stimulation entail a pooling of courage and resources, an access of self-confidence, producing a total impetus that is more than the sum of its parts. In Swinburne's words from "A Song in Time of Order," "When three men stand together / The kingdoms are less by three."

Though the epithet "Pre-Raphaelite" was of course derived from visual art, it was soon adopted by the literary critics. Sometimes the reference was merely to archaisms; a review in the *Athenaeum* in 1860 scolds an author because "she adopts . . . the Pre-Raphaelite spelling of Mr. Landor more than is agreeable. By his 'nipt,' 'clipt,' 'cropt,' 'stopt,' 'dropt' way of treating the tenses, all elegance is 'snipt' from the music."[1] More often, however, the allusion was to precision of detail. Peter Bayne's essay on "The Modern Novel" (1857) refers to Thackeray's realism as "a Pre-Raphaelite school of novel writing."[2] Two years later a reviewer in the *Athenaeum* remarks that Browning's "Saul" is "rich in its Pre-Raphaelite accuracy as a study of oriental scenery."[3] In a review of Swinburne's *Poems and Ballads* in 1866, finding the voluptuous descriptive language in bad taste, John Skelton objected to the "Pre-Raphaelite distinctness of delineation in some of his pictures."[4]

The foregoing random citations indicate elements in the Pre-Raphaelite complex. Inspired by Carlyle's *Past and Present* and Ruskin's "Nature of Gothic," the group glorified medieval hon-

esty at the expense of Victorian hypocrisy. They refused to accept the easy compromise by which the contemporary public relegated the arts to a minor role of elegant dilettantism, unrelated to the solid realities of finance and industry. At the same time, they insisted on uncompromising fidelity to recognizable detail, so that their works could not be accused of either obscurity or escapism. Their frankness in writing about sex evoked demands for censorship which eventuated a decade later in the obscenity trials of publishers who issued naturalistic novels.

The effect of the Pre-Raphaelite impact can be gauged by comparing the three great Oxford critics who determined the century's attitudes toward the arts. Ruskin, though he provided the young poets with their gospel of the primacy of beauty, was distressed by their emotionalism and candor. Arnold, who remained aloof from committing himself to any critical pronouncement on their work, presumably lumped them with his condemnation of the Romantic poets for being too much absorbed in their own emotions. Pater, however, who was only twenty years younger than Ruskin, was the totally committed apostle of aestheticism and initiated the whole next generation of poets and critics into the faith.

In another respect, too, the Pre-Raphaelite poets inaugurated a new era: their preoccupation with foreign literatures put an end to the parochialism that was stultifying English authorship. Here again a few of their immediate predecessors led the way. Coleridge and Carlyle introduced German romantic narrative and idealist philosophy; Byron imitated Pulci. In the mid-Victorian period Arnold inveighed against the provincialism of the English mind; but his actual contribution of knowledge about recent foreign writers was not extensive: Heine and Joubert, Sainte-Beuve and Sénancour were scarcely dynamic specimens of what the Continent could offer. The Pre-Raphaelites, on the other hand, widened the horizon in many directions. Rossetti made available the lyric elegance of Dante's contemporaries and the impudence of Villon; Swinburne dedicated himself to Hugo, Baudelaire, and Gautier; Morris discovered the Icelandic sagas for himself and transmitted them to the English public; all the

group were proponents of the new American poets, Poe and Whitman. With regard to their own compatriots, too, their critical judgments were independent and decisive. They rescued Blake from obscurity; they promoted the ascendancy of Keats; they magnified Browning, theretofore little known to the public; and they launched FitzGerald's translation of the *Rubáiyát* on its fantastic renown.

The inherent ambiguity of the Pre-Raphaelite movement is well illustrated by the divers outcomes. Though one basic tenet was the depiction of contemporary subjects with saturated detail, the other was decorative design, using color and composition in a picture, meter and melody in a poem, to produce an aesthetically delightful effect. From the latter principle developed not only the symbolism and aestheticism of the nineties but also the whole present-day concept of the alienated artist, socially isolated and psychologically introverted, producing nonrepresentational pictures or incomprehensible poems of private self-expression. The principle of current relevance, on the other hand, anticipated the naturalistic fiction of the eighties (which was supposedly imported intact from France); Rossetti's "Jenny" and Meredith's "Modern Love" are as much forerunners of George Moore as are Zola and Maupassant. More remarkably, from the same principle, through Swinburne's diatribes against autocrats and prelates, and Morris's crusade for the practical application of art and its function in social amelioration, came the modern doctrine of total commitment. There is an obviously direct line of descent from Carlyle through Ruskin and Morris to Bernard Shaw, the Fabian Society, the English Labour party, the American New Deal, and all the writers and college dons who have concerned themselves with the Spanish civil war or the eradication of imperialism.

Such a range of apparently incompatible effects may appear to indicate that the concept of Pre-Raphaelitism in literature is an illusion, since it is applied to poets of wide diversity who chanced to be coevals and friends. As the phrase has come to be generally accepted, however, an effort to define the "school" is essential. The basic facts are indisputable: the group was catalyzed by

Dante Gabriel Rossetti; his stimulating poetic theories and techniques were derived from his principles of painting; he and his poetic disciples spent several years in close intimacy during which they read and discussed each other's work, promoted each other's fame, and often experimented with similar themes and forms.

A study of the group must necessarily deal with each poet individually, with regard to both biography and criticism, but must also strive to focus attention upon their interrelationships. The closest scrutiny will therefore be accorded to the poetry of the years 1858 to 1871, from Morris's *Defence of Guenevere* to Rossetti's *Poems*, Morris's *Earthly Paradise*, and Swinburne's *Songs Before Sunrise*. These were the years of cohesiveness among the group, and the years when virtually all their most characteristic work was produced. Any attempt to impose arbitrary categories on their poetry, with the object of emphasizing similarities and demonstrating the existence of a "school," must be scrupulously avoided. Their power resided in their disparity.

Many books have been written about the Pre-Raphaelite movement in painting; but its parallel manifestation in poetry has been relatively ignored, and the interconnections between the two channels of creative expression have scarcely been mentioned. There is an urgent need, then, for a comprehensive survey of the group of poets. Biographical facts are necessary in order to understand their individual differences and also their mutual influences. Critical commentary on their writings is equally required for demonstrating both the extent of their originality and also the qualities that they shared. The painters of the Pre-Raphaelite Brotherhood must inevitably figure in the background, but only insofar as their work is relevant to an appreciation of the poetry.

The important topic of the vital effect of the Pre-Raphaelite poets upon the aesthetic movement of the eighties and nineties is too complex to be included in this survey. It has recently been set forth extensively, though discursively, in *The Pre-Raphaelite Imagination*, by John Dixon Hunt (1969). The final chapter of the present book is confined to a condensed review of how Rossetti and his confrères affected poets of their own generation. Meredith is treated more briefly than his poetic stature deserves,

but he was too intransigent a genius to remain long in any externally dominated orbit and so attention is limited to a short and early period of his career. Hopkins, too, is considered only in the light of his first poetry, before he struck off in his individual direction. The remaining ten poets, most of them now forgotten, figure in the closing chapter to illustrate Rossetti's seminal influence, whether in revitalizing an old poet, T. G. Hake, twenty years his senior, or in fostering a young prodigy, P. B. Marston, as many years his junior. The picture of the Rossetti circle would be incomplete without these disciples.

II. REVOLT AMONG THE ARTISTS

*A*t the middle point of the nineteenth century, English poetry was firmly established in what Arnold was later to define as a period of analysis.[1] The tremendous outpouring of ideological enthusiasm and stylistic experimentation in the Romantic revival had been succeeded by sober second thoughts. Faced with the crucial problems resulting from industrialism and urbanization, but deterred from precipitate action by the violence of the French Revolution and the destructiveness of the Napoleonic wars, the English people were in a mood for cautious reform based on thorough discussion, and every major writer became involved—sometimes reluctantly—in the dialectical exploration of immediate issues.

The authors were considering the problems mainly in the context of current conditions in their own country. The fruitful intercourse of English literature with the Continent, which had prevailed from the time of Chaucer until the Enlightenment, was interrupted by the antagonism evoked by the French Revolution and the prolonged war. When twenty years of warfare ended, serious English thinkers were beginning to recognize the urgency of the domestic crisis in social and political conditions resulting from the Industrial Revolution—a crisis which was still confined

to Britain. The alienation from the Continent was not, of course, complete. Carlyle was interested in Goethe and the German idealist philosophy, and Browning in the Italian Renaissance. But the prevalent mood was better represented by Thackeray, who in spite of several years' residence in Germany and France continued to regard foreigners with contemptuous amusement. By and large, English literature in the early Victorian age was more insular than it had been for centuries.

The concern for ethical and social discussion was by no means innate in the poets of the period, but was enforced by the pressure of contemporary opinion. The dominant new poets, Tennyson and Browning, had begun as disciples of their immediate Romantic forebears, Byron, Shelley, and Keats, and many of their important poems written during the thirties and forties reveal the crisis of conscience that was obliging them to abandon the aestheticism of their youth and to accept a responsibility to deal with the exigencies of their time. When Arnold and Clough emerged as the new poets in the late 1840s, they did not even record an internal struggle; by that time they took their moral responsibility for granted, and merely deplored the unhappy fact that, in Arnold's words from "Stanzas in Memory of the Author of *Obermann*,"

> ... Two desires toss about
> The poet's feverish blood:
> One drives him to the world without
> And one to solitude.

Undeniably the mid-Victorian poets were consummate craftsmen, refining upon the vast accumulation of metrical forms and technical devices that they inherited from the whole of previous poetry; but it is plain that they regarded their mastery of the poetic art as a means to an end, and this end was intellectual analysis. They were supported by the full weight of critical theory, from Aristotle onward, that the function of poetry is to inform as well as to delight; but the delicate balance between the two objectives can be maintained only by an oscillation in which, when one objective becomes dominant, the other must somehow reassert itself. In 1850 the instructive element was so concordant with the in-

tellectual climate that it could be disrupted only by a particularly eccentric and assertive adversary.

It is not surprising, then, that the disruptive force originated outside of literature, in the sister art of painting, which is necessarily less well adapted to dealing with general ideas and controversial doctrines; and it originated specifically in the person of a charismatic young man who in national origin, in education, and in temperament was so remote from the current English norm that he was able to defy the dragon of orthodoxy in both painting and poetry before becoming fully aware of his rashness.

Dante Gabriel Rossetti, somewhat like Coleridge or Ezra Pound, was endowed with a versatile mind, a persuasive tongue, and an infectious enthusiasm which served as a catalyst for the thoughts of other people and inspired them to achievements that sometimes excelled his own. Being equally gifted in painting and in poetry, he was predestined to foment an uprising that rallied bright and audacious young followers in both disciplines.

English painting stood just as desperately as English poetry in need of a fresh impetus. The great portraitists and landscapists of the late eighteenth century had established a tradition that was promptly institutionalized in the Royal Academy and thus was transmitted to subsequent artists. First they were trained in the orthodox methods and then they found that no other kind of picture stood much chance of being exhibited in a gallery or purchased by a collector.

Almost alone, J. M. W. Turner broke with the tradition and painted according to original theories. It is now obvious that his experiments in depiction of light and movement were direct precursors of impressionism and even of the nonrepresentational art of the twentieth century. The leisurely English process of absorption eventually led to Turner's acceptance as a major painter, but his example had no perceptible influence on younger artists, and in the forties the academic formulas of conventional themes and somber chiaroscuro offered nothing beyond a debilitated specter of the great Renaissance masters.

One self-confident young critic set out to be the champion of Turner's genius and thus to proclaim a new evangel. When the

first volume of *Modern Painters* came out in 1843, John Ruskin seemed to be raising the banner of aesthetic priority. Repeatedly he declared that "ideas of beauty are among the noblest which can be presented to the human mind, invariably exalting and purifying it."[2] As inexorably, however, as were all his contemporaries, Ruskin was captive to the sense of social and ethical responsibility. His evangelical upbringing was stronger than the slightly supercilious sophistication that he acquired at Oxford. Hence his eloquence was inadequate to disguise the inconsistency of his argument; while insisting on the primacy of beauty, he constantly identified it with "nobility of ideas": "Painting, or art generally, as such, with all its technicalities, difficulties, and particular ends, is nothing but a noble and expressive language, invaluable as the vehicle of thought, but by itself nothing. . . . The greatest picture is that which conveys to the mind of the spectator the greatest number of the greatest ideas."[3] Accordingly, Ruskin involved himself in complicated and abstract expositions of how "great" and "noble" ideas could be conveyed through paintings.

A similar moral preoccupation controlled a young painter who shared Ruskin's conviction that contemporary English painting was trite and insincere. William Holman Hunt's devout religious upbringing conditioned him to believe that the highest function of art was to inculcate Christian principles. At the Royal Academy School he encountered a more volatile and precocious fellow-student, John Everett Millais, and together they evolved the opinion that the only salvation for English art would be a revival of truth to nature. They experimented with forgotten techniques of applying paint, derived from early Renaissance frescoes, which enabled them to achieve sharper detail and brighter color. They knew little at first hand, however, about fifteenth-century Italian art, as the National Gallery did not yet offer an adequate representation of the early period.

At just the same time another English painter, Ford Madox Brown, enjoyed the opportunity that they lacked. Trained largely on the Continent, he had passed through several phases of imitating existing styles before he visited Italy in 1844 and became fascinated with Giotto and Fra Angelico. In the work of such

painters as these, as well as that of Holbein, he discovered the integrity and the fidelity to fact for which he had been searching. In Rome Brown also encountered a peculiar group of German painters who for thirty years had been trying in a true Romantic spirit to revive the medieval identification of art and Christianity by living under monastic conditions and imitating the religious paintings of the Italian primitives. They called themselves the Nazarenes or sometimes the Pre-Raphaelites. From them Brown learned the device of arranging the figures in a picture to fit an architectural framework, as in an altarpiece or a lunette.

Meanwhile Dante Gabriel Rossetti was an erratic pupil in the Royal Academy School, unwilling to accept the discipline of hard work and the dogmatic conventional instruction. In 1848, which was his twentieth year, he decided to seek individual guidance from two young painters, not many years his senior, whose work strongly appealed to him. Madox Brown, now back in England, was little known to the public, but Rossetti had admired several of his earlier pictures and in an almost fulsome letter begged Brown to give him private lessons in color. At the Academy school he was similarly impressed by Holman Hunt, and abruptly proposed that they share a studio. Both Brown and Hunt were incredulous and embarrassed when the suggestions were first made. Brown had entertained no thought of taking pupils, and Hunt had intended to occupy his new studio alone. Besides, the puritanical Hunt was scandalized by what he knew about young Rossetti's raffish ways. But the ardor of the self-elected disciple was irresistible, and both men acceded to his requests.

The earnest Hunt and the facile Millais had stimulated each other profitably, and Brown in his solitary quest had formed much the same theories. In the techniques of drawing and painting all three were far more adept than Rossetti; but his enthusiasm expanded their experiments into a revolutionary gospel. As soon as the joint occupancy of the studio began, Hunt painted his first picture that fully displayed his new method of meticulous detail copied from nature, and Rossetti began his first full-scale painting, *The Girlhood of Mary Virgin*. Nearby, Millais was at work on his *Isabella and the Pot of Basil,* another example of the new

technique. Rossetti shared with Hunt and Millais an enthusiasm for the poetry of Keats, who was still little known to the public, and in this year 1848 the publication of Milnes's biography of the poet strengthened their conviction that he was their favorite among the Romantics. Rossetti was delighted to learn that, after looking at reproductions of the Italian primitives, Keats decided "that some of the early men surpassed even Raphael himself."

To Rossetti the time seemed ripe to propagate the revolt against the established school of painting, and his Continental antecedents prompted him to begin by forming a secret society. He named it the Pre-Raphaelite Brotherhood, and to make up the mystical figure of seven members he enrolled, in addition to Hunt and Millais, his own younger brother (who was taking drawing lessons at the time) and three friends whose work showed an affinity with theirs. Brown, who was older than the others and was fixed in individualistic ways, was not officially included in the membership but remained closely associated with it.

The brotherhood met frequently for nights of beer, coffee, and heady talk about their intentions, and during the day they worked on canvases to be shown at the exhibitions of 1849. When these went on display, the critics began to realize that a startling innovation had emerged, and they greeted it with puzzled contempt. To Rossetti, it was obvious that the brotherhood must have its own organ to clarify its theories, and so he established a monthly magazine, which he named the *Germ*. As he believed that the new principles could be applied to poetry as well as to painting, the artists set their hands to versifying, usually awkwardly enough. Since Rossetti and his brother were the only two members with natural literary ability, they occupied the largest space in the magazine. The *Germ* survived for only four issues (January–April 1850), and it is remembered now as the vehicle for Rossetti's first published poems and for some by his young sister Christina; but its pages also contained manifestoes of the brotherhood's doctrine.

When it became publicly known that the new painters were not merely arrogant individuals but were united in an underground organization, the scorn of the critics turned to wrath.

Here was a subversive conspiracy to overthrow accepted authority. For the next few years the work of the brotherhood was exposed to a torrent of ridicule and vilification that is incredible to any modern observer, who is likely to regard their paintings as only slightly different from those of their predecessors. But their brilliant coloring almost hurt the eyes of the mid-nineteenth century, and their meticulous, sharp-edged details, in foreground and background alike, confused onlookers accustomed to the focusing of attention on the central figure by contrasts of high lights and dim shadows and by depth of perspective. Most of all, however, it was the strict realism of the pictures that was stigmatized as "hideous," "loathesome," and—when the subject was religious—"blasphemous." The most bitter abuse was heaped on a painting by Millais, *Christ in the House of His Parents*, which nowadays seems like an innocuous portrayal of the Holy Family in an ordinary carpenter's shop.

When the first shock of impact wore off, the new techniques seemed less offensive. Rossetti's young brother became art critic of the influential *Spectator*, where he was able to laud the work of his friends. More significantly, Ruskin came to recognize that the new group was practicing the principles that he had started to preach almost a decade earlier, and he praised them warmly (though judiciously) in two letters to the *Times* shortly after the Royal Academy Exhibition of 1851 had evoked a fresh outburst of invective. A little while later he dealt with them more fully in a pamphlet, and his authority did much to turn the tide, by vindicating them from the charges of deliberate archaism and of incompetence in perspective. Five years later, when the third volume of *Modern Painters* gave him an opportunity of reiterating his approval, he was no longer defending a forlorn cause.

As a functioning coterie, the Pre-Raphaelite Brotherhood lasted for only three or four years. Hunt and Millais developed along lines of their own that departed from the strict doctrine. Two of the less gifted members abandoned painting altogether. William Rossetti never reached the point of painting a picture, and devoted himself wholly to authorship. On the other hand, a number of young artists who were not members of the brotherhood

adopted the Pre-Raphaelite techniques so slavishly that in the eyes of the public they were de facto affiliates of the group. Dante Gabriel Rossetti alone survived from the founders, and it became obvious that his painting was radically unlike what they were now doing.

In spite of the affection subsisting between him and his associates, he was profoundly different from all of them in personality. Indeed, his compulsive power over them arose mainly from the utter difference. They were devout Christians, while he was an obstinate freethinker. They subscribed to Ruskin's theory that paintings must somehow serve a noble moral purpose, while to him the sole function of a picture was to embody sensuous beauty; they worked conscientiously and lived exemplary lives, whereas he neglected his vocation and consorted with drunkards and profligates.

He was not alone among them in assuming an intimate relationship between painting and poetry. They all chose topics for pictures from the plays of Shakespeare and the poems of Keats and Tennyson. When they were not explicitly presenting a scene in a narrative context there was likely to be a strong lyrical emotion conveyed through mood and form, as in Millais's *Autumn Leaves* or Arthur Hughes's *April Love*. Nevertheless, none of the others was immune from Victorian moralizing or even from Victorian sentimentality.

Rossetti, by contrast, was essentially and immutably a Romantic. To him painting, as much as poetry, existed not primarily to reproduce actual observation, or to tell a story, still less to embody an ethical theme, but to arouse an immediate emotional and imaginative response. Hence he subscribed to the Pre-Raphaelite tenet of realism only insofar as it prescribed clarity of color and precision of detail. He could never conceivably have painted scenes of contemporary life like Brown's *Work*, which depicted sewer-diggers in a busy London street, or *The Last of England*, a shabby family huddled under an umbrella on the deck of a squalid emigrant ship, or *The Awakened Conscience*, by Hunt, showing a suddenly remorseful girl turning away from her seducer in the midst of singing "Oft in the Stilly Night" in an over-furnished

drawing room, while the cat eats the canary in a corner. After his first two canvases, both on scriptural subjects, Rossetti was unable for several years to finish any pictures at all, and when he resumed painting his work became more and more purely decorative and symbolic, usually a single female figure of anything but normal anatomy, garbed in flowing robes and posed sinuously against a formal background of trees and flowers. Only the title of each picture identified it as portraying Proserpine or Lilith, Guenevere or Dante's Beatrice, or some other legendary femme fatale or *princesse lointaine*.

One of the most revolutionary doctrines of the first Pre-Raphaelites was that pictures should be painted if possible out-of-doors in natural sunshine; this practice enhanced their vivid presentation of color and light, which led to the school of impressionism. Rossetti, however, worked always in his studio, and when his settings were not indoors they represented shady and oppressively enclosed arbors or forest depths.

Soon forgetting the original Pre-Raphaelite insistence on realism, the public came to identify Pre-Raphaelitism solely with the long-necked, sad-eyed maidens of Rossetti and the more elaborate groupings of similar figures in the canvases of his later disciple, Edward Burne-Jones. Thus, ironically, the same man first gave effective impetus to the movement and subsequently subverted its basic principle.

III. ROSSETTI AS POET

*U*p to this point attention has been concentrated on Rossetti's activities in painting, because it was the sphere in which he first affected other creative people and first became known to the public. From his boyhood onward, however, his talent was equally divided between painting and poetry, and throughout his life he never fully decided which art he preferred. This is part of the reason why in neither art did he achieve the pre-eminence for which he seemed to be qualified.

In his own household his sister Christina was a poet as gifted and precocious as himself, and he persuaded the members of the Pre-Raphaelite Brotherhood also to write poems for the *Germ*. After the brotherhood dissolved, his influence exerted itself more on young poets than on young painters, and by the time he was thirty he had a fresh group of disciples, whose writings showed so much affinity with his that they have come to be classified as the Pre-Raphaelite Poets.

The term is obviously illogical, derived from the mere chance that Rossetti originally came to be recognized as a painter rather than a poet. If his development had first taken the other fork, his iconoclastic ideas might have been described as "pre-Spenserian," and then the art historians would have been saddled with the in-

congruous phrase "Pre-Spenserian Painters." Either epithet would be equally appropriate to describe the campaign to undermine the prestige of the great Renaissance masters, with their complex subtleties, their learning, and their sophisticated techniques, in favor of the direct statement and the rigid frame of reference that characterized Chaucer as fully as Botticelli.

In order to understand the underlying causes for the uniqueness in Rossetti's work, both as painter and as poet, which enthralled young English admirers, it is necessary to know his ancestry and early environment. Though born in London, he was more Latin than English by temperament and demeanor, so that his Italian vivacity and voluptuousness were totally alien to the sober Anglo-Saxon disposition.

In the early decades of the nineteenth century London was a favorite haven for refugees from the political turmoil of Continental countries, particularly Italy. After the Congress of Vienna, when the former local dynasties or foreign suzerainties were reestablished throughout the peninsula, underground conspiracies simmered perpetually, and whenever the secret police became too menacing the only safety was in flight. Many of the fugitives being intellectuals and artists, English culture was enlivened by such figures as Ugo Foscolo, the poet, and Antonio Panizzi, the bibliopole. More important revolutionaries, such an Giuseppe Mazzini, spent long periods in London, plotting for a free and united Italy.

One of the most remarkable of the refugees was Gabriele Rossetti, a versatile Neapolitan who had written librettos for Rossini's operas at the San Carlo before becoming curator of ancient sculpture at the Naples Museum. In addition to publishing poetry and drawing pictures, he gained renown as an *improvvisatore*, reciting his extempore verses at the banquets of eminent citizens. In revulsion from his Roman Catholic heritage, he became a skeptic and a Freemason, and after the restoration of the Bourbon monarchy he joined the revolutionary Carbonari. His inflammatory political poems singled him out for proscription, and in 1822 he was aided by English friends in escaping from the country. After two years in Malta, where he perfected his English, renewed

danger of arrest impelled him to move on to London. Here he took lodgings in Soho, the principal rendezvous of the exiles, met a few English intellectuals, and supported himself by teaching Italian. In 1826 he married Frances Polidori, whose father had once been secretary to the dramatist Alfieri but had lived in England for the past thirty years and had married an English woman. A brother of the new Mrs. Rossetti had been Byron's personal physician for a short time and had written a Gothic tale of terror, *The Vampyre*, which when first published had been attributed to Byron himself. A restless wanderer of the ultraromantic model, he committed suicide when he was twenty-six.

Thus the four children who were born to the Rossettis in successive years had a birthright of literature and romanticism on both sides of their parentage. To this was added an ingredient of scholarship, for Gabriele was devoting himself to meticulous research in the works of Dante, though his interpretations were vitiated by an obsession with proving that *The Divine Comedy* was a symbolic presentation of antipapal propaganda and ideals of Italian nationalism. As time went on, he extended his theory to embrace other authors, so that even Bunyan was claimed as an adept in occult mysteries.

The family atmosphere was peculiarly important in the development of the Rossetti children. Though they lived in a shabby region of central London rather than in the desolate Yorkshire moors, they were almost as much isolated as the four young Brontës. Both families, dominated by a scholarly but eccentric father, were obliged to find their stimulus and their delight among themselves. Close together in age, they felt no need for other playmates, and probably did not realize how exceptional was their absorption in literature and the arts. The two Rossetti girls were educated wholly in the home; the boys attended a neighboring school but remained aloof from the pranks and the games and the unintellectual and unaesthetic activities of their fellow-pupils. Instead, their close social contacts were mainly restricted to the Italian exiles who frequented the Rossetti house.

It was natural for them to grow up bilingual, highly articulate, and emotionally demonstrative; but each of the four displayed

the effects of the environment in an individual way. Maria Francesca, the eldest, who was austere and scholarly, retained her father's enthusiasm for Dante without his vagaries, and eventually published a praiseworthy book on the poet. Next in sequence came a son, who was christened Gabriel Charles Dante but soon dropped the "Charles" and reversed the other two names. As he was always known to his family and friends as "Gabriel," he will be so denominated in this book, the difference in spelling being sufficient to distinguish him from his father. In this son the traits that predominated were the power of melodious versification, the medieval predilection, and the rebellious temperament. The third child, William Michael, resembled Maria in his scholarly bent and his sense of responsibility. Finally came Christina Georgina, shy, elusive, but as deeply emotional and as poetically endowed as her elder brother.

The lack of identification with their social milieu extended to a disregard for the prevalent concern with public and moral issues. They did not grow up in a political party or even in a recognized stratum of society; as aliens, they could not be neatly categorized as proletarian, or bourgeois, or gentlefolk. Nor had they been exposed to the persistent puritan tradition of moral earnestness that in their contemporaries became a sense of social commitment. Finally, they did not have to go through the agonizing conflict between faith and reason that tormented so many of the English writers; the two boys, serenely accepting their father's freethinking, were not disturbed by any challenge to their creed, whereas the two girls, brought up by their mother in the Anglican communion, were immune to rationalistic doubts.

Dante Gabriel Rossetti was born at 38 Charlotte Street (later renamed Hallam Street) on 12 May 1828. From the age of nine to fourteen he attended King's College School, in the Strand, where he added French and Latin and a smattering of Greek to his linguistic range. He was not an industrious pupil, however, and derived most of his education from the books in his father's library and the interminable talk that flowed within the family and was enhanced by their stream of voluble visitors. From an early age he devoted himself to drawing pictures and to writing

verses, and he never doubted that he should learn to be a painter. For four years after leaving King's College School he was a student at Sass's Drawing School, then regarded as the best preparation for admission to the Royal Academy School.

During his adolescence, nevertheless, he spent as much time and energy in writing as in drawing. He wrote a play on a chivalric theme when he was about five; by the time he was twelve he had composed "Roderick and Rosalba," an adventurous prose romance of chivalry, and was working on a long poem in imitation of Scott, "Sir Hugh the Heron," which was printed two years later by his grandfather Polidori, whose hobbies included a private press. A little later Gabriel's interest shifted from tournaments to sex: a lurid tale named "Sorrentino" was abandoned when his family objected to passages in it as indecent.

From a friend of his father he acquired enough German to translate Bürger's *Lenore*, Hartmann von Aue's *Arme Heinrich*, and a large section of the *Nibelungenlied*. He was more fascinated, however, with the early Italian poets, and translated Dante's *Vita Nuova* into a formal and elaborate English that he considered appropriate. Before long he went on to the lyrics and sonnets of Dante's contemporaries, who were less known to the English public. This immersion in medieval amatory verse impregnated his imagination permanently with the themes of courtly love.

Thus his literary apprenticeship included a large proportion of foreign influences, but he found congenial models among English poets also. His early adherence to Scott and Byron was soon replaced by less obvious models when he became devoted to the oldest and the youngest of the Romantic poets, Blake and Keats, neither of whom was widely familiar to readers in those days. He had the amazing good luck to buy from one of the attendants in the British Museum a manuscript notebook of Blake's in both verse and prose, for which he paid ten shillings—which he had to borrow from his more provident brother. The notebook included Blake's attacks on Sir Joshua Reynolds and the neoclassical conventions of current English painting, and therefore may have helped to suggest the ideas that came to be formulated in the Pre-Raphaelite revolt.

Among senior contemporaries he enjoyed the early poetry of Tennyson, written before Victorian didacticism prevailed over Keatsian sensuousness; but here again Rossetti's taste was not confined to what was popular at the time, for he also discovered the much-neglected Browning. The subject matter of *Sordello* and *Paracelsus* appealed to his interests, and he got to know Browning's early style so well that when he came across the anonymous *Pauline* in the British Museum Library he became so convinced of its authorship that he copied the whole poem by hand and commended it to his friends, thus indirectly obliging Browning to acknowledge the poem and eventually to reprint it.

While still in his teens Rossetti wrote a number of the poems that were later to figure among his best-known work; several of them came out in the *Germ*, but its pages were known to only a few score readers. More than twenty years were to elapse before these were printed again and the others for the first time; hence his recognition as a poet came far later than his notoriety as a painter.

In poetry, as in painting, he sought the advice of a master whom he admired: just at the same time when he was importuning Ford M. Brown and Holman Hunt to help him with his pictures, he sent some of his translations and original poems to Leigh Hunt with an inquiry as to whether he might hope to earn a living as a poet. He must have been influenced by knowledge of Hunt's sponsorship of Keats and friendship with Byron and Shelley, and probably also he liked Hunt's best-known long poem, *A Story of Rimini*, with its theme from Dante and its rococo decorative detail. Rossetti's taste was never impeccable; he was apt to enjoy inferior writings if they were melodramatic or sentimental, such as those of C. R. Maturin or Ebenezer Jones. His brother admitted that "his intellectual life was nurtured upon fancy and sympathy, not upon knowledge or information."[1] As much as Keats, the twenty-year-old Rossetti was likely to be attracted by the facile emotionalism of Hunt's poem.

The old poet replied cordially to Rossetti's letter. While pointing out faults in the meter and melody of the translations, he praised their "evidences of a strong feeling of the truth and sim-

plicity of the originals," and there was no qualification in his opinion that Rossetti's own pieces were the work of "an unquestionable poet, thoughtful, imaginative, and with rare powers of expression." Hunt was positive, however, that "poetry, even the very best—nay, the best, in this respect, is apt to be the worst—is not a thing for a man to live upon while he is in the flesh, however immortal it may render him in the spirit."[2] Whether or not Rossetti's long delay in publishing his poetry was a result of Hunt's discouragement, at least the correspondence helped to confirm Rossetti's sense of affiliation with the great Romantic generation.

Two poems that he printed in the *Germ* form an epitome of the two essential types of Pre-Raphaelite art. "My Sister's Sleep" is the verbal equivalent of the realistic genre paintings, more like one by Brown or Hunt than was any canvas of Rossetti's own. The setting is unmistakably the Rossetti home in Charlotte Street, though for dramatic impact he invents a dying sister, at a time when both his actual sisters were in good health. The visual details are strictly accurate:

> Her little work-table was spread
> With work to finish. For the glare
> Made by her candle, she had care
> To work some distance from the bed. . . .
>
> Through the small room, with subtle sound
> Of flame, by vents the fireshine drove
> And reddened. In its dim alcove
> The mirror shed a clearness round. . . .
>
> Our mother rose from where she sat:
> Her needles, as she laid them down,
> Met lightly, and her silken gown
> Settled: no other noise than that.

The composition and lighting of the scene are those of an accomplished painter; the "broken lights" are provided by the bright moonlight outside the window, the red glow of the fire, the small flame of the candle, and their reflections in the mirror,

while the dying girl's bed and the mother's worktable are neatly counterbalanced. Nonvisual detail is handled just as expertly to suggest an unnatural hush by the mention of ordinarily unnoticed sounds—the murmur of the flame, the striking of the clock, the click of knitting needles, the rustle of silk, the "pushing back of chairs" in an upper room. The tonal effect of silence and religious devotion is enhanced by the style, for the words are monosyllabic and familiar and the metrical pattern is simple iambic tetrameter quatrains, varied from an ordinary ballad stanza only by rhyming *abba* rather than alternately. Though Tennyson had already discovered the effectiveness of this stanza for a subdued elegiac poem, *In Memoriam* was not published until two or three years after Rossetti wrote "My Sister's Sleep," and so his use of the form was an independent choice. The cool reportorial precision of the poem may startle the reader by the absence of overt lamentation, but thereby it conveys the paradox of sorrow conjoined with serenity, the psychological phenomenon of an emotional apathy that often cushions the impact of death, particularly in an environment of orthodox faith.

Just as "My Sister's Sleep" is a perfect transposition of Pre-Raphaelite realism into words, so "The Blessed Damozel" is a prototype of the other kind of Pre-Raphaelite picture, which Rossetti himself later standardized—the decorative portrayal of a single female figure in a graceful pose, suffused with unearthly melancholy and environed by emblematic objects that suggest eternal meanings. The three lilies in the girl's arm, the seven stars in her hair, the white rose at her breast are all familiar symbols. The heavenly setting is the solidly physical landscape of medieval art, with the golden rampart in the foreground, the flamelike ascending souls on either side, the distant view of reunited lovers behind. Rossetti succeeds, however, in locating the traditional scene in a more modern universe in the stanzas that describe the cosmic vastness:

> ... the sheer depth
> The which is Space begun;
> So high, that looking downward thence
> She scarce could see the sun. ...

Beneath, the tides of day and night
 With flame and darkness ridge
The void, as low as where the earth
 Spins like a fretful midge. . . .

From the fixed place of Heaven she saw
 Time like a pulse shake fierce
Through all the worlds. . . .

Clear primary Pre-Raphaelite colors dominate the picture—the gold balustrade, the white robe, the yellow hair, with the implication of pellucid heavenly blue encompassing the figure. The meter of the poem is again a suitably simple adaptation of ballad stanza, this time supplied with a lingering cadence by being extended from four lines to six. The poem's structure is ingeniously made symmetrical by the insertion occasionally of a passage that shifts attention from the damozel in heaven to her grieving lover on earth, with the accompanying changes between third-person and first-person in point of view. Of the poem's twenty-two stanzas, the lover's parenthetical laments form the fourth, eleventh, and seventeenth, thus being proportionately spaced; and then in the concluding stanza his words are reduced to the first half of the first line and the last half of the last one, and these two four-word half-lines are exactly balanced in syntax. Such meticulous composition is thoroughly representative of Pre-Raphaelite technique. At the same time, the device enriches the emotional force of the poem by providing a contrast between the serene and static perfection of heaven and the realistic and ephemeral earthly details as the lover wanders in an autumn wood, feeling leaves brush past his face and listening to birdsong and distant church bells.

The poem conveys something of the combination of earthly and transcendental love that distinguishes Dante's *Vita Nuova* and *Paradiso*; but Rossetti was influenced also by a very different poet. With their usual responsiveness to foreign literature, the Rossetti family discovered Edgar Allan Poe several years earlier than other English critics and even before Baudelaire launched the American poet's fame in France. In 1848, when the Pre-

Raphaelite Brotherhood drew up a list of "Immortals" which, they declared, "constitutes the whole of our creed," Poe's name was included. Throughout the next generation Poe's reputation in England was promoted almost solely by members of the Rossetti circle. Near the end of his life Rossetti asserted that the idea of "The Blessed Damozel" had been suggested by "The Raven": "I saw that Poe had done the utmost it was possible to do with the grief of the lover on earth, and so I determined to reverse the condition, and give utterance to the yearning of the loved one in heaven."[3] There are also a number of verbal parallels between Rossetti's poem and another of Poe's, "El Aaraaf."

Both "My Sister's Sleep" and "The Blessed Damozel" could be classified as religious poems, but this does not mean that when Rossetti wrote them he was personally inclined to the Roman Catholicism of his ancestry or the Anglo-Catholicism of his mother and sisters. Using the themes with the cool detachment of an artist, he might even be accused of sacrilege by some devout reader. At the end of "My Sister's Sleep" the nativity prayer is made to serve simultaneously as a prayer for the soul of the dead girl, with an epigrammatic use of paradox that verges on the witty. Similarly, in "The Blessed Damozel" the idea that earthly love survives in heaven—indeed, that yearning for reunion with an earthly lover can conquer heavenly bliss—is thoroughly heretical, if not positively blasphemous. Rossetti was neither defending nor impugning religious concepts; he was simply utilizing them for their aesthetic value.

One may indeed go so far as to suggest that in "The Blessed Damozel" the disconsolate lover's inherent egotism and lack of true spiritual perception are shockingly revealed by his vision of a physical and bisexual afterlife in which his dead sweetheart ignores all heavenly felicity in her yearning for their reunion. With deft irony, the poet subverts the whole implication of the poem in the last stanza, when the damozel—after her long and detailed forecast of her ecstatic future with her lover—dissolves in tears of despair as she recognizes the futility of her hope. It is reminiscent of the Lady of Shalott's death, or the hopeless "He will not come" at the end of Tennyson's "Mariana." As to the setting, Rossetti

employs—as Hardy was later to do—the traditional anthropo-
morphic heaven as the vehicle for a profoundly skeptical rejection
of consolatory faith.

Other early poems of Rossetti existed at least in first drafts
before 1850. In 1862 a paroxysm of grief impelled him to bury all
his manuscripts in his wife's coffin, where they remained for
seven years, until he was persuaded to recover them. The early
poems which were not printed in the *Germ* resemble "The
Blessed Damozel" in idealizing beautiful women as their lovers'
intercessors in heaven, a composite of Dante's Beatrice and the
Virgin Mary. Several of his "Sonnets for Pictures" describe
Madonnas with devout adoration, and "Ave" is a more extensive
glorification of the Virgin, hailing her as "Now sitting fourth
beside the Three, thyself a woman-Trinity" as daughter of God,
mother of Christ, "and wife unto the Holy Ghost." The rest of
the poem gives detailed and realistic scenes from Mary's earthly
life, similar to Rossetti's two early paintings, *The Girlhood of
Mary Virgin* and *The Annunciation*. In such poems, his sublima-
tion of physical beauty and love into divine transcendence seems
as orthodox as his sister Christina's later lyrics and sonnets. In
"The Portrait," on the other hand, he describes his painting of
his beloved in terms that accurately forecast the melancholy
sensuousness of his subsequent pictures:

> In painting her I shrined her face
> 'Mid mystic trees, where light falls in
> Hardly at all . . .
>
> A deep dim wood; and there she stands
> As in that wood that day; for so
> Was the still movement of her hands
> And such the pure line's gracious flow. . . .

This poem resembles "The Blessed Damozel" in exalting the
speaker's now-dead sweetheart as his spiritual redeemer:

> Even so, where Heaven holds breath and hears
> The beating heart of Love's own breast,—
> Where round the secret of all spheres
> All angels lay their wings to rest,—

How shall my soul stand rapt and awed,
When, by the new birth borne abroad
 Throughout the music of the suns,
 It enters in her soul at once
And knows the silence there for God!

Here the woman-worship of the courtly-love convention is uttered without stint, combined with the romantic poets' insistence on the supremacy of human affection over all restrictive rules.

An antithesis to this idealized view of womanhood is provided by another poem of about the same date, "The Card Player," which portrays a femme fatale who ruthlessly determines the destiny of the men who gamble with her. Her lurid jewelry and the dance hall in which she sits are in total contrast to the Blessed Damozel in her celestial paradise, and there are indications that the poems were intended to form a diptych: they are in the same stanza form and many phrases occur almost identically in both. By the end of the poem, the card dealer becomes an overt symbol of malign fate.

Among the many poems that Rossetti wrote while still in his teens were two long dramatic monologues, both inevitably suggesting comparison with those of Browning. This is especially applicable to "A Last Confession," which depicts the violence and the patriotic fervor of the Italian *risorgimento*. Many years later, Rossetti protested that "the first nucleus of the 'Confession' was the *very* earliest thing in the book, and was the simple and genuine result of my having passed my whole boyhood among people just like the speaker in the poem. Browning, by travel and cultivation, imported the same sort of thing into English poetry on a much larger scale; but this subject, if any, was my absolute birthright, and the poem was conceived and in a manner begun long before 1848 (the date afterwards put to it as characteristic of patriotic struggles) and at a time when Byron and Shelley were about the limits of my modern English poetic studies."[4]

The statement is somewhat disingenuous. It may readily be admitted that Rossetti's acquaintance with Italian refugees was more intimate than Browning's and that the poem resulted from firsthand observation. Nevertheless, the technique resembles

Browning's so closely that coincidence seems incredible; and the story itself is almost a combination of two monologues by Browning, "The Italian in England" and "The Confessional," both of which were published in 1845. There are also echoes of his earlier poem, "Porphyria's Lover." It is no derogation of Rossetti's originality to suggest that while the personality of the speaker was derived from people he knew, the manner of presenting it was influenced by his enthusiastic recognition of Browning's genius.

The conversational diction and the movement of the blank verse are almost indistinguishable from Browning's. Rossetti's poem differs most obviously from Browning's early monologues in being much longer; indeed, it is closer to the style of *The Ring and the Book*, which was written many years later. The situation is revealed slowly and tortuously, with elusive foreshadowings of the climactic tragedy. In the digressive passages the individual voice of Rossetti can be clearly perceived: the dream of heaven (ll. 112–33) is pictorial and symbolic in the vein of "The Blessed Damozel;" the detailed portrait of the girl (ll. 229–51) is exactly like many of Rossetti's later paintings; the vivid episode at the village fair (ll. 493–519) forms a word picture in the realistic mode (incidentally, the closing lines of this passage strangely anticipate T. S. Eliot's vignette of the wineshop in "Sweeney among the Nightingales").

The power of the dramatic situation is diluted by the leisurely pace, but the poem bears the stamp of authenticity. The fanatical and passionate speaker is unlike the high-minded patriot of "The Italian in England," and the humble person who saves him from capture is a carnival mountebank instead of a heroic peasant girl. The basic weakness of the poem is that Rossetti tried to combine the ideals of the Italian revolutionaries with a story of sensual passion, and the two ingredients do not blend. The theme of liberty is obscured by the lamentations about the agony of unrequited love, which are in the mood of Rossetti's subsequent "House of Life" and Swinburne's "Triumph of Time." Rossetti remains more concerned with emotion than with ideology.

The other long monologue (actually a soliloquy), "Jenny," has no story to tell, and as a sympathetic treatment of a young

prostitute it can be regarded as propaganda against rigid moral dogmas. The speaker has no illusions, however, about Jenny's mental limitations and mercenary motives. As the poem goes on, she becomes less an individual than an embodiment of a universal theme—woman's subjection to man's lust. The risk of pretentious generalization is controlled by the specific setting in the girl's room, with her clock and birdcage and the mirror on which former patrons have scrawled their names with their diamond rings. The description of a London dawn, in which this part of the poem culminates, makes it as good an example of Pre-Raphaelite realism as "My Sister's Sleep," though in a very different mood. Probably in this poem, as much as in "A Last Confession," Rossetti was drawing upon personal observation, first during his boyhood when he made his way to school every day among the streetwalkers of the Haymarket, and later with his bohemian young friends in the art classes.

The quick-moving open-ended tetrameter couplets and the mixture of whimsical colloquialism with reflective and literary passages express the personality of the good-natured, scholarly man-about-town who is talking to himself rather than to the drowsy girl who falls asleep with her head on his knee. The conclusion, when he carries her to her bed and leaves her unearned fee in her loosened hair, emphasizes the fact that he regards her as a beautiful artifact and not as an object of sexual desire. In spite of the speaker's ingratiating human warmth, the ultimate effect of the poem is again aesthetic rather than moral.

Rossetti seems to have regarded "Jenny" as his masterpiece. In a letter to Allingham in 1860 he said, "it is the most serious thing I have ever written," and when his manuscripts were disinterred he called it "the thing I most wanted." In 1870 he told his friend Dr. Hake that it ranked with "Eden Bower," "A Last Confession," and "The House of Life" as the four "things I would wish to be known by."[5] One must note that the version that eventually appeared in print was extensively revised from its original form. Rossetti rewrote it in 1858; and more than a decade later, when the exhumed poems were being prepared for publication, he was so worried about possible adverse responses among the critics

that he made further changes, chiefly to reduce the erotic explicitness. Swinburne's violent protestations against his "mutilating" "*the* modern English poem as yet achieved"[6] prevented more drastic modifications; but even when the book went to press Rossetti wrote defensively to Charles Eliot Norton that the poem had "been written neither recklessly nor aggressively (moods which I think are sure to result in the ruin of Art), but from a true impulse to deal with subjects which seem to me capable of being brought rightly within Art's province."[7]

The dramatic monologue, which Tennyson and Browning apparently developed independently of each other, is the one original genre contributed by Victorian poets, and it has a clear affinity with the Pre-Raphaelite tenet of strict realism. Such a typical painting as Hunt's *Awakened Conscience* or Millais's *Boyhood of Raleigh* is the visual equivalent of a dramatic monologue, recording a crucial moment that suggests not only past and future events but also a psychological situation. Rossetti's two monologues were the first significant ones written by any other poet than the two originators, and reveal how promptly he recognized the potentialities of their innovation.

Rossetti's gift of realistic observation is not so narrowly confined to "Jenny" as most critics have assumed. When he went with Hunt on a gallery-viewing tour of France and Belgium in the autumn of 1849 (taking Browning's *Sordello* along for light reading) he sent his brother a blank-verse report of his impressions, such as this view from a train:

> A constant keeping-past of shaken trees,
> And a bewildering glitter of loose road;
> Banks of bright growth, with single blades atop
> Against white sky, and wires—a constant chain—
> That seem to draw the clouds along with them
> (Things which one stoops against the light to see
> Through the lone window; shaking by at rest
> Or fierce like water as the swiftness grows);
> And, seen through fences or a bridge far off,
> Trees that in moving keep their intervals
> Still one 'twixt bar and bar. . . .
>
> ["London to Folkestone"]

The description of Paris includes a gruesome episode:

> the other day,
> In passing by the Morgue, we saw a man
> (The thing is common, and we never should
> Have known of it, only we passed that way)
> Who had been stabbed and tumbled in the Seine,
> Where he had stayed some days. The face was black,
> And like a negro's swollen; all the flesh
> Had furred, and broken into a green mould.
>
> Now, very likely, he who did the job
> Was standing among those who stood with us,
> To look upon the corpse. You fancy him—
> Smoking an early pipe, and watching, as
> An artist, the effect of his last work.
>
> ["The Paris Railway Station"]

The clinical detachment that added pathos to "My Sister's Sleep" is here used for an equally understated effect of horror.

The visit to Paris produced scandalous sonnets on the can-can and other diversions, but the trip resulted also in others in more formal style, describing pictures by Mantegna and Giorgione in the Louvre and by Memling in Bruges. These two latter were printed in the *Germ*, along with a slightly longer poem dealing with the carillons at Antwerp and Bruges and an ambiguous Browningesque sketch, "Pax Vobis," about a mentally disturbed priest in a bell tower at Ghent.

Rossetti's longest contribution to the *Germ* was his only completed experiment in imaginative prose, a short story entitled "Hand and Soul," which he composed one night between two and seven A.M. Written in a slightly archaic style that could pass as a translation from some volume of Italian novelli, it depicts a young painter of the thirteenth century, seeking to determine his role as an artist amid the turmoil of medieval Pisa. One is strongly reminded of Browning's Sordello, confused as to his objectives in poetry; but even more one feels that Chiaro dell' Ermo in the story is a portrait of Rossetti himself, seeking his artistic vocation among the distractions of Victorian England. Chiaro begins his career as a devoted realist, but lapses into trite conventionalism, only to be

redeemed through a vision in which his own soul materializes as a beautiful woman and lectures him eloquently on his artistic duty: "Give thou to God no more than he asketh of thee; but to man also, that which is man's. In all that thou doest, work from thine own heart, simply; for his heart is as thine, when thine is wise and humble; and he shall have understanding of thee." Chiaro then paints his masterpiece, which reproduces the figure of the beatific vision, and which is described in terms fully applicable to Rossetti's subsequent canvases. As Graham Hough has pointed out, the story explicitly records Rossetti's abandonment of the primary Pre-Raphaelite doctrine; its creed is "not fidelity to external nature, but fidelity to one's own inner experience, which is to be followed even if it contradicts formal morality. This fidelity to experience is all that God demands of the artist, it is as acceptable to him as a formal religious faith, and an art carried on in this spirit is itself a worship and service of God."[8] The story is framed, however, with an introduction and conclusion which emphasize the Pre-Raphaelite doctrines and which echo Browning in demanding belated recognition for the long-forgotten experimenters who were essential in preparing the way for the great masters. The story's theme is reminiscent of Ruskin in the identification of sincere and truthful art with religious worship. The brief tale is interesting also as an anticipation of the "Imaginary Portraits" that Walter Pater wrote a generation later.

Rossetti's early poems display a range of effects and a mastery of technique amazing in a poet scarcely twenty years of age. No wonder his family and friends were convinced of his genius. His themes, of course, were drawn mainly from literature and legend, but his individual tone was already strong and sure. Though he was jovial in social relations and often licentious in his talk, his inner imaginative life was intense enough to create a dream world more vivid than practical experience could provide. After his precocious display of creativity, however, he turned from poetry to painting, leaving most of the early writings unpublished for twenty years, while he reluctantly and intermittently strove to earn a living as an artist. His conscience told him that he ought to be finding profitable employment, for blindness had obliged his

father to give up his teaching and Mrs. Rossetti and her daughters were feebly attempting to conduct a private school; but William Michael had found a secure berth in the civil service and was also getting a foothold in journalism and so Gabriel adhered to his inner compulsion to paint.

During his twenties, while Rossetti was struggling to establish himself as a professional painter, he faced the dilemma of reconciling his angelic dream maidens with the more earthy types who frequented his studio as models. The first and most devastating of them was Elizabeth Siddal. When he met her in 1850 he felt, as he told Brown, that "his destiny was defined;" she seemed to be the preordained Beatrice to his Dante. With her long neck and pale features, her green eyes and mass of coppery hair, she looked as if she had stepped straight out of a Florentine fresco. For the next decade her narcotic, debilitated beauty haunted his paintings.

The daughter of a cutler, Lizzie had picked up enough education to be able to write pretty poems and paint pretty pictures, but her genteel manners were no more than a veneer acquired while she worked in a milliner's shop, and in her occasional tantrums she was capable of lapsing into her native South London dialect. Usually, however, her enigmatic silence left Rossetti's imagination free to sanctify her as his incarnated Madonna. He jealously insisted that she sit as a model to himself alone, and his infatuation with her was one of the forces that disintegrated the fraternal intimacy of the Pre-Raphaelite group. Before long his adoration led to a proposal of marriage.

The engagement lasted for ten years. Lizzie suffered from a consumptive tendency; her attenuated beauty and brooding sadness were partly the result of ill health. During her recurrent spells of illness Rossetti gradually changed from a bedazzled devotee to a pitying protector and nurse. His sexual needs being distorted by his bondage to a pathetic invalid, frustration drove him into the embraces of lustier women, while at the same time it thwarted the mood of energy and ambition which had produced an abundance of drawings and paintings during the first glow of his love affair. He began to suffer from insomnia and moods of morbid depression in which he felt that his pictures were inferior.

Hence he refused to submit them to exhibitions, repainted most of them interminably, and left many permanently unfinished.

Most of the poems that he wrote during these years are colored by his emotional conflict. Particularly it was recorded in sonnets that were eventually incorporated into his sequence, *The House of Life.* Probably to disguise their intimate biographical origin, he disregarded chronology when he came to arrange the sonnets for publication, but modern research has determined approximate dates of composition. A few originated in his teenage heyday, and those that were written after he met Lizzie reveal the change from a youthful erotic affectation to genuine bafflement and misery.

In one of three sonnets entitled "The Choice," for example, written when he was eighteen, the conventional love symbols are deployed gracefully but without deep conviction:

> Now kiss, and think that there are really those,
>> My own high-bosomed beauty, who increase
>>> Vain gold, vain lore, and yet might choose our way!
>> Through many years they toil; then on a day
> They die not,—for their life was death,—but cease;
> And round their narrow lips the mould falls close.

In "Known in Vain," however, five or six years later, there is poignancy in the dilemma of the artist who feels that love has enfeebled his creative power:

> As two whose love, first foolish, widening scope,
>> Knows suddenly, with music high and soft,
>>> The Holy of Holies; who because they scoff'd
> Are now amazed with shame, nor dare to cope
> With the whole truth aloud, lest heaven should ope;
>> Yet, at their meetings, laugh not as they laugh'd
>> In speech; nor speak, at length; but sitting oft
> Together, within hopeless sight of hope
> For hours are silent:—So it happeneth
>> When Work and Will awake too late, to gaze
> After their life sailed by, and hold their breath.
>> Ah! who shall dare to search through what sad maze
>> Thenceforth their incommunicable ways
> Follow the desultory feet of Death?

About the same date, "The Landmark" also expressed a bitter sense that he had unwittingly ignored a crucial opportunity:

> But lo! the path is missed, I must go back
> And thirst to drink when next I reach the spring
> Which once I stained, which since may have grown black.
> Yet though no light be left nor bird now sing
> As here I turn, I'll thank God, hastening,
> That the same goal is still on the same track.

At this time of inner crisis, a new figure appeared in both Rossetti's painting and his poetry—the prostitute, depicted more sensually than the early simple Jenny. For relief from the frigidity of Lizzie Siddal, he found consolation first with a model to whom the naïve Holman Hunt had become engaged shortly before he went off to spend two years painting in the Holy Land, leaving the girl in Rossetti's charge. She was succeeded in Rossetti's affections by a woman who called herself "Fanny Cornforth" and who had been frankly a streetwalker before she found a less disreputable vocation as a model. Blond and buxom, she soon figured in Rossetti's pictures as the very incarnation of voluptuous earthiness. In his poetry he never condoned lust, but he was discovering that his impossible vision of a love that should be simultaneously mundane and spiritual could be realized only by finding its two manifestations in different women.

His life was not, of course, wholly dominated by inner tensions. He was beginning to find buyers for his pictures, and he enjoyed friendships in the literary world. The Brownings were cordial to him when they visited England, and Ruskin—after his wife deserted him in favor of Millais—was so charmed by Lizzie Siddal's unearthly fragility that he subsidized a trip to the Continent for her in the hope of improving her health. Rossetti was sometimes exasperated by Ruskin's officious advice about his pictures, and even more by the demands of the wealthy but insensitive businessmen who purchased them; in spite of his financial straits he was capable of defying what he considered to be encroachments on his artistic independence. On the other hand, he was tireless on behalf of his Pre-Raphaelite associates, recommending them to his patrons and trying to get the best prices for their work.

His sense of frustration arose in part from his divided allegiance as painter and poet: he kept asserting that English poetry was in irreversible decline, having reached its climactic fulfilment in Keats. Painting, on the contrary, was about to achieve its highest splendor. "If any man has any poetry in him, he should paint, for it has all been said and written, and they have scarcely begun to paint it."[9] In 1854 he wrote to William Allingham, "I believe my poetry and painting prevented each other from doing much good for a long while, and now I think I could do better in either, but can't write, for then I shan't paint."[10]

At the height of his emotional quandary between the fragile Lizzie and his grosser mistresses, he was encouraged by acquiring new disciples who brought back something like the original enthusiasm of the Pre-Raphaelite Brotherhood. Two Oxford undergraduates, William Morris and Edward Jones (later famous as "Burne-Jones"), became ecstatic over his work and founded the *Oxford and Cambridge Magazine*, modeled to some extent upon the *Germ*. Jones soon came to London to petition Rossetti to accept him as an art pupil, and Morris later followed to study church architecture. To their vast delight, they persuaded Rossetti to contribute three poems to their magazine—"The Burden of Nineveh," "The Staff and Scrip," and a revised version of "The Blessed Damozel." In their unsophisticated romanticism Rossetti could see himself as he had been a decade before, and for a few months the three existed in an ebullient atmosphere of high-spirited pranks and hard work. By a conscious effort of will Rossetti projected himself temporarily into the world of feudal ideals which he had enjoyed in his adolescence and which his two new adherents inhabited wholeheartedly. Both young men were devotees of Malory, and Rossetti went along with them in painting Arthurian scenes and other episodes of chivalry.

Through these friends Rossetti enjoyed the most gratifying interlude of his whole life in 1857. A new debating hall had been added to the Oxford Union, and the members—with natural undergraduate radicalism—were happy to have it decorated in the most advanced modern mode. Along with Jones, Morris, and several others, Rossetti was commissioned to provide murals, and

he spent some months in Oxford, basking in the warm glow of admiration. Oxford's "dreaming spires breathed the last enchantments of the middle ages," as Arnold was soon to remark. Besides, the university was still permeated with memories of Tractarianism, though the vitality of the movement had been sapped a decade earlier when Newman and his devotees seceded to the Church of Rome. Jones and Morris were devout High Churchmen at that juncture, and were equally dedicated to its artistic equivalent, the Gothic revival. In the spirit of Ruskin, Morris was beginning his lifelong campaign against crude restoration of medieval buildings. To be working as a team to paint on walls in tempera was a return to the Middle Ages consistent with the most cherished Pre-Raphaelite tenets, and inevitably a medieval theme was chosen for the murals—scenes from *Le Morte Darthur*. In this congenial milieu Rossetti temporarily regained his self-confidence and verbal exuberance.

Among the fascinated undergraduates who dropped into the union to watch the bohemian painters at work the most remarkable was Algernon Charles Swinburne. His fragile physique and aureole of red hair appealed to Rossetti as a sort of male counterpart to his favorite woman model, Lizzie. Swinburne, for his part, was delighted to share in the iconoclastic and often lewd conversations with which the gang of artists beguiled their toil.

Swinburne had written verse in his boyhood, and was feeling a stirring of poetic ambition. He was also an amazing linguist, as facile in French and Italian, Latin and Greek, as he was in English. He had read voraciously in Elizabethan literature, and among contemporary authors he admired Browning and Ruskin. These affinities attracted Rossetti to him as a counterpoise to the less intellectual tastes of the painters. On his side, Swinburne was at first intimidated by Rossetti's nine years' seniority and his sometimes overbearing assertiveness, and admired him from a respectful distance.

At this time Morris, too, had turned his attention to poetry, and was often asked to read his verses for the entertainment of the group. Slower in mental processes than his confrères, and easily roused to roaring rage, Morris was something of a butt for Ros-

setti's banter, but Swinburne was enchanted with Morris's poems and thus acquired an enthusiasm for medieval themes.

For several years Rossetti, too, had been experimenting with a familiar medieval mode: some of the most effective poems that he wrote during the 1850s were modeled upon the folk-ballad. In his boyhood he had loved the English and Scottish popular ballads as much as the romances of chivalry, and during his teens he used the ballad form for his comic-grotesque narrative, "Jan van Hunks," an exercise in the burlesque Gothic mode of Southey's supernatural poems and *The Ingoldsby Legends*. In 1851 he embarked on more serious experiments. "The Staff and Scrip" used the ballad device of question-and-answer dialogue at various points; but it elaborated the simple quatrain stanzas by adding a two-stress fifth line rhyming with the first and third. In its length and its theme, as well as in this "tail-rhyme" effect, it recalls the verse romances as well as the traditional ballads. From the same year dates the most powerful of Rossetti's ballads, "Sister Helen," which exploits all the ballad techniques: the situation is conveyed by dialogue throughout, so that no narrator's personality intervenes; incremental repetition occurs in threes; and the refrain lines create an impression of ominous suspense. Besides, the story embodies the familiar ballad themes of betrayed love, revenge, and black magic. The poem is obviously modeled on the most eerily effective of the folk-ballads, "Lord Randal" and "Edward," but Rossetti elaborates it with all the ingenuity of a conscious artist. The ironic contrast between the little boy's innocent curiosity and his sister's obsession, the subtle changes in the phrasing of the final refrain line from stanza to stanza, the painter's vividness of details, the second climax when the girl confesses her despairing sense of guilt after she has achieved her vengeance—all of these are developed with a fullness and subtlety that are alien to the stark directness of authentic folk-ballads. The necessary simplicity of language, however, is in sharp contrast with the ornate diction of Rossetti's sonnets.

By this time, in painting and in poetry alike, Rossetti had become skeptical about one of the original dogmas of Pre-Raphaelite realism—the use of contemporary subjects. "I am beginning to

doubt more and more, I confess," he wrote in 1858, apropos of Brown's *Work*, "whether that excessive elaboration is rightly bestowed on the materials of a modern subject—things so familiar to the eye that they can really be rendered thoroughly (I fancy) with much less labour; and things moreover which are often far from beautiful in themselves."[11] The medieval enthusiasm of his new devotees encouraged his innate preference for the remote and the ornate.

Work on the Oxford murals dragged on beyond the promised date of completion, and the outcome of the whole venture was an absurd anticlimax. Knowing little of the techniques of fresco painting, the artists used unsuitable materials, and within a few years the paint faded from the walls. Much more permanent were the aftereffects of the Oxford sojourn upon the lives of Rossetti, Morris, and Swinburne.

Rossetti and Morris were constantly on the lookout for suitable models, and in the daughter of a groom in a livery-stable they found one who was—in Rossetti's favorite word—"a stunner." Jane Burden at eighteen was tall and long-necked, with masses of black hair and deep-set dark eyes. The two painters persuaded her to be depicted as Guenevere in the murals, and soon they were both in love with her. Though Janey looked like a tragedy queen, she was something of a hoyden and enjoyed the riotous laughter and ludicrous pranks of the artist group. When Morris subsequently proposed marriage, she must have been baffled by his formal courtship in the high chivalric tradition. Apparently he decided that she needed cultural improvement, and it was probably a course of belated education that delayed their wedding for a year.

While the adulation of Rossetti's Oxford friends gave him an illusion that he had regained his youthful energy, the boisterous interludes could not disguise the increasing bleakness of his personal problems. As Lizzie's health continued to decline, she became more querulous, and recurrent quarrels impelled both of them from time to time to flee from London to escape their oppressive propinquity. The engagement survived all crises, however, and Rossetti continued to support his difficult fiancée. In

1860, when she seemed to be at death's door, his conscience compelled him to marry her, and for a while the union appeared to be unexpectedly propitious. Swinburne, who had abandoned Oxford and come to live in London, was captivated by Lizzie's wistful grace, which combined with Rossetti's generous encouragement to stimulate the young poet to frenzied creativity. Lizzie was well enough for visits to other newly wed couples, the Burne-Joneses and the Morrises; during a stay at the Morris ménage at Red House, Upton, Rossetti suggested that Morris should provide the capital for establishing a firm to produce beautiful domestic artifacts for which the young artists could provide designs. When the concern was duly launched, Rossetti (as one of the eight partners) supplied an eloquent prospectus. In a sense "Morris, Marshall, Faulkner & Co." was the final transmutation of the Pre-Raphaelite Brotherhood.

Stimulated by all this creative energy, Rossetti thought about publishing a book of poetry. He sent his manuscripts to William Allingham and asked for advice and suggestions, being especially anxious as to "Jenny": "Will you tell me whether there is any objection you see in the treatment, or any side of the subject left untouched which ought to be treated? I really believe I shall print the things now, and see whether the magic presence of proof-sheets revives my muse sufficiently for a new poem or two to add to them."[12] In the event, however, he decided that he was not ready to expose his original writings to the world, and so in 1861 he brought out *The Early Italian Poets*, the translations that he had made more than a decade before. It earned him modest recognition in literary circles, and he felt encouraged to ask Ruskin to recommend a few of his poems to Thackeray, who was just then editing the new *Cornhill Magazine*. Ruskin was so outraged by "Jenny," however, that he refused to accede to the request.

One of the people who admired *The Early Italian Poets* was George Meredith, who was three months older than Rossetti and had already brought out four works of fiction and a book of verse. Meredith was a reader for the firm of Chapman & Hall, and Rossetti had recently tried vainly to persuade him to recommend republication of a long-forgotten play by Charles Jeremiah Wells,

one of the minor poets whom he extravagantly admired. Now, on the strength of Meredith's favorable view of his translations, he showed him the manuscript of his original poems, and Meredith declared that "he deals with essential poetry . . . rich, refined, royal robed."[13] Meredith naturally made the acquaintance of Swinburne, admired his poems, and recommended them to an editor. The two poets found that they shared Rossetti's passion for the Border ballads, and Swinburne projected a collection of them.

Another activity of Rossetti at the time was collaboration with Alexander and Ann Gilchrist in the first authoritative biography of Blake, with whom, as a poet-painter, he felt a close affinity. Rossetti's new circle of literary friends was becoming as intimate as the previous coterie of painters had been.

His home life, however, was far from unclouded. His association with Fanny Cornforth continued, though she too was now married; and his attraction to Jane Morris, while perhaps dormant, was not defunct. Lizzie's improved health enabled her to become pregnant, but when her baby was stillborn she lapsed into melancholia and hallucinations, and sought an anodyne in laudanum, which led to a condition not auspicious for her second pregnancy. Rossetti got away from his wretched home as often as he could, and one night in February 1862 he came back (possibly from a visit to Fanny) to find his wife dying from an overdose of her narcotic.

His grief and remorse were extravagant. Ignoring all the years when he had patiently tended her in illnesses, he blamed himself for neglecting her and perhaps for hastening her death by begetting their child; in a melodramatic gesture he displayed his self-condemnation by placing the sole manuscript of all his poems in her open coffin.

Rossetti's family and friends did what they could to console him. After a short stay at the house of his now-widowed mother, he shifted restlessly from one lodging to another for some months, until a plan was evolved for providing him with companionship and permanent quarters. A rambling old house in Cheyne Walk, Chelsea, which was said to have been the home of Sir Thomas

More, was acquired for joint tenancy by Gabriel and William Rossetti and Swinburne, with Meredith occupying a room on the days when his work for the publishers brought him to London from his country cottage. With a large room for a studio and an extensive though neglected garden for privacy, Tudor House suited Rossetti so well that it continued to be his home for the remaining twenty years of his life.

The house promptly became a rendezvous of literary and artistic bohemians. Swinburne at twenty-five was wholly unlike the diffident young scholar who had revered Rossetti in Oxford. He had become a militant radical, assailing monarchy and Christianity with equal fervor and proclaiming himself a worshiper of the ancient Greek gods. Even more vehement, if possible, was his antagonism to the precepts of conventional morality, and he indulged verbally in sins and vices that he was physically inhibited from practicing. Susceptible to alcohol, he performed ludicrous antics when tipsy.

Though Rossetti sometimes tried to curb Swinburne's obscenities, he contributed his own share to the heterodox atmosphere. He filled the house with chinoiseries and antique furniture and the garden with strange pets, such as kangaroos and wombats. His neighbor and friendly rival in collecting blue china, James McNeill Whistler, drifted in and out with his adherents. Fanny Cornforth was an increasingly strident habitué, and other models and artists' mistresses were likely to be present. In the censorious public imagination, London had acquired a miniature version of Montmartre.

Meredith soon withdrew from sharing the house. He found Swinburne's capers tedious, and as a strenuous exponent of physical and mental health he was appalled by Rossetti's habits of working by night and sleeping by day, eating heavy meals and taking no exercise. A year or so later, Swinburne became so obstreperous that he was expelled from the ménage. The conscientious William Rosetti remained unobtrusively in the background, trying to keep the finances in order.

In spite of domestic chaos, Rossetti's first five years at Tudor House were productive and apparently placid. He was painting

energetically to keep up with commissions, often making new versions of earlier pictures. Under the guise of serenity, however, he brooded over his guilt for Lizzie's death. When the expanding business of "The Firm" required the Morrises to move into London, he was disturbed by the proximity of the beautiful Jane. His hospitality to his friends alternated with periods of solitude, and he began to worry neurotically over his eyesight. After incarcerating his manuscript in Lizzie's grave he had almost wholly given up poetry; even the intimate emotional record that became *The House of Life* includes no sonnets that can be dated in the seven years after 1861, until he wrote the pair on two of his pictures, *Sibylla Palmifera* and *Lady Lilith*, which were printed by his brother and Swinburne in a pamphlet on the Royal Academy exhibition in the spring of 1868.

These two sonnets portray the contrast of "Soul's Beauty" and "Body's Beauty." In the former:

> This is that Lady Beauty, in whose praise
> Thy voice and hand shake still,—long known to thee
> By flying hair and fluttering hem,—the beat
> Following her daily of thy heart and feet,
> How passionately and irretrievably,
> In what fond flight, how many ways and days!

The voluptuous Lilith, on the other hand, represents the deadly tyranny of sensual love:

> Lo! as that youth's eyes burned at thine, so went
> Thy spell through him, and left his straight neck bent
> And round his heart one strangling golden hair.

If, as seems likely, the sonnets were written shortly before they appeared in the pamphlet, they symbolize the emotional dilemma that had just recurred in his life, when his suppressed love for Janey Morris forced its way to the surface. She was the unattainable charmer whose "flying hair and fluttering hem" had led his "heart and feet—how many ways and days." Fanny Cornforth, the model for the Lilith painting, was the golden-haired witch who

Draws men to watch the bright web she can weave
Till heart and body and life are in its hold.

Thereafter Rossetti insisted on having Mrs. Morris as the model for his pictures, and he wrote worshipful sonnets about her beauty and kindness.

Was I most born to paint your sovereign face
Or most to sing, or most to love it, dear?

There is no firm evidence as to whether sexual intercourse occurred; the sonnets that imply it may be utterances of the poet's wishful imagination rather than reports of actuality. Gabriel and Janey were no longer the romantic young couple who had met in Oxford a dozen years before; she was now the mother of two girls and he was over forty and growing bald and fat. Whatever their exact relations may have been, the two were frequently separated when one or the other fell ill.

The principal result of their intimacy was his resumption of writing poetry. During the next year he produced at least a score of sonnets as well as other lyrics. In March 1869 sixteen of his sonnets (old and new) were published in the *Fortnightly* under the title "Of Life, Love, and Death." The new poems were not consistent expressions of what he called his "regenerate rapture." Forebodings of future separation and loneliness overshadow the joy of his meetings with his beloved, as in "Winged Hours":

Each hour until we meet is as a bird
 That wings from far his gradual way along
 The rustling covert of my soul,—his song
Still loudlier trilled through leaves more deeply stirr'd:
But at the hour of meeting, a clear word
 Is every note he sings, in Love's own tongue;
 Yet, Love, thou know'st the sweet strain suffers wrong,
Full oft through our contending joys unheard.

What of that hour at last, when for her sake
 No wing may fly to me nor song may flow;
 When wandering round my life unleaved, I know
The bloodied feathers scattered in the brake,
 And think how she, far from me, with like eyes
 Sees through the untuneful bough the wingless skies?

By 1868 Rossetti's mental and physical health was causing so much anxiety that he was asked to spend three months in Scotland with his old friend William Bell Scott, a mediocre poet and painter who was one of his early enthusiasms and who might have been included in the original Pre-Raphaelite Brotherhood if he had lived in London instead of in the North. Scott and his wife now passed much of their time at Penkill Castle, the home of a wealthy Scottish spinster, Alice Boyd, who admired him and his work. Having always believed that Rossetti was more gifted with his pen than with his brush, Scott was delighted to learn that he had returned to writing poetry.

Unhappily the therapeutic rural atmosphere was offset by long nights of drinking with Scott, and Rossetti's feelings of guilt and anxiety led him to threaten suicide. On his next visit, a year later (while the Morrises were abroad so that Janey could "take the cure"), Scott encouraged his project of bringing out a book; but it became apparent that the poems that had appeared in print earlier and the few recent sonnets were not sufficient for the purpose. Disturbed by his distraught efforts to reconstruct "Jenny" from memory, Scott and Miss Boyd proposed that he take the macabre step of exhuming the manuscripts from his wife's grave. Upon his return to London the application was officially approved, and the papers were duly recovered from among Lizzie's still lambent hair.

He spent the next few months in revising the poems (just as he so often erased and repainted parts of his paintings), but his infatuation with Janey was more obsessive than ever. She was perhaps using her uncertain health as a pretext for seeing him less often, and he wrote pathetic letters to express his misery over her sufferings, his despair of ever doing justice to her beauty in his pictures, and his utter dependence on her: "You are the noblest and dearest thing that the world has had to show me; and if no less than the loss of you could have brought me so much bitterness, I would still rather have had this to endure than have missed the fulness of wonder and worship which nothing else could have made known to me."[14] Jane was indeed the very embodiment of the peculiar type of beauty that had pervaded Rossetti's pictures from the beginning. Henry James, who met her at this time, de-

scribed her as "a figure cut of a missal—out of one of Rossetti's or Hunt's pictures—to say this gives but a faint idea of her, because when such an image puts on flesh and blood, it is an apparition of fearful and wonderful intensity. It's hard to say whether she's a grand synthesis of all the Pre-Raphaelite pictures ever made—or they a 'keen analysis' of her—whether she's an original or a copy. In either case she is a wonder." When James looked at the "dark silent medieval woman" in the same room with one of Rossetti's portraits of her, he observed that the picture was "so strange and unreal that if you hadn't seen her you'd pronounce it a distempered vision, but in fact an extremely good likeness."[15]

Rossetti's infatuation was rendered the more agonizing by his sense of guilt over his miserable marriage. The opening of the grave had brought back poignant memories of his life with Lizzie, and in the spring of 1870 his friends became so concerned over his mental condition that he was persuaded to spend some weeks at a country house, where, unfortunately, an American acquaintance introduced him to chloral, a new remedy for insomnia. The Morrises and other friends came to be with him, and he was stimulated to a burst of creativity in both poetry and painting.

The recollections of his new American admirer, W. J. Stillman, testify to the continuing dominance of his personality: "His was a sublime and childlike egotism which simply ignored obligations, until, by chance, they were made legal, at which, when it happened, he protested like a spoilt child. And he had been so spoilt by his friends and exercised such a fascination on all around him, that no one rebelled at being treated in this princely way, for it was only with his friends that he used it. He dominated all who had the least sympathy with him or his genius."[16]

His book, which came out in April, included fifty-nine of his sonnets, most of them in a section entitled "Sonnets and Songs Towards a Work to Be Called 'The House of Life.'" At last there was an opportunity for the reading public to recognize the poet who had displayed such promise among his private circle almost a quarter of a century before. He appealed to his literary friends to give the book a good press, and the reviews were almost unanimously favorable, though Rossetti was worried by Swin-

burne's "rapturous paean" in the *Fortnightly*, "which is a darling bit of friendly enthusiasm but simply appals me (to speak truth) for the probable result of reaction from its excessive and super-natural laudation."[17] The first edition of a thousand copies was sold out within two weeks, and six further printings were required during the year.

When a reviewer commented on his influence on Morris and Swinburne, he remarked modestly in a letter: "I know that the volume and *élan* of their genius would always leave me far behind; and if I, as a rather older man, had any influence on them in early years, I feel in my turn that their work has duly reacted upon what I have done since."[18] Always diffident about his poetry, Rossetti was so astonished and gratified by all the praise that he wrote some thirty more sonnets during the next few months. His health and eyesight seemed to be improved, but his friends were worried by his heavy drinking and erratic behavior, and suspected that he was working too hard in the gloomy solitude of Tudor House. In the summer of 1871, when Morris decided to move out of London to Kelmscott Manor, a beautiful old house in Oxfordshire, Rossetti agreed to be a joint tenant. He was soon absorbed in furnishing and decorating the house, and above all in reading with Janey and accompanying her on long walks, in which he became more observant of natural beauty than he had been before. Morris had promptly gone off to Iceland in pursuit of sagas, and for weeks Rossetti enjoyed the exclusive company of his beloved.

The idyllic interlude was terminated by a devastating article on "The Fleshly School of Poetry" in the October issue of the *Contemporary Review*.[19] Though signed "Thomas Maitland," it was the work of Robert Buchanan, a prolific poet, novelist, and hack journalist, who had been conducting a feud with William Rossetti and Swinburne for several years. Indeed, the attack was probably aimed largely at Swinburne, who had scandalized the critics with his *Poems and Ballads* five years previously, and who was well known to be Rossetti's protégé; but Swinburne's notoriety was no longer topical and Rossetti's book gave Buchanan an opportunity to revive the furor.

Rossetti retorted with an article in the *Athenaeum* on "The Stealthy School of Criticism" and his friends rallied to his defense; but the damage had been done. Buchanan's lead was followed by the *Quarterly Review*, which described "Jenny" as "repulsively realistic" and the sonnets as "emasculated obscenity."[20] Soon afterwards Buchanan expanded his original article and issued it in pamphlet form. Typical of his virulent diatribe was his condemnation of the sonnet "Nuptial Sleep" for "putting on record . . . the most secret mysteries of sexual connection and with so sickening a desire to reproduce the sensual mood, so careful a choice of epithet to convey mere animal sensations that we merely shudder at the shameless nakedness."

Coming after a year of fame and praise, the assaults were disastrous to Rossetti's already unstable emotions, causing him to lose his hard-won self-confidence and assume that his life work was a failure. Besides, he was particularly vulnerable to the charge of immorality because his conscience was not clear. An inconsistent strand of prudery in his complex nature had shown itself in efforts to persuade Swinburne to modify the sexual excesses in his poems, and he still suffered from a morbid conviction that his infidelities had contributed to his wife's suicide. He was not wholly convinced by his own assertions that physical passion in his sonnets was merely symbolic of spiritual truths.

In consequence he began to suffer hallucinations, believing that he heard Lizzie speaking reproachfully to him in the song of birds (meaningful birdsong had been a recurrent image in his poetry from "The Blessed Damozel" onward). With a paranoiac delusion that there was a conspiracy to degrade him, he took bitter offense at *Fifine at the Fair*, the new poem by his old friend and idol Browning, because unluckily some elements in the story of a philanderer seemed to resemble the complications of Rossetti's married life.[21] He even suspected a personal reference in Lewis Carroll's latest nonsense poem, *The Hunting of the Snark*.

Upon realizing his derangement, his brother took him to be cared for at the home of a medical friend; but they were not aware that he had brought a bottle of laudanum, and during the night he took a heavy overdose, thus morbidly reproducing the cir-

cumstances of Lizzie's death. Doctors were summoned just in time to save him, and after two days in a coma he struggled back to life.

The next three months were spent in various parts of the country, under the solicitous care of friends, and though his health improved his delusions continued. He was positive that he could recover his equilibrium only at Kelmscott; when he was allowed to return there he became more serene, painted several of his best pictures, and composed lively limericks, an art form which he had long practiced. Whenever the Morrises were away he filled the house with loyal friends. Two years later, however, his delusions of persecution recurred and the equivocal joint occupancy with Morris was brought to an end. He never saw Morris again, and his relations with Janey settled down into an amiable middle-aged and invalidish friendship.

Back at Tudor House, he became more and more inaccessible. The intimacy with Swinburne, which had been slowly diminishing, came to an end. Rossetti found more pleasure in his menagerie of exotic pets than in the literary admirers who sought permission to visit him, though those who were admitted found him as fascinating as ever. Fanny Cornforth, now about to be married for a second time, was a frequent visitor and a constant drain on his purse. Janey Morris, with or without her daughters, saw him frequently, either in London or on his holiday trips to health resorts. Though his pictures were fetching handsome prices, his generous gifts and the peculations of various parasites kept him in debt. His solicitor and friend, Theodore Watts-Dunton, and other new admirers did what they could to maintain stability in his habits and his finances, but his physical and mental health steadily deteriorated.

He added about a dozen new sonnets during these final years, but his main poetry-writing took the form of ballads, which were safely objective and immune from any charge of moral obliquity. "Rose Mary," "The White Ship," and "The King's Tragedy" are much longer than "Sister Helen" and less economically constructed; the two historical narratives remain close to their documentary sources and "Rose Mary" is a conventional tale of the

supernatural in the manner of "Christabel" and *The Lay of the Last Minstrel.*

In 1881 Rossetti brought out his collected poems in two volumes; one was substantially similar to the *Poems* of ten years before, except that the sonnets were removed from it and—increased by the insertion of later ones to a total of 102—were entitled "The House of Life" and included in the second volume, *Ballads and Sonnets.* He made changes in the titles and phrasing of some sonnets to minimize erotic implications and to obscure any possible identification of Mrs. Morris as the beloved.

During the winter of 1881 he was gravely ill and depressed, and became partially paralyzed. As a forlorn hope he was taken to a friend's home at Birchington-on-Sea, and there a second stroke caused his death on Easter Sunday, 9 April 1882, a month short of his fifty-fourth birthday.

Quantitatively Rossetti's poetry cannot compete with that of his major contemporaries. He wrote no long poem, and his complete works are minuscule in comparison with the output of Tennyson or Browning, Swinburne or Morris. Only the less prolific poets, Arnold and Clough, produced a comparable total of pages, and Hopkins a slimmer one.

In range of form and theme, too, his work is not impressive. At the beginning of his career, indeed, he gave promise of versatility. His dramatic monologues showed remarkable proficiency in this "poetry of experience" at an early stage of its development. His youthful work even included two poems on public events. The sonnet "On Refusal of Aid Between Nations," with its unexpectedly modern tone of pessimism about a world from which the spirit of brotherhood has vanished, shows some of the despairing dignity of the crisis sonnets of Milton and Wordsworth; and "Wellington's Funeral" is a miniature ode that can be profitably compared with Tennyson's more pretentious one on the same occasion. But Rossetti soon turned away from the external world and confined himself to lyrics, sonnets, and the traditional genre of the ballad.

Just as his paintings went out of favor because of their formal decorative composition and their treatment of subjects symboli-

cally rather than literally, so his poems came to be condemned by many critics as insincere, a mere display of verbal and melodic virtuosity. His verse forms were highly patterned; his imagery was ornate; his addiction to medieval themes and techniques was remote from the modern world; he frequently used Catholic themes and attitudes without being an orthodox believer; he was neither realistic nor socially conscious.

Critics have always differed sharply as to the merits of Rossetti's poetry. As Browning grew old and cranky he found it highly obnoxious, in spite of all the enthusiasm that the Pre-Raphaelites had lavished on his own work while he was still little known:

I have read Rossetti's poems—and poetical they are—scented with poetry, as it were—like trifles of various sorts you take out of a cedar or sandalwood box: you know I hate the effeminacy of his school,—the men that dress up like women,—that use obsolete forms, too, and archaic accentuations to seem soft—fancy a man calling it a lilý—liliés and so on...; It is quite different when the object is to *imitate* old ballad-writing, when the thing might be; then how I hate 'Love' as a lubberly naked young man putting his arms here and his wings there, about a pair of lovers—a fellow they would kick away in the reality....[22]

Robert Buchanan's notorious vituperation took a similar line. Comparing Rossetti's poetry with his paintings, he declared:

There is the same thinness and transparency of design, the same combination of the simple and the grotesque, the same morbid deviation from healthy forms of life, the same sense of weary, wasting, yet exquisite sensuality; nothing virile, nothing tender, nothing completely sane; a superfluity of extreme sensibility, delight in beautiful forms, hues, and tints, and a deep-seated indifference to all agitating forces and agencies, all tumultuous griefs and sorrows, all the thunderous stress of life, and all the straining storm of speculation.... The fleshly feeling is everywhere.... It is generally in the foreground, flushing the whole poem with unhealthy rose-colour, stifling the senses with overpowering sickliness, as of too much civet. Mr. Rossetti is never dramatic, never impersonal—always attitudinizing, posturing, and describing his own exquisite emotions.[23]

Given the controversial attitudes of the late Victorian decades, such strictures from the virile and wholesome coterie were in-

evitably countered by the aesthetes. Walter Pater found all the traits of Pre-Raphaelitism in general, and Rossetti's poetry in particular, prefigured in "The Blessed Damozel":

Common to that school and to him, and in both alike of primary significance, was the quality of sincerity, already felt as one of the charms of that earliest poem—a perfect sincerity, taking effect in the deliberate use of the most direct and unconventional expression, for the conveyance of a poetic sense which recognized no conventional standard of what poetry was called upon to be.... Here was one, who had a matter to present to his readers, to himself at least, in the first instance, so valuable, so real and definite, that his primary aim, as regards form or expression in his verse, would be but its exact equivalence to those *data* within. That he had this gift of transparency in language—the control of a style which did but obediently shift and shape itself to the mental motion ... —was proved afterwards by a volume of typically perfect translations from the delightful but difficult "early Italian poets": such transparency being indeed the secret of all genuine style, of all such style as can truly belong to one man and not to another. His own meaning was always personal and even recondite, in a certain sense learned and casuistical, sometimes complex or obscure; but the term was always, one could see, deliberately chosen from many competitors, as the just transcript of that peculiar phase of soul which he alone knew, precisely as he knew it.[24]

Oscar Wilde naturally gave similar priority to poetic technique:

In Rossetti's poetry ... a perfect precision and choice of language, a style flawless and fearless, a seeking for all sweet and precious melodies and a sustaining consciousness of the musical value of each word are opposed to that value which is merely intellectual.... While, then, the material of workmanship is being thus elaborated and discovered to have in itself incommunicable and eternal qualities of its own, qualities entirely satisfying to the poetic sense and not needing for their aesthetic effect any lofty intellectual vision, any deep criticism of life or even any passionate human emotion at all, the spirit and the method of the poet's working—what people call his inspiration—have not escaped the controlling influence of the artistic spirit. Not that the imagination has lost its wings, but we have accustomed ourselves to count their innumerable pulsations, to estimate their limitless strength, to govern their ungovernable freedom.[25]

Thus, in the years after Rossetti's death, the criteria were firmly shifted from a moral to an artistic basis. The twentieth-century

critics therefore confined themselves for a while to argument about the validity of his artistic methods. Writing in 1932, Lord David Cecil said:

If Rossetti had given scope to the less purely aesthetic, more human side of his talent, he would certainly have been a more popular poet; and he might have been a greater one. His method of writing is as conscious as his choice of theme. He deliberately chooses different manners for different subjects; his narrative poetry is in the simple, coloured, concrete, angular style of the Pre-Raphaelites; his sonnets in a majestic, polysyllabic, abstract, Latinized diction, which rather recalls Milton. But both styles are conscious styles.... We feel his language clothes his thought admirably, but not that it is its incarnation. His rhythms, too, lack the irresistible lilt and rush of the natural singer....[26]

Paull F. Baum insists upon the "restrainedness and deliberation" in *The House of Life*:

Many of Rossetti's sonnets seem cramped for room, as if he had planned a large poem in which various divisions and subdivisions would have their proper place and space, then had gradually compressed the material until the original outlines became confused, ideas being forced together that were meant to stand apart.... It may seem perverse to hold ... that Rossetti was not primarily a lyric poet. In all but form, however, his best poetry is rather dramatic than lyric. Even when he is working from personal subjects, the "crises" of his own experience, he dramatizes as it were instinctively. He projects and objectifies; he does not sing of himself directly, but of a self seen as from a distance and "set" into a background.[27]

Twenty years after Baum, Graham Hough declared that

there is a good deal of literature in the bad sense in Rossetti's poetry. The decorative romantic poems, the ballads, the modern Browningesque monologues—all have easily recognizable literary models: they add something of their own to their several conventions, but not perhaps very much.... His dream world is built up out of easily recognizable properties, most of which have been used before, and its hushed stillness is due not so much to a real remoteness from this vale of tears as to an extremely efficient sound-proofing system.... The young Rossetti took sincerely and wholeheartedly from the *Vita Nuova* the idealization of a love still virginal: but he had no idea of how this was to be accommodated to the demands of the senses, or to the demands of the soul for something that would last beyond life. ... Hence in his poetry the mere romantic confusion of unrelated

notions that could only have made sense if fitted into some coherent scheme of belief.[28]

After registering their strictures, however, Cecil and Baum and Hough and virtually all the other recent critics express high praise for Rossetti's mastery of poetic form. Cecil remarks:

> The fact that he is a conscious artist makes him consistent. Reading him we have that delightful sensation so rarely permitted us by the reckless poets of England, that we are safe. As with Milton and Spenser and Gray, and with how few others, we can start a poem of Rossetti's sure of a smooth and steady flight, unbroken by bumps and jolts into the prosaic, the ridiculous, and the irrelevant. He is never patchy; the golden glaze of his beautifully finished style harmonizes his whole picture in the same level glow. And it does more than harmonize; it dignifies it. Rossetti's conscious craft is not that of the *petit maître*; it is a lofty speech adopted in no irresponsible spirit for lofty themes.[29]

Baum adds in praising the use of symbolism in *The House of Life*: "Of course Rossetti is not wholly with the great mystics; he cannot dwell constantly in their white light. . . . It is much, however, that he had seen the vision, though he held to it but fitfully; and . . . one might maintain that his failings on the side of 'fleshliness' are simply the tokens of his great desire for the great truth, the shadows which are humanly inseparable from the light."[30] Hough admits somewhat grudgingly of the poems:

> Perhaps the first thing to say . . . is how well, with few exceptions, they are written. . . . From his earliest works . . . his writing, however frail and overwrought its sentiment, has an assurance, precision and directness of attack. . . . The dramatic monologues *A Last Confession* and *Jenny* are as good as anything of Browning's of the same kind, with perhaps the evidence of a less commonplace mind behind them. . . . His confused and partial return to the medieval concept of an ideal love, dominating the whole of life, is a genuine enrichment of the content of poetry. The bread-and-butter treatment of sexual themes, the "passionless sentiment" of Tennyson, is replaced by something which, for all its divagations, is a more adequate version of experience.[31]

The ambivalent attitude of the foregoing critics is displayed even more openly by John Heath-Stubbs. Of "The Blessed Damozel," he remarks:

If we take it at its face value, the whole conception is cheaply senti-
mental and muddled to the point of absurdity. . . . There is, however,
another line of approach, which may help us to a more sympathetic
understanding of this and of the rest of Rossetti's work. The world
of this poetry is a kind of limbo, a half-sensuous, pagan dream world,
such as was explored by Edgar Allan Poe, and sometimes, by Shelley.
. . . Rossetti is an explorer of the subconscious, of subtle states of mind
between waking and sleeping. . . . In some respects *The House of Life*
contains the most satisfactory of Rossetti's work. . . . Nevertheless,
an undisciplined, rootless man like Rossetti was incapable of attain-
ing the crystalline clarity and perfect balance of his models. His
archaic and affected diction, the movement of his lines, clogged with
lifeless monosyllables, the vagueness of his sensuous images—all these
tend to blur his picture, and make his passion seem strained and
unreal.[32]

It has remained for W. W. Robson, as a disciple of the austere
F. R. Leavis, to revive all the earlier charges against Rossetti in
full force. He begins mildly enough by mentioning his "obvious
literariness": "Whether in his simple or his elaborate manner,
one is conscious all the time of the artifice, the sophistication, of a
poet using a diction and movement which he well knows to have
been used before by other poets. There is little that is fresh, spon-
taneous, un-literary, immediate. . . . In a Rossetti sonnet . . . our
response is predominantly a response to *words*, words heavily
charged with literary association and reminiscence; there is noth-
ing that is strong in imagery or concrete in evocation. . . ." After
another page or two, Mr. Robson begins to sound like Buchanan:

His most interesting work, in my opinion, is his turbid, mannered
love-poetry, with its characteristic alternation of the hectic and the
languid, of overripe voluptuousness and the chill of desolation. . . .
Willowwood is everywhere in this poetry: romantic idealization, and
half-glimpsed behind it, its corollary of selfishness, and incapacity
for a mutually respecting relation with another; ahead of it, the
nemesis of inevitable disappointment, weariness with oneself, a sense
of irretrievable waste and loss. . . . Rossetti's guilt, remorse, and sensa-
tion of spiritual bankruptcy remain egocentric. The result is that doom
of the emotionalist—monotony; the monotony which so soon afflicts
the reader of his poetry, small in bulk though it is. Worse still is the
pretentiousness which commonly accompanies the over-valuing of
one's experience.[33]

Though the wheel of critical opinion about Rossetti seems to have described a large circle during the past century, there is perhaps no other English poet who has consistently left critics so baffled—not to say exasperated—by a conflict between their accepted aesthetic and psychological criteria, on the one hand, and on the other a disquieting response to some indefinable and profoundly individual mesmerism inherent in his poems. It was this uniqueness that prompted Gerard Manley Hopkins to add a special fourth category to his three divisions of "the language of Poetry": "I may add there is also *Olympian*. This is the language of strange masculine genius which suddenly, as it were, forces its way into the domain of poetry, without naturally having a right there. Milman's poetry is of this kind I think, and Rossetti's *Blessed Damozel*. But unusual poetry has a tendency to seem so at first."[34]

Rossetti's reflective and descriptive poems are naturally the most inert. The early "Dante at Verona" is a versified biographical and critical study, a by-product of his translating of the *Vita Nuova*. Its allusive and elliptical style is reminiscent of Browning's *Sordello*, which it almost rivals in obscurity. Of Rossetti's strictly intellectual pieces, the most effective is "The Burden of Nineveh," the best poem inspired by the British Museum since Keats's "Elgin Marbles" and "Grecian Urn." The imaginative reconstruction of an ancient culture shows not only archaeological knowledge but the acute temporal sense which Professor Jerome Buckley has pointed out to be a phenomenon of the Victorian consciousness. The quadruple rhymes appropriately retard the poem's movement, and the inscrutable figure of the bull-god is ironically contrasted with glimpses of contemporary London:

> Now, thou poor god, within this hall
> Where the blank windows blind the wall
> From pedestal to pedestal,
> The kind of light shall on thee fall
> Which London takes the day to be:
> While school-foundations in the act
> Of holiday, three files compact,
> Shall learn to view thee as a fact

Connected with that zealous tract:
 "Rome,—Babylon and Nineveh."

In contrast with these rather wordy poems, Rossetti's sonnets for pictures show that he knew how to produce a vignette that gives a verbal equivalent for a painting and the feeling that it evokes in him. In this sort of impressionistic criticism he was a disciple of Ruskin and a forerunner of Pater. More numerous are his sonnets on his own paintings; here the creative impulses were so intertwined that it is usually impossible to determine which came first, the poem or the picture. Comparable literary interpretation can be found in his sonnets on his five favorite English poets—Blake, Chatterton, Coleridge, Shelley, and Keats.

However skillful, such poems about art and literature are bound to lack emotional intensity. Rossetti makes a closer contact with human passions in his narrative poems, though these too, through the use of archaic technique, are held at a distance from the modern reader's experience.

Folk ballads and romances of chivalry had been loved by Rossetti since his boyhood, as they were by the Romantic generation that influenced him most. Three of the poets that he admired highly, Chatterton, Coleridge, and Keats, had sought to reproduce the aloof impersonality and deceptive simplicity of medieval narrative, and Rossetti successfully followed suit.

His ability to create a replica of the diction and devices of folk ballad is demonstrated in "Stratton Water;" but the happy ending is out of key both with the archetypes on which it is modeled and with the suspense so well established by the ominous approach of the flood. As the climax nears, the poet ineptly seeks to lighten the tone with a few facetious phrases:

There seemed no help but Noah's Ark
 Or Jonah's fish that day....

But woe's my heart for Father John
 And the Saints he clamoured to!
There's never a saint but Christopher
 Might hale such buttocks through.

Rossetti's ever-present sense of risibility seems to break through the remarkably successful assumption of a ballad-singer's grimness.

This was the only poem in which he confined himself strictly to the simple ballad quatrain and ballad diction. "Sister Helen" uses the more complex form of dialogue and refrain, but the situation is presented with an immediacy and psychological complexity that are alien to authentic ballads and owe something to the dramatic monologue.

His longer medieval narratives are closer to the verse romances than to the ballads. At an early age he began and abandoned an ambitious poem entitled "The Bride's Prelude," but even though he later returned to work on it and brought it to a total of 920 lines it did not get beyond the end of Part 1, and remains, like "Christabel," a cryptic fragment.

As far as it goes, the poem consists of a prolonged confession by the bride to her sister on the eve of her wedding. In great detail Aloyse tells Amelotte the full story of her life and how she was seduced by an illegitimate kinsman, who subsequently rose to eminence and is now belatedly about to marry her. The account of her mental torment during her pregnancy is convincing but is prolonged until its nightmarish intensity begins to diminish. Apart from the Old French names there is little effort to locate the action in place and time, and the background of feudal war and revenge is conveyed in confused glimpses through Aloyse's agonized recollections. Many of Rossetti's characteristic visual scenes are interspersed in breaks in the monologue. Sharp aural effects—a hound splashing in the moat, the distant music of minstrels—are used, as in "My Sister's Sleep," to emphasize the oppressive stillness within the chamber. The stanza form is exceptional: consisting of two unrhymed lines of four and three stresses, followed by a four-stressed triplet, it tends to be soporific rather than melodious. The poet made a wise decision in discontinuing the task.

Based on a dull little tale in the *Gesta Romanorum*, "The Staff and Scrip" is a less diffuse narrative, confined to 215 lines and presented so far as possible in dialogue. A returning pilgrim ex-

changes his staff and scrip for sword and shield to fight on be-
half of a defeated queen, and dies in unequal combat. The most
interesting feature of the story is the calculated avoidance of cli-
max: for the rest of the queen's life she keeps the staff and scrip
above her bed, but she never opens the satchel to seek the identity
of the pilgrim, and so the reader is cheated of the expected revela-
tion of some romantic anterior episode.

The queen's name "Blanchelys" again implies an Old French
setting, but otherwise—as in "The Bride's Prelude"—the action
could take place anywhere in medieval Europe. Indeed, follow-
ing the practice of the romances (and of the Gothic novel) Ros-
setti is usually vague and inconsistent as to historical and geo-
graphical location. When he does use an identifiable place-name
in "Sister Helen" it is inappropriate: editors of textbooks con-
scientiously annotate "the banks of Boyne" as referring to a
river in Northern Ireland; but the other proper names in the poem
are all English or Scottish, and furthermore the feudal way of life
which is depicted never existed in medieval Ireland.

The longest poem in the middle ground between folk ballads
and medieval romances, "Rose Mary," is a good example of Ros-
setti's technique. He uses the octosyllabic meter popularized by
Coleridge and Scott, but instead of their free-flowing couplets he
creates closed five-line stanzas of a couplet and a triplet. The in-
terpolated "beryl songs" are an ornate device, varying the simple
stanzas of the narrative with their eerie pattern of long and short
lines and internal rhymes. They were apparently inserted to ex-
plain the situation more clearly, but they are more confusing than
helpful.

The story is basically identical with "Sister Helen"—the false
knight who deserts his sweetheart for another woman. Rossetti's
use of this particular folk-ballad motif in his two most powerful
narratives reveals his obsession with seduction and betrayal, and
the personal undertone appears in a significant detail: Rose Mary
has the heavy dark hair that in the paintings and sonnets is the
distinctive feature of Jane Morris, while the rival woman has the
golden tresses of Fanny Cornforth.

The narrative is developed with effective use of irony. If Rose

Mary is a virgin, as her mother believes, she can see a true vision in the magic beryl and thus save her lover from his enemies. Her mother transmits the warning, only to learn later that the vision was false and served to lure the knight into a trap. Thus she suspects that her daughter has secretly had intercourse with Sir James. In an agony of remorse Rose Mary realizes her guilt for her lover's death. Next, when the mother prays by the corpse she discovers a letter proving that the knight was about to marry another girl, the sister of the enemy who slew him. The final irony is that when Rose Mary destroys the evil beryl stone at the cost of her own life (like the Lady of Shalott breaking her spell) she still believes in the loyalty of her lover and thus wins absolution for her sin. This ending suggests ambiguous moral questions about the nature of sin and redemption. In its depiction of feudal ruthlessness and treachery the poem recalls several by Morris, such as "The Haystack in the Floods" and "Shameful Death"; but Rossetti contributes levels of implication beyond Morris's impassive chronicling of events.

Since his other two late narrative poems retell familiar episodes of medieval history, they have specific settings instead of the generalized chivalric region and era that he previously employed. Each poem being narrated by someone who participated in the action, they might be termed dramatic monologues; but the dramatic immediacy and irony are lacking, since both speakers are looking back on events long past.

In "The White Ship" the narrator is the sole survivor of the wreck in which Henry I lost his son and daughter and three hundred courtiers. The stanza form, like that of "Sister Helen," is ballad with refrain, and the refrain lines emphasize the irony that a poor Norman butcher was rescued while all the royal and noble personages perished: "Lands are swayed by a King on a throne. . . . The sea hath no King but God alone." As there is no variation in the refrain, however, it is not printed with every stanza and so the reader is mercifully spared the repetition which loses in tedium what it gains in suspense.

"The King's Tragedy" is narrated by Catherine Douglas, the heroine of the vain attempt to protect James I of Scotland from assassins. In this poem Rossetti reverts to the simple ballad qua-

train, with occasional substitution of five-line and six-line stanzas. He intersperses five stanzas adapted from James's own famous poem, "The King's Quair," though he feels obliged (with apologies in the headnote) to curtail James's meter in order to conform with his own. The tragic climax of the poem is not so much the king's death as the hopeless effort of Kate Barlass to save him and the vengeful sorrow of his bereaved queen. In this final poem Rossetti remains faithful to one of his recurrent topics, a devoted and self-sacrificing woman whose love transcends mortal limitations.

In two peculiar poems, "Troy Town" and "Eden Bower," he tried to adapt the ballad with refrain to themes far removed from the folk tradition. Both deal with his other most frequent archetype, the ruthless woman who destroys a man by her seductive beauty. In both, as in "Sister Helen" and "Rose Mary," witchcraft plays a part: Helen of Troy invokes the aid of Venus to win Paris's love, and Lilith similarly conspires with the serpent to tempt Adam away from his new mate, Eve. In each poem the ominous refrain lines insist upon the catastrophic outcome—the destruction of Troy and mankind's fall from grace. The two poems, however, are ingenious rather than deeply moving.

Rossetti is seldom at his best in the lyric mode. His extended lyrics, such as "The Stream's Secret" and "Love's Nocturn," suffer from the defects that are so deleterious in Swinburne—rhetorical verbiage, elaborate stanza patterns, overextended metaphors and personifications. Lulled by the hypnotic melodies, the reader loses contact with the poet's personal feeling. Only in two brief pieces did he achieve the concentration and individuality of the pure lyric. "The Woodspurge" captures the psychological paradox in which emotional paralysis is combined with acute sensuous perception, and "Sudden Light" expresses the elusive sense of dejà vu which tempts many people to believe in reincarnation:

> I have been here before,
> But when or how I cannot tell:
> I know the grass beyond the door,
> The sweet keen smell,
> The sighing sound, the lights around the shore.

You have been mine before,—
 How long ago I may not know:
But just when at that swallow's soar
 Your neck turned so,
Some veil did fall,—I knew it all of yore.

Has this been thus before?
 And shall not thus time's eddying flight
Still with our lives our love restore
 In death's despite,
And day and night yield one delight once more?

Here the poet's decorative devices—the parallelism of the open-
ing lines of the stanzas, the concealed internal rhymes in the
closing lines—provide unity and melody without being unduly
conspicuous.

Ultimately, it is in the sonnet that Rossetti can be classified
as preeminent among the Victorian poets. His early translating
of poems by Dante and others of the same era determined his
preference for the Italian rather than the English form and sup-
plied the faintly archaic diction that is part of his individual tone
—echoes of the *dolce stil nuovo*. His prefatory sonnet to *The
House of Life* was among his last, and remains one of his best.
By a tour de force he simultaneously defines the distinctive quali-
ties of the sonnet and exemplifies what he is describing; a whole
treatise on a literary genre is condensed into 106 words and con-
veyed wholly through an interwoven sequence of metaphors:

A Sonnet is a moment's monument,—
 Memorial from the Soul's eternity
 To one dead deathless hour. Look that it be,
Whether for lustral rite or dire portent,
Of its own arduous fulness reverent:
 Carve it in ivory or in ebony,
 As Day or Night may rule; and let Time see
Its flowering crest impearled and orient.

A Sonnet is a coin: its face reveals
 The soul,—its converse, to what Power 'tis due:—
Whether for tribute to the august appeals
 Of Life, or dower in Love's high retinue,

It serve; or 'mid the dark wharf's cavernous breath,
In Charon's palm it pay the toll to Death.

In two famous sonnets Wordsworth defended this form from charges that its brevity precluded poetical significance: he listed some of the great poets who employed it and declared that it could be a vehicle for the most intimate emotional utterance. Rossetti characteristically emphasizes rather its potential for exquisite technique.

Perhaps to illustrate the alternative forms of the sonnet, this one is a hybrid, with a Petrarchan octave and a Shakespearean sestet. Each of its two parts consists of an extended metaphor and the metaphors are united by the fact that both deal with sculpture—a monument and a coin. Hence emerges another basic pattern, contrast. A monument is the largest product of the sculptor's art; a coin is the smallest. A monument is expected to last for many centuries; a coin is soon worn smooth by handling. A monument records the past; a coin is current in the present. Resembling both, a sonnet is simultaneously tiny in scope and vast in implication, ephemeral in mood but permanent as a glimpse of an eternal human emotion. The contrasts are carried into details of phrasing: "lustral rite" (expiation of past sin) and "dire portent" (prophecy of future disaster), day and night, white ivory and black ebony, and so, of course, life and death. Paradox is conspicuous in "moment's monument" and "dead deathless," and these phrases are further emphasized by alliteration and assonance. Further, lines 9 and 10 point out the double significance of a sonnet; like the two faces of a coin it displays not only the poet's intimate and transient emotion but also a large general theme—life, love, death.

In the sequence that is introduced by this sonnet, modern readers may feel that the general themes overshadow the personal experiences; each "moment" has been all too marmoreally turned into a "monument." The impression is due largely to the prevalence of personifications, which we tend to equate with frigid eighteenth-century poetic diction. Rossetti, however, makes the personified figures so pictorially specific that they function as symbols rather than as abstractions. Some Victorian readers, in-

deed, like Browning, objected to the too explicitly physical portrayal of an adult Eros.

In 1870, a year after the first installment of the sonnets had appeared in the *Fortnightly*, Rossetti wrote to his friend Dr. Hake: "I should wish to deal in poetry chiefly with personified emotions; and in carrying out my scheme of the 'House of Life' (if I ever do so) shall try to put in action a complete *dramatis personae* of the soul."[35] By this time, then, if not earlier, he had conceived an organizing principle for the sequence as a psychological analysis of passionate love.

The title of the sequence, *The House of Life*, being derived from astrology, suggests the power of fate and the universality of the feelings that are chronicled. The personal element is further obscured by the deliberate avoidance of chronological order, which, if it had been observed, might have revealed a biographical correlation comparable to that in *Astrophel and Stella* or *Sonnets from the Portuguese*. In their existing order it would be impossible without external evidence to infer that the sonnets deal with three different women. The pathetically dependent Lizzie, the lusty and aggressive Fanny, and the aloof, cryptic Jane are as elusive in the sonnets as are the dark lady, the fair lady, and the beloved friend in Shakespeare's (which also, many critics believe, are not in the order in which they were originally written). The most explicitly autobiographical sonnet is 36, "Life-in-Love," which tells how his new passion "vivifies / What else were sorrow's servant and death's thrall." Previously there has been only

> The waste remembrance and forlorn surmise
> That lived but in a dead-drawn breath of sighs
> O'er vanished hours and hours eventual.

In the sestet he describes the tress of Lizzie's hair which he preserved—"all love hath to show / For heart-beats and for fire-heats long ago;" and the sonnet ends with the morbidly vivid detail reported by those who opened Lizzie's grave—"all that golden hair undimmed by death."

Rossetti implies an elementary thematic classification by divid-

ing the sequence into two parts, "Youth and Change" (sixty sonnets) and "Change and Fate" (forty-two sonnets). One might assume that the sonnets in the first section would be the earliest written; but thirty-three of them (well over half) did not exist in time for inclusion in the first edition (1870). These do have enough exuberance, however, to justify their inclusion in the "Youth" section, for most of them were composed during the brief revival of health and spirits in 1870–71, when Rossetti's passion for Jane was at its zenith (and perhaps was reciprocated). On the other hand, the pervasive sense of frustration and despair in the second section is as gloomy in early sonnets, such as 68, "A Dark Day," dating from his difficult years as Lizzie's lover, as in the latest ones (such as 61, "The Song Throe"), written when he was ill and isolated from Jane.

Rather than comparing *The House of Life* with other famous sequences of love sonnets, it may be preferable, as Professor William E. Fredeman has suggested, to consider it as resembling Tennyson's *In Memoriam*, which, also written at intervals over many years, without a predetermined structure, eventually coalesced into a poem with a distinct unity.[36] Just as in *In Memoriam* several sections sometimes form a continuous unit, followed by an abrupt break, so in Rossetti's poem there are groups of interrelated sonnets, such as the four entitled "Willowwood" (49–52) and the three entitled "True Woman" (56–58). Two such groups, "The Choice" (71–73) and "Old and New Art" (74–76) are among the earliest in the whole sequence, having been written in 1847–49, before Rossetti had encountered Lizzie Siddal, and they have sometimes been condemned as irrelevant to the love theme. They do have a logical place, however, where they occur in the "Change and Fate" division, for both groups portray the young poet and painter confidently facing his career before encountering obstacles and disillusionment. The three sonnets in "The Choice" show him deciding on a life of creative action instead of either hedonism or ascetic withdrawal; following immediately, the other group of three summarizes the Pre-Raphaelite doctrine and declares Rossetti's dedication of himself to the cause. Obviously, then, the sonnets are not all to be seen as

"monuments" to actual "moments" in the poet's love life, or susceptible of rearrangement into a coherent biographical narrative. Some of them have traits of symbolic elaboration or even of "metaphysical" ingenuity inappropriate to immediate transcription of a specific experience.

From the evidence of the shifting arrangement of the sonnets at various stages of their accumulation, it seems clear that Rossetti was working toward a logical structure for the whole sequence. In its final form, then, *The House of Life* is a series of variations on a theme, which he described in "The Stealthy School of Criticism" as "the analysis of passion and feeling;" and in the same essay he spoke of the sonnet "Nuptial Sleep" (the principal item in Buchanan's indictment) as a "sonnet stanza" and "no more a whole poem, in reality, than is any single stanza of any poem throughout the book." In defending the integrity of the poem as a whole, Professor Fredeman goes so far as to point out that the proportion between the two sections of the sequence is approximately that between the octave and the sestet of a single sonnet, with the word "Change" in both headings to indicate a thematic link. This could be expected of a poet who as a painter was scrupulous about the compositional balance of each picture, and who indeed refused to display his paintings in exhibitions where they would be hung indiscriminately among others.

At the mathematical center of the sequence come the four "Willowwood" sonnets, equivalent to Carlyle's "center of indifference," a declaration of frustration and self-pity. Subsequent to these, in the concluding sonnet of the first section and the first two of the second, Rossetti marks the transition by recognizing that a poet's sufferings can be transmuted into art; and thereafter the poem is suffused with autumnal color and imagery, in contrast with the springtime vitality of the first section. As the poet accepts his limitations and the futility of love, he begins, in spite of his preoccupation with death, to find something like serenity. In "The One Hope," the sonnet that Rossetti placed last in the sequence, though it was not among the last to be written, he affirms a mood of resignation and a persistent hope that "When vain desire at last and vain regret / Go hand in hand to death" he

may find Peace. Some commentators insist that what he expects to find is Love in some transcendent realm, but the text of the sonnet offers no evidence for this interpretation. Rather, it echoes the introductory image of the coin that pays the toll to Death, and it expresses the same mood as Swinburne's "Garden of Proserpine" and many poems of Rossetti's sister Christina.

When viewed in this light, *The House of Life* is not a miscellaneous batch of sonnets arbitrarily lumped together, but a philosophical poem, in the elegiac mood, epitomizing the theme of mutability and disappointment, the dominance of fate over individual wishes. The apparent lack of cohesion is a result of the pictorial and symbolic method, which avoids didactic progression and leaves the reader to draw the inferences. Whether or not any particular sonnet can be identified with Rossetti's personal life, all have been subjected to the annealing influence of his distinctive imagination and his emotional power.

The prevailing pictorial technique does not preclude variety. Some of the sonnets resemble the brightly colored and sun-drenched paintings of the first Pre-Raphaelites. A good example is "Silent Noon":

> Your hands lie open in the long fresh grass,—
>> The finger-points look through like rosy blooms:
>> Your eyes smile peace. The pasture gleams and glooms
> 'Neath billowing skies that scatter and amass.
> All round our nest, far as the eye can pass,
>> Are golden kingcup-fields with silver edge
>> Where the cow-parsley skirts the hawthorn-hedge.
> 'Tis visible silence, still as the hour-glass.
>
> Deep in the sun-searched growths a dragon-fly
> Hangs like a blue thread loosened from the sky.—
>> So this wing'd hour is dropt to us from above.
> Oh! clasp we to our hearts, for deathless dower,
> This close-companioned, inarticulate hour
>> When twofold silence was the song of love.

Here is the Pre-Raphaelite attention to detail—the pink finger-tips, the dragonfly, the kingcups and cow-parsley (surely the first time that this vulgar name appears in poetry). The colors are

the brilliant green of fresh grass and blue of sky (picked up by the hue of the dragonfly), the gold and silver of the flowers. The general effect is not unlike such an idyllic painting as Holman Hunt's *Hireling Shepherd*.

More often, however, the pictorial sonnets resemble Rossetti's own style of painting, highly decorated and artificially grouped, as in the opening sonnet, "Love Enthroned":

> I marked all kindred Powers the heart finds fair:—
> Truth, with awed lips; and Hope, with eyes upcast;
> And Fame, whose loud wings fan the ashen Past
> To signal-fires, Oblivion's flight to scare;
> And Youth, with still some single golden hair
> Unto his shoulder clinging, since the last
> Embrace wherein two sweet arms held him fast;
> And Life, still wreathing flowers for Death to wear.
>
> Love's throne was not with these; but far above
> All passionate wind of welcome and farewell
> He sat in breathless bowers they dream not of;
> Though Truth foreknow Love's heart, and Hope foretell,
> And Fame be for Love's sake desirable,
> And Youth be dear, and Life be sweet to Love.

The dominant figure of Love occupies the central position in the upper portion of the canvas, while grouped below him are the other allegorical figures, each individualized by a brief description, expanding from the phrases sufficient for Truth and Hope to the fuller detail and more active postures of Fame, Youth, and Life. To prevent the two halves of the canvas from breaking apart, the last three lines recapitulate the list of ancillary figures in such a way as to emphasize their participation in the totality of Love.

Some of the sonnets are constructed upon complex antitheses. "Love's Lovers" (8) describes the frivolous women who are attracted by Love's jeweled girdle and "gold-tipped darts," or feel flattered by the "silver praise" of his songs, or "prize his blindfold sight" and the wings that soon waft him away, whereas "my lady only loves the heart of love." "Passion and Worship" (9) is built around two musicians, "flame-winged" Passion with a hautboy and "white-winged" Worship with a harp; both are

cherished by the lady—Passion's "mastering music walks the sun-lit sea" whereas Worship's gentle harp is preferable "where wan water trembles in the grove / And the wan moon is all the light thereof."

Only a few of the sonnets, of course, form complete single pictures. More often the visual images are confined to a few lines and mingle with other kinds of poetic utterance. The three sonnets depicting voluptuous passion (6, 6a, 7), centering on the notorious "Nuptial Sleep" (which is numbered outside of the series because Rossetti capitulated to criticism and omitted it from the 1881 edition), combine brief pictorial images with psychological states and physical sensations. Similarly, 39, "Sleepless Dreams," employs the scene of a dense wood at night to record the misery of Rossetti's insomnia. Sometimes the structural device is dramatic dialogue, as in 38, "The Morning's Message." An exceptional experiment is the third of the "Willowwood" group, which is a song uttered by Love; to enhance the melodious effect, the same rhyme-sound is carried over from the octave to the sestet, the rhyme-word "Willowwood" occurs in both the first and the ninth lines, and two of the rhymes with it are triple—"widow-hood" and "pillow should." In 26, "Mid-Rapture," which is another specimen of pure lyric, the first line is repeated as the last one, giving the effect of a completed musical pattern.

The foregoing examples must suffice to represent the range of variety that Rossetti was able to achieve within the formal limitations of the sonnet. On the other hand, many recurrent images tie the whole sequence together. The personified figure of Love is the most obvious. Song and music reappear frequently, as do wings, flames, and mirrors. The setting for many of the sonnets, as in Rossetti's paintings, is a shadowy, enclosed space; favorite words are "bower" and "glade," "grove" and "thicket" and "covert," "shrine" and "chamber." The scene is often viewed in twilight or moonlight. A peculiar recurrent simile is the birth of a child (sometimes stillborn); one cannot help connecting this almost obsessive image with its equivalent in Rossetti's brief married life.

A casual reader may find the sonnets monotonously similar be-

cause of the pervasive melancholy, the personifications, the complicated sentence structures, the ornate patterns of parallels and antitheses in phrases and sounds. Careful scrutiny, however, reveals a variety in moods as extensive as that in techniques. A number of the sonnets depict springtime rural scenery and express the ecstasy of love. At the other extreme are those which utter desperate remorse and self-contempt, even contemplation of suicide, such as 85, "Vain Virtues," 86, "Lost Days," and 97, "A Superscription," which merited the epithet "terrible sonnets" long before it came to be applied to some written by Hopkins. Between the two extremes can be found diversified moods of physical passion, quiet reflection, or passive resignation. Often states of mind are paradoxically mixed, as when foreboding thoughts of separation intrude upon the intensity of a love-episode. A few of the sonnets contain scholarly references that may require explication; thus Rossetti's information about Lilith in 78, "Body's Beauty," is derived from Burton's *Anatomy of Melancholy* and from Goethe's "Walpurgisnacht" section of *Faust*, 88, "Hero's Lamp," is also indebted to Burton, and 87, "Death's Songsters," is based, of course, on Homer. Rossetti's familiarity with the history of art shows in 94, "Michelangelo's Kiss." Biblical references and echoes occur throughout.

The distinctive poetic voice of Dante Gabriel Rossetti does not result wholly from his pictorial method and his despondent (sometimes morbid) tone; it resides also in his metrical and verbal techniques. In writing poetry, as in painting pictures, he revised meticulously in pursuit of perfection. "He abhorred," says his brother, "anything straggling, slipshod, profuse, or uncondensed."[37] Contrasting his own concentrated effects with Swinburne's verbose fluency, Rossetti remarked: "I lie on the couch, the racked and tortured medium, never permitted an instant's surcease of agony until the thing on hand is finished."[38] His brother stated the same trait more bluntly: "His practice with poetry is first to write the thing in the rough, and then to turn over dictionaries of rhyme and synonyms so as to bring the poem into the most perfect form."[39] The result is sometimes intolerably ornate, but usually it supplies the connotative intensity that vin-

dicates poetic compression. His addiction to the formal rigor of the Petrarchan sonnet, his adept use of subtly varied refrains in his ballads as an equivalent to the "repetition with variation" in a decorative design or a musical composition, his modifications of the basic quatrain by adding one or two lines, are methods of providing picture-frames or compositional patterns to the poems. The lingering cadences of "The Blessed Damozel," achieved by the simple device of extending the primitive ballad quatrain through two more lines, echoed through later poetry, as for instance in Wilde's "Ballad of Reading Gaol."

As important as stanza structure is the selection of language. Though Rossetti's verbal effects usually seem complex, his vocabulary is remarkably simple, and not merely in the ballad-imitations. The mournful and portentous movement of his lines results primarily from sequences of equally stressed monosyllables that retard the tempo:

> Yet one more thing comes back on me tonight
> Which I may tell you.
>> ["A Last Confession"]

> "I wish that he were come to me,
> For he will come," she said.
>> ["The Blessed Damozel"]

He achieves strong control of tempo when he inserts a long Latinate word in the midst of monosyllables, producing a sort of ripple in an otherwise slow and regular movement:

> Which with snatched hands and lips' reverberate stroke
> Then from the heart did rise.
>> ["The Stream's Secret"]

> What song did the brown maidens sing,
> From purple mouths alternating?
>> ["The Burden of Nineveh"]

In *The House of Life* occasionally a whole line is dominated by polysyllables:

> Like multiform circumfluence manifold
> Of night's flood-tide.
>> [41]

> Tragical shadow's realm of sound and sight
> Conjectured in the lamentable night.
>
> [62]

Such lines occur only rarely, however, to vary the monosyllabic austerity. Partly as a consequence of Rossetti's adherence to short words, but surprising in view of his personal and literary antecedents, the proportion of Anglo-Saxon words is remarkably high, pointing toward the later efforts of William Morris and Charles Doughty to reinvest the diction of poetry with pre-Chaucerian vigor.

Archaisms in Rossetti's poetry were so exasperating to his contemporary critics that they came to be regarded as the chief token of the Pre-Raphaelite manner. In an era committed to topical relevance in poetry, archaisms were ridiculed as sheer affectation and insincerity, and no credit was given to their possible connotative or melodic value. In "The Portrait," for instance, which is presumably not set in any earlier time, we find "mine eyes," " 'mid," "knoweth," "passing fair," " 'tis," "athirst," "eve," "twixt." Such words contribute a touch of formal tradition which places the poem (which is one of Rossetti's most moving pieces) in a long procession of laments that fades back through the centuries. In *The House of Life*, which is consistently maintained in an eternal world of art rather than in the ephemeral surroundings of mid-Victorian England, archaisms and inkhorn terms are more prevalent:

> Like fiery chrysoprase in deep basalt.
>
> [35]
>
> Within each orb Love's philtred euphrasy.
>
> [37]
>
> That had Love's wings and bore his gonfalon.
>
> [48]

In 44 we even find the word that later became the monopoly of Yeats:

> What unsunned gyres of waste eternity?

Far more representative of *The House of Life*, however, are passages like these:

Or (woe is me!) a bed wherein my sleep
Ne'er notes (as death's dear cup at last you drain)
The hour when you too learn that all is vain
And that Hope sows what Love shall never reap.

[44]

Though Rossetti always remained within the pattern of traditional meters, he made use of substituted feet and extra unaccented syllables:

And the Knight laughed, and the Queen too smiled,
But I knew her heavy thought.

["The King's Tragedy"]

Lazy laughing languid Jenny,
Fond of a kiss and fond of a guinea.

["Jenny"]

Such instances do not go far toward producing syncopated effects like Swinburne's, but they do form a link between the younger poet's singing melodies and the liberating metrical innovation of Coleridge.

Also presaging Swinburne in an inconspicuous manner is Rossetti's employment of alliteration, assonance, and repetition. The opening line of "Jenny" (quoted just above) is a good instance of his alliterations, and here are a few others, from *The House of Life*:

and the bonds of birth were burst. . . .
Leaves us for light the halo of his hair.

[2]

Blazed with momentous memorable fire.

[62]

Cast up thy Life's foam-fretted feet between.

[97]

His assonances often take the form of internal rhyme:

Around the *vase* of life at your slow *pace* . . .
And *all* its sides *al*ready understands.
There, *girt*, one breathes *alert* for some great race.

[95]

Rossetti's most characteristic device, however, which enhances the effects of deliberate emphasis and decorative pattern, is the repetition of a whole word:

> Into the silence languidly
> As a tune into a tune.
>
> ["The Card Dealer"]

> And compassed in her close compassionate hand.
>
> ["The Stream's Secret"]

> Beholding youth and hope in mockery caught
> From life; and mocking pulses that remain
> When the soul's death of bodily death is fain;
> Honour unknown, and honour known unsought.
>
> [*The House of Life*, 92]

Rossetti's handling of rhyme seemed capricious to his contemporary readers, though it is orthodox enough by twentieth-century standards. One cannot help suspecting that a lingering trace of his father's Italian accent affected his two frequent idiosyncracies—the rhyming of vowels or consonants that are not mechanically identical and the stressing of a normally unaccented syllable to produce a rhyme. Also, of course, these habits contribute to an archaic effect, recalling Chaucer or Spenser, whose pronunciation and stressing often differ from later usage. Examples of "slant" rhymes are "of—love" (*passim*), "God—cloud" ("The Blessed Damozel"), "years—stirs" ("My Sister's Sleep"), "since—inns" (*The House of Life*, 91), "neck—ache" (*The House of Life*, 6). As examples of Rossetti's shifting of stress, one may cite "spheres—barriers" ("The Blessed Damozel"), "galleries—prize" ("The Burden of Nineveh"), and many in *The House of Life*: "ecstatically—be—sanctuary—me" (3), "harp-player—here" (9), "see—poppy—rosary" (24). This particular device produces an effect of "dying fall" that makes Rossetti's verse seem sinewless and passive.

Since Rossetti was not at all interested in the major controversies over faith and doubt, religion and science, ethics and materialism, his dejected tone has little in common with the intellectual despondency that colors many poems of his contem-

poraries, Tennyson, Arnold, and Clough. Instead, his melancholy originated partly in his temperament, partly in his personal misfortunes, partly in the sense of futility inherent in the hedonistic attitude. It was this last that made him respond to Fitz-Gerald's translation of the *Rubáiyát* before any other author or critic recognized its merits. Nevertheless, Rossetti's persistent melancholy points clearly forward to that of later poets—James Thomson, Hardy, Housman—who were influenced by scientific determinism and the horrifying implications of the struggle for survival.

This, however, is only one of the respects in which Rossetti's personality and work anticipated the next generation. He was the first English poet who entirely fulfilled the public image of the *poète maudit*—manic-depressive in temperament, alienated from the mores of his time, sensually self-indulgent, and disintegrating under the influences of sex, alcohol, and drugs. According to this stereotype, he lived in his imagination, communicated by symbols, and produced sporadic masterpieces in interludes of inspired creativity. Precursors can be recognized among the Romantic poets whom Rossetti admired, but none of them fully embodied the image. Though Blake existed in a dream world and wrote poetry incomprehensible to the layman, he led a remarkably normal life; Coleridge's opium-induced nightmares did not prevent him from composing a large corpus of sound critical and philosophical prose; Byron's erotic excesses and aberrations went along with an extroverted social life, strenuous physical activity, and death in the cause of freedom; Keats's unfulfilled projects were due to bodily illness and not to psychopathic disturbance. The relevant representatives of the *poète maudit* are less eminent figures such as Beddoes in England and Poe in America.

Rossetti's poetry was consistent with his personality, not so much in its preoccupation with sexual love as in its concentration upon sensuous perception. By simply ignoring the prevalent Victorian addiction to social and moral generalizations, he gave his readers an uncomfortable feeling that his poetry was somehow immoral. It was this, as much as his glorification of passion, that Buchanan really meant by calling him "fleshly."

IV. CHRISTINA ROSSETTI

It is remarkable that the principal women poets of the nineteenth century were all recluses, either from choice or by the compulsion of ill health. Emily Brontë, Christina Rossetti, and Emily Dickinson withdrew further and further from external contacts until their lives ended; Elizabeth Barrett followed the same course up to the age of forty, when she was forcibly emancipated by Browning. It is further noteworthy that all four belonged to closely knit family units fulfilling the needs of affection and intellectual stimulus.

The love poems of all four are a strange amalgam of frustrated passion and religious devotion, persistently preoccupied with death. Emily Brontë in "Remembrance":

> But, when the days of golden dreams had perished,
> And even Despair was powerless to destroy,
> Then did I learn how existence could be cherished,
> Strengthened, and fed without the aid of joy.
>
> Then did I check the tears of useless passion—
> Weaned my young soul from yearning after thine;
> Sternly denied its burning wish to hasten
> Down to that tomb already more than mine.

For Emily Dickinson,

> The heart asks pleasure first;
> And then, excuse from pain;

And then, those little anodynes
That deaden suffering;

And then, to go to sleep;
And then, if it should be
The will of its Inquisitor,
The liberty to die.

Elizabeth Barrett was incredulous when faced with the reality of a virile lover in "Sonnets from the Portuguese," 3:

What hast *thou* to do
With looking from the lattice-lights at me,
A poor, tired, wandering singer, singing through
The dark, and leaning up a cypress tree?
The chrism is on thine head,—on mine, the dew,—
And Death must dig the level where these agree.

Christina Rossetti chimes in with much the same tone in "Song":

When I am dead, my dearest,
 Sing no sad songs for me;
Plant thou no roses at my head
 Nor shady cypress tree;
Be the green grass above me
 With showers and dewdrops wet:
And if thou wilt, remember,
 And if thou wilt, forget.

Upon this common ground-note of feminine abnegation, Christina Rossetti erected her decorative structure of Pre-Raphaelite melody.

The youngest of the four Rossetti children, Christina Georgina was born on 5 December 1830, and thus was two-and-a-half years younger than her poet brother. Like him, she showed a precocious literary bent: she started to compose a tale in imitation of the *Arabian Nights* before she was old enough to write, and by the age of ten she was at work on another one dealing with the Crusades. Her earliest surviving verses date from 1842. Study, however, had no appeal for her. "She was by far the least bookish of the family," her brother William reports, "generally not applying herself with assiduity to either her books or her studies. She 'picked up' things rather than acquired them."

She was fully competent, however, to hold her own in the vigorous interchanges of her siblings. Indeed, they admired her critical ability and stood somewhat in awe of her anger. "She was of a lively, and a somewhat capricious or even fractious temper," says William; "but she was warm-hearted, engaging, and a general favourite."[1]

Until the age of fifteen her health seemed robust, but she then began to suffer chest pains that were tentatively diagnosed as angina pectoris, and thereafter she was treated as somewhat of an invalid. There is a good possibility that the illness was partly if not entirely psychosomatic, since it occurred soon after her father's breakdown in health and consequent loss of income. Her sister Maria had been obliged to take uncongenial employment as a governess, her brother William had been withdrawn from school to become a clerk in an office, and their mother began giving lessons in elementary French and Italian. Through these sacrifices her brother Gabriel was enabled to continue with his art studies; but the secure family stronghold had been breached, and Christina could see plainly enough that she would soon reach an age when she, too, must earn her share. Invalidism can have been a subconscious defense against the ominous prospect.

Whether physical or neurotic, however, her frail health contributed to a strong increase in religious earnestness. By the time she was eighteen she had given up going to the theater, in spite of her love of drama and music, because she believed that actors and other stage folk were prone to too much self-indulgence. She also abjured her favorite game of chess because she considered herself too eager to win.

The struggle for self-control was by no means merely in conformity with the Victorian convention of female humility, but was a desperate battle against the turbulent Neapolitan passions in the Rossetti blood. In her childhood she was once so agonized by a rebuke from her mother that she snatched a pair of scissors and gashed her own arm. It was her intense devotion to her wise and serene mother that enabled her gradually to suppress her tantrums.

Weak health and moral scruples combined with innate shyness

to inhibit easy dealings with her brothers' boisterous companions. When the boys organized a little verse-reading club they knew that she would be too nervous to attend, but they found that she would not even allow them to read her poems at the meetings, "under the impression," Gabriel told Holman Hunt, "that it would seem like display, I believe—a sort of thing she abhors."[2]

Upon the organizing of the Pre-Raphaelite Brotherhood, however, she could not remain utterly aloof, and the most diffident member of the group, James Collinson, promptly fell in love with her. Not yet eighteen, she responded readily to his admiration; but when he proposed marriage she was faced with a challenge to her religious tenets, for he had recently left the Church of England to become a Roman Catholic. As she and her sister were tending toward the High Church wing of Anglicanism, she felt no strong prejudice against the Roman Communion; but she had no intention of being converted, and she apparently disapproved of the requirement that any children of the marriage must be brought up in the Roman faith. Collinson soon decided that love was stronger than sectarianism, and he announced his reversion to the Church of England. His second proposal was then accepted, but Christina soon found that he was boresomely phlegmatic, and she was probably more relieved than distressed when after a few months a crisis of conscience supervened and he was reconverted to Rome. She promptly broke off the engagement, and inflexibly declined to have anything more to do with him. His behavior must have convinced her that his personality was unstable—a fact that his fellow-members of the Pre-Raphaelite Brotherhood had already recognized. Modern psychoanalytic opinion, however, would probably infer that she was afraid of sexual relations and relied upon the religious issues to rationalize her physical revulsion. Collinson's vacillations may well have been due to an equal terror of sex.

Christina's most recent biographer, Lona Mosk Packer, advanced a more dramatic hypothesis which rests on circumstantial evidence and has not been accepted unquestioningly by other scholars.[3] According to Mrs. Packer, Christina became infatuated with William Bell Scott, a romantically handsome Scottish painter

and poet twenty years her senior. When Dante Gabriel Rossetti read some of Bell Scott's poems in 1847 he wrote one of his typically ecstatic letters of appreciation, which led to a prolonged friendship. Christina had a first momentary glimpse of Scott when he visited London, about the time of her seventeenth birthday, and before she met Collinson. By Mrs. Packer's theory, Christina saw him again about a year later and felt such a strong attraction to him that she became disillusioned with her lethargic fiancé. Scott was married to a scatterbrained woman who is said to have been physically incapable of sexual relations, and apparently the Rossettis were not aware of her existence until William visited Scott's home in northern England in 1850, three or four months after Christina ended her engagement. If we assume that she broke off with Collinson because she had some hope of attracting Scott, the fateful irony of the belated discovery that he was not a bachelor could well have precipitated a psychological crisis. At any rate, the emotional conflict encountered during the year of her engagement, when she was only eighteen, made her miserable for years, though it also brought maturity to the poetry in which she uttered her sorrow and her determination.

The verse that she had been writing during the preceding five years showed a steady development of technical skill, but naturally it was derivative. Most of the pieces were occasional, a few were comic, and before her fifteenth birthday she was able to write several poems that foreshadow her pictorial and melodic powers, such as "Serenade" and "Summer." The latter has detailed and richly colored scenes in the authentic Pre-Raphaelite mode:

> See in the south a radiant form,
> Her fair head crowned with roses;
> From her bright footpath flees the storm;
> Upon her breast reposes
> Many an unconfinèd tress,
> Golden, glossy, motionless. . . .
>
> Let us bind her as she lies
> Ere the fleeting moment flies,
> Hand and foot and arm and bosom,

With a chain of bud and blossom;
Twine red roses round her hands;
Round her feet twine myrtle bands.
Heap up flowers, higher, higher,
Tulips like a glowing fire,
Clematis of milky whiteness,
Sweet geraniums' varied brightness,
Honeysuckle, commeline,
Roses, myrtles, jessamine;
Heap them higher, bloom on bloom,
Bury her as in a tomb.

By the time Christina was sixteen her poems had accumulated to a total that enabled her devoted grandfather Polidori to print a collection of them on his private press. The longest and most remarkable piece was "The Dead City," a symbolic dream-vision which suffers from an inept choice of trochaic tetrameter as the verse form but which depicts its scene with Poe-like weirdness. Beginning in a sunny summer wood, the narrator passes through a blighted zone and a period of darkness, and comes to a magnificent deserted city. After exploring the empty streets and markets and the ornate royal palace she makes her way to a luxuriant park, in the midst of which stands a multicolored marquee decorated with flowers and jewels. Inside is spread a sumptuous banquet:

In green emerald baskets were
Sun-red apples, streaked and fair;
 Here the nectarine and peach
 And ripe plum lay, and on each
The bloom rested everywhere.

Grapes were hanging overhead,
Purple, pale, and ruby-red;
 And in panniers all around
 Yellow melons shone, fresh-found,
With the dew upon them spread.

And the apricot and pear
And the pulpy fig were there,
 Cherries and dark mulberries,
 Bunchy currants, strawberries,
And the lemon wan and fair....

On couches around the banquet tables recline numerous guests of all ages, smiling and healthily flushed, but turned to stone. The whole poem displays Christina's gift of sensuous description in the manner of Keats, her aptitude in the Pre-Raphaelite art of precise detail, and a brooding melancholy that dimly forecasts James Thomson's *City of Dreadful Night*.

Another ambitious dream poem dating from the same year is entitled "Repining." A young woman much like Tennyson's Mariana or the Lady of Shalott sits drearily day after day at her spinning wheel and laments, "Come, that I be no more alone." When the visitant arrives, it is an angelic figure who summons her forth for a panoramic view of the world, somewhat as Queen Mab led Ianthe in Shelley's poem. What they witness is a series of catastrophes: a village in a sheltered valley is overwhelmed by an avalanche, a ship sinks in a stormy sea with all on board, a whole city burns and its inhabitants are incinerated, and finally a battlefield is displayed in all its blood and agony. Duly reproved, the girl begs to return to her quiet isolation. In spite of its adolescent morbidity and trite moral, the poem shows touches of lurid power; and its theme—the choice of reclusion—not only allegorizes the Pre-Raphaelite rejection of social activism but also draws a blueprint for Christina's future life.

As is inevitable with a young writer, some of the poems derived their themes from her reading, but even these reveal her personality through the choice of material. Apparently her favorite novelist when she was sixteen was Charles Robert Maturin, and she wrote four dramatic monologues that she put into the mouths of women in three of his sensational novels. "Immalee" is a sonnet spoken by a young girl in *Melmoth the Wanderer* when she is living with the natives on a tropical island, blissful in her innocence:

> The deer are not afraid of me, and I
> Hear the wild goat, and hail its hastening hoof;
> The squirrels sit perked as I pass them by,
> And even the watchful hare stands not aloof.

"Isidora" is a sequel, uttered by the same character after she has been rescued by her Spanish kinsfolk, renamed at baptism, and

married to the accursed Melmoth; on her deathbed she goes through an agonized struggle between her Christian conscience and her love for her husband, whose soul she can rescue from perdition only at the cost of her own. "Lady Montrevor," from *The Wild Irish Boy*, is a disillusioned, worldly woman who stoically faces old age and death:

> I do not look for love that is a dream—
> I only seek for courage to be still;
> To bear my grief with an unbending will,
> And when I am a-weary not to seem.

Another unhappy leader of society, "Zara," from Maturin's *Women*, has lost her lover to a rival and pours out bitter prophecies of their misery, only to end by recanting her demand for revenge:

> I forgive thee, dearest, cruel, I forgive thee;—
> May the cup of sorrow be poured out for me;
> Though the dregs be bitter, yet they shall not grieve me,
> Knowing that I drink them, O my love, for thee.

In the convincing stoic mood extracted from unpromising sources of debased Byronism, these monologues bear a resemblance to the poems that Emily Brontë had been writing at almost the same time.

Many other poems of Christina's teens reiterate the theme of renunciation. A sonnet of 1847, for instance, is reminiscent of her brother's poem, "My Sister's Sleep," in describing the deathbed of a "maid replete with loving purities." Another sonnet is sufficiently categorized by its title, "Vanity of Vanities," and a third deplores the woes of the young who "have a wound no mortal ever drest, / An ill than all earth's remedies more strong." These poems and subsequent ones written during 1848, before the Collinson engagement, show that Christina had already dramatically imagined an ascetic career so compulsively that she was committed to endow it with actuality.

As well as displaying her distinctive voice and mood, the early poems furthered her technical expertise. "I Have Fought the Good Fight," giving the testimony of a Christian martyr dying

after a mauling from the lions in the arena, is entirely in a series of questions and answers, fitted into trochaic hexameter couplets. Six months later the same technique is used in "Death is Swallowed Up in Victory," this time in terza rima: the argument between a devout dying Christian and a skeptical, worldly friend is dexterously adapted to the successive triplets. Similarly, Christina's practice in the formal requirements of the Petrarchan sonnet was a valuable discipline, controlling what might have become excessive fluency.

By the age of eighteen she had perfected her characteristic poetic manner. Her sonnets move with a pellucid grace wholly different from the ornateness in those of her brother. Her lyrics sing to apparently spontaneous melodies that seldom depart from simple quatrain patterns. "When I am dead, my dearest," of which a stanza was quoted at the beginning of this chapter, and which has remained among her best-known lyrics, was written in December 1848. The illusion of spontaneity is the outcome of firm technical control. The alliterations in the first two lines of the quoted stanza, and the parallelism in its closing lines, are no accident, and the second stanza further develops the verbal pattern:

> I shall not see the shadows,
> I shall not feel the rain;
> I shall not hear the nightingale
> Sing on as if in pain;
> And dreaming through the twilight
> That doth not rise nor set,
> Haply I may remember,
> And haply may forget.

Other lyrics dating from the same epoch are equally adroit and have proved to be lastingly popular. "Dream Land" produces an hypnotic effect through its pattern of melody, reinforcing the mood of the death-wish. The simple words and images proceed so naturally that the reader needs to remind himself of the difficulties inherent in the metrical form, which demands groups of three rhymes in lines of only six syllables, interspersed with four-syllable lines:

She left the rosy morn,
She left the fields of corn,
For twilight cold and lorn
 And water springs.
Through sleep, as through a veil,
She sees the sky look pale,
And hears the nightingale
 That sadly sings. . . .

Rest, rest forevermore
Upon a mossy shore;
Rest, rest at the heart's core
 Till time shall cease:
Sleep, that no pain shall wake,
Night, that no morn shall break,
Till joy shall overtake
 Her perfect peace.

The interwoven phrasal echoes and the melancholy cadence of the short lines enhance the uniquely hushed effect of the four-stanza poem.

Another lyric on the same theme, "Sound Sleep," induces its mood by heavy assonance and rhyme. The first and last stanzas have six lines, the second and third have five; each stanza uses a single rhyme-sound throughout; and the rhymes are all feminine:

Some are laughing, some are weeping;
She is sleeping, only sleeping.
Round her rest wild flowers are creeping;
There the wind is heaping, heaping
Sweetest sweets of Summer's keeping,
By the cornfields ripe for reaping.

Several of the most touching poems of 1849 are sonnets, which presumably record the tensions attendant upon the Collinson engagement. "After Death" offers in words a typical Pre-Raphaelite picture:

The curtains were half drawn, the floor was swept
 And strewn with rushes, rosemary and may
 Lay thick upon the bed on which I lay,

Where through the lattice ivy-shadows crept.
He leaned above me, thinking that I slept
 And could not hear him; but I heard him say,
 'Poor child, poor child': and as he turned away
Came a deep silence, and I knew he wept.
He did not touch the shroud, or raise the fold
 That hid my face, or take my hand in his,
 Or ruffle the smooth pillows for my head:
 He did not love me living; but once dead
 He pitied me; and very sweet it is
To know he still is warm though I am cold.

Equally intense, though less pictorial, are two further sonnets on the same theme, "Rest" and "Remember"; and a number of other poems dwell likewise on the symbolic identification of sleep and death. In spite of the identity of theme, they escape tediousness through the unremitting elegance of the poetic style.

Christina Rossetti's poetry comes closer to the pure lyric mode than that of any other Victorian, male or female, for the obvious reason that it contains a minimum of intellectual substance. Though she was equipped with a normally keen mind, it was firmly suppressed by several forces. First, of course, a well-brought-up young woman in the Victorian age was not expected to be interested in abstruse topics or to entertain opinions of her own. Next, the social isolation of the Rossetti household shielded her from contact with current controversies; she never encountered an epiphany like that of Mary Ann Evans upon meeting the Hennell-Bray household. She possessed nothing of Elizabeth Barrett's wide classical scholarship or Emily Brontë's restless curiosity. Further, there was the self-conscious detachment from social theorizing that her brother sought to impose on his Pre-Raphaelites. Finally, and probably most influential, her religious faith was so absolute that it kept her immune from any infection of material concerns and rational doubt. Her "Death is Swallowed Up" differs fundamentally from other religious debate-poems of the time, such as Tennyson's "Two Voices" and Clough's "Dipsychus," in that the worldly voice is not provided with plausible arguments.

Fulfilling the feminine archetype that Wordsworth saw in his French daughter ("Thou liest in Abraham's bosom all the year") and Tennyson saw in his sister ("Nor thou with shadowed hint confuse / A life that leads melodious days"), Christina accepted the Christian doctrine with no taint of questioning. Her religion, says her brother, "was far more a thing of the heart than of the mind. . . . Faith with her was . . . an entire acceptance of a thing revealed—not a quest for any confirmation or demonstrative proof. . . . To learn that something in the Christian faith was credible *because it was reasonable,* or because it rested upon some historic evidence of fact, went against her."[4]

It is significant, however, that her one fragment of theological dogma was dislike of the Roman church for its excessive "Mariolatry." The Virgin Mother, who figures often in the poetry and the early paintings of her brother, is seldom mentioned in Christina's religious poetry, which is single-minded in its adoration of Jesus Christ. Hence one of her recurrent themes is the mystical marriage vows of conventual initiation. In a group of dramatic monologues entitled "Three Nuns," written during the year of the Collinson engagement, she portrays three different temperaments who are alike in their grateful relinquishment of sex, beauty, and material enjoyments and who pray for the reward of an early death. The epigraphs are stanzas of an Italian convent song, concluding:

> Rispondimi, cor mio,
> Perche sospiri tu ?
> Risponde: Voglio Dio,
> Sospiro per Gesù.

"I sigh for Jesus": this is essentially the refrain of the numerous death-wish poems that dominate her whole output. "In reality," Lona Mosk Packer points out, "all three nuns are Christina herself. The trio roughly represents the three sides of her nature, the poetic, the erotic, and the religious."[5]

In spite of her modesty, Christina must have felt gratified when her poems began to appear in print. Two were published in October 1848, in the *Athenaeum,* the most prestigious literary journal

of the era, and a year later the four issues of the *Germ* included no fewer than seven of her pieces, one being the extensive "Repining." Thus before she was twenty she was more an established poet than her gifted brother. Perhaps her contribution to the family finances might be made through authorship.

It may have been this hope that led her to write a prose story, *Maude*—though in the outcome it did not appear in print until after her death. The equivalent of her brother's *Hand and Soul*, which dates from the same time, it is a fictionized self-portrait. Gabriel's Chiaro dell' Ermo is a young painter seeking to achieve the highest form of art; Christina's Maude Foster is a young girl poet struggling to control what she regards as her worldly faults: pride in her poems, aesthetic enjoyment of music—even though it is the choir of the neighboring Tractarian church—and especially her dread of receiving the Sacrament when she feels that her state of mind is not sufficiently pure. The identification with Christina is enhanced by the insertion of a number of her recent poems as specimens of Maude's work—though one cannot help feeling that this was a device for selling the poems by smuggling them into a work of prose fiction. Maude's frail health is also autobiographical, and of course the story ends with her early death.

Mrs. Packer views *Maude* as a flimsily veiled record of Christina's disturbed conscience in loving Scott while engaged to Collinson. It is not necessarily a fatal blow to this theory that it has to be based wholly on inferences from Christina's writings, in default of documentary evidence; a hopeless passion for a married man was the sort of unconventional behavior that Victorian propriety considered so unseemly that Christina's brother could have felt justified in concealing it when he wrote his memoir of her life. More damaging is the fact that the theme had already haunted Christina's precocious poetry for several years before she met either Collinson or Scott; she depicted a whole sequence of would-be "Blessed Damozels," bidding farewell to a lover on their deathbeds or on the eve of entering convents. The deserted or self-sacrificing maiden was a stereotype of Romantic literature, particularly in the writings of women. The biographical fallacy has been conspicuously manifested in books about the two Emi-

lys, Brontë and Dickinson, on the basis of a similar preoccupation in the poetry of both. One cannot help feeling suspicious of the hypotheses that infer such identical frustrated passions for all three spinsters. A common literary tradition and a common psychological type seem to provide a more plausible explanation.

Though Christina may have remained despondent for some time after the breaking of the engagement, her physical health had improved to the point where it could no longer be an excuse for not assuming the sordid business of wage-earning. Her mother, who had been a governess in early life, had set up a little elementary school, and Christina spent a year or two, as her brother describes it, in "teaching the small daughters of the neighbouring hairdresser or the neighbouring pork-butcher their p's and q's."[6] During these years she probably saw Bell Scott from time to time on his sporadic visits to London from his home in Newcastle-on-Tyne, though his only reference to her in his autobiography merely mentions his encountering her unexpectedly at Ford Madox Brown's art school for working-class people, where she was taking drawing lessons.

Mrs. Packer interprets all Christina's poems of this period as revealing her passion for Scott. Some of them depict the misery of lovers who are far apart. Some deal with struggles against sensual temptation. Typical is "The Three Enemies," a dialogue poem in which a pretty girl defies the seductions of the flesh, the world, and the devil. "A Fair World, Though a Fallen," which is a sonnet defending religious earnestness against a rationalistic hedonist, is seen by Mrs. Packer as emerging from arguments between Christina and the skeptical Scott. In "A Bruised Reed Shall He Not Break" Christ seeks to encourage a former sinner in whom He sees embryonic signs of grace; when she replies inertly, "I cannot wish" to hate sin and choose His love, He can only counsel, "Resign thyself, be still, / Till I infuse love, hatred, longing, will."

In the autumn of 1852 Scott spent some days as a guest in the Rossettis' house. Mrs. Packer thinks that Christina's parents became aware of her emotional involvement and decided to interrupt it by taking her away from London altogether. The little

neighborhood school was not prospering, and a sister of Mrs. Rossetti's was able to arrange for her to take charge of one in Frome, Somerset. The year that Mr. and Mrs. Rossetti and Christina spent there was the longest country sojourn of this essentially urban family. Gabriele Rossetti's health became more and more feeble; Christina, lonely and miserable, wrote a larger quantity of poems than the year before. Her poet brother's letters advised her to eschew subjective vagueness and make her work specific and pictorial: "I wish you would try any rendering either of narrative or sentiment from real abundant Nature, which presents much more variety, even in any one of its phases, than all such 'dreamings.' "[7]

Perhaps as a result of his suggestions as much as from any inner stresses she may have been enduring, some of her new poems showed an increase in imaginative range and emotional energy. One of her most striking sonnets is "A Pause," which bursts into rapture when the absent lover arrives:

> They made the chamber sweet with flowers and leaves
> And the bed sweet with flowers on which I lay;
> While my soul, love-bound, loitered on its way.
> I did not hear the birds about the eaves,
> Nor hear the reapers talk among the sheaves:
> Only my soul kept watch from day to day,
> My thirsty soul kept watch for one away:—
> Perhaps he loves, I thought, remembers, grieves.
> At length there came the step upon the stair,
> Upon the lock the old familiar hand:
> Then first my spirit seemed to scent the air
> Of Paradise; then first the tardy sand
> Of time ran golden; and I felt my hair
> Put on a glory, and my soul expand.

Since the speaker is apparently mortally ill at the beginning of the sonnet, the end can be interpreted allegorically as the coming of death and the longed-for union with a forgiving Christ; but it reads like some of Elizabeth Barrett's sonnets dealing with an earthly lover, and the ambiguity is itself an evidence of an advance in poetic subtlety.

The death of Mrs. Rossetti's parents during the year brought her a small inheritance, which combined with the dependable William's improved salary to enable the household to reestablish itself in London. A few weeks after their arrival, Gabriele Rossetti died.

In the poems of the next few months Christina continued to be preoccupied with evil and temptation. A startlingly gruesome sonnet, "The World," personified its subject as a witch who is seductively beautiful by daylight, but at night is

> Loathesome and foul with hideous leprosy,
> And subtle serpents gliding in her hair. . . .
> With pushing horns and clawed and clutching hands.
> Is this a friend indeed, that I should sell
> My soul to her, give her my life and youth,
> Till my feet, cloven too, take hold on hell?

At this time she also wrote the final part of a triptych poem, "Three Stages," which had been commenced six years before. The first section depicted the conventional love-sick maiden waiting for a suitor who never appears; the second, a year later (full of echoes of Tennyson's "Palace of Art"), announces that the "happy dream" is ended forever and that she will replace her palace with a hermitage; now the third section confesses that her resolution has relaxed, allowing her to feel again the "full pulse of life . . . full throb of youth," even though she knows that "These joys may drift, as time now drifts along; / And cease, as once they ceased."

In the autumn of 1854 Scott gained some attention by publishing a volume of poetry, and shortly afterwards he became enamored of a rich and witty patroness, Lady Trevelyan. If Mrs. Packer's hypothesis is valid, this development caused a fresh crisis in Christina's feelings. Since her return from Somerset she had been engaged in mild welfare work in a slum area, under the sponsorship of her parish church, and now she made a desperate effort to escape entirely from her restrictions and to assume an authentic vocation of self-sacrifice. Many Englishwomen were finding both spiritual exaltation and social emancipation by join-

ing Florence Nightingale's corps of nursing sisters at the Crimean front. One of them was Christina's aunt, and Christina herself volunteered, only to be rejected as too young and inexperienced. It may have been this disappointment that brought on a recurrence of illness, which her physicians were now inclined to diagnose as consumption.

Several of the poems written during these months are noteworthy departures from her now overfamiliar tone of melodious dejection, her themes of dying lovers or languid dreamlands. "Dead Before Death," written three days before her twenty-fourth birthday, is a bitter sonnet of utter desolation. The octave describes a once confident pair as "changed and very cold, / With stiffened smiling lips and cold calm eyes. . . . / Grown rigid in the sham of life-long lies." The sestet enforces the mood with violent rhetorical devices:

> All fallen the blossom that no fruitage bore,
> All lost the present and the future time,
> All lost, all lost, the lapse that went before:
> So lost till death shut-to the opened door,
> So lost, from chime to everlasting chime,
> So cold and lost for ever ever more.

Two weeks later, "Echo" implores a lost lover to visit the speaker's dreams:

> Yet come to me in dreams, that I may live
> My very life again though cold in death;
> Come back to me in dreams, that I may give
> Pulse for pulse, breath for breath;
> Speak low, lean low,
> As long ago, my love, how long ago.

As printed, this poem has the perfect lyric dimensions of three stanzas (statement, expansion, climax), permitting sufficient repetition and variation without monotony; in the original manuscript, however, it had seven stanzas. From the notebooks Mrs. Packer provided the full texts of this and other poems and thus demonstrated how much of the illusion of easy and discriminating artistry in Christina's lyrics arose from rigorous eliminations,

whether performed by herself or by her wise editorial brother.

Her next poem is an amazing specimen of grotesque fantasy, entitled "My Dream," which describes a gigantic crocodile, adorned with a golden crown and girdle and wearing insignia of knightly orders on his chest. He becomes a tyrant over the lesser saurians, who "quaked before his tail, / Broad as a rafter, potent as a flail." Soon his autocracy encourages him to devour his subjects:

> The luscious fat distilled upon his chin,
> Exuded from his nostrils and his eyes,
> While still like hungry death he fed his maw.

When the monster lapses into a gorged slumber he shrinks in size and loses his blazonry. Soon a winged white ship, "like an avenging ghost," glides in from far away, whereupon

> The prudent crocodile rose on his feet,
> And shed appropriate tears and wrung his hands.

Though Mrs. Packer interprets this poem as an erotic allegory (on the banks of the Euphrates, not the Nile), it seems more likely to be a topical caricature of the Tsar, forecasting the defeat of Russia in the war that was then at its height. Whatever its signification, the poem is wholly unlike Christina's previous work.

After two short poems about passing springtime and a premature deathbed, she seems to have written nothing more for six months, probably because of illness. She then produced "Cobwebs," a nightmarish sonnet depicting an utterly inert and colorless landscape:

> No ripples on the sea, no shifting sand,
> No beat of wings to stir the stagnant space:
> No pulse of life through all the loveless land
> And loveless sea. . . .

The dreary emphasis of this sonnet is produced by twenty-one occurrences of the word "no" (or "nor"), like the tolling of a knell.

Among the other poems written in the winter of 1855–56, "An After-Thought" begins with four stanzas sympathetically imagining Eve's grief in leaving Eden, but then adds three stanzas con-

ventionally evoking the longed-for entry into heaven after death —though even here the orthodoxy is questionable, since apparently "the blessed dead" are happy because they are in eternal slumber, more like Swinburne's Garden of Proserpine than like the Christian paradise. A number of more conventionally devotional poems, written during 1856, dwell on the same identification of death with rest and sleep. They were interspersed, however, with more original pieces.

A weirdly impressive poem, written in doggerel ballad stanzas, is "A Chilly Night," describing a horde of ghosts, who cannot communicate with the living survivor. She implores the ghost of her mother to "Make a lonely bed for me / And shelter it from the wind."

> My Mother raised her eyes,
> They were blank and could not see:
> Yet they held me with their stare
> While they seemed to look at me. . . .
>
> She knew that I could not hear
> The message that she told
> Whether I had long to wait
> Or soon should sleep in the mould:
> I saw her toss her shadowless hair
> And wring her hands in the cold.
>
> I strained to catch her words,
> And she strained to make me hear;
> But never a sound of words
> Fell on my straining ear. . . .

The morbid gloom of this and a few other poems of Christina's, enhanced by almost casual simplicity of language, conveys a very different tone from the melodious melancholy of her best-known lyrics. Similarly, there is grim irony in the sonnet "Acme," which asserts that occasional brief surcease from sorrow is to be welcomed not because it ultimately heals but because the aftereffect is more poignant than ever:

> Refine the lulling pain
> To quickened torture and a subtler edge.
> The wrung cord snaps at last: beneath the wedge
> The toughest oak groans long but rends at length.

In her unrest of spirit, Christina's mind reverted to Maturin's sentimental novel, *Women*, which she had used in poems a decade earlier. A sonnet of January 1855 (first printed in Mrs. Packer's biography) is a monologue of Zara in an agony of loneliness after losing her lover. Eighteen months later, "Look on This Picture and on This'" is a soliloquy of the lover as he hesitates between the worldly Zara and her saintly rival Eva. The manuscript of the poem is twice as long as the printed version, and the frenetic conflict of emotions is all the more incoherent. Mrs. Packer attributes it all, of course, to some fresh crisis in the affair with Scott, and sees the end of the poem—when the speaker envisions the spotless Eva's ascent to heaven—as Christina using her renunciation to take "a subtle vengeance" on the guilty lovers. This view is to be questioned, however, not merely because of the source in Maturin's novel but also because of the resemblance to Tennyson's "Locksley Hall" in its fluctuations of mood as well as in its long fluent lines. A complicating factor is that Scott's wife visited London that summer, and when she dined with William and Christina Rossetti the two women seem to have taken to each other immediately. If indeed we are to recognize Lady Trevelyan as the mischievous temptress in "Look on This Picture," the innocuous deserted woman could as well be Mrs. Scott as Miss Rossetti. Additional evidence that the poem was dramatic rather than personal can be seen in her next one, "The Hour and the Ghost," which reverses the situation. It is a grim little conversation between a bride, her husband, and the accusing apparition of a former lover who comes to abduct her from the nuptial couch. The bride desperately pleads with her husband to "keep thy heart for me" after she dies; but the ghost gloatingly predicts:

> Thou shalt visit him again
> To watch his heart grow cold;
> To know the gnawing pain
> I knew of old;
> To see one much more fair
> Fill up the vacant chair,
> Fill his heart, his children bear;
> While thou and I together

In the outcast weather
Toss and howl and spin.

The longest poem of the autumn, "The Lowest Room," was condemned by her brother Gabriel for "a real taint, to some extent, of modern vicious style, derived from [Mrs. Browning]— what might be called a falsetto muscularity."[8] He was presumably objecting to its being almost Christina's only poem that undertakes to deal with ideas. The poem consists mainly of an argument between the narrator and her younger sister. The speaker has been reading the *Iliad* and pines for the lusty heroic days of physical combat and passionate love; the serene sister, after trying to laugh her out of her romantic illusions and reconcile her to the placid routines of domestic life, becomes more earnest in promulgating the Carlylean ethic:

> "Too short a century of dreams,
> One day of work sufficient length;
> Why should not you, why should not I,
> Attain heroic strength?
>
> "Our life is given us as a blank;
> Ourselves must make it blest or curst;
> Who dooms me I shall only be
> The second, not the first?"

Though inwardly aware that she is motivated by envy of the girl's beauty and happiness, the embittered elder sister harshly quotes Solomon's "Vanity of Vanities" and cites Homer's fatalism in support of her dark view. The other gently murmurs a reference to Jesus Christ and goes out into the garden to pick flowers and await the arrival of her fiancé. The end of the poem occurs twenty years later, when the lovely younger sister is a happy wife and mother "in the home-land of love."

> While I? I sat alone and watched;
> My lot in life, to live alone
> In mine own world of interests,
> Much felt but little shown.

> Not to be first: how hard to learn
> That lifelong lesson of the past;
> Line graven on line and stroke on stroke,
> But, thank God, learned at last.

The trite language of the whole poem, as well as the sentimental adherence to the Victorian domestic ideal, proves how wise Christina was in avoiding didactic verse. In the poems of the next few months she reverted to purely emotional situations, uncomplicated by ideology.

"Light Love" introduces a new element: when the lover callously announces his forthcoming marriage to a handsomer and more responsive woman, the deserted one is left with their baby for consolation. "A Triad," which was later to shock a reviewer by its "voluptuous passion," is a Pre-Raphaelite decorative panel and at the same time candidly portrays three types of women who are all inadequate in the love relationship:

> Three sang of love together: one with lips
> Crimson, with cheeks and bosom in a glow,
> Flushed to the yellow hair and finger-tips;
> And one there sang who soft and smooth as snow
> Bloomed like a tinted hyacinth at a show;
> And one was blue with famine after love,
> Who like a harpstring snapped rang harsh and low
> The burden of what those were singing of.
> One shamed herself in love; one temperately
> Grew gross in soulless love, a sluggish wife;
> One famished died for love. Thus two of three
> Took death for love and won him after strife;
> One droned in sweetness like a fattened bee:
> All on the threshold, yet all short of life.

After the asperity of this sonnet, "Love from the North" is a sentimental ballad on the "Young Lochinvar" theme, wherein a gentle and sympathetic bridegroom is left at the altar when his masterful rival carries the girl off to his northern fastnesses. Finally, Christina's last poem of 1856 is one of the few in which she writes recognizably about her dynamic brother. "In an Artist's

Studio" is a perceptive sonnet pointing out that he depicts Liz-
zie Siddal "in all his canvases"

> Not wan with waiting, not with sorrow dim;
> Not as she is, but was when hope shone bright;
> Not as she is, but as she fills his dream.

By 1857, Christina's poetic output had settled into a regular
alternation among several types of poem—hymn-like statements
of religious devotion, dialogues and narratives of dramatic situ-
ations, and sonnets and lyrics of personal emotion, usually rang-
ing from melancholy to agony but with cheerfulness sometimes
breaking in.

The narrative poems include "In the Round Tower at Jhansi,"
a melodramatic news item from the Indian mutiny, and "Maude
Clare," a counterfeit folk-ballad with the stereotyped situation of
an abandoned sweetheart who appears at a wedding to denounce
her betrayer. This overworked theme of the trustful and deserted
girl receives a fresher treatment in "An Apple Gathering," a
country lass's soliloquy in a mood of gentle regret.

Among the personal lyrics it is possible to see parallels and con-
trasts that suggest intentional balancing. Thus, "Introspective"
and "Winter: My Secret" both express stoic, silent endurance.
"Introspective" is grim and terse in recording

> First the shattering ruining blow,
> Then the probing, steady and slow....
>
> Dumb I was when the ruin fell,
> Dumb I remain and will never tell;
> O my soul, I talk with thee,
> But not another the sight must see.

On the other hand, the tone of "Winter: My Secret" is whimsi-
cally conversational, with comic extravagance of rhyme:

> I tell my secret? No indeed, not I:
> Perhaps some day, who knows?
> But not to-day; it froze, and blows, and snows,
> And you're too curious: fie! . . .

I cannot ope to everyone who taps,
And let the draughts come whistling through my hall;
Come bounding and surrounding me,
Come buffeting, astounding me,
Nipping and clipping through my wraps and all.
I wear my mask for warmth: who ever shows
His nose to Russian snows
To be pecked at by every wind that blows?

Likewise, the verse form and rhetorical structure are identical in one of her saddest prayers for divine comfort and in her most ebullient rhapsody of happiness. "A Better Renunciation" voices her typical mood of despondency:

My life is like a faded leaf,
 My harvest dwindled to a husk:
Truly my life is void and brief
 And tedious in the barren dusk;
My life is like a frozen thing,
 No bud nor greenness can I see;
Yet rise it shall, the sap of spring;
 O Jesus, rise in me.

My life is like a broken bowl. . . .

The self-same tune is transposed into ecstasy five months later in "A Birthday":

My heart is like a singing bird
 Whose nest is in a watered shoot:
My heart is like an apple tree
 Whose boughs are bent with thickset fruit;
My heart is like a rainbow shell
 That paddles in a halcyon sea;
My heart is gladder than all these
 Because my love is come to me.

The second stanza of this much-loved lyric, incidentally, provides Christina's most fully Pre-Raphaelite word-picture, with the woman enthroned on "a dais of silk and down" ornamented with "vair and purple dyes . . . doves and pomegranates and peacocks . . . gold and silver grapes . . . and silver fleur-de-lys."

A comparable technique of contrast is employed within a single poem in "A Peal of Bells": the first stanza interprets the sound of joy-bells with luscious sensuous images of golden lamps burning scented oil and hung among the fruit of orange trees, whereas the second stanza, parallel in structure, verbalizes a solemn funeral knell in a grisly view of the corpse:

> There's plaited linen round his head,
> While foremost go his feet—
> His feet that cannot carry him. . . .
> His lights are out, his feast is done.

In the summer of 1858 Christina enjoyed one of her few trips away from home when she visited Mr. and Mrs. Scott in Newcastle. Inevitably, Mrs. Packer sees this as the occasion of a fresh emotional crisis that affected the poems written during the next months. A fortnight after returning to London Christina wrote three noteworthy poems in one day. "At Home" is apparently a recollection of one of the merry parties she enjoyed with the Scotts; but it has been intensified to become a ghostly visit of a dead person to observe the friends who remain alive and spare no thought for her in their hedonistic enjoyment. In "To-day and To-morrow" the method of contrast is used to conclude a joyous lyric of springtime love with a sour little sequel:

> I wish I were dead, my foe,
> My friend, I wish I were dead,
> With a stone at my tired feet
> And a stone at my tired head.
>
> In the pleasant April days
> Half the world will stir and sing,
> But half the world will slug and rot
> For all the sap of spring.

Finally, "Up Hill" uses her favorite question-and-answer technique for a particularly concise statement of the unremitting rigor of life and the welcome rest after death.

"The Convent Threshold" is a long dramatic epistle of a novice bidding farewell to her lover before taking the veil. His seducing

her has led to violence and murder between the families. She beseeches him to take the same route of repentance as the only way to erase their sensual guilt. Vivid descriptive passages contrast the joy of redeemed martyrs in heaven and the lustful excesses of earthly life. The middle part of the poem recounts two dreams. One is of a "fire-footed" spirit with a "hundred pinions" who forced his way into heaven with insatiable clamor of "Give me light," but who finally, "drunk with knowledge," discarded "from aching brows the aureate crown" and "left his throne to grovel down / And lick the dust of Seraphs' feet." In the second dream, the girl realizes that she is dead, and when the lover comes to ask "Do you dream of me?" she has to answer, "Find you a warmer playfellow." In the intervals of her dreams she prays, and

> When this morning broke
> My face was pinched, my hair was grey,
> And frozen blood was on the sill
> Where stifling in my struggle I lay.

The macabre power of the dream sequence is mitigated in the coda, when the novice forecasts an ultimate reunion of the lovers in heaven.

A longer and equally eerie poem is "From House to Home," though its originality is obscured by its resemblance in stanza-form and imagery to Tennyson's "Palace of Art." It describes a beautiful glass castle and luxuriant pleasance, which are termed "a tissue of hugged lies." In the garden and heath all harmless little creatures flourish happily—squirrels, mice, lizards "in strange metallic mail":

> Frogs and fat toads were there to hop or plod
> And propagate in peace, an uncouth crew. . . .
>
> All caterpillars throve beneath my rule,
> With snails and slugs in corners out of sight. . . .
>
> Safe in his excavated gallery
> The burrowing mole groped on from year to year;
> No harmless hedgehog curled because of me
> His prickly back for fear.

In this "fair delusion" of an Eden, the speaker is often accompanied by an angelic figure "with spirit-discerning eyes like flames of fire," closely resembling the one who had figured in "Repining" eleven years earlier.

> We sang our songs together by the way,
> Calls and recalls and echoes of delight;
> So communed we together all the day,
> And so in dreams by night. . . .
>
> This only can I tell: that hour by hour
> I waxed more feastful, lifted up and glad;
> I felt no thorn-prick when I plucked a flower,
> Felt not my friend was sad.

When he issues a cryptic ultimatum "To-night," she insists, "Not so; tomorrow shall be sweet," whereupon he turns away from her:

> Running and flying miles and miles he went,
> But once looked back to beckon with his hand,
> And cry, 'Come home, O love, from banishment:
> Come to the distant land.'

Immediately the sumptuous paradise is transformed into a dead and frozen landscape and she falls into an agony of despair that ends in a death-like trance, in which she has a vision of a pale, sad woman being tortured with ridicule and thorns and a cup of gall; the parallels with the Crucifixion are obvious. The suffering woman, however, is "anchored fast in heaven" by "a chain of living links," and the bitter gall in her cup gives place to "new wine and virgin honey" by means of which "her lips and cheeks waxed rosy-fresh and young." There follows a tremendous apocalyptic panorama of the heavenly kingdom, full of echoes from the Book of Revelation and also from Dante's *Paradiso*; as in "The Blessed Damozel," lovers are reunited. Upon waking from her dream, the speaker asserts that

> Therefore, O friend, I would not if I might
> Rebuild my house of lies, wherein I joyed
> One time to dwell; my soul shall walk in white,
> Cast down but not destroyed.

She takes a vow of patience and endurance of pain, secure in her faith that "To-morrow I shall put forth buds again / And clothe myself with fruit."

In spite of its derivative elements, "From House to Home" was the most impressive and sustained poem that Christina Rossetti had yet written, and it was rivaled five months later by "Goblin Market," which has remained her most famous work. Ironically, this poem is ordinarily classified among literature for children, simply because the two characters are young girls and because goblins occur in fairy tales. To anyone who reads it in maturity, of course, it is a terrifying allegory of temptation and redemption. Christina's familiar themes of the evil of self-indulgence, the fraudulence of sensuous beauty, and the supreme duty of renunciation become all the more sinister when disguised as whimsical child's play. The tumbling irregular meter and the cumulative catalogues enhance the grotesque comic effect, somewhat as in "The Pied Piper of Hamelin" (which also has its inherent horror).

The "little men" have partially the form of squirrels, wombats, rats, and other small animals that Christina loved and often described affectionately; but it must be remembered that they were conspicuous in the delusive garden of delight at the beginning of "From House to Home." Even such harmless creatures represent worldly affections. Still more, their wares are the smooth and luscious fruits, "sweet to tongue and sound to eye," that Christina had been extolling ever since her earliest poems; but now their juices are nauseatingly saccharine.

The symbolism is obvious enough. The two sisters, Laura and Lizzie, who look alike but differ in nature, could be the two sides of Christina's own character, the sensuous and the ascetic, which had been portrayed in many of her poems ever since "Repining." When Laura succumbs to the goblins' blandishments and devours their fruit she becomes avid for more, just as in "From House to Home" the girl wants her self-indulgences to last forever. As in the other poems, Laura lapses into deathly despair when her hedonistic pleasure is abruptly terminated. Now the character of Lizzie takes the lead: there is fantastic absurdity and yet mag-

nificent courage in the scene when she induces the goblins to try to force her to eat, ensuring that she becomes beplastered with "the drip of juice that syruped all her face," though not a drop enters her lips. Thus she can bring Laura the antidote to her craving, with the sacramental words, "Eat me, drink me, love me." In the final macabre episode Laura goes through hideous contortions of a poisoned victim and endures symbolic death, after which Lizzie nurses her back to health and sanity.

A more specific biographical origin for "Goblin Market" has been suggested by Violet Hunt, who grew up within the Pre-Raphaelite orbit. According to her, Christina's sister Maria "for a week of nights crouched on the mat by the house door and saved her sister from the horrors of an elopement with a man who belonged to another."[9] Violet Hunt assumed that the attractive wooer was Collinson, who had married during the intervening years; but the anecdote did not gain wide credence, partly because Violet Hunt was not a particularly dependable reporter, but more because the sedate engagement to Collinson seemed very unlikely to have produced a passionate sequel. Mrs. Packer's hypothesis about Bell Scott restores some measure of plausibility, as Maria Rossetti might well have become alarmed during one of Scott's visits if she observed an attraction between her susceptible sister and the handsome, unscrupulous painter-poet. Certainly some specific debt of gratitude seems implicit in the heartfelt praise for a stalwart sister, forming the coda to the poem.

Two short ballads, "Sister Maude" and "Noble Sisters," written during the next few months repeat the central situation but in an opposite mood; in both, the protective sister is denounced as a jealous meddler. It is a familiar folk-ballad motif, as is that of "Cousin Kate," in which a seduced village girl gloats over the prettier cousin who lured her titled lover away from her; the speaker is proud of her handsome son, whereas Kate is incapable of producing a legitimate heir. The contrast between these stereotyped practice-pieces in the folk-ballad genre and the originality and intensity of "Goblin Market" perhaps reinforces the inference that the latter poem had a personal basis.

The Rossetti circle considered "Goblin Market" to be such an

achievement that they asked Ruskin to submit it to the newly established *Cornhill Magazine*, but Ruskin was outraged by the irregular versification. "Your sister," he chided, "should exercise herself in the severest commonplace of meter until she can write as the public likes; then if she puts in her observation and passion all will become precious. But she must have Form first." [10] There was some compensation when "Up Hill" was accepted by the rival new popular magazine, *Macmillan's*, and the outcome was that the Macmillan firm accepted a collection of her poetry for publication as a volume. *Goblin Market and Other Poems* came out in 1862, shortly after the appearance of her brother's first book, *The Early Italian Poets*.

William Morris's first, *The Defence of Guenevere*, had been published in 1858, and Swinburne's two plays, *The Queen Mother and Rosamond*, in 1860. George Meredith's *Modern Love* appeared in 1862. With the perspective of time, we see clearly that a significant new school of poets had emerged almost simultaneously. The moving spirit of the group, Dante Gabriel Rossetti, was at the time the least conspicuous to the public, as his volume consisted of translations; though he had written many of his best poems, they were known only to his friends. Christina, on the other hand, was soon recognized as a major poet. Elizabeth Barrett Browning had died a few months before *Goblin Market* appeared, and so Christina Georgina Rossetti inherited her laurels as the leading English woman poet. Rather than being a modest camp-follower of Pre-Raphaelite poetry, she found herself in the forefront. Swinburne, with his customary hyperbole, termed her "the Jael who led their host to victory."

In the summer of 1861 she had enjoyed her first foreign travel when her brother William took her and their mother to France. By that time she had undertaken a charitable project that was to occupy her for the next decade as a social worker at a "Home for Fallen Women." As an "associate" of the Anglican sisterhood that administered it, she was qualified to wear a modified nun's habit, and could regard herself as half way toward becoming a novice. Oddly enough, however, the same years witnessed her second offer of marriage.

Charles Bagot Cayley, who was seven years her senior, first encountered the Rossetti family as early as 1847, shortly after his graduation from Cambridge, when he took Italian lessons from their father. Perhaps the only time Christina had ever seen him was five years later, when he called to express sympathy at the time of Gabriele's death. In 1861 she became acquainted with his sisters, and a year or so later the family came to regard him as her acknowledged suitor. A diffident, unworldly scholar, he had won some reputation with yet another English translation of *The Divine Comedy*, but spent most of his time in vague philological researches. As our knowledge of this courtship, as of Christina's previous one, is derived chiefly from William Michael Rossetti's memoir of his sister, Mrs. Packer surmises that both tepid affairs have been unduly emphasized by attributing to them the poems of passion and frustration which actually arose from continued obsession with William Bell Scott. If so, Christina was peculiarly persistent, for by the time Cayley entered the scene she had known Scott for about fifteen years and he was now fully committed to a new patroness and soul mate, Alice Boyd, a wealthy Scottish spinster at whose castle he spent much of his time.

Christina's poetry during 1860–65 included a steady output of devotional pieces, notably a tour de force in monorhyme entitled "Passing Away." The most interesting poems, however, are distinctly worldly, written in an almost colloquial style, with touches of sardonic humor. "No, Thank You, John," is agreeably blunt:

> Rise above
> Quibbles and shuffling off and on;
> Here's friendship for you if you like; but love,—
> No, thank you, John.

"Promises Like Pie-crust" is in the same insouciant mood:

> Promise me no promises,
> So will I not promise you:
> Keep we both our liberties,
> Never false and never true.

"The Queen of Hearts" is a lively allegory of rivalry in love represented as a card game: the speaker confesses her efforts to cheat,

and wonders why they are never successful. Even when the theme of a poem is tragic, the tone is austere, as in "Wife to Husband":

> You can bask in this sun,
>> You can drink wine, and eat;
>>> Good-bye.
> I must gird myself and run,
>> Though with unready feet;
>>> I must die.

This taciturn little poem is reminiscent of "A Woman's Last Word" and other dramatic lyrics in Browning's most recent volume, *Men and Women.* Plainly, Christina Rossetti was determined not to accept classification as a sweet, melancholy female singer of religion and heartbreak. In fact, "The Iniquity of the Fathers upon the Children," a monologue of a girl born out of wedlock, who suspects that the dignified spinster "Lady of the Hall" is her mother, so shocked the poet's worldly brother Gabriel by its uncultivated diction and its harsh challenge to convention and social injustice that he forbade her to print it in her second book—an astonishing reaction in the author of "Jenny."

While a poem like this fulfills the Pre-Raphaelite doctrine of honest realism, the alternative Pre-Raphaelite practice of decorative medievalism is represented by several other poems. "A Royal Princess" is a monologue with the formal structure and hypnotized passivity of a Dante Gabriel Rossetti painting:

> Two and two my guards behind, two and two before,
> Two and two on either hand, they guard me evermore;
> Me, poor dove that must not coo—eagle that must not soar. . . .

> All my walls are lost in mirrors, whereupon I trace
> Self to right hand, self to left hand, self in every place,
> Self-same solitary figure, self-same seeking face.

> Then I have an ivory chair high to sit upon,
> Almost like my father's chair which is an ivory throne;
> There I sit uplift and upright, there I sit alone.

The Kafkaesque symbolism of isolation is unexpectedly shattered when, after several stanzas indicting sweated labor in the tone of Keats's "Isabella," the princess decides to step forth and confront the rebellious serfs who are clamoring at the gates.

Another poem in the manner of the metrical romances, "The Prince's Progress," developed out of a lyric written in 1861, and was expanded in 1865, at Gabriel's suggestion, to provide a substantial title-piece for her next volume. In places the narrative uses folk-ballad techniques such as dialogue, and weaves them with fairy-tale elements into an elaborate tapestry. The apparently conventional story, however, is permeated with ironies and with grim symbolism, such as the blasted wasteland through which the prince has to fare (much like that in Browning's "Childe Roland"). Obviously the poem is a moral allegory of the vices of procrastination and trivial self-indulgence; without much effort it can be read also as a condensed *Faerie Queene* or *Pilgrim's Progress*, with the prince as an ineffectual Red Cross Knight or Christian seduced by Duessa or Vanity Fair, and the patiently waiting princess as his soul longing for release from the mansion of worldliness. Of course, by the Packer hypothesis the poem is autobiographical, with significance in the fact that the princess pined ten years for her dilatory lover before dying.

This suggestion is weakened, however, by the fact that the poem is one of an extensive group in which, to lend novelty to her projected second book, Christina was making a vigorous effort to write a variety of objective narratives. In contrast with the melancholy frustration that concludes "The Prince's Progress," there is an idyllically happy ending in "Maiden Song," Christina's freshest and gayest fairy tale of love, which creates its mood of pastoral innocence not only through simple ballad-like meter and rustic vocabulary but also by the participation of the small creatures that the poet loved:

> When Meggan pluckt the thorny rose,
> And when May pulled the brier,
> Half the birds would swoop to see,
> Half the beasts drew nigher,
> Half the fishes of the streams
> Would dart up to admire.

While these two girls, out on a hillside to gather strawberry-leaves, are wooed and won by a herdsman and a shepherd, the third sister, Margaret, stays at home,

Fragrant-breathed as milky cow
 Or field of blossoming bean,
Graceful as an ivy bough
 Born to cling and lean;
Thus she sat to sing and sew.

In a final scene reminiscent of Tennyson's "Beggar Maid," the king hears Margaret singing as he rides by:

With his crown upon his head,
 His sceptre in his hand,
Down he fell at Margaret's knees
 Lord king of all that land
To her highness bending low.
Every beast and bird and fish
 Came mustering to the sound,
Every man and every maid
 From miles of country round:
Meggan on her herdsman's arm,
 With her shepherd May,
Flocks and herds trooped at their heels
 Along the hillside way. . . .

Little girls' make-believe of grandeur has seldom been so charmingly captured in rhyme. W. M. Rossetti says that it "was deservedly something of a favorite with its authoress."[11]

Other poems in the narrative group widen the range of effects. In contrast to the village realism of "The Iniquity of the Fathers," the fairy-tale naïveté of "Maiden Song," or the elaborate symbolism of "A Royal Princess" and "The Prince's Progress," Christina tried folk-tale motifs of the supernatural and simple episodes of bucolic life. The authentic superstitious *frisson* is achieved in "The Poor Ghost," written in her favorite dialogue technique; and "The Ghost's Petition," in which the eerie effect is enhanced by an internal feminine rhyme in the second line of each tercet, enforces the same message, that the welcome oblivion enjoyed by the dead is painfully disturbed by the lamentations of their survivors. One hears almost an anticipation of the rhythm and tone of Thomas Hardy when the husband's apparition admonishes the widow:

> "We are trees which have shed their leaves:
> Our heads lie low there, but no tears flow there;
> Only I grieve for my wife who grieves.
>
> "I could rest if you would not moan
> Hour after hour; I have no power
> To shut my ears where I lie alone. . . ."

"Jessie Cameron" is a more extended ballad that adopts the cautious stance of a peasant storyteller. The rejected lover is described thus:

> Some say that he had gypsy blood,
> That in his heart was guile;
> Yet he had gone through fire and flood
> Only to win her smile.
> Some say his grandam was a witch,
> A black witch from beyond the Nile,
> Who kept an image in a niche
> And talked with it the while. . . .

When the girl and her lover have been engulfed on the shore by a rising tide, the narrator maintains his (or her) detachment:

> Whether the tide so hemmed them round
> With its pitiless flow
> That when they would have gone they found
> No way to go;
> Whether she scorned him to the last
> With words flung to and fro,
> Or clung to him when hope was past,
> None will ever know.

In a poem like this, Christina captures something of the genuine folk flavor better than her brother did with his greater ingenuity in "Stratton Water" or "Sister Helen."

Several shorter poems about the love affairs of country girls, such as "Margery" and "Last Night," fall somewhere between the sentimentality of Tennyson's "May Queen" and the colloquial taciturnity that was later perfected by Hardy. The large group of narrative poems unquestionably demonstrated that Christina's

range was by no means confined to the personal lyric and the devotional supplication.

As the year 1864 occurred midway in Cayley's five-year courtship, it is perhaps astonishing to find Christina's lyrics of these months particularly afflicted with self-recrimination for stultified emotions. According to Mrs. Packer, the reason was that Scott's position with the Newcastle art school had terminated and he was moving his household to London. One must always remember, however, that poets are perfectly free to express imagined circumstances and moods rather than actual ones.

When *Goblin Market and Other Poems* went into a second edition in 1865 her brother Gabriel became convinced that she was really a significant poet, and he took over full responsibility in arranging her second volume; he not only provided illustrations and negotiated with the publishers (by both of which activities he seriously delayed its ultimate issue) but also advised Christina as to the selection of pieces and the detailed revision of those to be included. Some of the poems show that she was trying to get away from the simple metrical patterns that had previously sufficed. Shifted stresses, internal rhymes, abrupt pauses are apt to disconcert readers who expect metrical fluency. Her poet brother protested against "the metrical jerks." Though not always pleasing, her discordant devices are appropriate to the tone of acerbity that was becoming audible. One senses almost a foretaste of Emily Dickinson in "Eve," a haunting glimpse of how Eve's remorse shocked the creatures that Christina always loved to describe:

> The mouse paused in his walk
> And dropped his wheaten stalk;
> Grave cattle wagged their heads
> In rumination;
> The eagle gave a cry
> From his cloud station; ...
> The raven perched on high
> Forgot his ration;
> The conies in their rock,
> A feeble nation,

Quaked sympathetical;
The mocking bird left off to mock;
Huge camels knelt as if
In deprecation;
The kind hart's tears were falling;
Chattered the wistful stork. . . .

Only the serpent in the dust,
Wriggling and crawling,
Grinned an evil grin and thrust
His tongue out with its fork.

Christina's health was a cause of increased anxiety, for persistent coughs and occasional spitting of blood seemed to confirm the suspicion of tuberculosis. In the hope of both physical and mental therapy her brother William took her and their mother in the summer of 1865 on a month's trip to France, the Alps, and Italy, the first time any of them had seen their ancestral homeland. Christina's response was recorded in several enthusiastic sonnets and lyrics, but the return to the English climate and to her precarious health meant a resumption of the melancholy poetic tone. The next summer she went to Scotland to stay with Alice Boyd and the Scotts at Penkill Castle, where she sat as a model for a series of Pre-Raphaelite murals that Scott was painting for the main staircase. Soon after her return to London Cayley finally made a proposal of marriage and was rejected, ostensibly because, though an Anglican, he was inclined to skeptical opinions on religious matters. His poverty was alleged to be a contributing factor, and perhaps also Christina's frail health, though actually she was feeling better than in recent years. None of these reasons seem to be very substantial; as in her engagement to Collinson, one can infer only that she preferred spinsterhood to matrimony. Sir Maurice Bowra's opinion is that "something which made her shrink from the claims of the flesh . . . was more than an unusual fastidiousness, more even than a desire to keep herself unspotted from the world. It was a deep conviction that she was dedicated to God and that any concession to the body would be an act of disloyalty to Him."[12]

It was perhaps during the subsequent months that she began to

write one of her major poems, a "sonnet of sonnets" entitled "Monna Innominata." When the poem was published in 1881 she supplied a headnote linking it with the famous cycles of love sonnets: it might, she averred, have been the reply of Beatrice to Dante or of Laura to Petrarch, if either of those beloved women had been gifted as a poet; or it could have been composed by Elizabeth Barrett if she "only had been unhappy instead of happy." In spite of this insistence upon literary models, William Rossetti stated positively that the poem arose from his sister's personal feelings, and naturally he cited the rejection of Cayley as what she meant when she referred in her headnote to a barrier between the fictitious poet and her lover which "might be one held sacred by both, yet not such as to render mutual love incompatible with mutual honour."[13] The depth of emotion is indeed convincing, and perhaps only the brevity of the fourteen-sonnet sequence precludes it from taking rank alongside her brother's *House of Life* or Mrs. Browning's *Sonnets from the Portuguese*. The tepid affair with Cayley, and the tenuous reasons for rejecting him, scarcely account for the passionate moods of the sonnets. Mrs. Packer's explanation comes in patly: of course, the "barrier" between the lovers is the fact that the beloved is already married, as were Dante's and Petrarch's. The precipitating impulse then would be the happy and yet frustrating weeks that Christina spent in Scotland with Scott's peculiar triangular ménage of wife and soul mate.

So far as any specific situation can be inferred from the sonnets themselves, it does not exactly fit either Cayley or Scott. Sonnets 5 and 6 imply that both lovers are devoutly religious, whereas by William Rossetti's testimony Christina rejected Cayley for unorthodoxy, and we know that Scott was much more of a freethinker. Sonnet 12 indicates that the poet "grieved" her lover by rejecting his suit and she expresses a hope that he will find a more beautiful and witty bride, all of which fits the Cayley episode. It is not irrelevant to remember that at the time when Christina wrote the sonnets, her brother Gabriel was in the midst of his long and unhappy love for Jane Morris, the wife of his best friend. It was at this time, too, that Scott and Miss Boyd

persuaded Gabriel to exhume his own sonnets and to start expanding them into *The House of Life.* We may perhaps assume that "Monna Innominata" presents a composite theme, including elements from Christina's feelings for both Cayley and Scott and from Gabriel's current ethical dilemma, along with the overt echoes from famous preceding sonnet cycles.

Christina emphasized the affiliation with the great Italian originators by prefacing each sonnet with a line from Dante and one from Petrarch. As much as in *The House of Life,* therefore, the form and theme are in the strict tradition. Nevertheless, Christina's style differs distinctly from her brother's formal ornateness and pictorial personifications, and more closely resembles Elizabeth Barrett's direct address to the beloved person, with its disarming feminine appeal:

> Come back to me, who wait and watch for you:—
> Or come not yet, for it is over then,
> And long it is before you come again,
> So far between my pleasures are and few.
> While, when you come not, what I do I do
> Thinking, 'Now when he comes,' my sweetest 'when':
> For one man in my world of all the men
> This wide world holds; O love, my world is you.
> Howbeit, to meet you grows almost a pang
> Because the pang of parting comes so soon;
> My hope hangs waning, waxing, like a moon
> Between the heavenly days on which we meet:
> Ah me, but where are now the songs I sang
> When life was sweet because you called them sweet?
>
> [1]

The apparently ingenuous language is compatible here with masterly skill in manipulating the sonnet structure. Even the slight technical infraction of rhyming "you" with itself in lines 1 and 8 can be admired as a device for stressing the key word.

The individual voice of Christina Georgina Rossetti is audible most clearly in the subtlety with which the sonnets unite the topics of secular and religious love. In many previous poems, such as "Twice," she had sharply contrasted the two, envisaging divine

affection as a refuge and solace after disenchantment with erotic passion. In "Monna Innominata," on the other hand, the loving couple and the Deity form a mutually dependent triangle:

> Trust me, I have not earned your dear rebuke,—
> I love, as you would have me, God the most;
> Would lose not Him, but you, must one be lost,
> Nor with Lot's wife cast back a faithless look,
> Unready to forego what I forsook;
> This say I, having counted up the cost,
> This, though I be the feeblest of God's host,
> The sorriest sheep Christ shepherds with His crook.
> Yet, while I love my God the most, I deem
> That I can never love you overmuch;
> I love Him more, so let me love you too;
> Yea, as I apprehend it, love is such
> I cannot love you if I love not Him,
> I cannot love Him if I love not you.
>
> [6]

Similarly, in Sonnet 8 the poet pictures herself as Esther using her sexual charms to convert her lover to a life of devotion.

By the age of forty Christina had established the final pattern of her life and poetry. Of the thousand poems in her collected works, more than half were written after 1870, but they added little of significance to her achievement. In that year she published a prose volume, *Commonplace and Other Short Stories*, some of which had been written during the preceding eighteen years. The title piece, of novelette length, is a conventional specimen of Victorian domestic fiction, but also a revealing portrait of Christina's own experiences and emotional dilemmas. Half of the shorter sketches are in the same unpretentious vein, and there are also two allegorical fairy tales and one "imaginary portrait," "The Lost Titian," that blossoms into Pre-Raphaelite floridity in its depiction of a Renaissance painter and his work. The lack of unity in the collection, and the avoidance of sensationalism, as flaunted in the title, doomed the book to failure.

On the other hand, she gained some popular esteem with *Sing-Song: A Nursery-rhyme Book*, published in 1872, which raised

the artistic standard of verse for very young children and pointed the way toward *A Child's Garden of Verses*. Gabriel described it as "alternating between mere babyism and a sort of Blakish wisdom and tenderness."[14] In 1874 she brought out *Annus Domini*, a volume of prayers for every day in the year, and also *Speaking Likenesses*, another children's book that she dismissed as "a Christmas trifle, would-be in the *Alice* style."

All this literary activity was accompanied by a catastrophic decline in her health. The undefined maladies of previous years may have been partly psychosomatic, but in 1871 she suffered a long and wasting illness that proved to be the onset of Graves's disease—exophthalmic goiter—which was not only incurable and painful but also disfiguring. Stoically accepting the loss of physical attractiveness, she adopted the role of a recluse, sedulously resisting the personal publicity that she was incurring as a successful author. At the same time the close family structure was disintegrating. Gabriel underwent the crucial illness that almost caused his death; William, until then the psychological and financial mainstay, married and set up his own home; Maria in 1873 entered an Anglican sisterhood. Christina might well have gone into the convent herself if her health had permitted and if her aging mother had not required her constant company. As a substitute, she devoted an increasing proportion of her subsequent poetry to religious topics.

The secular poems were in a persistent tone of weariness and resignation, obsessed with themes of physical infirmity and the loss of beauty. The "double sonnet of sonnets" entitled "Later Life" is a sort of dejected sequel to "Monna Innominata." The first half of the sequence is devoted mainly to affirming faith in God's love, "even while His rod / Of righteous wrath falls on us smiting sore." Shame and penitence mingle with stoic acceptance of tedium and frustration. Later units of the series record individual days of gloom and memories of past pleasures, and it ends with four sonnets on death.

In the religious poems the fervor of her worship and the agony of her supplications for divine mercy have seldom been rivaled by an English poet, and certainly never by a woman. They merit

comparison with those of Donne, Crashaw, and Herbert, as in the metaphysical paradoxes of "Wrestling":

> Alas, my Lord,
> How should I wrestle all the livelong night
> With Thee my God, my strength and my delight?
>
> How can it need
> So agonized an effort and a strain
> To make Thy face of mercy shine again?
>
> How can it need
> Such wringing out of breathless prayer to move
> Thee to Thy wonted love, when Thou art Love? ...

When her long poem "Mirrors of Life and Death" came out in the *Athenaeum* it evoked high praise from Gerard Manley Hopkins, who was soon to surpass her utterances of spiritual struggle.[15]

From year to year her life became more sorrowful and circumscribed. Maria died in 1876 after two operations for cancer; in the next year Christina and her mother fulfilled the miserable duties of nursing Gabriel through months of psychotic depression; and five years later they were again tortured through weeks at his bedside during his last illness. This bereavement was soon followed by the death of Cayley, whose loyal devotion had sustained her through the years since she rejected his proposal. In 1886 occurred the death of the mother whose inseparable companion she had always been. William Bell Scott died in 1890. Of the old literary coterie the only survivor was Swinburne, with whom a warm mutual affection and admiration continued though they seldom emerged from their respective seclusions long enough to meet. She thought highly of his poetry, in spite of being so distressed by his pagan doctrines that she pasted blank paper over the most outrageous chorus in her copy of *Atalanta in Calydon*. He, for his part, hailed her third volume of poetry, *A Pageant*, in 1880 with what Gabriel described as "screaming and dancing ecstasy;"[16] he later dedicated one of his books to her in a roundel that described her as inhabiting "the shrine of holiest-hearted song." During these later years she enjoyed also the respectful admiration of younger painters and writers who had

succumbed to her brother's fascination even in his alienated final period—Frederick Shields, Theodore Watts-Dunton, William Sharp, Edmund Gosse.

In such circumstances her writing was more than ever her essential lifeline. Between 1879 and 1892 she published five volumes of scriptural meditations, and her poetry in these years began to sound a new note. In place of the proper Victorian feminine posture of renunciation, such poems as "The Thread of Life" expressed the profound self-reliance of a soul that has confronted and conquered the powers of darkness. Now that death had become an intimate companion of her days, her poetry might have been expected to display some intensification of the morbid obsession that had haunted it from her girlhood onward. The subject did indeed continue to occur often, but the earlier avidity for death as total oblivion gave place to the new serene tone in such groups of sonnets and lyrics as "Out of the Deep Have I Called upon Thee," "Gifts and Graces," and "Faint Yet Pursuing." Self-abasement has changed into sensible acceptance:

> Death is not death, and therefore do I hope:
> Nor silence silence; and I therefore sing
> A very humble hopeful quiet psalm,
> Searching my heart-field for an offering:
> A handful of sun-courting heliotrope,
> Of myrrh a bundle, and a little balm.

Shortly after her sixtieth birthday she displayed the first symptoms of cancer, and in May 1892 she underwent a major operation. Her status as a poet won its widest public recognition in 1893 when the poems that had been mingled with the prose in three of her devotional books were extracted and issued in a volume under the modest title *Verses*. Gratifying though it must have been, the reviewers' praise no longer meant much in her now totally solitary life. The cancer recurred, and after many weeks of physical anguish and mental depression she died on 29 December 1894.

Christina Rossetti's contribution to English poetry is more extensive than the handful of much reiterated anthology pieces in-

dicates. Her range encompasses romantic narratives, symbolic dream-visions, realistic dramatic monologues, imitation folk-ballads, playful fantasies, a cantata ("All Thy Works Praise Thee, O Lord"), a pageant ("The Months"), as well as hundreds of lyrics and sonnets. Touches of humor and gaiety occasionally relieve the prevalent melancholy, even in the later poems. Her love of hedgehogs and moles and other small deer contributes an element of quaint whimsy, sometimes in poems otherwise serious.

Yet in another sense her verse is remarkably homogeneous. Her style and prevailing moods changed amazingly little through more than forty years: one of her first published poems, "Dream Land" (in the *Germ*, January 1850), reads exactly like the one that stands as her final lyric, "Sleeping at Last" (probably written in 1893). Except for the calculated amorphousness of *Goblin Market* she always observed metrical form scrupulously, and therefore felt particularly secure in the sonnet. Like all her group, she enjoyed the rigors of the old French forms, as represented by her terminal poem, "Sleeping at Last," which is a rondeau. When toward the end of her life she read the recently printed work of Emily Dickinson, she admired her "wonderfully Blakean gift" but deplored the "startling recklessness of poetic ways and means."[17] In Christina's poetry one is seldom startled by any conspicuous novelty of form or phrase; rather, one is gratified by the effect of effortless rightness. She was much addicted to building a series of stanzas with parallel structure, and she made uncommonly frequent use of the question-and-answer technique, with its cumulative repetition.

Just as she conformed to strict patterns in meter, so also she confined herself to a narrow range of metaphoric and pictorial imagery. Luscious ripe fruit, robin redbreasts and other small singing birds, autumn fields with reapers and sheaves of golden grain—these and a few other images recur interminably. Only in a few late poems does she include distinct details that indicate observation of nature.

The various elements of literary convention and religious orthodoxy paradoxically add up to produce a clearly original voice. With her upbringing, she could not be sincere unless she were

conventional. The tensions in her poetry arise from the utterance of authentic passion through the formal words and melodies, the narrow range of metaphors, the standard religious and erotic themes. A refreshing note of feminine individuality can be detected on the rare occasions when wry humor or conversational irony ruffles the pellucid surface. Sir Maurice Bowra says that her poetry

reveals an almost dual personality. One side of her was Pre-Raphaelite, fond of pictorial effects and unusual images, capable of telling a story with a proper sense of its dramatic possibilities, and, what was rarer in her circle, with a certain whimsical humour and playful fancy. She was often enough content to withdraw into fancies and dreams and to find a full satisfaction in the world of her imagination. . . . But she had another side, grave and serious and intimately bound with her inner life. . . . She was completely orthodox. But she was also a poet of genius, and she brought to her religion a concentration and an intensity which only a poet could bring. Her faith was the centre of her life, and to it she gave her passionate allegiance, her ruthless self-examination, and her unremitting candour.[18]

V. WILLIAM MORRIS

A greater contrast can scarcely be imagined than that between Dante Gabriel Rossetti and his most devoted disciple. Rossetti's background was Latin, Catholic, urban, cosmopolitan; William Morris was brought up in the Protestant, rural, middle-class English tradition. It is true that the family originated over the Welsh border and that the poet was probably one-quarter Celtic. It is true, too, that his father was a successful London businessman. Toward the end of the eighteenth century, the poet's grandfather moved from Wales to Worcester, married an English woman, and flourished commercially. His son began as a clerk in a brokerage firm in London and before long became a partner. After he married the daughter of landowning Worcestershire neighbors, the young couple lived in the city for seven years, until Morris was prosperous enough to move to Walthamstow, which, though not far from London, was a quiet village on the edge of Epping Forest. Here their son William was born on 24 March 1834. By the time he was six years old, his father could afford to buy a hundred-and-fifty-acre estate on the other side of the forest and thus promoted himself to the status of local squire. In the course of years the family grew to a total of nine children.

Thus the boy's first recollections were all of domestic tranquility and the routine of country life. As his health was frail in early childhood, he taught himself to read at the age of four, and thereafter would leave his books only for rambles in the woods, where he became intimately familiar with trees, plants, and small wild creatures. The picture is reminiscent of the boyhood of Walter Scott, and so it is appropriate that Morris was soon entranced by the Waverley novels, all of which he had devoured by the time he was seven. To an imaginative child, secluded from the normal activities of his age, these tales of feudal duties and chivalric ideals served as a substitute for actual experience and shaped an outlook that persisted throughout his life.

At the age of nine, being now ruggedly healthy, he began to attend a small school conducted by two maiden ladies. At this juncture his father became suddenly wealthy through a lucky investment: in partial assignment of a debt he accepted shares in a new copper mine, and within a few months they increased in value from £272 to about two hundred thousand. Shortly before, he had signalized his increased social prestige by receiving a grant of arms, which gratified the little boy's precocious expertise in heraldry. Thus when Mr. Morris died in 1847, his eldest son inherited a gentleman's rank and more than a gentlemanly income.

Just before his fourteenth birthday, he entered Marlborough College, where he remained for four years. The school, which had been recently founded, was not yet well organized or academically distinguished, and so Morris was largely free to follow his own impulses. Situated in a remote region of Wiltshire, the school was in the midst of beautiful scenery and a wealth of historical sites. Morris found Savernake Forest delightfully similar to his beloved woodlands at home in Essex. He took no part in games, and enjoyed long solitary walks. The other boys were chiefly impressed by his violent outbursts of anger and his talent for inventing inexhaustible stories "about knights and fairies." As he was sometimes overheard talking to himself, his schoolmates concluded that he was a bit mad.

The school itself occupied a Jacobean mansion built on the site of a medieval royal castle, and the school library chanced to be rich in books on archaeology and ecclesiastical architecture,

which he read eagerly and remembered with photographic accuracy. The religious tone of the school was High Church, and Morris's admiration for the new Gothic chapel and the excellent choir soon converted him to the current vogue of Anglo-Catholicism. All these influences reinforced the romantic medievalism derived from his early reading.

During his first year at school, his mother moved her family from the large manor house to a slightly smaller property in the same neighborhood, and he spent his vacations there in omnivorous reading along his favorite lines. At Marlborough his wanderings led to exploration of prehistoric sites and old country churches, and by the time he left the school he was better informed about archaeology than any other subject.

The disorders at the school reached a crisis in 1851, and Morris, who hoped to study for the Church, realized that he was not being adequately prepared to enter Oxford. He therefore withdrew from Marlborough and spent more than a year in private study at a local school in Walthamstow with a master who proved to be an excellent tutor and made his pupil into a competent classical scholar.

When he went up to Exeter College, Oxford, at the end of his eighteenth year, Morris was a muscular, ruddy-faced, curly-haired, loud-voiced lad who looked the very embodiment of rustic vigor. He later initiated his college friends into the rugged old bucolic sport of single-stick. He soon found, to his disappointment, that the educational methods at the university were no more satisfactory than at Marlborough. Thanks to his rapidity in reading and his capacious memory, he had no trouble in keeping up with the scholarly requirements, but the tutors proved lax and the lectures boresome. He felt an equal distaste for both types of undergraduate—the industrious bookworms and the riotous athletes and drinkers. Within his first week he formed an inseparable friendship with Edward Burne Jones (who inserted a hyphen in his name after he became famous), and soon they joined with a half-dozen other young men, mainly in Pembroke College, to form a coterie that endlessly discussed all the exciting new topics of the mid-century.

Jones supplied Morris with interests that complemented his

own. At school in Birmingham, he had been as noted for his fantastic drawings as Morris at Marlborough had been for his imaginative fairy tales. Morris's enthusiasm for Scott and Tennyson was expanded by Jones to include Shakespeare and Keats. Jones was acquainted with Celtic and Scandinavian folklore, and introduced Morris to Thorpe's *Northern Mythology*, while Morris, in his turn, expounded to Jones the treasures of Oxford's medieval architecture and the illuminated manuscripts in the Bodleian.

To begin with, they worked together in intensive study of theology and church history, as well as Latin verse of the Middle Ages, but they soon branched out into current books. Ruskin's first two volumes of *Modern Painters* and his *Stones of Venice* became their aesthetic bible, and they were enthusiastic also over Carlyle's *Past and Present*, Kingsley's social novels, and above all Charlotte Yonge's *Heir of Redclyffe*, which was at that time the fictional epitome of the Oxford Movement's social and religious ideals.

Though Morris and Jones retained their High Church tenets, they began to waver in their intention of becoming clergymen. Literature and art grew from being a pleasant pastime into an obsessive concern. Morris gave all his spare time to drawing architectural details or taking rubbings of old brasses in the churches of the neighborhood; Jones spent days in Bagley Wood sketching flowers and leaves with meticulous accuracy. In the Long Vacation of 1854 Morris traveled in Belgium and northern France, discovering—as Rossetti had discovered on a similar tour five years earlier—a new world of medieval art. He was enchanted with the paintings of Memling and Van Eyck, the cathedrals of Amiens, Beauvais, and Chartres, the exhibits in the Musée Cluny and the Louvre. Above all, as he remarked nearly forty years later, "I first saw the city of Rouen, then still in its outward aspect a piece of the Middle Ages: no words can tell you how its mingled beauty, history, and romance took hold on me; I can only say that, looking back on my past life, I find it was the greatest pleasure I have ever had."[1] He came home with an intensified scorn for classical and Renaissance art in all its forms.

About this time he and Jones first heard of Pre-Raphaelitism,

four or five years after it had become notorious in London. They discovered the movement through Ruskin's *Lectures on Architecture and Painting.* "I was reading in my room," says Jones, "when Morris ran in one morning bringing the newly published book with him; so everything was put aside until he read it all through to me. And there we first saw about the Pre-Raphaelites, and there I first saw the name of Rossetti. So many a day after that we talked of little else but paintings which we had never seen."[2] When a picture by Millais, *The Return of the Dove to the Ark,* was put on display in a shop in the High Street, Jones remarks, "then we knew."

At this point their excitement was all for art, but before Morris's twenty-first birthday he unexpectedly discovered a talent for writing poetry. Two years before, in his first term at the university, the topic announced for the prize awarded to "an English poem on a sacred subject" had been "The Dedication of the Temple;" and though Morris, as a freshman, was ineligible to compete, his attention was probably attracted because of his interest in architecture. He wrote a long blank-verse poem that traced the whole history of Solomon's temple from the first apparition of the angel on the threshing-floor of Araunah the Jebusite, through the construction of the edifice, on to the birth and death of Jesus and the fall of Jerusalem, and ending with the Crusades. The sumptuous building is vividly described, and there are some attractive depictions of scenery. The most remarkable passage is utterly digressive, expressing ecstatic praise for the foggy, damp English climate in contrast with the harsh sunshine of Palestine.

None of his friends knew of the existence of this manuscript, and he himself had probably come to regard it with contempt, and so he gave Jones to understand that "The Willow and the Red Cliff" was the first poem he had ever written. Jones hailed it with amazement and enthusiasm and passed the word to their friends, whose response has been recorded by Richard Watson Dixon:

As he read it, I felt that it was something the like of which had never been heard before. It was a thing entirely new: founded on nothing previous: perfectly original, whatever its value, and sounding truly

striking and beautiful, extremely decisive and powerful in execution.
. . . He reached his perfection at once; nothing could have been al-
tered in "The Willow and the Red Cliff"; and in my judgment, he
can scarcely be said to have much exceeded it afterwards in anything
that he did. . . . I expressed my admiration in some way, as we all did;
and I remember his remark, "Well, if this is poetry, it is very easy to
write." From that time onward, for a term or two, he came to my
rooms almost every day with a new poem.[3]

Morris subsequently destroyed his early unprinted manuscripts,
but a copy of his first poem survives in a letter to his sister. As the
language proves to be commonplace and the rhymes mechanical,
it may sound supercilious to suggest that Dixon was right in say-
ing that it was a prototype of all Morris's later poetry. Neverthe-
less, there is something in the movement of the lines and the
directness of utterance that may well have sounded novel to
young men who at the moment were at the height of intoxication
with the fluent melodies of Tennyson. Morris was alone in ques-
tioning his friends' belief that Tennyson was "the greatest poet
of the century," and he may have adopted his blunt declarative
syntax and elementary ballad rhythm to challenge Tennyson's
ornateness. Significantly, too, Dixon's admiration was evoked by
hearing the poem read aloud, rather than seeing it in written form.
Morris's emphatic chanting manner of reading could have lent
effectiveness for the obvious phrases and strong stresses conduce
to easy aural comprehension. Morris not only adopted the de-
vices of folksong and oral narrative verse, but cast himself in the
role of a minstrel entertaining an audience rather than an author
writing for the printed page.

The opening stanzas of "The Willow and the Red Cliff" depict
a bleak landscape:

> Above the river goes the wind
> And moans through the sad grey willow
> And calls up sadly to my mind
> The heave and swell of the billow.
>
> For the sea heaves up beneath the moon,
> And the river runs down to it,
> It will meet the sea by the red cliff,
> Salt water running through it.

> The cliff it rises steep from the sea,
> On its top a thorn tree stands,
> With the branches blown away from the sea
> As if praying with outstretched hands.

As the ballad progresses a lovelorn maiden bewails her lover's desertion and finally leaps off the cliff into the sea, leaving behind the betrothal ring that she hung on a willow branch when her sweetheart departed. It is the standard romantic theme of "Mariana" and "The Lady of Shalott" and many poems by Gabriel and Christina Rossetti, but Morris sets it to a different tune with his anapestic variations and his paucity of metaphor.

Another early poem to be found in one of his letters is a meditation that starts from the kiss of Judas and proceeds to various other famous kisses:

> Then the words the Lord did speak
> And that kiss in Holy Week
> Dreams of many a kiss did make:
>
> Lover's kiss beneath the moon,
> With it sorrow cometh soon:
> Juliet's within the tomb: ...
>
> Angelico's in quiet light
> 'Mid the aureoles very bright
> God is looking from the height.

The trochaic tetrameter triplets, the predominance of monosyllables, the archaisms and inexact rhymes, combine to produce an angularity that somehow approximates the visual effect of a medieval painting.

Another surviving poem of that year, "Blanche," is in the same stanza form and narrates a dream in which the speaker's unfaithful sweetheart appears beside him:

> There she knelt upon her knees
> There beside the aspen trees
> O! the dream right dreary is.
>
> With her sweet face turned to me
> Low she moaned unto me
> That she might forgiven be.

> Then I lifted up her head
> And I softly to her said
> Blanche, we twain will soon be dead. . . .

After several stanzas in which he forecasts their reunion in heaven in terms reminiscent of "The Blessed Damozel,"

> Yes, she said, but kiss me now
> Ere my sinning spirit go
> To the place no man doth know.
>
> There I kissed her as she lay
> O! her spirit passed away
> 'Mid the flowers her body lay.

The poem achieves a kind of eeriness through its sheer literalness of statement.

Two other poems of the same period show strongly the influence of Elizabeth Barrett Browning; but Morris soon outgrew his devotion to her work after it led him to acquaintance with her husband's. In the summer of 1855, also, he made an amazingly belated discovery of the poetry of Chaucer, which immediately became for him the ideal of poetic directness and truth.

Morris's most remarkable physiological trait was a superabundance of muscular energy. At school he kept his restless hands occupied during his spare hours by weaving nets; at Oxford he had to resort frequently to a gymnasium to tire himself out with fencing and boxing. This physical hyperactivity must have had much to do with his abrupt and vehement behavior. Seeing the outside world through the lenses of his childhood romanticism, he never learned to understand the motives of other people. Though his fellow-students admired his ability, the sweet-natured Jones and the youthful Cormell Price were his only close friends. He appears to have been devoid of sexual passion, and regarded women according to the conventions of the medieval Court of Love rather than as human beings. Hence his poetry from beginning to end gives a uniquely objective impression, like the two-dimensional scenes of a tapestry. His themes are passionate and violent, but the reader seldom feels any vicarious participation.

When Morris came of age he acquired full control of an income

of £900 a year—a munificent sum by the standards of his college friends—and he formulated grandiose schemes for devoting his life and his fortune to the cause of social betterment. Already during the preceding two years he and Jones had talked seriously about founding an Anglican monastic order, with Sir Galahad as its patron, to be what Jones termed a "Crusade and Holy Warfare against the age;" but the notion evaporated as Morris became doubtful of orthodox religious tenets. Their young adherent Price reported in May 1855 that "our Monastery will come to nought I'm afraid ... Morris has become too questionable on doctrinal points, and Ted [Jones] is too Catholic to be ordained. He and Morris diverge more and more in views though not in friendship."[4] As a more feasible project to be financed, Morris laid plans for establishing a magazine, to be entitled the *Brotherhood*.

The spring and summer of 1855 were full of stimulating experiences for Morris. In the home of an Oxford acquaintance he saw two paintings by Holman Hunt and a Rossetti watercolor, at a house in London Madox Brown's *Last of England* and a Millais picture, at the Royal Academy exhibition Millais's *Rescue*. A copy of the *Germ* fell into his hands and became a model for the projected magazine. When the summer term ended he and Jones spent a week in Cambridge to enlist volunteers for the venture. Then in July the two friends went on a month's tour of northern France which reinforced Morris's fascination with Gothic architecture. On the other hand, when his sore feet obliged them to give up their intention of walking, he was infuriated by "a nasty, brimstone, noisy, shrieking railway train that cares not twopence for hill or valley, poplar tree or lime tree ... ; that cares not twopence either for tower, or spire, or apse, or dome ...; verily railways are ABOMINATIONS. ..."[5] At the end of the tour, while strolling at night on the quais at Le Havre, Morris and Jones had a momentous discussion. They agreed to abandon any lingering thought of taking Holy Orders and to terminate their undergraduate careers as soon as possible so that Morris could become an architect and Jones a painter.

Back in England, they foregathered with Price in Birmingham to discuss plans for their periodical, now definitely named the

Oxford and Cambridge Magazine. Incredible though it sounds, they then first encountered Malory's *Morte Darthur*, which was still little known; Morris bought a copy of Southey's 1817 edition in a bookshop, and it immediately became their ultimate gospel of medieval romance, though at first they felt embarrassed to confess their rapture over such an obscure book.

Though the autumn was much occupied with preparing for the printing and distribution of the magazine, Morris found time to read industriously for his Final Schools, and passed the examination creditably. To his great satisfaction, he was accepted as an architectural pupil by George Edmund Street, one of the most noted of the current neo-Gothic church designers. As Street's headquarters were in Oxford, Morris would not have to part from the group of friends that meant so much to him.

The magazine duly came out on 1 January 1856, and continued to appear monthly throughout the year, entirely at Morris's expense; the editor was William Fulford, the most vivacious member of "the Brotherhood" (as they still called themselves, in memory of the abortive monastic project). In planning the magazine, they had agreed that "there is to be no shewing off, no quips, no sneers, no lampooning. . . . Politics to be almost eschewed: to be mainly Tales, Poetry, friendly Critiques, and social articles."[6] The solid 72-page double-columned numbers were very different from the usual undergraduate ephemera, and could be compared without discredit with the established literary journals. To keep up its bulk and quality through twelve issues was a heavy burden on the little circle of young and inexperienced writers. Except for Fulford, Morris was the most prolific; he was represented in all but two of the numbers, and his total of contributions amounted to eighteen.

During the preceding months he had turned largely from the writing of poetry to prose romances couched in rhythmic sentences and archaic vocabulary. They differed little from his poems except for the absence of rhyme and meter and the presence of some details derived from his own experience. The only one that undertook to deal with contemporary life was far less vivid and plausible than the others, which displayed his specialist's

knowledge of medieval customs, religion, and art. Eight of the tales appeared in the magazine, two being extended through two installments each. Of his remaining contributions, one was a description of Amiens cathedral, one a review of Browning's *Men and Women*, one an essay on an engraver, and only five were poems. Most of these contributions were material left over from his year of prolific writing, for during 1856 he was too busy with his new career to have much time for poetry or prose, and his insatiable energy was turning toward outlets that required manual dexterity—carving woodcuts, modeling in clay, illuminating manuscripts, making embroideries.

His stories in the *Oxford and Cambridge Magazine* reveal Morris's simplistic code of values, particularly his Carlylean concept of heroism and duty. "Gertha's Lovers" shows how the people of an invaded country are united in fortitude and brotherly devotion by the perpetual pressure of their enemies. In "Svend and his Brethren" a young prince becomes so disgusted with the corruption of the rulers that he goes away in search of a more honest country. The most interesting of the stories is "The Hollow Land," which is comparable to Rossetti's "Hand and Soul" as a projection of the author's personal objectives. An artist who has been driven into exile finds a sort of lotus land, but leaves it to return home, where he defeats his guileful enemy and devotes himself to producing great paintings of deep ethical meaning.

At the moment when the first issue of the magazine came out, Jones was in London, full of the hope of seeing a painter—any painter—for the first time in his life, "and of all men who lived on earth, the one that I wanted to see was Rossetti. I had no dream of ever knowing him, but I wanted to look at him." The opportunity occurred at a meeting of the Working Men's College, where Rossetti was teaching drawing; "and so I saw him for the first time, his face satisfying all my worship, and I . . . had my fill of looking; only I would not be introduced to him."[7] A few evenings later, Jones did meet his idol at a private party and found his conversation as fascinating as his appearance. Rossetti invited his young worshiper to visit his studio the next morning, and there Jones learned with delight that Rossetti had somehow seen more

than one of Morris's poems and wanted information about him.

Jones returned to Oxford inebriated with bliss, and by the end of the term he gave up any thought of taking his degree, and removed himself to London to become Rossetti's pupil. Morris naturally came down to visit him almost every weekend, and the two young men fell totally under Rossetti's spell. When they heard him say with his customary dogmatism that the *Morte Darthur* and the Bible were the two greatest books in the world, they at length felt emboldened to admit their secret veneration for Malory; it seemed like their initiation into an esoteric confraternity.

Positive that painting was the only valid form of visual art, Rossetti tried to convert Morris from architecture and handicrafts. "Rossetti says I ought to paint," Morris reported to one of his friends, "he says I shall be able; now as he is a very great man, and speaks with authority and not as the scribes, I *must* try. I don't hope much, I must say, yet will I try my best—he gave me practical advice on the subject. . . . So I am going to try, not giving up the architecture, but trying if it is possible to get six hours a day for drawing besides office work."[8] As earnest for his devotion, he started a collection of Pre-Raphaelite paintings by buying Arthur Hughes's *April Love*, Brown's *Hayfield*, and a watercolor by Rossetti, *The Blue Closet*.

In the summer, when Street moved his offices to London, Morris was more than satisfied to desert his much-loved Oxford and sink himself entirely in the Pre-Raphaelite microcosm of all-night talking and compulsive painting. He and Jones felt triumphant when Rossetti consented to contribute three poems to the magazine, little suspecting that it was equally a triumph for the poet to have gained the starry-eyed adulation of young men who represented the academic establishment. In the Oxford "brotherhood" he found a ready-made replica of the original Pre-Raphaelite Brotherhood, a dedicated band of crusaders (even with the same mystical number of seven members) who had cast in their lot with the Middle Ages in preference to the classical tradition, the innovations of the Renaissance, or the gross ugliness of their own century.

Morris and Jones took lodgings together in Bloomsbury, and

Jones wrote that "we know Rossetti now as a daily friend, and we know Browning too, who is the greatest poet alive, and we know Arthur Hughes and Woolner, and Madox Brown.... Topsy [Morris, so nicknamed for his shaggy head] has written several poems, exceedingly dramatic—the Brownings, I hear, have spoken very highly of one that was read to them; Rossetti thinks one called 'Rapunzel' is equal to Tennyson. . . . The Mag. is going to smash—let it go! the world is not converted and never will be."[9]

The magazine was indeed steadily losing subscribers, but Morris was too much engrossed in his new activities to care. When it ceased publication with the December number, leaving stacks of unsold copies, he paid off its deficit of several hundred pounds without complaint.

By this time he had given up his work with Street to devote himself wholly to painting. To have more studio space at lower rent, he and Jones took over rooms in Red Lion Square that at one time had been occupied by Rossetti, and this move fortuitously brought new tasks for his vigorous hands, for they could find no furniture that satisfied them, and so Morris undertook to design and decorate some himself, with Rossetti's help. The massive chairs, table, cabinet, and wardrobe, uncompromisingly medieval in style, were totally unlike the ugly commercial products of the time, as were the oil paintings on the chairbacks and cupboard doors and wardrobe panels. In spite of such temptations to handicraft, however, Morris worked faithfully at painting for two years, reluctantly drawing figures from models and going through the other standard routines; but he grew unwontedly morose as he realized his lack of aptitude to depict the human form. His one surviving oil painting, *Queen Guenevere*, is indeed discouraging, being muddy in color and angular in posture. He was much happier when illuminating manuscripts or making wood carvings.

He was so enslaved by the older man during these months that when Jones chided him for drawing his designs in Rossetti's manner instead of following his original bent, he replied furiously, "I have got beyond that: I want to imitate Gabriel as much as I can."[10] Rossetti was adamant in insisting that poetry was a moribund art, whereas English painting was on the threshold of its

first triumphs. Hence Morris was encouraged in his heresy that his writing of poems was a sort of pastime to be enjoyed as a relaxation from serious artistic work.

The summer and autumn were spent in Oxford by the three friends and a half-dozen of Rossetti's younger painter-protégés in the rowdy cooperative venture of decorating the walls of the new Union Debating Hall with Arthurian scenes. Characteristically, Rossetti's picture was left incomplete, whereas Morris's was the first to be begun and the first finished, so that he could get to work on decorating the ceiling, more congenial because the designs were purely conventional motifs. He was also happy to be designing a suit of medieval armor and supervising its manufacture by a local blacksmith.

A change seemed to come over Morris at this time: the idealistic young visionary was overlaid by the bohemian artist. He began to grow fat and unkempt; Rossetti announced that "Topsy had the greatest capacity for producing and annexing dirt of any man he ever met with." The most radical change, however, was produced by his meeting with Jane Burden, the willowy, sad-eyed daughter of a groom at Simmonds's Stables. He and Rossetti caught sight of her and her sister at the theater, and Rossetti promptly invited her to serve as the model for Guenevere in the murals. There seems no doubt that both men fell in love with her in their different ways; but Rossetti was restrained by his miserable fidelity to Lizzie Siddal, and so Morris was free to conduct a courtly wooing. She figures as a decorative medieval maiden in his poem, "Praise of My Lady":

> My lady seems of ivory
> Forehead, straight nose, and cheeks that be
> Hollow'd a little mournfully.
> *Beata mea Domina!*
>
> Her forehead, overshadow'd much
> By bows of hair, has a wave such
> As God was good to make for me.
> *Beata mea Domina!*

Finally, after eighteen more stanzas inventorying every trait of her face and body, the poet sums up:

All men that see her any time,
I charge you straightly in this rhyme,
What, and wherever you may be,
 —*Beata mea Domina!*—

To kneel before her; as for me
I choke and grow quite faint to see
My lady moving graciously.
 Beata mea Domina!

One is tempted to speculate as to the psychological causes that may have compelled Morris to choose this girl of the lower classes as his Dulcinea. Jane was only eighteen, and must have been on a low level of literacy. She produced the illusion of cryptic profundity by the simple expedient of looking abstracted and speaking little. Morris was so strongly under Rossetti's almost hypnotic influence that he may have felt a need to imitate his master in this respect as in others; or his intensifying defiance of the observances of genteel society—demonstrated in his slovenly dress, his profanity, and his refusal of invitations to the homes of conventional acquaintances—may have found gratification in the company of the stableman's daughter. His captivation may have arisen, however, simply from lack of previous experience with the opposite sex apart from his mother and sisters. At any rate, we can be certain that Janey felt both bewildered and flattered when the wealthy young gentleman treated her like a composite of a Virgin in a stained-glass window and a princess in a fairy tale.

The painting of the murals gradually slowed its momentum during the winter, though the breakfast parties and evening gatherings continued to flourish. On 1 November "Swinburne of Balliol" was introduced to the group and proved to be another of the secret fraternity of Malory addicts. "We have hitherto been three," Jones ecstatically exclaimed, "and now there are four of us." In spite of all the conviviality, however, it is possible to detect elements of strain in Rossetti's relationship with Morris during the Oxford months. There seemed to be a trace of sadism in the relentless raillery with which the older poet persecuted his unhappy devotee, evoking and then quelling Morris's tantrums like a puppet-master manipulating the strings. Possibly Rossetti was

annoyed by observing that his pupil was about to abandon paint-
ing in favor of poetry, for Morris was writing copiously in prep-
aration to publish a volume of verse.

The group of friends were unanimously impressed by the
poems that he read aloud in his resonant singsong. Price's diary
with customary undergraduate brevity records the evening of
30 October when "King Arthur's Tomb" was performed for a
dozen listeners: "Topsy read his grind [i.e., poem] on Lancelot
and Guenevere—very grand."[11] Shortly afterward, Swinburne
heard "The Haystack in the Floods," and he recalled in after
years that "the poignancy and splendour of the ending caused him
an anguish which was more than his nerves were able to bear."[12]
One of Rossetti's young painter assistants, Val Prinsep, gives a ful-
ler account of another such evening:

> The effect produced on my mind was so strong that to this day, forty
> years after, I can still recall the scene; Rossetti on the sofa with large
> melancholy eyes fixed on Morris, the poet at the table reading and
> ever fidgetting with his watch chain, and Burne-Jones working at
> a pen-and-ink drawing.
>> Gold on her head, and gold on her feet,
>> And gold where the hems of her kirtle meet,
>> And a golden girdle round my sweet;
>> *Ah! qu'elle est belle, La Marguerite*
> still seems to haunt me, and this other stanza:
>> Swerve to the left, son Roger, he said,
>>> When you catch his eyes through the helmet slit,
>> Swerve to the left, then out at his head,
>> And the Lord God give you joy of it.
> I confess I returned to the Mitre with my brain in a whirl.[13]

One can appreciate how electrically the young mid-Victorian
listeners were startled out of their elegant equanimity by such
blunt portrayals of medieval eroticism and medieval savagery.

Thus encouraged, Morris brought out *The Defence of Guene-
vere and Other Poems*, which appeared in February 1858, dedi-
cated to Rossetti. Of the thirty poems in the book, the first four
were on themes from the *Morte Darthur*, one was retelling of the
fairy tale of "Rapunzel," and some of the rest recounted episodes

suggested in one way or another by Froissart's *Chronicles*. We know that "Praise of My Lady" departed from strictly objective or dramatic narrative in favor of personal emotion; but even this poem conformed to the Court-of-Love convention so slavishly that it seemed like a monologue by a medieval troubadour rather than William Morris's tribute to Jane Burden. Only the haunting pesudo-sonnet, "Summer Dawn," though marred by its inept rhyming of "dawn" with "corn," produces an impression of inner emotion:

> Pray but one prayer for me 'twixt thy closed lips,
> Think but one thought of me up in the stars.
> The summer night waneth, the morning light slips
> Faint and grey 'twixt the leaves of the aspen, betwixt
> the cloud-bars,
> That are patiently waiting there for the dawn:
> Patient and colourless, though Heaven's gold
> Waits to float through them along with the sun.
> Far out in the meadows, above the young corn,
> The heavy elms wait, and restless and cold
> The uneasy wind rises; the roses are dun;
> Through the long twilight they pray for the dawn,
> Round the lone house in the midst of the corn.
> Speak but one word to me over the corn,
> Over the tender, bow'd locks of the corn.

The unexpected repetitions in the last lines may have been due simply to Morris's impatience with technical refinements, but they contribute to an atmospheric effect that he seldom achieved again.

When an undergraduate listener to a reading of "The Defence of Guenevere" was tactless enough to ask Morris "in whose style the poem was written, he answered 'More like Browning than any one else, I suppose.' "[14] The impact of the poems was indeed largely due to the fact that many of them were dramatic monologues and some others were dialogues. In contrast with the complex self-revelations typical of Browning's speakers, the Morris poems are more concerned with situation than psychology; but the first-personal method produces a compelling sense of im-

mediacy. Obliged to identify oneself with the passionate love and hate, the code of honor that dictates ruthless revenge, the imminence of violent death that overshadows every hour of love and joy, one is brought disturbingly close to the realities of medieval life. In poems narrated in the third person, such as "The Haystack in the Floods" and "Golden Wings," the tone is inflexibly matter-of-fact, reporting hideous ferocity or miserable anguish with impassive coolness.

The title poem, "The Defence of Guenevere," originally began with twenty-six lines of expository narrative, but Morris somehow mislaid the first page of his manuscript, and so the poem as printed began with an abrupt "But" and plunged directly into the dramatic situation. Only the first ten lines, a twelve-line interruption in the middle, and the last nine lines are narrated; the rest consists of the queen's own words as she vindicates herself from the charge of adultery. The structure of "King Arthur's Tomb" is more elaborate: the first part consists largely of Launcelot's interior monologue as he recalls memories of the queen; the next section develops an ironic situation when he arrives in Glastonbury on the very day when Guenevere has been stricken with remorse, and they meet beside Arthur's grave; for the rest of the poem she utters a distraught version of her past, with occasional interruptions of protest by Launcelot.

When the first four of Tennyson's *Idylls of the King* came out a year later, his very different attitude toward the guilty passion of Guenevere and Launcelot was reinforced by the romantic narrative verse in which it was conveyed. Morris, by giving both lovers a chance to tell the story from their own points of view, included the thoroughly Pre-Raphaelite implication that they transcended moral judgments by sacrificing all for love. Readers who have been conditioned by Tennyson's subsequent development of symbolic elements in the Arthurian legend are apt to be puzzled by Morris's fidelity to the chronicler's impartiality and literalness: for instance, Arthur has not been ferried after death to a magic island of Avalon, but is prosaically buried in the monastery graveyard at Glastonbury. The name of the isle does occur once, toward the end of the volume, but only in "Near Avalon," an odd little description of a ship with a portrait of Guenevere painted on

each sail, bearing six knights each with a lock of yellow hair in his helmet. This can scarcely be Arthur's funeral barge.

"Sir Galahad, a Christmas Mystery" inevitably challenges comparison with Tennyson's monologue by the same knight, which was, of course, already familiar to the public. Morris touches on some of the same points, but in a different tone. Galahad begins by expressing envy for Palomydes and Launcelot because of their consummated love affairs; then in a mystical vision Christ comforts him with assurances that sexual love decays with old age whereas divine love endures forever. The format shifts from interior monologue to dramatic action as three angels and four female saints appear and arm Galahad for his quest. With an abrupt change of mood, the conclusion introduces Sir Bors, with Sir Percival and his sister, to report gloomily on the misfortunes befalling their fellow knights in their search for the Grail.

The three long poems are closely similar in form as well as in theme. All are in iambic pentameter—"The Defence of Guenevere" in terza rima, the other two in quatrains. Better than Tennyson's subsequent work they could be described as "idylls" on the Guenevere-Launcelot intrigue and on the Grail quest. The fourth Arthurian poem, "The Chapel in Lyonesse," shifts to tetrameter stanzas resembling in the earlier part those of "The Lady of Shalott," and presents a concise dramatic episode. Sir Ozana le Cure Hardy, on his deathbed, recounts his months of delirium with a spear-shaft in his chest. When he lapses into a coma, Sir Galahad tells how he has tended his friend in his mortal sickness; then Sir Bors comes in and comments on the scene. After Ozana's dying expression of hope to rejoin his dead mistress, Galahad—with a shift to the meter of Tennyson's poem—has the last words:

> Ozana, shall I pray for thee?
> Her cheek is laid to thine;
> No long time hence, also I see
> Thy wasted fingers twine
>
> Within the tresses of her hair
> That shineth gloriously,
> Thinly outspread in the clear air
> Against the jasper sea.

Morris must have had a definite thematic purpose in juxtaposing the two poems in each pair. Just as "King Arthur's Tomb" controverts "The Defence of Guenevere" by showing her ultimate confession of guilt, so "The Chapel in Lyonesse" modifies Galahad's renunciation of earthly love by portraying his sympathy with the dying lover Ozana and by attributing to him a vision that is not of the Holy Grail but of a reunion of lovers in Heaven just like that of "The Blessed Damozel."

Later in the book, "A Good Knight in Prison" is loosely connected with the Arthurian group insofar as Launcelot is a protagonist; but otherwise it savors more of the Crusades than of Malory, in that the speaker, Sir Guy, has spent ten years as a prisoner of Paynims who are specifically Muslims. He gloomily recalls his lady at home and his rival, King Guilbert, whom he once wounded in a tournament at Camelot. Launcelot with his archers and *perrière* easily captures the castle, after which Sir Guy goes home and weds his Lady Mary. The poem lacks the subtleties of the preceding four and seems to be an exercise in the manner of the simplest *chansons de geste*, wherein figures from the Matter of Britain mingle anachronistically with others from different sources.

Among the poems with historical settings in the time of the Hundred Years War, the longest is "Sir Peter Harpdon's End." Written in blank verse, it is a series of dramatic dialogues, though in each scene the central character talks at such length that the effect is more of monologue than of conversation. The date is after the death of Edward III and the Black Prince. Harpdon, "a Gascon knight in the English service," is hopelessly clinging to a dilapidated castle in Poictou after the English power has waned and the best leaders are dead or in prison. In a conversation with his lieutenant, followed by a long soliloquy (very much in the Browning style) we learn that he has been accused of incompetence or cowardice by his jealous cousin, Sir Lambert, and was assigned to this desperate outpost without a chance to bid farewell to his beloved, Lady Alice de la Barde. Lambert arrives to persuade Peter to change to the French side and, on being defied and insulted, tries to stab him but is knocked down and captured. When he pleads abjectly for his life, Peter compromises by con-

demning him to have his ears cut off in public. After an abrupt
hiatus the story resumes after the castle has been attacked by the
French, the few defenders slain, and Sir Peter carried off to prison.
It is now his turn to beg for his life, and Lambert's turn to gloat,
with obscene malice. The handsome young knight goes to the
scaffold with proper dignity, though frankly confessing his terror
of death and his regret

> because
> There was no beautiful lady to kiss me
> Before I died, and sweetly wish good speed
> From her dear lips. O for some lady, though
> I saw her ne'er before; Alice, my love,
> I do not ask for; Clisson was right kind,
> If he had been a woman, I should die
> Without this sickness: but I am all wrong,
> So wrong and hopelessly afraid to die.
> There, I will go.
> My God! how sick I am,
> If only she would come and kiss me now.

The final scene starts with Lady Alice's soliloquy as she waits
anxiously for word of her lover. A squire arrives to break the news
and to give her the details of his valiant defense of the crumbling
castle, all of which she accepts with stunned fatalism.

An even grimmer picture of the moral chaos while French and
English were engaged in guerrilla fighting, with perpetual be-
trayals and ambushes, occurs in "The Haystack in the Floods."
The impersonal point of view in this poem enables Morris to en-
hance the sinister effect tremendously through the description of
the sodden colorless landscape. The tetrameter couplets, being
the same form that Scott used in his narrative poems, point up the
difference between Scott's historical view and Morris's. When
Sir Robert and his paramour are waylaid by Godmar and his
thirty followers, his own men turn against him, tie him up, and
hand him over to his enemy. Jehane knows that she will be sent
along to the French authorities to be tried for witchcraft if she
rejects Godmar's advances, but she scorns to buy Robert's life by
compliance. Then, when Godmar threatens her with rape,

> A wicked smile
> Wrinkled her face, her lips grew thin,
> A long way out she thrust her chin:
> "You know that I should strangle you
> While you were sleeping; or bite through
> Your throat, by God's help—ah!" she said,
> "Lord Jesus, pity your poor maid!"

At the end, after she has witnessed her lover beheaded with God-mar's sword, she is led off helplessly to the fate she dreads.

A similar episode is narrated through a totally different technique in "Concerning Geffray Teste Noire." An elderly knight, John of Castel Neuf, is dictating reminiscences to a messenger for transmission to John Froissart in case he needs to include the information in his *Chronicles*. John's foe Geffray was a Gascon knight fighting on the English side; but, unlike Sir Peter Harpdon, Geffray was powerful, ruthlessly pillaging the French-held area from his stronghold at Ventadour. In blunt colloquial language appropriate for a fighting man, John tells how he was appointed to arrange an ambush to capure Geffray when he sallies out to raid a sumpter train. While camouflaging their weapons in a wood, John and his henchmen come upon two skeletons, one of them, in rusted mail, being that of a woman with gold hair still clinging to the skull and an arrow through her throat. By analyzing the evidence, John reconstructs how a knight tried to save his lady's life by putting his coat of mail on her when they were attacked by foes; he must have fought off his assailants and ridden on, mortally wounded and carrying her body in his arms till he collapsed. To his surprise, John finds himself falling in love with the tall beautiful girl whom he visualizes from the slender bones. It comes as an anticlimax when Geffray escapes with his life from the ambush and later dies snugly in his bed. John is satisfied because he eventually could afford to bury the two skeletons under handsome effigies in his new castle. The sense of unremitting brutality is enhanced at one point in the poem when the old man digresses to memories of his service in quelling the peasants' revolt of 1358, when as a boy of fifteen, fighting beside his father, he ignominiously fainted at the sight—and smell—of women burned to death.

Several briefer poems add further glimpses into the blood-thirsty fourteenth century. "The Eve of Crécy" is a lyric medita-tion of an impoverished knight looking forward eagerly to the battle in which he may win royal favor so that he can build a fine castle and marry the lovely Margaret. "The Judgment of God" depicts the savagery of the ordeal by single combat in the lists, with the crowd howling for blood. In "Shameful Death" an old knight recalls the day when his brother was captured and hanged by enemies, and proceeds to boast of how thoroughly he avenged the murder. A shocking element in this poem, as in some of the others, is the tacit assumption that the Church guarantees God's sanction for the code of vengeance.

When one compares the group of Froissart poems with the Malory ones, it seems clear that Morris was again using thematic contrast. The Arthurian pieces show the visionary ideals of chivalry when propagated in Arthur's Round Table, glimmering with a pristine purity even though mournful and sensual; the fourteenth-century pieces reveal the degeneration of the code into barbarous tortures, cold-blooded treachery, and implacable vindictiveness.

The remaining poems are set in less localized medieval times and places. The most elaborate, "Rapunzel," recounts the familiar fairy tale in a series of brief episodes. The first consists of antiph-onal lyric stanzas uttered by the Prince, Rapunzel, and the witch. Next is the Prince's meditation after spending a year spellbound in the wood. In the third he has climbed to her turret chamber, but their love joy is darkened not only by fear of the witch's curse but also by Rapunzel's recollection of seeing a knight killed in single combat near her tower. Even in the final scene, which resumes the lyric pattern to depict the marriage of the lovers, the note of evil is sustained by the raucous screams of the witch down in hell.

Something of the same intangible whiff of weirdness is percepti-ble in other pieces. "Spell Bound" is a soliloquy of a man who is prevented by a mysterious enchantment from returning to the girl who waits for him. "The Wind" is an equally hallucinative portrayal of a man in some sort of psychotic trance:

For my chair is heavy and carved, and with sweeping green behind
It is hung, and the dragons thereon grin out in the gusts of the wind;
On its folds an orange lies, with a deep gash cut in the rind.
 Wind, Wind! thou art sad, art thou kind?
 Wind, wind, unhappy! thou art blind,
 Yet still thou wanderest the lily-seed to find.
If I move my chair it will scream, and the orange will roll out far,
And the faint yellow juice ooze out like blood from a wizard's jar;
And the dogs will howl for those who went last month to the war. . . .

He tells how, many years before, he made love to a girl on a springtime hilltop, piled daffodils on her where she lay in the long grass, and came back later to find her dead. None of the other poems contains such a tantalizing use of symbols.

"The Blue Closet" (suggested by Rossetti's picture) also deals with some realm of magic, where two queens and their two hand-maidens, isolated in a castle by the seashore, are allowed to sing one sad song each Christmas eve until Louise's lover's corpse returns from the dead to kiss her and set them free to die. "The Tune of Seven Towers," too, is eerily suggestive of some indefinable past disaster that has left a castle haunted.

Without recourse to the supernatural, the remaining poems produce various effects of sorrow and terror. "Golden Wings" contrasts a luxurious castle full of peace and lovemaking with the misery of one maiden who has no suitor and who kills herself with a great sword. "The Sailing of the Sword" is a maiden's lament because her two sisters' lovers have come back from a sea foray bringing them gifts, whereas her lover has brought back another girl. "Two Red Roses Across the Moon" gives a conventionalized picture of a knight in combat and his lady waiting to reward him with her kisses upon his victory. "Riding Together" uses an uncommon semi-refrain device, with the first and third lines in each quatrain ending "together—weather" to create a hypnotic impression of sustained motion in a poem recording two crusaders' loyal friendship and heroic fighting against hopeless odds. In "The Little Tower" a knight hastens home through torrents of rain to prepare his castle for an imminent siege. "The Gilliflower of Gold" and "Sir Giles's War Song" are paeans of

the mad joy of combat in tournaments. Finally, "Welland River" is the only poem in the collection that is totally an imitation of the folk ballad in situation and form.

Most of the poems, to be sure, have a general flavor of folk poetry in the detached point of view, the use of dialogue, the simple vocabulary and standardized metaphors, the elementary rhythmic measures—usually quatrains, triplets, or couplets, in tetrameter or pentameter. A third of the poems employ the folk-song device of a recurrent refrain, varying from a single line to a full stanza. "The Chapel in Lyonesse" is described in the subtitle as "A Mystery," and the same term could be applied to "Rapunzel" and "The Blue Closet," which also follow the form of medieval folk drama in being a series of set speeches in lyric rhythms. Morris's genuine lack of poetic self-consciousness equipped him to approximate the effect of folk poetry better than any other author of the nineteenth century. Like a bard of preliterate times, he assumed that it was his business to tell a story as powerfully as possible through wholly traditional methods.

This does not, however, preclude a considerable degree of technical skill; an oral storyteller, as much as any other artist, must manipulate his devices expertly or he will lose his audience. In almost every one of the poems, Morris produces an individual effect by adapting the form to the emotional and pictorial purpose. The tempo varies widely. In the two poems on Launcelot and Guenevere the mood of hopeless frustration is created by a very leisurely movement, clogged with detail and analogues, couched in long sentences with many run-on lines:

> "Christmas and whitened winter passed away,
> And over me the April sunshine came,
> Made very awful with black hail-clouds, yea
>
> "And in Summer I grew white with flame,
> And bowed my head down—Autumn, and the sick
> Sure knowledge things would never be the same,
>
> "However often Spring might be most thick
> Of blossoms and buds, smote on me, and I grew
> Careless of most things, let the clock tick, tick,

"To my unhappy pulse, that beat right through
My eager body; while I laughed out loud,
And let my lips curl up at false or true,

"Seemed cold and shallow without any cloud."

This movement is diametrically opposite to the short phrases and crashing rhymes of the poems about fighting:

Although my spear in splinters flew
From John's steel-coat, my eye was true;
I wheel'd about, and cried for you,
 Hah! hah! la belle jaune giroflée.
Yea, do not doubt my heart was good,
Though my sword flew like rotten wood,
To shout, although I scarcely stood,
 Hah! hah! la belle jaune giroflée.

The variety of metrical effects is the more remarkable when one observes the exceptionally large proportion of monosyllables. In the first thirty lines of "The Defence of Guenevere" there are only twenty words of more than one syllable, and most of these are inflected forms of monosyllables, such as "knowing," "touching," "heartily," "mightiness." The vocabulary contains few archaisms, since Morris employs the bare bones of language that change but slightly from century to century. Virtually the only unfamiliar words are the names of armor and weapons—"basnet," "hauberk," "glaive," "perrière." Yet out of these restricted materials Morris was able to make his verses sing or wail, march or dance or droop, by his control of line-length, sentence structure, rhyme pattern, and especially the placing of stresses, ranging from almost equal distribution over a number of significant monosyllables in a line ("My knight said, 'Rise you, sir, who are so fleet . . .' ") to exact identity of metrical and oral emphasis:

The clink of arms is good to hear,
 The flap of pennons fair to see;
 Ho! is there any will ride with me,
 Sir Giles, le bon des barrières?

This elementary mechanism guaranteed that each poem would be read with the momentum or retardation that suited it.

If any of the poems can be said to contain a general idea at all, it must be described as outrageously trite. "Old Love" requires seventy-two lines to express the pathos of fading beauty and passion; "The Defence of Guenevere" takes much longer to say that a moral dilemma is hard to solve. None of the characters reveal any inner ethical conflict. Even Guenevere's repentance in "King Arthur's Tomb" is abrupt and unmotivated. Though scrupulously devoid of overt moral meaning, the poems as a group begin to imply the activist ethic of Browning. Guenevere, Sir Peter Harpdon, John of Castel Neuf, and most of the other characters, unlike the Duke and the Lady in "The Statue and the Bust" who are condemned by Browning for the sin of "the unlit lamp and ungirt loin," are to be regarded sympathetically because they followed their emotional impulses without vacillation.

The paucity of ideas is probably why the poems give their peculiarly two-dimensional effect, consisting of narration and description without depth. The visual details conform loyally to the Pre-Raphaelite requirements: a troop of horsemen with lances upright and pennons fluttering, or a pair of lovers in a walled garden, provide the proper components for a well-composed picture, precise and devoid of perspective. The action undeniably has life, but it is the life of automata rather than of people.

If Rossetti is to be seen as foreshadowing symbolism, Morris may be regarded as foreshadowing naturalism. Both poets are apt to appear immoral by the mere absence of the moral implications that are expected in literature: Rossetti can thus be accused of sharing the passive sensuousness of his poetic atmosphere, Morris of conforming to the callous savagery that he depicts in its unvarnished crudity. Like the "clinical fiction" of Zola, his poems report phenomena and leave the reader to supply commentary for himself.

Seekers after psychological clues in a poet's recurrent themes and images may well be tantalized by Morris's. His plausible expressions of the fighting man's blood-lust are easily identifiable as a projection of his exuberant physical vigor. But what of his fascination with traitors and with rivals in love? These can be accepted at their face value as standard romantic motifs; but it

might be suspected that one of them reveals his growing alienation from his social background and that the other hints at the situation between himself and Rossetti. The unnaturally reluctant lovers, too, in "Rapunzel," "Spell Bound," and "The Wind" may conceivably betray some sexual timidity of his own.

The Defence of Guenevere attracted scarcely any attention, though a few perceptive readers thought well of it. In a letter, years afterwards, Browning called Morris "you whose songs I used to sing while galloping by Fiesole in old days,—'Ho, is there any will ride with me?'"[15] Ten years after the book came out Walter Pater praised it as "the first typical specimen of aesthetic poetry":

The poem which gives its name to the volume is a thing tormented and awry with passion, like the body of Guenevere defending herself from the charge of adultery, and the accents fall in strange, unwonted places with the effect of a great cry.... Reverie, illusion, delirium: they are the three stages of a fatal descent both in the religion and the loves of the Middle Age.... The strangest creations of sleep seem here, by some appalling licence, to cross the limit of the dawn.... [Morris] has diffused through *King Arthur's Tomb* the maddening white glare of the sun, and tyranny of the moon, not tender and far-off, but close down—the sorcerer's moon, large and feverish. The colouring is intricate and delirious, as of "scarlet lilies." ... It is in *The Blue Closet* that this delirium reaches its height with a singular beauty, reserved perhaps for the enjoyment of the few.[16]

Oddly it is Swinburne, with unusual moderation, who gives the book its best definition: "Upon no piece of work in the world was the impress of native character ever more distinctly stamped, more deeply branded. It needed no exceptional acuteness of ear or eye to see or hear that this poet held of none, stole from none, clung to none, as tenant, or as beggar, or as thief. Not yet a master, he was assuredly no longer a pupil."[17]

By the time *The Defence of Guenevere* came out, Rossetti and Jones had gone back to their studios in London, but Morris remained in his lodgings in Oxford, visiting his friends in town only at intervals. The cause was partly that he had relinquished painting as a career, but also because he wanted to be near Jane Burden, who accepted his proposal of marriage sometime during the spring. He spent most of the next year in cultivating her mind and

manners by such methods as reading aloud to her from *Barnaby Rudge*. In the summer, with two friends, he rowed down the Seine from Paris to Rouen; as one of them, Philip Webb, had been his comrade in Street's architectural office, they spent the time in discussing Morris's intention of building a house for himself, and he returned to France in the autumn to buy antiques for it.

Apparently during these months he went through some sort of psychological crisis which rendered his behavior unstable and unwontedly passive, though his friends attributed his illness to his bad habits in eating and drinking. He was sufficiently restored to health to marry Jane in April 1859, and after a Continental honeymoon they lived in lodgings in London until the new house was built at Bexley Heath, ten miles south of London. Morris put all his individual theories into it: the architectural style was derived from the massive farm buildings of medieval granges, and the use of brick and tile, which had been out of fashion for a long time, earned it the name of "Red House." Morris devoted himself fanatically to landscaping the grounds and designing the furnishings, which were handmade to his specifications.

Surviving manuscripts indicate that Morris was eager to undertake a long poem immediately after the publication of his book; but the year of emotional disturbance supervened. Fragments of "The Maying of Guenevere" suggest that he was thinking of expanding his cycle on the Arthurian theme; but the success of Tennyson's poem put an end to that project. He went further with plans for a cycle of dramatic poems on the fall of Troy, written in unpretentious blank verse with interspersed lyrics; half of the projected twelve episodes were drafted before the attempt was given up. Work on the house was absorbing all his energy.

The tiles for the floor and the painted glass for the windows were of his own design, and he set Jones to work at covering the staircase walls with scenes from the Trojan War. Jane helped with painting the floral patterns in the ceiling of the great drawing room; she also embroidered hangings, under her husband's tutelage. Morris loved to invite his literary and artistic friends to come for uproarious weekend parties, in which Jane proved to be a joyous tomboy.

Out of the shared delight in equipping the house emerged the

idea for a firm to produce beautiful furnishings as a commerical venture. Jones had received several commissions for stained-glass for churches, and Webb had been designing brass candlesticks and table glass. Besides, Morris's income was beginning to shrink alarmingly and he welcomed the prospect of a profitable business. Each of the friends bought a share at the reasonable price of one pound, and Morris's mother was persuaded to lend a hundred pounds without security. Thus was launched the firm of Morris, Marshall, Faulkner & Co. Quarters were rented in Red Lion Square and workmen were hired. Rossetti contributed a flamboyant prospectus that listed the range of decorative arts to be practiced by the group. For the first three or four years there were no profits, but Morris's formidable energy and versatility, combined with the artistic talents of his associates, eventually built it into a paying concern.

After five years the happy country life at Red House came to an end. The increasing complexity of the business required larger quarters in London and closer supervision, just when a severe bout of rheumatic fever left Morris unable to make frequent trips into town. A big house was therefore leased in Bloomsbury, with rooms upstairs for the Morris family. When they removed in the autumn of 1865, leaving most of the gargantuan furniture behind, Morris was so heartbroken that he never could go back and see the place again.

He had good reason for discouragement. In spite of its waxing reputation, the firm was still in financial straits, due to his hopelessly impractical management. In the hope of attracting converts to his style of domestic art, he insisted on charging the lowest possible prices, which often resulted in a net loss; and his passion for innovation led him to shift workmen constantly from one project to another, leaving unfinished items that deteriorated or were misplaced. His bullying manner and apoplectic bouts of fury became more intolerable; and Jane, now the mother of two daughters, lapsed into ill health in the noisy London house.

In spite of his multifarious concerns, Morris managed at last to get back to the writing of poetry; but the other preoccupations may have been responsible for his eschewing the short, carefully

constructed poems of his first period in favor of a long, loose-jointed narrative in fluent Chaucerian couplets, *The Life and Death of Jason.* The violence and emotional tension which the dramatic-monologue technique had forced the reader to share with the characters in *The Defence of Guenevere* and the unfinished Troy poem yield place to the aesthetic distance of objective portrayal.

In the mid-sixties the "Hellenic Revival," promoted by two unlike sponsors, Arnold and Swinburne, was at its height, and Morris admirably captured the classic coolness that Arnold had recently recommended in his essay "On Translating Homer"—"not only rapid in movement, simple in style, plain in language, natural in thought; [but] also, and above all, *noble.*"[18] That the *Iliad* is Morris's model is evident in such passages as the catalogue that takes four hundred lines to enumerate and describe the heroes who volunteered for the quest of the Golden Fleece; and he follows the *Odyssey* in recounting the perils and temptations of the seafarers. In the first three books there are also echoes of Pindar's fourth Pythian ode. The immediate source for the whole story is the *Argonautica* of Apollonius of Rhodes, but Morris makes extensive changes and additions. The portrayal of Jason is in some ways more sympathetic than in the sources—e.g., Morris omits the early episode of his marrying and abandoning the queen of Lemnos and later his murder of Medea's brother; but he is still, like Morris's earlier protagonists, an exponent of the activist principle. Driven by insatiable lust for adventure and exploration, like Tennyson's Ulysses, he is ruthless and unscrupulous in his methods. In the return journey from Colchis, Morris departs entirely from his sources and from all plausibility. His love for the primitive culture of northern Europe prompted him to invent a year-long voyage up the Danube, a winter encampment in the snowbound forests, a *portage* to the Rhine, and a return home by way of the North Sea, the English Channel, the Bay of Biscay, and the Straits of Gibraltar. By never giving names for the strange regions, Morris obliges his reader to participate in the Argonauts' sense of penetrating undiscovered territory, even though it is not hard for us to interpret the geographical clues.

The insertion of Germanic scenes in the classic legend is in accord with the medieval literary habit of viewing the ancient world through the eyes of a later epoch. Along with the Homeric directness of the poem there is something of the Chaucerian familiarity. One is repeatedly reminded of the Knight's Tale and of *Troilus and Criseyde* by the turns of phrase and the homely touches of ordinary behavior in the midst of heroic gestures, as for instance when Jason, the guest of honor at a royal banquet, looks enviously on the men who have a chance to fondle the passing waitresses. Many incidental details are frankly medieval, such as Medea's magic rituals or Jason's performance in "the lists" with Medea looking on from the gallery.

It is perhaps another medieval feature that the love story of Jason and Medea is made more prominent than in Apollonius; but even so, Jason is strangely passive in the affair. At Colchis it is Medea who becomes infatuated and makes all the advances. Jason accepts her aid in stealing the Golden Fleece, but in spite of his chivalric assurances he does not seem enthusiastic that the bargain requires him to take her home with him. Through the months and perils of the journey there is no reference to lovemaking between them, and so one is not altogether surprised when ten years later he wants to discard her in favor of the lovely young Glauce. As the hero's nobility degenerates, Morris sentimentalizes the situation by showing Medea as a patient and pitiful wife rather than the avenging fury depicted by Euripides; even the murder of her sons is divested of its horror.

In view of these narrative qualities, it is not remarkable that the sole personal intrusion of the poet, which occurs in Book 17, is a fervent tribute to Chaucer:

> Would that I
> Had but some portion of that mastery
> That from the rose-hung lanes of woody Kent
> Through these five hundred years such songs have sent
> To us, who, meshed within this smoky net
> Of unrejoicing labour, love them yet.
> And thou, O Master! Yea, my Master still,
> Whatever feet have scaled Parnassus' hill

Since like thy measures, clear and sweet and strong,
Thames' stream scarce fettered drove the dace along
Unto the bastioned bridge, his only chain.—
O Master, pardon me, if yet in vain
Thou art my Master, and I fail to bring
Under men's eyes the image of the thing
My heart is filled with; thou whose dreamy eyes
Beheld the flush to Cressid's cheek arise,
When Troilus rode up the praising street,
As clearly as they saw thy townsmen meet
Those who in vineyards of Poictou withstood
The glittering horror of the steel-topped wood.

The final lines link Morris's classical poem, by way of Chaucer, with the fourteenth century that he had depicted so fully in his previous book.

Running to over two thousand lines, the poem formed a substantial volume when published in 1867. The monotony of the decasyllabic couplets is sometimes varied by the insertion of a lyric, most of them being sung by Orpheus, who is conveniently a member of the crew. The most charming one, however, is the nymph's song to Hylas:

I know a little garden-close
Set thick with lily and red rose,
Where I would wander as I might
From dewy dawn to dewy night,
And have one with me wandering. . . .

For which I cry both day and night,
For which I let slip all delight,
That maketh me both deaf and blind,
Careless to win, unskilled to find,
And quick to lose what all men seek. . . .

In view of the song's melodious grace, one would be ungrateful to protest that the very English scene is inappropriate as a spell uttered by a nymph in Mysia. The sincere feeling must reflect Morris's longing for Red House in his new distracting environment of the business in London.

Following this clue, one is tempted to infer a wider personal symbolism underlying the poem. Throughout the earlier action, Jason is the ever-adolescent adventurer, avid for experience but learning nothing from it, whereas Orpheus is the wise poet who sees deeply into eternal truths. His singing contest with the Sirens resembles Tennyson's "Sea Fairies" and "Lotos Eaters" in opposing hedonistic withdrawal. In Circe's island, sexuality is equated with trance-like indifference. Hylas's surrender to the nymphs is another example of evading the harsh realities of life. In the final situation of the poem, Glauce offers an idyllic escape from responsibility, while Medea represents unpleasant duty; only on the day of his death does Jason come to terms with reality. This can all be seen as a polarizing of the poetic vacillation between alienation and participation, almost as clear as Tennyson's depiction of it in many poems a generation earlier. Nor is the problem confined to the conflicting claims of aestheticism versus social awareness. It has relevance also to Morris's personal predicament at the time, when his marriage was proving incapable of supplying the ideal love that might have compensated for the sordidness of contemporary life. His deep yearning for an archaic rural existence was being overwhelmed by the demands of his commercial undertaking. Life was destroying art, just as in Circe's garden human bestiality invades a lovely natural scene.

A poem of this kind is impervious to critical analysis, and cannot be represented by brief excerpts. Page after page may be read without the discovery of a single distinctive phrase or noteworthy metaphor. In style it is the antithesis of Keats's *Endymion*, which is in the same metrical form and also retells a Greek myth. Keats "loaded every rift with ore" until the reader becomes so bedazzled that he cannot keep track of the story; Morris allows nothing to stand between his reader and the events. He is as near to the ideal of the invisible author as anyone has been able to come.

The effect of *The Life and Death of Jason* is strictly cumulative. Anyone who can afford enough time to read the whole poem will be rewarded with a sense of having lived for a while in the clear sunlight of the ancient Aegean in days when people accepted the existence of goddesses and centaurs, harpies and sorceresses, as familiarly as sailors or merchants. Our willing suspension of

disbelief is achieved by the absence of any calculated devices for producing it.

As so many copies of *The Defence of Guenevere* remained unsold, the Oxford publisher required Morris to pay all the costs of producing *Jason* himself; but the success of Swinburne's *Atalanta in Calydon*, two years before, had conditioned the public to admire a long poem based on Greek legend, and so Morris's reviews were favorable. Even on the other side of the Atlantic it was hailed by Henry James in the *North American Review* for its "comprehensive sense of form, of proportion, and of real completeness."[19] The book sold so unexpectedly well that within a few months the rights were transferred on a royalty basis to a London firm favored by Rossetti, and Morris felt encouraged to go on with a much more ambitious project that he had been planning for more than a year.

This was to be a great cycle of verse narratives after the model of *The Canterbury Tales*. Originally *Jason* was intended to serve as one of the stories, but it grew to such dimensions that Morris set the other scheme aside until he finished it. Along with it he had written two others in 1866 which were not incorporated into the completed cycle. One on Orpheus and Euridice remained unpublished, and the other, on a little-known story by Pausanias about Aristomenes of Messene, proved so difficult that it was never completed. A tentative prologue was also written, running to about 2,700 lines in tetrameter quatrains.

After the success of *Jason* encouraged him to believe that the vast *Earthly Paradise* might be favorably received, Morris resumed work on it energetically, once writing seven hundred lines in a single day. He had not reconsidered his original opinion that "if this is poetry, it is easy to write." In later years he remarked that "if a chap can't compose an epic poem while he's weaving tapestry, he had better shut up; he'll never do any good at all." In commenting on a poem by someone else, he declared, "That talk of inspiration is sheer nonsense, I may tell you that flat. There is no such thing; it is a mere matter of craftsmanship."[20] It was as an expert craftsman, therefore, that he laid down his design for *The Earthly Paradise*.

In the nineteenth century, epic poetry was so scorned as obso-

lete that any poet who felt impelled to write a long narrative went to ingenious lengths to evade the pejorative term. Tennyson gave his twelve episodes a plural title; Browning broke up his Roman murder story into a series of disparate monologues. Indeed, *The Life and Death of Jason* was the only poem of the century that won much favor in the traditional epic mode. Morris realized that for a far more extensive poem he must find an escape from the monolithic structure and, like his contemporaries, build his long poem out of smaller units. *The Canterbury Tales* was an obvious prototype, but he was aware that he could not command the needful diversity through Chaucer's inimitable range of social types and literary genres. Morris had to invent his own method of variation.

His solution of the problem was resourceful. As though preparing cartoons for a sequence of murals or tapestries, he planned his twenty-four stories according to the artistic principles of balance and contrast. The time is late in the fourteenth century, the setting an unknown land in the western Atlantic. Like that of Boccaccio's *Decameron*, the occasion is a flight from the Black Death; but these refugees are a shipload from Norway who decide to sail westward in search of the fabled Earthly Paradise, the land of eternal youth. After years of toil and danger along the North American seaboard, including a sojourn among the Mayans, they arrive at an island inhabited by survivors of a centuries-old Greek colony. As the leader of the explorers had lived in Constantinople in his boyhood, being the son of an officer in the Varangian Guard, he can speak Greek and establishes friendly relations with the colonists. For a cultural exchange program, it is decided that each month for a year one of the Greeks will tell one of the classical myths that have lingered in their memories, and a representative of the visitors will respond with a traditional tale he has heard in his own country. In order to give himself a wider range of sources, Morris included among his travelers a Swabian priest and a Breton squire, while the leader of the party remembers a story from the *Arabian Nights* that he learned in his Byzantine youth.

The contrasting of classic Greek with northern European settings is a development from the books of *The Life and Death of*

Jason that dealt with the Argonauts' adventures among prehistoric Celtic tribes. Like *Jason*, too, the stories are viewed through medieval lenses, without concern for anachronism. The verse form in most of the link passages and in seven of the stories is the same Chaucerian couplets that were used in the preceding book; but ten of the tales are in rhyme royal and seven in tetrameter couplets, and this diminishes the monotony that was one of the defects of *Jason*. Its other defect—diffuseness—is likewise mitigated now that the separate tales are relatively brief, though they vary widely in length, from a minimum of about three hundred lines to a maximum of over five thousand.

Further variety is provided by the personal passages in which Morris speaks in his own voice. These are the preliminary "Apology," the concluding "Envoy," and the twelve lyrics on the months that form the transitions before each pair of stories. These are all in rhyme royal, and the apology and envoy are reminiscent of the medieval "fixed forms" by having every stanza end with a refrain line—variations on "the idle singer of an empty day." With characteristic modesty, Morris disclaims any rivalry with either the epic or the philosophic poets, such as Milton or Wordsworth:

> Of Heaven or Hell I have no power to sing,
> I cannot ease the burden of your fears,
> Or make quick-coming death a little thing,
> Or bring again the pleasure of past years,
> Nor for my words shall ye forget your tears,
> Or hope again for aught that I can say,
> The idle singer of an empty day.
>
> But rather, when aweary of your mirth,
> From full hearts still unsatisfied ye sigh,
> And, feeling kindly unto all the earth,
> Grudge every minute as it passes by,
> Made the more mindful that the sweet days die—
> Remember me a little then I pray,
> The idle singer of an empty day. . . .
>
> Dreamer of dreams, born out of my due time,
> Why should I strive to set the crooked straight?
> Let it suffice me that my murmuring rhyme

Beats with light wing against the ivory gate,
Telling a tale not too importunate
To those who in the sleepy region stay,
Lulled by the singer of an empty day.

Along with this overt manifesto of "aesthetic poetry" Morris
conveys implied condemnation of the sordid commercial environ-
ment of the present day, when he speaks about "The heavy
trouble, the bewildering care / That weighs us down who live
and earn our bread," and ends with a forecast of future social
reformers:

... pardon me
Who strive to build a shadowy isle of bliss
Midmost the beating of the steely sea,
Where tossed about all hearts of men must be;
Whose ravening monsters mighty men shall slay,
Not the poor singer of an empty day.

The contrast is immediately made explicit in the opening lines of
the "Prologue":

Forget six counties overhung with smoke,
Forget the snorting steam and piston stroke,
Forget the spreading of the hideous town;
Think rather of the pack-horse on the down,
And dream of London, small, and white, and clean,
The clear Thames bordered by its gardens green. . . .
While nigh the thronged wharf Geoffrey Chaucer's pen
Moves over bills of lading—mid such times
Shall dwell the hollow puppets of my rhymes.

The monthly interludes emphasize the charm of English rural
scenery and the cycle of the seasons, in a manner reminiscent of
"The Shepheardes Calender" and of Herrick, with melancholy
overtones of regret for the swift passage of time and joy:

O June, O June, that we desired so,
Wilt thou not make us happy on this day?
Across the river thy soft breezes blow
Sweet with the scent of beanfields far away,
Above our heads rustle the aspens grey,

Calm is the sky with harmless clouds beset,
No thought of storm the morning vexes yet.

See, we have left our hopes and fears behind
To give our very hearts up unto thee;
What better place than this then could we find
By this sweet stream that knows not of the sea,
That guesses not the city's misery,
This little stream whose hamlets scarce have names,
This far-off, lonely mother of the Thames?

This lyric, and the equally lovely one for August, record excursions up and down the Thames from Oxford, where the Morris and Burne Jones families spent the summer of 1867. By this time the poem was so well advanced that Morris was able to rewrite the prologue in its final form, discarding the monotonous ballad-like quatrains in favor of Chaucerian couplets.

His daughter tells us that "he saw the stories as brilliantly-defined pictures,"[21] and so while he wrote the poems Jones drew illustrations for them, with the intention of publishing a folio de luxe with five hundred woodcuts, of which about one hundred were actually made; but the scheme encountered such difficulties of production that it was abandoned. Instead the plan became two volumes of ordinary octavo size, the first of which, containing the prologue and the twelve springtime and summer stories, came out in April 1868. That the poem was still far from finished is proved by the contract with the publisher, which stipulated a total length of 34,000 lines. When completed, it ran to 8,000 lines more, and so there had to be two further volumes instead of one.

Nor was the change solely a matter of length: late in 1868 Morris discovered a new literary source which he immediately started to incorporate into the poem, and so several of the originally announced tales were discarded to leave space for new ones. From the outset, a noteworthy feature of the project was Morris's avoidance of the feudal motifs that had occupied his first book; he was seeking for the more unsophisticated quality of folk legend. He therefore drew his stories from the great reservoirs of popular tales in the late Middle Ages—two from the *Gesta Romanorum*, two from William of Malmesbury's *De Gestis Regum Anglorum*,

two from Mandeville's *Travels*. In the first volume of *The Earthly Paradise* the non-Greek stories were placed in a vague fairy-tale region that included kings and knights and castles but without specific identity, as the second April story admits in its opening lines: "In a far country that I cannot name, / And on a year long ago past away, / A King there dwelt...." Though the narrators are Norsemen, none of the stories in the first volume are Scandinavian, for, in spite of the title, "Ogier the Dane," the sixth non-Greek story, is from Celtic folklore filtered through a French metrical romance.

The first story in the second volume, "The Land East of the Sun and West of the Moon," is localized "in Norway, in King Magnus's days" and is much longer than any that preceded it; but, as the title indicates, its theme is a universal episode of enchantment. The first half is from the *Volunda Saga* by way of one of Thorpe's books, but the conclusion grafted onto it is from the *Arabian Nights*. Following it, "The Man who Never Laughed Again" was derived wholly from the *Arabian Nights*. In September 1868, however, Morris began the study of Icelandic under the tutelage of Eirikr Magnússon, and was so bewitched that within a few months he devoured the whole corpus of the Eddas. He collaborated with Magnússon in a translation of "Gunnlaug Wormtongue," which came out in the *Fortnightly Review* in January 1869, and their book-length version of *The Grettis Saga* followed three months later. Inevitably this new enthusiasm invaded *The Earthly Paradise*: the non-Greek story for November threw the whole structure out of proportion by its unprecedented length and introduced a radically different narrative tone. "The Lovers of Gudrun" is straight out of the *Laxdaela Saga* and adopts the chronicler's stance of exact historical reporting and geographical precision. The next story, "The Fostering of Aslaug," is taken from the *Völsunga Saga*, and the final tale of the series, though it comes nearer to the romances of chivalry than the others, is from a German source, being the adventure of Tannhäuser in the Venusberg, in Tieck's version.

In technique, the most ingenious tale is "The Land East of the Sun," which is modeled on Chaucer's device in *The Book of the*

Duchess, wherein the dreamer and the figure in the dream are identical. By using several narrators, Morris examines how an artist relates to his creation. Another problem of the artist—his ability to function in a hostile world—appears in "The Fostering of Aslaug." The theme of the prologue may also be regarded as an allegory of the artist's search for a realm of pure and timeless beauty, from which he is perpetually excluded by the harsh realities. The idea recurs in "The Writing on the Image" (a scholar isolates himself in a land of the living dead), in "Ogier the Dane" (the hero finds a country of changeless loveliness where "no talk there was of false and true," but is sent back to the world of conflict and duty), and in Tannhäuser in "The Hill of Venus." Morris is apparently disturbed by the dilemma of the artist: his defiant insistence that he is merely "the idle singer of an empty day" betrays a gnawing anxiety because he is not fulfilling a valid social function.

His depression casts gloom over the tales, rendering the dominant note passive and fatalistic. There is no Orpheus to incite to action, as there was in *Jason*. Only in the two Bellerophon tales is there a hero who remains a fighter; by his fortitude he destroys the Chimaera (illusion). The seafarers of the prologue are frustrated in their search for a timeless refuge from the troubled world, and in their tales the characters are helpless in the grasp of destiny.

"L'Envoy," which concluded *The Earthly Paradise* when the third volume came out in October 1870, repeated Morris's devout praise of Chaucer and reiterated also the humility that he had professed at the outset, but with insistence that the book embodied his authentic identity. The book is instructed to carry a message from the author to his master; in this passage, therefore, "he" is Morris, "thou" is Chaucer, and "I" is *The Earthly Paradise*:

> "But of thy gentleness draw thou anear,
> And then the heart of one who held thee dear
> Mayest thou behold! So near as that I lay
> Unto the singer of an empty day.
>
> "For this he ever said, who sent me forth
> To seek a place amid thy company,

That howsoever little was my worth,
Yet was he worth e'en just as much as I;
He said that rhyme hath little skill to lie;
Nor feigned to cast his worser part away
In idle singing of an empty day.

"I have beheld him tremble oft enough
At things he could not choose but trust to me,
Although he knew the world was wise and rough:
And never did he fail to let me see
His love,—his folly and faithlessness, maybe;
And still in turn I gave him voice to pray
Such prayers as cling about an empty day.

"Thou, keen-eyed, reading me, mayest read him through,
For surely little is there left behind;
No power great deeds unnameable to do;
No knowledge for which words he may not find,
No love of things as vague as autumn wind—
—Earth of the earth lies hidden by my clay,
The idle singer of an empty day. . . ."

In retrospect, we can see that the vow of fealty to Chaucer was actually a farewell. In the tales of the third volume, the Chaucerian manner was perceptibly giving place to the ruggedness of the folk epic; the new feeling even affected the last two months of the Greek material, in which the Bellerophon myth was expanded into two installments to allow for a more spacious epic movement.

In the Icelandic sagas Morris found a new imaginative world that was scarcely known to the English-speaking public, and its blunt directness and savage strength proved to be his ultimate poetic model, completing the sequence that began with Scott and proceeded through Malory, Froissart, and Chaucer. With Magnússon as his mentor, Morris turned his broad back on the whole culture that centered in the Mediterranean. In this reversion to primitivism, the parallel with Wagner is significant; it was twenty-five years since *Tannhäuser* marked his turn toward traditional Germanic material, but the Nibelungen cycle was still incomplete at the time when Morris committed himself irrevocably to the Germanic themes.

The shift of allegiance marked the end of his poetic subjection to Rossetti. In spite of the active role that Rossetti played in the organizing of Morris & Co., the close intimacy between the two had imperceptibly eroded. When Rossetti, after his wife's death, set up his bachelor enclave in Chelsea, Swinburne was installed as Young Poet in Residence. The removal of the Morrises from Red House to London made it more convenient for them to see Rossetti frequently, but undoubtedly it was Jane that he preferred to consort with.

The personal lyrics of the months in *The Earthly Paradise* offer evidence that Morris's marriage had foundered in incompatibility. The poems for September, December, January, and April all express yearning for dead love. Even more poignantly intimate is "Near but Far Away," a sonnet that he left unpublished. In language reminiscent of Meredith's *Modern Love*, a woman is described as being momentarily moved by the "unspoken miseries" in her lover's eyes. When he tries to stammer out "a prayer from out my heart . . . in shame's strong net":

> She stayed me, and cried 'Brother!' Our lips met
> Her hands drew me into Paradise,
> Sweet seemed that kiss till thence her feet were gone,
> Sweet seemed the word she spake, while it might be
> As wordless music—But truth fell on me
> And kiss and word I knew, and, left alone,
> Face to face seemed I to a wall of stone,
> While at my back there beat a boundless sea.

In another poem of the same period which he did not publish, the triangular situation is stated clearly. In spite of his protestations of love, the woman leaves him "Half-forgotten, unforgiven and alone," and when his friend visits him:

> Then face to face we sit, a wall of lies
> Made hard by fear and faint anxieties
> Is drawn between us and he goes away
> And leaves me wishing it were yesterday.

A third poem of the unpublished group, "Why Dost Thou Struggle?" puts words into the mouth of the woman:

"I wore a mask because though certainly
I loved him not yet was there something soft
And sweet to have him ever loving me
Belike it is I well nigh loved him oft—

"Nigh loved him oft and needs must grant to him
Some kindness out of all he asked of me
And hoped his love would still hang vague, dim,
About my life like half-heard melody.

"He knew my heart and over-well knew this
And strove poor soul to pleasure me herein;
But yet what might he do? some doubtful kiss,
Some word, some look might give him hope to win. . . ."

Proper conventional appearances were maintained. The Morrises and Rossetti attended parties together, though the other guests could not overlook how totally Rossetti and Jane were absorbed in each other. Morris must have been aware of the significance in the sensuous portraits of her that Gabriel painted during the late sixties; one of them was described as being La Pie de' Tolomei, who was imprisoned by her jealous husband because of her love for Dante. Nor could there be any doubt as to who inspired his sudden outburst of passionate love sonnets. Morris, with his chivalric ideal of honor, perhaps assumed that the relationship between his wife and his friend was innocent (as indeed it may have been), or he may have felt willing to countenance the emotional therapy that rescued Rossetti from despondency and restored his poetic impulse. In his pitiable efforts to retain even a semblance of affection from his wife, he may have felt satisfied when she had a more romantic admirer to gratify her psychological needs.

In the hope of curing her painful backache, Morris took her to a German spa for the summer of 1869 and impatiently attended on her while trying to write the later episodes of *The Earthly Paradise*, Rossetti meanwhile bombarding her with love letters. From the available evidence, one is tempted to infer that by this time Morris was feeling greater warmth of affection toward the wife of his friend Burne-Jones than toward his own wife. Jones was involved for several years in an emotional entanglement with

a Greek woman, one of Rossetti's models, who attempted suicide when Morris tried to help Jones to evade her. It was to produce gifts for the gentle and kindly Georgiana Burne-Jones that Morris spent countless hours making elaborate illuminated manuscripts.

His relationship with Rossetti was further complicated in 1870 through Rossetti's paranoic dread of criticism when his poems were belatedly published; Morris was one of the friends arbitrarily commanded to write laudatory reviews. In his contribution to the *Academy* a trace of constraint may be detected under the surface of warm praise. He declares that "an original and subtle beauty of execution expresses the deep mysticism of thought, which in some form and degree is not wanting certainly to any poets of the modern school, but which in Mr. Rossetti's work is both great in degree and passionate in kind." He also compared *The House of Life* with Shakespeare's sonnets "for depth of thought, and skill and felicity of execution." There was something oddly evasive, however, in his praise of the short pieces: "Nor do I know what lyrics of any time are to be called great if we are to deny that title to these." He found much in *The House of Life* "not free from obscurity, the besetting vice of sonnets," and both obscurity and laboriousness were imputed to "The Stream's Secret," "Love's Nocturne," and several other poems.[22]

Morris's poetic friends, on the other hand, had been appalled by the gargantuan bulk of *The Earthly Paradise*. When the second volume came out in October 1869, Swinburne wrote to Rossetti: "His Muse is like Homer's Trojan women—she drags her robes as she walks; I really think a Muse (when she is neither resting nor flying) ought to tighten her girdle, tuck up her skirts, and step out. . . . My ear hungers for more force and variety of sound in the verse. It looks as if he purposely avoided all strenuous emotion or strength of music in thought and word."[23] Rossetti in his reply agreed that "Topsy writes too much both for his own sake and for that of his appreciators;"[24] and Morris himself admitted in a letter to Swinburne that the tales "are all too long and flabby, damn it! . . . If I could find anything else that really amused me except writing verse I would give up that art for the present, for I am doing no good."[25]

After his completion of *The Earthly Paradise*, he felt pecu-
liarly uncertain about his next literary undertaking. He consid-
ered large-scale Arthurian poems on Tristram and on Balin and
Balan; but the risk of comparison with Tennyson deterred him.
He and Magnússon had already added another translation, *The
Völsunga Saga*, to their two previous ones, but he was not content
to remain a collaborative translator. For a while, the void was dis-
guised by his preoccupation with acquiring a house.

Five years in London had proved to be all that the family could
endure, and so in the spring of 1871 he was delighted to find an
Elizabethan house in the depths of the country at Kelmscott,
thirty miles up the Thames from Oxford. Rossetti was invited to
be a co-tenant, partly no doubt for financial reasons but partly
also to provide him with a wholesome rural alternative to the ir-
regular life he was leading in Chelsea, which was assumed to have
contributed to his mental depression. At midsummer he and the
Morris family moved into the manor, and immediately Morris
went off for a visit to Iceland with Magnússon and two other
friends. In a six-weeks packhorse expedition they explored all the
scenes of the heroic events chronicled in the sagas, and Morris
was deeply stirred. Sleeping in tents, cooking meals over camp-
fires, he felt that at last he had escaped from the sordid modern
world and was identified with the very essence of primitive ex-
istence.

After his return to England, he spent most of his time at the
business premises in Queen Square, looked after by his wife's
spinster sister (whom he found unutterably boring), and going
down for weekends at Kelmscott Manor, where Rossetti func-
tioned virtually as master of the house. Except for the period of
his prolonged breakdown in 1872, Rossetti was there most of
the time for three years, reveling in the happiness of Jane's com-
pany. Otherwise, he soon found country life lonely, and the
drafty old house was bad for his health. Whenever Jane was
away, he imported large parties of friends to keep his spirits up.

Morris worked dispiritedly on his next book, an elaborately
constructed masque entitled *Love Is Enough*. His daughter has
said that it is his only work that deals with his inner life, and its

melancholy portrayal of a hopeless quest for love is a clue to his mood. The main episode tells how King Pharamond has a dream of a lovely maiden singing in a garden and leaves his domain to wander "through the world . . . / Till either I find her, or find the world empty." Upon encountering her, he immediately loses her again, and when he goes home he finds his subjects disaffected and a usurper on his throne. On the literal level, the story suggests Morris's own recent return from Iceland; as an allegory, it implies the vanity of romantic wishes and the folly of evading duty.

The central story was derived from the *Mabinogion*, but the Celtic tale is overlaid with details that suggest a Carolingian setting: the names of the hero and heroine are Provençal variants of Germanic originals and the emperor and empress who witness the play could be descendants of Charlemagne. As elsewhere, Morris is interested in the migrations of legendary themes in medieval Europe.

Though cast in dramatic form, the story is conveyed largely in narrative rather than as direct action. The ingenious structure is slightly reminiscent of *A Midsummer Night's Dream*. A peasant and his wife have come to the city for the wedding festivities of their emperor. After a grand procession, the emperor and his bride take their places to see the morality play, and the country couple also find a vantage point. The player king and his partner are shown to be in love with each other, outside of their roles as Pharamond and Azalais. Thus the omnipresence of love is displayed in four layers; and the theme is further emphasized between the acts in lyric choruses, each with the burden that "Love is enough," and also in addresses to the audience by an allegorical figure of Love himself, who comes before the curtain in successive disguises, as a king, as an artist ("a maker of Pictured Cloths"), and as a pilgrim. By a skillful device, these linking figures are merged into the play in the fourth scene, when Love comes upon the stage for a conversation with Pharamond and the "Music" is audible as a background for their dialogue.

Morris seeks for variety by changes of meter. The speeches by Love are in heroic couplets, the incidental "Music" is in complicated stanza patterns; Joan and Giles speak in iambic tetrameter

couplets, the emperor and empress in pentameter quatrains; the dialogue of the morality play is in unrhymed dactylic tetrameter faintly suggesting the rhythms of Middle English verse. Such self-conscious devices enhance the decorative quality of the poem but deprive it of emotional vitality. The elaborately interlocking planes of action, along with the alternating thematic tunes provided by the various meters, combine to produce an effect astonishingly like the intricate decorative designs that Morris was producing for woodcuts and illuminated manuscripts. As a matter of fact, he again planned a handsome illustrated quarto, with his own page-borders and Jones's woodcuts; but, as had happened with *The Earthly Paradise*, the scheme was abandoned before the poem was tardily finished and printed in 1872.

Meanwhile the expanding business invaded the living quarters in Queen Square, and so at the end of 1872 Morris took a house in Hammersmith as the town residence for his wife and daughters. In spite of his intense love for the rural quietude of Kelmscott, he could no longer endure to share it with the dynamic co-tenant. To an understanding woman friend he wrote: "Rossetti has set himself down at Kelmscott as if he never meant to go away; and not only does that keep me from that harbour of refuge (because it is really a farce our meeting when we can help it) but also he has all sorts of ways so unsympathetic with the sweet simple old place, that I feel his presence there as a kind of slur on it."[26]

In frustration and low spirits, Morris did not find a satisfactory literary project for two years. He worked on a translation of *Heimskringla* and started a modern novel about two brothers in love with the same woman, but gave it up when Mrs. Burne-Jones and her sister did not care for it. His business, meanwhile, was struggling along under the unwieldy amateur partnership with which it had begun, Morris and two or three assistants being left to do all the work. When reorganization became essential it entailed ill will, financial disputes, and threats of litigation; but in 1875 Morris emerged as proprietor of the firm and—more importantly for his peace of mind—occupant of his own house, for Rossetti, whose hallucinations were becoming alarming, was dislodged from Kelmscott Manor.

The family tensions were not wholly resolved. Jane and the girls spent the winter of 1875 at a South Coast resort, ostensibly for her health but also to be near Rossetti, who was recuperating there. The deepest sorrow of Morris's life began shortly afterward, when his favorite daughter developed symptoms of epilepsy and he assumed that she had inherited the malady through him. As usual, he sought solace in intensive activity. He expanded the firm into a variety of new products—wallpaper, carpets, tapestries, printed fabrics; he not only produced the designs but shared the manual work, cutting blocks and stitching embroideries. Dissatisfied with commercial dyes, he ransacked old herbals to revive the secrets of vegetable dyes, and spent long days at the vats so that his clothes and even his skin became impregnated with mixed colors.

Still, however, he had time for writing. In 1875 he brought out a volume entitled *Three Northern Love Stories*, consisting—in spite of the title—of prose translations of six tales from the sagas. A few months later came a translation of Virgil, which, in deference to medieval usage, he entitled *The Aeneids*. For his verse form he selected the septenary, or "fourteener," the seven-stress iambic couplets that had been used in Chapman's *Homer*. Actually, of course, this is simply the ballad quatrain printed as two lines instead of four; but the typography ensures a more sustained flow, suitable to epic movement. The choice of this traditional but supposedly "primitive" meter, as well as Morris's downright vocabulary, offended scholarly critics who emphasize the subtlety and elegance of Virgil's style; but on the other hand he demonstrated that the *Aeneid* was not the effete and factitious exercise that some romantic writers had maintained it to be, but was in the great tradition of the epic, which derives its strength from its primitive origins.

At the same time, Morris was hard at work on an epic-length poem of his own. *The Story of Sigurd the Volsung and the Fall of the House of the Niblungs* came out in 1876. The material came mainly from the *Völsunga Saga*, which Morris and Magnússon had translated into English prose six years before, and which he considered the greatest epic theme in the world. He regarded it, too, as the property of the whole Germanic area. "This is the

Great Story of the North," he wrote in the preface to his translation, "which should be to all our race what the Tale of Troy was to the Greeks." With his acute sense of Nordic identity, he felt that this could serve as a national English epic more appropriately than the Celtic Arthurian legends.

At the same time, there is an implicit resemblance to the *Idylls of the King*. Morris is not only recounting a massive ancient story but also offering a noble model for the contemporary world. There is a subtle change from the passive, fatalistic attitude of his previous poems to a heroic note of commitment and responsibility. Some of Sigurd's more ferocious actions are omitted or modified. Like Tennyson's Arthur, Sigurd is less a tribal warrior than a visionary exponent of peace and progress. The problems of leadership are clearly symbolized. Regin, the cunning dwarf, seeks power through gold, whereas Sigurd manages to inspire the Niblungs with a Carlylean code of equality and dutiful work until treachery and violence supervene. Even in the conclusion of the poem, the cataclysm of Ragnarok is displayed as necessary for the return of Baldur the Beautiful, in a cycle of destruction and regeneration.

The function of poetry is significant throughout. Regin, a master of poetic technique, manipulates it for his own advantage, whereas Sigurd values heroic poems as inciting the listeners to emulation. Gunnar in his songs affirms his kinship with the whole human race. These clues imply that Morris had tardily accepted the standard Victorian compulsion to see his poetic vocation as entailing a moral and social responsibility.

In his fidelity to his source, he weakened the unity of the poem by incorporating much of the preliminary action. The saga writer, after all, regarded himself as a historian, obliged to record all the facts. Hence the first quarter of Morris's poem constitutes a complete story, dealing with Sigmund and Signy and their son Sinfiotli. Having a superhuman and barbaric vitality of their own, these primordial figures set a tone which changes in Book 2 with the birth of Sigurd and the more sympathetically human action that ensues. Morris does omit, however, the closing section of the saga, which is anticlimactic.

Perhaps the most interesting feature is the representation of Gunnar, whom one cannot help feeling to be something of a self-portrait. Passionate and obstinate, he is not only a prince but also a poet, and is converted from aloofness to humanitarian concern, using history in his songs to inspire heroic behavior. A further resemblance is in his agony because his wife loves another man. In this respect, moreover, Morris departed significantly from the saga story. Instead of showing Gunnar as compelled by irresistible passion to slay his dearest friend, Morris turns to the German version of the story, in the *Nibelungenlied*, which depicts Gunnar as motivated by greed for the ring. One suspects that Morris's self-identification inhibited him from rendering the stark tragedy of Gunnar's actual motive. From this source also comes Gudrun's action in taking revenge on her brothers for Sigurd's death.

With similar independence of choice, he interpolated details from related sources—the "Lay of Sigrdrifa," "First Lay of Gudrun," "Snorra Edda," "Reginsmál," "Fáfnismál," "Short Lay of Sigurd," and two lays of Atli. To combine them into a coherent epic, Morris labored with unaccustomed care; the surviving manuscripts show repeated revisions, resulting in as many as seven versions of the climactic episode, Sigurd's final meeting with Brynhild. All the care with sources and structure was rewarded by the achievement of genuine epic dignity, conveying not only the brutal violence but also the tragic splendor of the antique tale.

Each of the four books has firm symmetrical structure, opening with a description and ending with a strong climax. Morris's delight in Icelandic scenery lends vividness to the landscape settings. The use of appropriate seasonal backgrounds is comparable to that in *Idylls of the King*. The plenitude of descriptive detail, the imagery, the moral commentary, and the speeches of psychological revelation render the poem four times as long as its source, and add modern complexities to the elemental narrative directness of the original.

The poem is written in long lines with couplet rhymes, but instead of the iambic heptameter of the *Aeneid* translation it is in a six-stress alternation of iambs and anapests, in the manner of

Swinburne's contrapuntal meters and also remotely reproducing the movement of classical hexameter. A suggestion of Old English meter is contributed by strong caesuras and extensive use of alliteration. Bernard Shaw describes how Morris used to rock "from one foot to another like an elephant" while reading the poem aloud.[27]

Though it was less warmly received than *Jason* or *The Earthly Paradise*, Morris regarded *Sigurd* as the poem that he "wished to be remembered by."[28] He sought to transmit what had fascinated him in the saga—"such startling realism, such subtilty, such close sympathy with all the passions that move [us] today."[29] Culminating his poetic ambition, it signalizes his shift to new objectives both in literature and in his outlook.

Until 1874 he had remained unaffected by the social pressures that had impelled Ruskin, for instance, fifteen years earlier, to embrace radical economic theories and deliver aggressive speeches. Though the activities of Morris's firm partook of the nature of handicrafts, and its products were intended to be substitutes for the ugly mass-produced furnishings of the time, it was primarily a business, rather than a nonprofit cooperative like Ruskin's "Guild of St. George." The incidental animadversions on modern urban sprawl in *The Earthly Paradise* merely expressed the traditional poetic preference for the simple life. A letter written on his fortieth birthday betrays the first hint of active concern with contemporary problems:

Surely if people lived five hundred years instead of threescore and ten they would find some better way of living than in such a sordid loathsome place [London], but now it seems to be nobody's business to try to better things—isn't mine, you see, in spite of all my grumbling—but look, suppose people lived in little communities among gardens and green fields, so that you could be in the country in five minutes' walk, and had few wants, almost no furniture for instance, and no servants, and studied the (difficult) art of enjoying life, and finding out what they really wanted: then I think one might hope civilization had really begun. But as it is, the best thing one can wish for this country at least is, meseems, some great and tragical circumstances, so that if they cannot have pleasant life, which is what one means by civilization, they may at least have a history and something to think of —all of which won't happen in our time.[30]

Five months later, another letter shows that his foreboding of national catastrophe was becoming more intense:

Neither do I grudge the triumph that the modern mind finds in having made the world (or a small corner of it) quieter and less violent, but I think that this blindness to beauty will draw down a kind of revenge one day: who knows? Years ago men's minds were full of art and the dignified shows of life, and they had but little time for justice and peace; and the vengeance on them was not increase of the violence they did not heed, but destruction of the art they heeded. So perhaps the gods are preparing troubles and terrors for the world (or our small corner of it) again, that it may once again become beautiful and dramatic withal: for I do not believe that they will have it dull and ugly forever.[31]

With typical impetuosity, no sooner did he become aware of the issues than he plunged headlong into the turmoil, and during 1876 he became a leader in two totally unlike agitations. One was the Society for the Preservation of Ancient Buildings—an unwieldy title that he promptly reduced to "Anti-Scrape." Horrified not only by the destruction of old houses to make way for new streets, but also by the ruthless remodeling of Gothic churches in the name of "restoration," Morris organized the society, enlisted members, and wrote propaganda.

His other crusade was the Eastern Question Association, founded hastily to prevent England from taking part in the Russo-Turkish War. Morris served as treasurer, contributed funds, wrote articles, and made incendiary speeches until his voice wore out; he was prepared if necessary to participate in mass demonstrations. It was for this cause that he wrote his first political poem, a rousing bit of doggerel entitled "Wake, London Lads," which was chanted to a popular tune, with loud cheers, by an audience of workingmen at an antigovernment rally.

For the remaining twenty years of his life, Morris's insatiable energy was directed primarily toward radical political action. After the Eastern crisis simmered down he served for a year as treasurer of a working-class group, the National Liberal League; but when a Liberal government came into power he soon decided that they were as heedless of the masses as the Tories were. In 1883 he found his haven in the Social Democratic Federation, a

dedicated Marxist league; he plodded through a French translation of *Das Kapital*, finding the economic arguments "stiffer going than some of Browning's poetry" but accepting them nonetheless.

His new adherence required him to abjure the Pre-Raphaelite tenet of art for art's sake. In a lecture of 1881 he declared that beautiful pictures of that sort "cannot fill the gap which the loss of popular art has made, nor can they, especially the more imaginative of them, receive the sympathy which should be their due. As things go, it is impossible for any one who is not highly educated to understand the higher kind of pictures."[32] A few months later he wrote:

I never could really sympathize with Swinburne's work; it always seemed to me to be founded on literature, not on nature.... Now I believe that Swinburne's sympathy with literature is most genuine and complete.... Now time was when the poetry resulting merely from this intense study and love of literature might have been, if not the best, yet at any rate very worthy and enduring: but in these days ... the issue between art, that is, the godlike part of man, and mere bestiality, is so momentous, and the surroundings of life are so stern and unplayful, that nothing can take serious hold of people, or should do so, but that which is rooted deepest in reality and is quite at first hand: there is no room for anything which is not forced out of a man of deep feeling, because of its innate strength and vision.[33]

Just at the same time, ironically enough, Swinburne was condemning Morris's poetry as too antiquated. To their friend Theodore Watts he wrote: "For my sake, withhold him from more metrification à la Piers Plowman. I always foresaw that he would come to reject Chaucer at last as a modern. It is my belief that you encourage all this dashed and blank Volsungery which will end by eating up the splendid genius it has already overgrown and incrusted with Icelandic moss."[34]

Caught in the dilemma between his new theory and his old practice, Morris had lamented more than a year earlier: "As to poetry, I don't know, and I don't know. The verse would come easy enough if I had only a subject which would fill my heart and mind: but to write verse for the sake of writing is a crime in a man of my years and experience."[35] Instead, he disciplined himself to the unaccustomed task of composing lectures on the social func-

tion of art and speeches on radical politics. His addresses on "Art, Wealth, and Riches" and on "Art and Democracy," with their frontal attacks on capitalism and the profit system, aroused wide antagonism. He also harangued open-air mass meetings, at one of which, in Hyde Park, he was pushed about by an unruly mob. To obtain funds for the Democratic Federation he sold his personal library, and he largely financed its weekly paper, *Justice*, of which he and his fellow-members of the executive committee peddled the first number on the pavements of Fleet Street. Among his contributions to the paper were several proletarian exhortations in verse. Reprinted in penny pamphlet form as "Chants for Socialists," these simple-minded rhymes served their purpose by being sung at meetings and thus reaching hundreds of hearers who were impervious to more subtle literary works.

Morris promptly became enmeshed in left-wing intrigue. The founder and chairman of the Social Democratic Federation, Henry M. Hyndman, was both devious and autocratic; as the only other prosperous member of the coterie of intelligentsia, Morris felt obliged to take the lead in opposing him, while Friedrich Engels watched their amateur efforts at subversion with ironic contempt. At the beginning of 1885 Morris and his followers withdrew from the federation and founded the Socialist League, with its own organ, the *Commonweal*, which Morris edited, with Marx's son-in-law as his assistant.

Much of the paper's contents was written by the two editors, and in it Morris published serially a long poem, *The Pilgrims of Hope*, which was a determined effort to come to grips with the current social crisis. If any Victorian poet was qualified to write verse for the populace, it was Morris. His simple vocabulary and emphatic rhythms made for easy readability, while his emotional sincerity and naïveté required no subtlety of response. The long, galloping lines of *The Pilgrims of Hope* are in the meter that Tennyson had used in some of his recent novelistic poems, such as "Maud" and "Despair." In a series of monologues the poem recounts the life story of a village couple who come to live in London because the young husband has a vague impulse toward humanitarian reform. They are horrified by what they see of the

degradation of the laboring poor and the aimless extravagance of the rich. After their baby is born the husband is invited by a fellow-workman to attend a radical meeting, where he hears a Communist lecturer closely resembling Morris himself:

> My heart sank down as I entered, and wearily there I sat
> While the chairman strove to end his maunder of this and of that.
> And partly shy he seemed, and partly indeed ashamed
> Of the grizzled man beside him as his name to us he named.
> He rose, thickset and short, and dressed in shabby blue,
> And even as he began it seemed as though I knew
> The thing he was going to say, though I never heard it before.
> He spoke, were it well, were it ill, as though a message he bore,
> A word that he could not refrain from many a million of men. . . .

When Richard, the narrator, becomes involved in political agitation he loses his job and soon afterward is committed to prison for two months after a brawl at a mass meeting. He then finds one enthusiastic convert, a gentleman who helps the family in its penury, but the outcome is that the new friend falls in love with Richard's wife. There is a faint reminiscence of Meredith's *Modern Love* as the miserable couple try to sustain an illusion of wedded harmony; but the antipodal unlikeness of the two poets is thereby enhanced. Morris's trio agree to go off to Paris together to support the Commune of 1871. They fight valiantly at the barricades until the wife and friend are killed in a last desperate defense and Richard makes his way back to England, still not knowing whether the other two ever were lovers. In a gloomy conclusion he lapses into middle age in the farming community of his boyhood.

The authentic effect of the poem arises from its identification with Morris's inmost feelings, not only in the hopeless triangle involving wife and friend but also in the nostalgia for rural life—which is described with loving detail—and the Carlylean-Ruskinian doctrines of work and duty. The familiar clichés of Marxism assume a pathetic dignity when voiced by Morris's ardent protagonist.

The depiction of Richard's troubles with the police was based on firsthand experience. In 1885 Morris was arrested for pro-

testing in court when a fellow-agitator was convicted; though he was acquitted, the authorities instituted a campaign of harassment against the Socialist rallies, and he spent much time in court making bail for arrested speakers. On one occasion he was himself fined as a public nuisance for speaking on a street corner. With prodigious energy, in spite of serious attacks of sciatica and gout, he carried placards in parades, traveled over England and Scotland to deliver speeches, and attended interminable quarrelsome committee meetings. He did not reissue *The Pilgrims of Hope* in book form because he wanted an opportunity to expand and polish it. Instead, he found time—mainly during train journeys—to write a translation of the *Odyssey* in the same meter as his *Sigurd the Volsung*. Published in 1887, it was inevitably condemned by some purists as more like the sagas than like Homer, but Oscar Wilde, who was no mean classicist, reviewed it warmly: "Of all our English translations this is the most perfect and the most satisfying. It is, in no sense of the word, literary; it seems to deal immediately with life itself, and to take from the reality of things its own form and colour; it is always direct and simple, and at its best has something of the 'large utterance of the early gods.' "[36]

During 1886–87 Morris contributed to the *Commonweal* a prose romance, *A Dream of John Ball*, which, in the manner of Carlyle's *Past and Present*, glorifies a fourteenth-century peasant leader as an exemplar for modern social reconstruction. Using the medieval dream-vision technique, and reminiscent of *Piers the Plowman*, the narration is presented through the persona of Chaucer, thus justifying archaisms of language, and Morris vividly captures the charm of the English countryside in the Middle Ages. John Ball's ideology proves to be so like Morris's own that Marxist socialism can be displayed as indigenous in the English masses.

Richard's dejected mood at the conclusion of *The Prisoners of Hope* reflected Morris's disillusionment. Years of trying to mediate among left-wing groups—Shaw's Fabians, Kropotkin's Anarchists, Hyndman's Socialists—convinced him that the intellectuals were incorrigible, while the honest workingmen could not make head or tail of his ideals and attended his meetings only for the refreshments served afterward. The financial depression

of 1887, provoking riots among the unemployed, encouraged him to think that the great revolution was imminent; but in November a monster demonstration, planned for Trafalgar Square, was efficiently broken up by police and troops, and Morris narrowly escaped the bludgeoning suffered by some of his friends. As late as 1890 he was providing money generously for the Socialist League and its journal, but he was so out of favor that he was ousted from the editorship, and soon afterward he resigned from the organization.

Repulsed in his encounter with the modern world, Morris retreated with relief into his beloved Middle Ages. His final serial in the *Commonweal*, though ostensibly a forecast of the future, is as much a return to an idealized Chaucerian England as was *A Dream of John Ball*. Entitled *News from Nowhere*, it depicted an idyllic society purged of politics, capitalism, and machinery, with an affectionate description of Kelmscott Manor as the setting and with pleasant humor in the characterizations. Closely modeled on More's *Utopia*, it is a series of dialogues rather than a connected narrative. Significantly, however, a major element in the rudimentary plot is that the hero and heroine, Dick and Ellen, are separated for an interval while she imagines herself to be in love with another man.

The time that was now released from political activities was devoted to establishing the last and probably most famous of Morris's handicraft projects, the Kelmscott Press. During the last five years of his life he designed and produced dozens of beautiful books with pseudo-gothic typography, elaborate marginal decorations, and ornate bindings. Printed on handmade paper, with de luxe editions on vellum, they set a new standard for the format of English books which soon affected the productions of commercial publishers.

To symbolize his undiminished adherence to his literary master, his greatest undertaking was a monumental edition of Chaucer, and he planned to follow it with a similar volume of Malory; he brought out many works of Caxton and other medieval writers, but also his own and those of his Pre-Raphaelite friends. The most characteristic of the press's productions, perhaps, was a series of prose romances of his own authorship.

Virtually unique in modern literature, these stories had their archetypes in the late Middle Ages, not only in Malory and his predecessors but also in the Eddas, which Morris had already translated. He had written small-scale anticipations as early as his youthful contributions to the *Oxford and Cambridge Magazine.* In rhythmic prose, with simple Germanic vocabularies and conjunctive syntax, they chronicled the deeds of heroes in some vaguely defined primitive Northland. The evocative titles suggest their folktale atmosphere. The first ones, which came out before the press was established, were *The House of the Wolfings* and *The Roots of the Mountains.* The later ones included *The Story of the Glittering Plain, The Wood Beyond the World, The Well at the World's End,* and *The Water of the Wondrous Isles.* Published at a time when prose fiction automatically connoted social realism, these books could not be regarded as novels. Their style and subjects were akin to Morris's previous poetry, and yet they were not in verse. Not being amenable to accepted categories, they have remained ever since almost in a critical limbo.

They can probably best be regarded as further projections of Morris's utopianism. In this neverland of valiant fighting men, pure maidens, and adventurous voyages there was no trace of the political and psychological frustrations which had defeated him in real life and which he had no ability to represent in literature. When he was writing the later volumes his health was declining and his violent temper seemed to have mellowed. At last he was able to dwell at ease in a splendid, impossible realm of his imagination.

A collection of lyrics and versified folktales that he had been writing during many years was published by the press in 1891 under the modest title of *Poems by the Way.* He resumed translating in collaboration with Magnússon and they contributed three volumes to the "Saga Library." Near the end of his life he versified A. J. Wyatt's prose translation of *Beowulf* in a meter that sought to reproduce the original Anglo-Saxon rhythm.

He continued to participate in Socialist demonstrations and became reconciled with Hyndman; he encouraged the formation of the Independent Labour party and was even invited to be a Socialist candidate for Parliament; his protests against the re-

modeling of old buildings and the desecration of beautiful land-scapes were as vitriolic as ever. Nevertheless his fighting spirit was ebbing. In the summer of 1896 he made a last pilgrimage to his beloved North, but the trip to Norway taxed his endurance to the utmost. After his return his strength declined rapidly, though he continued with active plans for the press until his death on 3 October.

The inclusiveness of the Pre-Raphaelite phenomenon in poetry is demonstrated by the extreme unlikeness between Morris and Rossetti. When Rossetti died in 1882, Morris wrote to Bell Scott that "it makes a hole in the world," but he went on to express his sense of deficiencies in his former friend's work: "He had some of the very greatest qualities of genius, most of them indeed; what a great man he would have been but for the arrogant misanthropy that marred his work, and killed him before his time; the grain of humility which makes a great man one of the people and no lord over them, he lacked, and with it lost the enjoyment of life which would have kept him alive, and sweetened all his work for him and us."[37]

Both poets are undeniably to be regarded as "Romantic" for such traits as erotic preoccupation, medievalism, melancholy, and unworldliness, but even in these respects they were unlike. Mor-ris's melancholy was never morbid, and though unworldly he was not alienated from the real world. While both selected archaic genres for their narrative poetry, Rossetti preferred the conciseness of the folk ballad, Morris the expansiveness of the metrical romance and the epic. Rossetti's medieval master was the intense and introspective Dante, Morris's was the extroverted Chaucer. Rossetti withheld his poems for years while he polished every phrase; when Morris got an idea for a poem he would com-pose hundreds of lines in a day, and his sole idea of revision was to discard an unsatisfactory poem and start over again. If Ros-setti represents the ultimate of poetic sophistication with his verbal patterns and metaphoric elaboration, Morris goes to the other extreme in his effect of primitive ingenuousness. His choice of words seldom merits attention for individuality, and when he uses any metaphor at all it is likely to be of the stereotyped variety

that descends from the kennings of Old English verse and the "rose red" or "snow white" of the ballads. As medievalists they must be assigned to different areas and epochs: Rossetti belongs to the highly formalized thirteenth and fourteenth centuries in Italy and Provence, the time of troubadour contests, the sonnet and the villanelle, of Boccaccio and Marie de France, when the Renaissance dawn had already broken; Morris belongs to the earlier centuries and in the Northern countries, when poets and audiences alike were innocent of technical subtleties, and the function of a good poem was to hold the attention of naïve listeners by recounting a compelling story.

Hence, perhaps, both poets present obstacles to present-day readers. Rossetti demands such intensive observation of every line that the overall effect of a poem may be obscured; Morris can be appreciated only by absorbing his long poems at high speed, so that the total impression compensates for the absence of individual perfections.

VI. ALGERNON CHARLES SWINBURNE

The English aristocracy has never been notable for producing creative geniuses in the fine arts. Whenever the trend of fashion has set toward literature, there has been a quota of elegant dilettantes in the court circle: Wyatt and Surrey under Henry VIII, Sidney and Raleigh under Elizabeth, Dorset and Rochester under Charles II. It needed the explosive force of the Romantic revolt, however, to uncover two major poets in the ruling class—Byron and Shelley; and in the second generation of Romantics, known as the Pre-Raphaelites, they had a worthy successor in Algernon Charles Swinburne. In all three poets, the qualities of emotional excess and ideological intransigence went far beyond the bounds of their contemporaries. Unparalled in their defiance of accepted political opinions and moral restraints, the three embodied their nonconformity in extravagant rhetoric that compelled attention.

There were probably two reasons for the inherent similarity in the three rebellious aristocrats. One was that the traditional orientation of their rank toward nonliterary vocations—government, the armed forces, management of estates, field sports—had set up patterns of expectation that could be shattered only by an exceptionally strong compulsion. The other reason was that

social prestige protected the occasional deviant nobleman from the sort of anxiety about financial resources or public opinion which may handicap less privileged persons in departing from convention. Aristocratic origin guaranteed freedom to be as eccentric as one pleased, in being a poet as much as in any other aberration.

The Swinburne family was of the tough Border breed that supported the Earls of Northumberland against the Scots throughout the Middle Ages. Family tradition insisted that an early peerage had become dormant in the fourteenth century; the authenticated hereditary title was a baronetcy conferred in 1660. Three generations of the baronets married women with royal blood. These earlier generations were devoted Catholics and Royalists; in the dispersal of Jacobites after the Rebellion of 1745 the current baronet settled in France, where his children were born and grew up. One of his sons entered the Austrian imperial service and eventually became a baron, but the eldest returned to England on inheriting the title and what remained of the estates. A rugged character who survived into his ninety-ninth year, this sixth baronet was in early life an enthusiast for the French Revolution, and he remained an assertive freethinker and antimonarchist.

His second son followed a more conventional pattern by entering the Royal Navy, in which he rose to the rank of admiral, and by marrying the daughter of an earl. Their eldest child, Algernon Charles, was born on 5 April 1837, at the family's town house in Grosvenor Place. His early years were spent mainly at their country property in the Isle of Wight, with autumns at his grandfather's estate in Northumberland. As his father, whom he deeply admired, was away at sea much of the time, Algernon lorded it over a female circle consisting of his devoted mother, his four adoring younger sisters, and another equally adoring little girl, Mary Gordon, his first cousin on the maternal side and second cousin on the paternal. He was fascinated equally by the gentle seascapes of the English Channel viewed from Bonchurch and the fierce turbulence of the North Sea as he saw it when visiting Capheaton at the season of equinoctial gales. His father taught him to swim at an early age and swimming in all weathers soon became his chief physical exercise, though he also enjoyed

sailing and pony-riding. His earliest education was provided by his mother. Lady Jane Swinburne was totally fluent in French and Italian, and trained her son in those languages so thoroughly that he was reading their literatures as soon as English. When his voracity for other knowledge outgrew her competence, he was tutored by a neighboring rector.

When he entered Eton at the age of twelve he was a pale, fragile child with a mop of red hair and a peculiar prancing gait. As a result of his wholly feminine upbringing he was exceptionally naïve; his High Church mother had forbidden him to read any novels, and, though this ban was lifted when he went off to school, he was still required to promise that he would not look into Byron's poetry. He arrived at Eton with a copy of Bowdler's Shakespeare under his arm, and his first gift to a fellow-pupil, a cousin of his own age, was an abridgment of Froissart.

In spite of his unusual appearance and his incompetence in games, he showed an innate dignity and even a latent ferocity that protected him from bullies. Easily irritated, he would display peculiar muscular jerkings of his arms and legs, but his fits of annoyance would soon pass over. Otherwise, he was chiefly conspicuous for his precocious literary tastes: all his spare time was spent in the school library, absorbed in old folios, so that the librarian used to point him out to visitors as one of the sights of the place. Before he was thirteen he was devoted to the Elizabethan dramatists, not only Marlowe and Marston and Ford but such an obscure author as Nabbes. He devoured Johnson's *Lives of the Poets*. Among recent poets, his favorite was Walter Savage Landor. Endowed with a prodigious verbal memory, he would entertain his school-fellows by the hour, in his room or on walks in Windsor Forest, by reciting poetry, in French or Italian as well as English.

His linguistic ability stood him in good stead when he won a prize for writing French and Italian verse and was granted distinction in composing Greek elegiacs, though apparently his skill lay in reproducing metrical effects rather than in grammatical accuracy. He was less attracted to the Latin poets, except Catullus, for the characteristic reason that he was obliged to memorize as-

signed passages instead of being free to choose his own favorites.

His mother seems to have intended him to be a poet. On the eve of entering Eton he was taken to visit Wordsworth, a few months before the old laureate's death; and two or three years later he was similarly introduced to Samuel Rogers, the surviving friend of all the Romantic poets. The aged poet, in a gesture of apostolic succession, laid his hand on the boy's head and intoned, "I prophesy that you will be a poet too." Of the copious verses written in his school days, only two specimens escaped destruction. One was a blank-verse Jacobean tragedy, "The Unhappy Revenge," dealing with the betrayal of Rome to the Huns by Eudoxia because the emperor Maximus had raped her. An amazing achievement for a boy of thirteen, it uncannily reproduces the style of Massinger and Webster and their voluptuous emphasis upon torture. From a year later dates "The Triumph of Gloriana," two hundred lines in strictly regular heroic couplets and Augustan diction. It was written as a school assignment to celebrate a visit of Queen Victoria to Eton, and one cannot help suspecting it of being an intentional burlesque.

Severe and frequent canings were still customary in the public schools of those days, and Swinburne was keenly aware of the punishment, though probably he was not so often exposed to it as he claimed. He may have been caned for incompetence in arithmetic, or for minor pranks, but his schoolmates all remembered him as well behaved. Other boys who later became authors have tended to recall their swishings with shame and vengefulness, but Swinburne seems to have gloried in them as a testimony to his manliness, and throughout his later life he wrote in both verse and prose about his sufferings in vivid detail. These passages can be absolved from the charge of perversion because of their consistently comic tone: the bravado may become tedious, but the mock-heroic humor renders it innocuous.

In his sixteenth year the hitherto docile and studious lad turned rebellious and idle. His behavior was so unpredictable that the boys took to calling him "mad Swinburne." Perhaps the long-remembered thrashings occurred at this juncture. Whatever his specific misconduct may have been, the disturbing onset of ado-

lescence was serious enough to require his withdrawal from the school.

The Crimean War was at its height, and Swinburne was consumed with desire to be trained as a cavalry officer. Meanwhile he spent more than a year in desultory reading and in outdoor activity, mainly swimming and riding, though he was such a precipitate horseman that he was often thrown from his mount. In an effort to prove his fitness in terms of both strength and courage, he undertook a foolhardy cliff-climbing escapade that might have cost him his life. His mother seems to have sympathized with his ambitions, but when he was past seventeen and insisted upon a final decision, his father vetoed the scheme on the basis of his inadequate physique.

The delicate, pretty child had developed into a strangely disproportionate youth. He never grew beyond five feet four inches, and his oversized head and neck were supported on narrow sloping shoulders. His arms and legs were short; his hands and feet were tiny; his fine brow and eyes loomed above a retreating chin; the puppet-like figure was surmounted by a waving mass of red hair like an aureole. Adding to the peculiar impression were a high-pitched, excited voice and his galvanic gestures. Though the description sounds grotesque, his friends at all stages of his life insisted that he had a unique kind of beauty that could not be judged by human standards. He was like a gaudy tropical bird, or a being from another planet. The physical traits suggest that he was sexually abnormal, an inference that his conduct throughout his life did nothing to refute. It seems impossible, however, to arrive at a diagnosis of his condition. Homosexual, impotent, androgynous—the customary epithets seem inapplicable. Here again one must have recourse to saying that he was sui generis, a creature not susceptible to accepted classifications.

From this time, Swinburne felt resentful toward his father, whose tastes and values were totally unlike his own; and his bond with his mother became all the closer. In preparation for Oxford he was tutored by a curate in his grandfather's Northumberland parish, who found him "too clever by half" but disinclined to study. In January 1856, he matriculated at Balliol College.

At that time Balliol had not entered on the era that was soon to give it a reputation as the intellectually elite college of the university, and Swinburne heartily disliked it. During his first two terms he remained much to himself, his keen interest being stimulated only by his tutor in Italian, Aurelio Saffi, a political refugee in the circle centering upon Mazzini. Then toward the end of the year he fell under the influence of John Nichol, a morbid but brilliant Scot, four years his senior. When Nichol organized a discussion club, the Old Mortality Society, in November 1856, Swinburne was one of the six charter members. All of them, as well as others who were admitted later, were among the cleverest undergraduates, and Swinburne was thus drawn out of his isolation.

An extreme radical, Nichol nurtured the republican tenets that Swinburne had already acquired from his grandfather. Soon he was uttering paroxysms of hatred against Napoleon III and paeans of devotion to Mazzini, in whose honor early in 1857 he composed an irregular ode which shows touches of poetic originality among echoes of Milton and Shelley. It may have been one of the poems he read in March 1857 to a fellow-member, Birkbeck Hill, who reported that "they are really very good, and he read them with such an earnestness, so truly feeling everything he had written, that I for the first time in my life enjoyed hearing the poetry of an amateur."[1] Another poem written at this time was "The Temple of Janus," which he submitted for the Newdigate Prize. Though dutifully observing the use of heroic couplets and the assigned classical topic, he was able to smuggle in a few praises of tyrannicide and sneers at the "crowned snake of Naples" that his friends could recognize as revealing his current obsession. Perhaps for this reason, the poem did not win the award.

Along with his revolutionary political views, Nichol was agnostic in religion; and, though Swinburne had recently gone through a period of ritualistic orthodoxy, he quickly absorbed his friend's rationalism. Though he later claimed that Nichol had "taught him logic," there can be little doubt that, on the contrary, Nichol's influence was harmful in imbuing him with violent prejudices which fed on his innate tendency to treat ideas emotionally in-

stead of rationally. In an era when most authors felt responsible for trying to see and convey all sides of an intellectual issue, Swinburne aligned himself immediately and passionately on one side or the other. He was incapable of debate: his expression of any opinion was either screaming, twitching fury, or extravagant rhapsody.

Another year elapsed before these ideological stimuli were countered by an equally strong artistic influence. On returning to Oxford after the long vacation of 1857 (spent partly with Nichol in Scotland), Swinburne found the project of painting the Union murals in full swing. On 1 November he was introduced to Morris and Jones, and the next time Rossetti came to Oxford he too met the young admirer, who already knew his poems in the *Germ*, and who was soon admitted to their sacred triumvirate on the strength of his enthusiasm for Malory. He listened to Morris reading his early verses, one of which may have been "Blanche," for Swinburne adopted the same trochaic tercets and stark narrative manner for a long Arthurian poem which he immediately began to write, entitled "Queen Yseult."

While following mainly the version of the story in the metrical "Sir Tristrem" attributed to Thomas the Rhymer, Swinburne treated it in a manner that reveals significant elements in his imagination. One strange detail occurs when Tristram is visiting King Mark's castle and Yseult comes to guide him to her room:

> Then she raised him tenderly,
> Bore him lightly as might be,
> That was wonderful to see.
>
> So they passed by trail and track,
> Slowly in the night all black,
> And she bore him on her back.
>
> As they twain went on along
> Such great love had made her strong,
> All her heart was full of song. . . .
>
> Till she stood on the strewn floor
> Right within the chamber door,
> With the weight of love she bore.

The inertia of the lover and the physical prowess of the lady are a disturbing departure from the conventions of courtly love. There is something touchingly naïve, too, in the depiction of the marriage night in Brittany, when Tristram is suddenly afflicted with qualms of conscience and distresses Yseult of the White Hands by evading consummation:

> Sidelong to him crept she close,
> Pale as any winter rose
> When the air is grey with snows. . . .
>
> Soft as lighteth bird on bough
> Thrice he kissed her, breathing low,
> Kissed her mouth and maiden brow,
>
> And in under breath said he
> When his face she could not see,
> "Christ, look over her and me."
>
> Low sweet words of love she said
> With her face against his head
> On the pillows of the bed.

Reluctantly he kisses her throat and shoulder, meanwhile praying "That for Mary's maiden sake / Christ would keep his faith awake."

> She lay out beside him there,
> All her body white and bare,
> Overswept with waves of hair.
>
> So her love had all it would,
> All night sleeping as she could,
> Sleeping in her maidenhood.

The mixture of sensual detail with chivalric ideals of purity recalls what Keats said about his *Endymion*, explaining the space of life between boyhood and maturity when "the soul is in a ferment, the character undecided, the way of life uncertain, the ambition thick-sighted: thence proceeds mawkishness."[2]

In December 1857 the Old Mortality Society started a periodical called *Undergraduate Papers*, which ran for three numbers. The first issue contained the opening canto of "Queen Yseult,"

as well as an essay by Swinburne on Marlowe and Webster. To subsequent numbers he contributed a violent diatribe against theocratic influence in the government of Napoleon III and a clever burlesque review of a book by an imaginary "Spasmodic" poet, Ernest Wheldrake. He may have been the author also of "Modern Humanism," an ironic blast against the lectures that Matthew Arnold was then delivering at Oxford as professor of poetry.

Swinburne reported to Nichol that Morris and his friends "all praise the poem far more than I (seriously speaking) believe it deserves. Morris says it is much better than his own poem, which opinion I took the liberty to tell him was absurd." Swinburne had decided that it was "too imperfect, feeble and unfinished to publish for a year or two."[3] Accordingly, only six of the projected ten cantos were ever written. Other surviving poems of the period are equally slavish imitations of Morris: a fragment of a different version of the story of Tristram and Iseult, in a more florid meter, with the title "Joyeuse Garde;" a dialogue between Lancelot and an angel; a deathbed monologue of the troubadour Rudel; two counterfeit folk ballads; and a decorative Pre-Raphaelite narrative called "A Lay of Lilies":

> The girls are like the lilies, very white.
> The first is fairest for her pale hair's gold,
> One for her cheeks, one for her eyes' delight,
> One for her smile round which the dimples fold,
> One for her warm lips' mould. . . .

Experiments in other manners include seven sonnets sedulously echoing Shakespeare's, two or three orotund odes, and several lyrical descriptive pieces.

Though none of this material was printed until after his death, apparently Swinburne's reputation for poetic promise was already spreading. During the Christmas vacation at home in the Isle of Wight, when he made another literary pilgrimage by calling on Tennyson, the laureate not only asked him to dinner and read "Maud" to him, but expressed satisfaction that the "very modest and intelligent young fellow . . . did not press upon me any verses

of his own."[4] His abandonment of "Yseult" was due to his absorption in a new undertaking, "Rosamond." Like Morris, he turned from the Arthurian legends to a better authenticated later era. The idea may have occurred to him as early as the spring of 1857, when the Old Mortality went on a picnic to the ruins of Godstow Nunnery, where the ill-fated mistress of Henry II spent her final days. By February 1858, he reported that the tragedy was "now verging on a satisfactory conclusion." Though Morris praised it with his usual generosity, Swinburne—who was now frantic with delight over Browning's *Sordello*, terming it "one of my canonical scriptures"—said, "I suspect I must be Eglamor, to Morris as Sordello."[5]

Swinburne had attracted the notice of Benjamin Jowett, the domineering Regius Professor of Greek, as a promising scholar, but he scolded the young man for wasting time in the unprofitable craft of poetry. This may have been the reason why, after passing his Moderations examination with second-class honors, he chose to read for an honors degree in law rather than Literae Humaniores.

By this time he had completely emerged from his chrysalis. From the Rossetti circle he had learned to indulge in hilarious horseplay and coarse language, indelicate limericks and outrageous puns. Both Rossetti and Nichol were heavy drinkers, and with Swinburne's unstable nervous structure a small quantity of alcohol was enough to destroy every vestige of restraint. He acquired a reputation not only for subversive political and religious opinions but also for ludicrous pranks. He delivered incoherent speeches in the Union, culminating in a defense of regicide just when the Prince of Wales was in residence at the university. For a period he was confined to college as a penalty for persistent refusal to attend chapel. Jowett became worried lest the university should incur future scorn by expelling a young genius for some infringement of discipline. On his advice, therefore, when Swinburne failed the Michaelmas examination in his minor subject, he withdrew for a term in order to cram history and law in the home of a country clergyman, William Stubbs, later a famous scholar and ecclesiast. Jowett warned Stubbs that his pupil was "in some re-

spects the most singular young man I have ever known. . . . He has extraordinary powers of imitation in writing, and he composes (as I am told) Latin mediaeval hymns, French vaudevilles, as well as English poems, with the greatest facility."[6]

His chief recent triumph had been in inventing a border ballad in Northumbrian dialect and imposing it on the country folk at Capheaton as a genuine traditional piece. His last poem in the Morris manner was a blank-verse monologue, "The Queen's Tragedy," in which the morbid fancies of a murdered king's widow dwell upon the horror of his death. An epic on the Albigenses was projected and set aside, but a tragedy on Catherine de Medici was in full spate.

Rossetti's friend William Bell Scott provides a glimpse of Swinburne at this juncture, with his mixture of poetic ecstasy and comical phrases from Dickens: "Is not young Swinburne a regular trump? Sara Gamp, Pre-Raphaelite hair and also his poetry took me rather by surprise. I rather think he *is* a poet, not merely by instinct of imitation associating with Morris and others. He read to me the ballad of a lady turned into a dragon and his tragedy so far as it is gone. His ballad really is a ballad, not a fantastic mystical modern invention, and his play characters talk like reasonable or rather unreasonable people." Scott observed also that "at present there seem only two people in the world to him, Topsy and Rossetti, and only those books or things they admire or appropriate will he entertain. The only exception to this is unhappily French literature."[7] His enthusiasm for Victor Hugo was of long standing, and now he was becoming addicted to Balzac and Flaubert.

Though he applied himself sporadically to study under Stubbs's kindly encouragement, he could not control the verse-writing compulsion. When he read "Rosamond" to Mr. and Mrs. Stubbs they ventured a mild protest against the most erotic passages, whereupon he rushed upstairs with a scream of fury, locked himself in his room, burned the whole manuscript, and then sat up all night rewriting it from memory.

Early in 1860, to compete for a special poetry prize at Oxford, he wrote a poem on "The Death of Sir John Franklin," a topical

subject because the bodies of the explorer and his crew had recently been found. Though the metrical scheme is terza rima, a more impressive threnodic effect is achieved by running the tercets together, in both typography and sentence structure, to make larger units of varying length. A trace of Rossetti's style can be observed in the use of unstressed syllables in the rhyming position (in the third stanza the rhyme words are "thing—tendereth—thanksgiving—difference—wing—sense—it—experience . . ."); but otherwise the language and imagery have a noble dignity remote from Pre-Raphaelite mannerisms. Swinburne's admiration for active heroes was sincerely stirred by the explorers' fate, and his description of the Arctic wilderness is ferociously vivid.

In spite of its merits, the poem did not win the prize, and the disappointment put the final touch to his disillusionment with the university. In the spring he returned with the intention of sitting for his examinations. On this second attempt he passed in classics, but Jowett advised him to postpone the final test in law, and so he left Oxford for good, though as a gesture of defiance he kept his name on the register of undergraduates for twenty years.

With much difficulty he convinced his father that authorship was the only career he could tolerate, and so he was granted a modest allowance that enabled him to take lodgings in London, near the British Museum, where he resumed his intimacy with Rossetti, Morris, and Jones. Working hard on his poetry, he saw few other people, but would drop in on the Joneses, who lived near him, two or three times a day, Jones's wife reports, "bringing his poems hot from his heart. . . . When repeating poetry he had a perfectly natural way of lifting his indescribably fine eyes in a rapt unconscious gaze, and their clear green colour softened by thick brown eyelashes was unforgettable."[8]

He set himself to writing a comedy imitative of John Fletcher, entitled "Laugh and Lie Down," dealing with a Milanese courtesan, Imperia; her favorite pastime is the flagellation of her adoring young page-boy, who sometimes dresses as a girl and who is attractive to both sexes. The surviving fragments of the play suffice to show that it is an early specimen of two psychopathic interests —bisexuality and algolagnia—which were beginning to permeate

Swinburne's writings. The whipping of a page-boy recurs in another unfinished drama, "The Loyal Servant," a brilliant pastiche of Marston. A third Jacobean imitation of this era was one called "The Laws of Corinth."

During the summer he finished revising his two completed tragedies, *The Queen Mother* and *Rosamond*, and they were published in a volume in December, subsidized by the author's long-suffering father. As may be expected, the plays are saturated with reminiscences of the Jacobean dramatists. After its several rewritings, *Rosamond* emerged as a sequence of static dialogues and soliloquies, arranged in five brief episodes, which showed indications of its Pre-Raphaelite inception. Rossetti and Burne-Jones liked to paint imaginary portraits of "Rosa mundi," the unchanging embodiment of feminine allure, and Swinburne's heroine accepts the role:

> Yea, I am found the woman in all tales,
> The face caught always in the story's face;
> I Helen, holding Paris by the lips,
> Smote Hector through the head; I Cressida
> So kissed men's mouths that they went sick or mad,
> Stung right at brain with me. . . .

King Henry's passion for this enchantress is as much agony as ecstasy:

> God help! your hair burns me to see like gold
> Burnt to pure heat; your colour seen turns in me
> To pain and plague upon the temple vein
> That aches as if the sun's heat snapt the blood
> In hot mid-measure. . . .

Queen Eleanor in her jealousy ruthlessly manipulates her paramour Bouchard to carry out her revenge. Intending comic relief, Swinburne inserted the character of a choir boy who, like his other boys, is a victim of the birch:

> Euh! I can touch the prints of the big switch;
> One, six, twelve—ah! the sharp small suckers stung
> Like a whole hive loose, as Hugh's arm swung out.

The movement of the blank verse owes much to Browning, whom Swinburne had lauded extravagantly in a paper at the Old Mortality Club when the other members had scarcely heard of him. By omitting connective words, lumping stressed monosyllables together, and placing most of the major pauses within the lines, he simulates Browning's rugged energy. The Queen's delight in her prospective poisoning of her rival is in the very tone of "The Laboratory":

> feel this flasket next my waist,
> Full to the wicked lips, crammed up and full
> With drugs and scents that touch you in the mouth
> And burn you all up, face and eyes at once—
> They say so; they may lie, who knows? but kill
> The thing does really. . . .

The larger part of the volume was occupied by *The Queen Mother*, a full-scale five-act tragedy, telling how the autocratic old Catherine tries to use her son's mistress to persuade him to order the slaughter of the Huguenots. The dominance of the two positive women over the vacillating king is consistent with Swinburne's usual tendency to show men as helpless victims of feminine control. The portrayal of Catherine is reminiscent of Lady Macbeth, and the heroine, Denise, dies in a vain last-minute attempt to halt the massacre.

The principal model was the tragedies of Chapman, specifically *The Revenge of Bussy d'Ambois*, which dealt with the same historical event. Unexpectedly combined with this, however, was the influence of a recent and now forgotten play by Charles Jeremiah Wells, *Joseph and His Brethren*, which Rossetti admired inordinately and which Swinburne considered to be the only verse play of the Romantic generation that avoided lyrical effusiveness and caught the true Renaissance subtlety and intensity. As in *Rosamond*, the versification smacks of Browning as much as of the Elizabethans. Here is the king addressing his beloved:

> Eh, sweet,
> You have the eyes men choose to paint, you know;
> And just that soft turn in the little throat

And bluish colour in the lower lid
They make saints with.

One might be listening to that connoisseur, the Duke of Ferrara. In the violence of his sadism, however, Charles is wholly unlike Browning's coolly heartless nobleman. His love scenes with Denise are lurid with mutual torture, and the depiction of St. Bartholomew's Eve, with the king's blood-lust infecting the courtiers, is a powerful evocation of horror. Swinburne's ideological loathing for priestcraft and tyranny is ambiguously yoked to his imaginative identification with Charles's perverse gloating over his victims.

The predominant role of the women in both plays is to some extent derived from the chivalric exaltation of the sex in the Courts of Love; but the attribution of cruelty and aggression comes from the more primitive tradition of the femme fatale, the serpent woman, as typified in the legend of Lilith, which appealed strongly to Rossetti. The subject acquired new prominence in the middle of the nineteenth century with the concern over women's rights. The conventional asumptions about female docility were abruptly challenged. Tennyson showed awareness of the trend as early as 1833 in "A Dream of Fair Women," which implies that virtue or vice are irrelevant to the fatal power of feminine beauty. It is the theme of *The Princess*, as displayed in the contrast of the belligerent Lady Blanche and the gentle Lady Psyche. In 1859 the first installment of the *Idylls of the King* was built upon the same contrast of "The True and the False," with two naïve heroines and two unscrupulous ones. The novelists, too, bent to the winds of change. Becky Sharp, Beatrix Esmond, Hypatia, Jane Eyre, Pip's Estella, in their various ways, were symptoms of the new female assertiveness. Swinburne, with his acute sexual sensibility, was particularly qualified to translate this social and intellectual phenomenon into terms of sheer passion.

The book was an unmitigated failure. Not a single copy was sold, and there seem to have been only two reviews. The critic in the *Spectator* termed the language "painfully distorted, vague, elliptical, and bristling with harsh words." He went on: "In feeling and in thought, the daring, the disagreeable, and the violent are in

these dramas substituted for boldness, beauty, and strength."[9] The *Athenaeum* was equally caustic: "We should have conceived it hardly possible to make the crimes of Catherine de Medici dull, however they were presented. Mr. Swinburne, however, has done so.... The tragedy of Woodstock, once again told, though shorter as a play, is gladly handed over to others who are disposed to venture into the labyrinth."[10] Accepting a comment by Bell Scott, Swinburne himself admitted that "the amount of fine talk is awful and quite wrong."[11]

By this time he was wintering with his parents on the Riviera, despising the Mediterranean scenery because it was not like England and writing copious verse in preparation for a projected book of poems. He was also "trying to write prose, which is very hard,"[12] intending a volume of short stories, *The Triameron*, in imitation of Boccaccio. Besides, he composed seven chapters of a prose chronicle of Queen Fredegond, a draft of a tragedy on Mary Stuart's lover Chastelard, and a screamingly comic and improper burlesque of French fiction, "La Fille du Policeman," guying bedroom melodrama and French ignorance of English customs. The most notable of the poems was "A Song in Time of Revolution," not only because it proclaimed his political and religious doctrines but also because it was his first use of a diction and a metrical pattern that soon became habitual with him:

> The wind has the sound of a laugh in the clamour of days
> and of deeds:
> The priests are scattered like chaff, and the rulers broken
> like reeds.
>
>
>
> There is none of them all that is whole; their lips gape open
> for breath;
> They are clothed with sickness of soul, and the shape of the
> shadow of death. . . .

The tremendous impression of energy resides partly in the Old Testament rhetoric, but equally in the long lines, the alliterations, and the alternation of iambs and anapests. Swinburne had learned the typographical trick, later adopted by Morris also, of forcing

the reader to sustain a rapid tempo by printing what would normally be quatrains as couplets. One set of rhymes is thus concealed at the caesura, with consequent diminution of emphasis and enhancement of melody.

Although this and subsequent poems of Swinburne's impressed his readers as a unique new manipulation of meter that broke the monopoly of iambic feet and of the ten-syllable average line which had controlled English poetry for five hundred years, he really marked the culmination of tendencies that had been developing for half a century. His mingling of duple and triple feet was in accord with the "new principle" promulgated by Coleridge—"that of counting in each line the accents, not the syllables."[13] Swinburne applied Coleridge's theory in a distinctive way by maintaining an approximately equal number of duple and triple feet in each line, thus establishing a more conspicuous "tune" than could result from intermittent variations. Any such poem cannot be classified as either iambic or anapestic because it is both at once. Even this contrapuntal effect, however, was not entirely a novelty. Obviously, it accords with ancient Greek and Roman meters, which ordinarily mingled two or more types of feet in each line. Several early Victorian poets tried out English equivalents of the classical hexameter, and were scolded by purists who stupidly assumed that they were unaware of the different principles underlying Greek and English meters. Clough, in "The Bothie" and "Amours de Voyage," employed six-foot lines and alternating types of feet not with any intention of sounding like Homer but in the hope of achieving a flexibility of movement resembling informal speech. Scholars were pointing out, too, that Old English poetic patterns mingled duple and triple feet, along with alliteration and caesura.

The pattern of mingled duple and triple feet, though Swinburne's most distinctive innovation, was merely one element in the mid-Victorian departure from the iambic pentameter norm. Within the preceding twenty years Browning in "Saul" had embodied David's rapturous joy of life in a torrent of anapestic pentameter. In "Locksley Hall" Tennyson had demonstrated how an effect of vehemence could be conveyed through eight-stress

trochaic couplets, and Elizabeth Barrett Browning used the same line-length, arranged in quatrains, in "Lady Geraldine's Court-ship." Swinburne and his Oxford friends admired her poetry extravagantly, and he could have found an almost exact antecedent for the meter and even for the language of "A Song in Time of Revolution" in Lucifer's opening speech in her "Drama of Exile" (1844):

> Through the seams of her shaken foundations,
> Smoke up in great joy!
> With the smoke of your fierce exultations
> Deform and destroy! . . .

Swinburne's preference for long lines was certainly influenced also by his idol, Victor Hugo, who endowed the classical French alexandrine with unprecedented vigor through the use of rhetorical emphasis.

Just as much as his line-length and his "anapestic dance" of meter, Swinburne's characteristic phrasal structure descended from earlier practices. Antithesis and balance are the very essence of the Augustan poetic method, as it is also a trait of the Anglican liturgy in the automatic coupling of synonyms and antonyms ("In all time of our tribulation; in all time of our prosperity; in the hour of death, and in the day of judgment, Good Lord, deliver us"). The cumulative monotony of "A Song in Time of Revolution" results mainly from the precise symmetry of every line, with the caesura as its pivot:

> The sound of a word was shed, the sound of the wind as a
> breath,
> In the ears of the souls that were dead, in the dust of the
> deepness of death. . . .

Swinburne soon learned to muffle the mechanical regularity with a variety of more subtle stratagems.

Other probable models might be mentioned, but the foregoing suffice to indicate that the apparently individual quality of Swinburne's prosody is not essentially original, but was achieved by a fusing and exaggerating of many existing manners. Swinburne was a diabolically ingenious parodist, as already proved by his

"Spasmodic" poet Wheldrake and his French "sensation" fiction in the vein of Paul de Kock. One is tempted to say that all his poetry is a kind of serious parody, an intensified concentration of elements that other poets had refrained from carrying to their fullest extension. No aesthetic self-restraint obliged him to be wary of excessive alliterations or prolonged accumulations of rhymes.

His mastery of words and rhythms was as much a part of his inexplicable personality as were his physical and emotional abnormalities. His fabulous memory and his polyglot talent, which enabled him to compose verses as fluently and as expertly in four other languages as in English, supplied unlimited phrases and sentences and stanzas that seemed to fall into enchanting melodies through sheer magic.

Upon his return to London in the spring of 1861 Swinburne made the acquaintance of Richard Monckton Milnes, an elegant minor poet and wealthy man-about-town, notorious for his library of pornography and, in the eyes of the righteous, a dangerous corrupter of youth. He promptly told Swinburne about the writings of the Marquis de Sade, and the young poet realized that they might supply literary sanction for the topics that he had previously been employing almost spontaneously. He composed a poem of 114 lines in French, "Charenton en 1810," in the style of Hugo, extolling Sade's genius and his noble conduct while confined to a madhouse. When, after months of suspense, he acquired a copy of *Justine*, he was reduced to shrieks and tears of laughter by what he regarded as its exaggerations and its monotonous crudity. He shared his amusement with Rossetti and his friends, and for several years he and Milnes exchanged long letters in which they assumed the identities of characters in Sade's novel.

At this time he became intimately identified with the Rossetti circle, recently augmented by the energetic personality of George Meredith, who listened to Swinburne's poems with some skepticism, remarking, "he is not subtle; and I don't see any internal centre from which springs anything that he does. He will make a great name, but whether he is to distinguish himself solidly as an Artist, I would not willingly prognosticate."[14]

A bond of mutual appreciation developed between Swinburne and Lizzie Rossetti, whose red hair matched his. In spite of her frail health she retained traces of girlish gaiety and found him a congenial playmate, sometimes romping about the studio with him until Rossetti scolded them for distracting him. Swinburne spent hours in reading aloud to her, and always remembered her as "wonderful as well as a most loveable creature."[15] He was the last person to be with her and Gabriel on the evening of her suicide, and the next morning, as he later recorded, the bereaved artist implored him, "in the name of her regard for me—such friendship, he assured me, as she had felt for no other of his friends—to cleave to him in this time of sorrow, to come and keep house with him as soon as a residence could be found."[16] During the painful months that ensued, Swinburne's companionship did much to revive Rossetti's spirits.

At this time Rossetti introduced Swinburne to FitzGerald's translation of Omar Khayyám, which had lain unrecognized by critics for three years. Swinburne was enchanted by it, and they went down to Meredith's country cottage to share their discovery. As Meredith walked to meet them at the railway station he could see and hear Swinburne dancing along the road chanting the rhythmic quatrains at the top of his penetrating voice. According to a circumstantial but possibly over-dramatized report, Swinburne snatched paper and pen and forthwith composed his long poem "Laus Veneris" in the same stanza form.

Whistler has reported an expedition about this time which Swinburne took with Rossetti and Meredith to Hampton Court: each poet undertook to write a poem during the short train journey from Waterloo Station, and Swinburne produced "Faustine" because "he wanted to know how many rhymes he could find to the name."[17] He achieved a total of forty-one stanzas.

When Rossetti leased the large old house in Chelsea, Swinburne made it his London headquarters, though he was often away in the country on visits to relations and friends. His peculiarity of behavior was becoming notorious. Henry Adams, who met him at Milnes's country estate, was reminded of "a crimson macaw among owls":

To the three types of men-of-the-world before him he seemed quite original, wildly eccentric, astonishingly gifted, and convulsingly droll. . . . They could not believe his incredible memory and knowledge of literature, classic, medieval, and modern; his faculty of reciting a play of Sophocles or a play of Shakespeare, forward or backward, from end to beginning; or Dante, or Villon, or Victor Hugo. They knew not what to make of his rhetorical recitation of his own unpublished ballads—"Faustine," the "Four Boards of the Coffin Lid," the "Ballad of Burdens"—which he declaimed as though they were books of the Iliad. . . . Swinburne, though millions of ages from them, united them by his humor even more than by his poetry. The story of his first day as a member of Professor Stubbs's household was professionally clever farce, if not high comedy, in a young man who could write a Greek ode or a Provençal chanson as easily as an English quatrain.

When bidding Adams goodnight, one of the fellow-guests, a Scottish laird, described Swinburne as "a cross between the devil and the Duke of Argyll."[18]

At another of Milnes's ingeniously diversified house parties, when the guests included Thackeray and his daughters and the archbishop of York, Swinburne again recited some of his more lascivious poems, such as "Les Noyades," to the horror of the archbishop and the irrepressible giggling of the two girls. Thackeray had already read and liked the manuscript of the poetry, probably shown to him by Milnes in the hope of publication in the *Cornhill Magazine*. Swinburne's unfailing charm for gentle and sincere people evoked an immediate response from Anne Thackeray, who wept when the party broke up and remained his warm friend as long as he lived.

The ménage in Cheyne Walk soon betrayed symptoms of strain. Meredith, who also rented quarters in the house for his weekly trips to town, became exasperated with Rossetti's irregular habits of eating and sleeping and Swinburne's pranks when tipsy, such as his preference for capering about the rooms naked. Still, it must be remembered that Swinburne never forfeited the inbred courtesy of an aristocrat; his considerate behavior toward Rossetti's mother and sisters, for example, earned Christina's lifelong affection.

With the help of friends he was beginning to make his way into

print. Thanks to Meredith he sold a ballad and a short story to *Once a Week*, and Milnes gave him a more profitable introduction to R. H. Hutton, the editor of the *Spectator*. Here during the summer of 1862 he published seven poems, including "A Song in Time of Revolution," its companion piece "A Song in Time of Order," and the savagely erotic "Faustine." Equally significant in his work for this journal were reviews which demonstrated his vigorous prose and independent judgment. He defended Meredith's *Modern Love* eloquently against the charge of immorality; he praised Victor Hugo in a series of articles that won the French poet's gratitude; and he pleased Baudelaire likewise with a favorable review of *Les Fleurs du Mal* when the book was anathema to English propriety. This essay is especially noteworthy for introducing into England the doctrine of "Art for Art's sake." Swinburne had encountered it when he read Gautier's *Mademoiselle de Maupin* at Oxford, and now he found that Baudelaire had developed it in a discussion of Poe's *Poetic Principle*. Aware of Baudelaire's encounters with censorship, Swinburne asserted that "perfect workmanship makes every subject admirable and respectable," and he went so far as to claim that "there is not one poem of the *Fleurs du Mal* which has not a vivid and distinct background of morality to it."[19] Hutton was remarkably tolerant in opening his columns to Swinburne's subversive poems and essays, but after six months he lost his patience when the poet tried to hoax him with two reviews of French poets whom he had invented, complete with specimens of their salacious work.

His interest in French poets and painters was stimulated by James McNeill Whistler, a neighbor in Chelsea and a frequent visitor to Tudor House. In the spring of 1863 Swinburne accompanied Whistler on a trip to Paris and made the acquaintance of Fantin-Latour and Manet. At the Louvre he was fascinated by the Greek statue of the Hermaphrodite, which had previously inspired poems by Shelley and Gautier. Swinburne's "Hermaphroditus" (which included echoes of Gautier's "Contralto") addresses the beautiful bisexual figure with typical emphasis on the interrelation of physical beauty, sexual desire, frustration, and pain.

In Whistler's London studio one day, Swinburne lost consciousness in a seizure that suggested symptoms of epilepsy, though it was possibly brought on by intensive literary effort. He had finished writing his play "Chastelard," after several years of intermittent work. Like "The Queen Mother," it is a tragedy centering on a wilful and unscrupulous woman. Mary Stuart is confronted with a dilemma in disposing of her French minstrel lover before her marriage to Darnley. She vacillates between secret murder and legal execution, and when in a weak moment she tries to rescind the death sentence she is amazed to find that he refuses clemency, life not being worth living without her love. He proposes merely that they have sexual relations for the last time in his cell before he is led to the block. At the end she avidly watches his execution with the sinister figure of her next lover, Bothwell, beside her.

At the same time, Swinburne was at work on a novel about contemporary society, first called "A Year's Letters," a title later changed to "Love's Cross Currents." He handled the epistolary technique skillfully to display the complex relationships in an aristocratic family dominated by a wise and candid matriarch. The central character, Reginald Harewood, is largely a self-portrait, with his record of birchings at school and indolence at the university; his devoted half-sister and his beautiful and athletic girl cousin are both involved in marital difficulties, and Reggie plays a rather passive role in the action.

Though few of Swinburne's poems had yet been printed, their reputation for lewdness began to spread from his impassioned reading of them at literary parties. When Browning heard one of his performances, he remarked that "he had genius, and wrote verses in which to my mind there was no good at all." Upon learning later from Milnes that a publisher had used his comment as a pretext for rejecting the proposed volume, Browning expressed contrition, because he liked Swinburne personally and had "received courtesy from him"; but he reiterated his opinion that the poems were "moral mistakes."[20] When Ruskin read the manuscript he advised Swinburne earnestly that "every man of intellectual power should now devote himself to overthrowing [the world's] idols and leading the way to healthy conceptions

and healthy work. I should be sorry that you publish these poems, for I think they would win you a dark reputation, and take away from your future power of teaching and delighting."[21]

Simultaneous discouragements from two influential authors may have precipitated Swinburne's convulsive seizure, along with the irregular way of life at Tudor House. He was sent to the Isle of Wight to recuperate through his favorite pastimes of riding and swimming, and when his parents went abroad in the autumn he moved to the neighboring home of his aunt, Lady Mary Gordon, whose daughter, his double-cousin and childhood playmate, now twenty-three, was developing intellectual interests.

There was a masculine strain in Mary's nature, just as there was a feminine strain in Swinburne's. She wished she could have been his fellow-pupil at Eton; he taught her Greek verbs and she was fascinated by his bragging about the thrashings he had endured. Like the other members of Swinburne's family, she was deeply religious, and her obsession with the martyrs made her sympathetic with anyone who suffered painful punishment. Swinburne's ego must have expanded under her admiration for his fortitude.

They collaborated in writing a historical novel for youthful readers, *The Children of the Chapel*: Swinburne's contribution to it included an adept pastiche of a Tudor masque. Though the book was as properly religious as any by Charlotte M. Yonge, the action provides evidence of Swinburne's preoccupation with flagellation and transvestism. Another novel which the two cousins planned together, but which Mary finally wrote thirty years later, *Trusty in Flight*, gave a faithful picture of them both as a devoted brother and sister; the ending represented Swinburne's unfulfilled wish, as the hero joins the army and perishes heroically in battle.

In one of Swinburne's finest poems, "The Triumph of Time," written at this period, the apparent authenticity of the emotion and the details of the seaside setting give an impression that it recorded a personal experience. His biographers accepted an anecdote that he had fallen in love with a certain Jane Faulkner, and that his proposal of marriage was received with incredulous

laughter. Open to suspicion because of its similarity to the episode of Pope and Lady Mary Montagu, the legend was finally discredited when a modern scholar proved that at the time the girl was ten years old.[22] A more recent suggestion is that the unhappy love affair was with his admiring cousin Mary Gordon, and that he probably never declared his feelings to her because of their close kinship and his physiological traits; about this time she became engaged to an army officer twenty-one years her senior and Swinburne perhaps resolved to say nothing that might detract from her happiness. This story also may evoke doubts, because of its resemblance to that of Byron and Augusta Leigh. Its chief proponents, Cecil Y. Lang and Jean Overton Fuller, see traces of the situation in *Love's Cross Currents* and in several of the poems in addition to "The Triumph of Time."[23] As with Mrs. Packer's hypothesis about Christina Rossetti and William Bell Scott, it remains a plausible inference without external verification.

At any rate, the healthful regimen and Mary Gordon's inspiriting company stimulated Swinburne to undertake another poetic drama, this time modeled on Greek tragedy. *Atalanta in Calydon* turned out to be a more beautiful work than his Jacobean plays, partly because the mythological theme supplied a less perverse and morbid emotional atmosphere, but mainly because the choruses varied the pace and gave opportunity for Swinburne's overwhelming lyrical power. The fresh-air scenes of riding and hunting are a relief after his previous tormented characters and suffocating indoor settings. There may have been something of the hoydenish Mary Gordon in the portrayal of Atalanta, the fleet-footed huntress who scorned the male sex. He reported that the choruses took shape in his mind while he listened to Mary practicing Handel on the organ, and he chanted the first and loveliest of them to her while they were cantering together across the Downs.

In the spring of 1864, during a visit to Florence, he paid his respects to Walter Savage Landor, whom he had long venerated, both for his political intransigence and for the classical purity of his verse. Legend has it that the old poet, in his ninetieth year, was confused and annoyed when the strange-looking young man

burst into the room and fell on his knees in front of him to beg for his benediction. When Swinburne called again, however, they enjoyed an amicable conversation. Thus Swinburne completed the cycle of affiliation with the senior Romantic poets that he had started as a schoolboy with Wordsworth and Rogers.

Upon his return to London he was distressed by receiving notice from Rossetti that he was no longer acceptable as a tenant at Tudor House, and he had to move his precious books and other possessions into lodgings. Along with his poetry he was working intermittently on a critical book about William Blake, whose fame was being assiduously promoted by the Rossetti brothers. He spent laborious hours in the British Museum, puzzling out the Prophetic Books, and he formulated with greater assurance the doctrine of Art for Art's Sake that he had previously suggested in his Baudelaire review. Though Blake would seem to most readers to be an intensely doctrinaire poet, Swinburne took an opposite view: "To him, as to others of his kind, all faith, all virtue, all moral duty or religious necessity, was not so much abrogated or superseded as summed up, included and involved, by the one matter of art. . . . He had a faith of his own made out of art for art's sake, and worked by means of art; and whatever made against this faith was as hateful to him as any heresy to any priest."[24]

In this interpretation of Blake, Swinburne was indirectly stating his own poetic practice, in which a strong social and moral impulse inheres in the external concentration upon beauty. Swinburne had uttered his political prejudices in only two poems; he wrote "A Song in Time of Order" as a sequel to "A Song in Time of Revolution," though predating it in the subtitle as "1852" to place it in a historical context when "Bonaparte the Bastard" and his ally the pope were at the height of their prestige and when the three courageous dissenters would be indeed alien to the prevalent opinion. Rossetti counseled Swinburne against including doctrinaire poems in his proposed collection. Nevertheless, his rebelliousness was patent throughout. His fixation upon passionate and often perverse sex challenged the prudish taboos of the era; his assertion that physical love is a compound of ecstasy and agony contradicted the sentimental stereotype of domestic affection; his

fatalistic insistence upon the prevalence of cruelty, both in individual behavior and in the human predicament, negated alike the smug belief in a benevolent deity and the Rousseauistic faith in man's innate goodness. No wonder he found a kindred spirit in Blake as a worshiper of beauty and believer in the virtue of the flesh. Even his verbose rhetoric and elusive symbolism were not altogether unlike the cryptic Prophetic Books.

His friends were trying hard to find him a publisher. Rossetti submitted the manuscripts to the Macmillan firm, expressing his "certainty that Swinburne . . . is destined to take in his own generation the acknowledged place which Tennyson holds among *his* contemporaries." Alexander Macmillan replied that he "certainly thought it a work of genius, but some parts of it were very *queer*—very. Whether the public could be expected to like them was doubtful." After reading specimens aloud to his wife and sister-in-law, Macmillan regretfully sent a rejection.[25]

In the outcome, *Atalanta in Calydon* appeared before either *Chastelard* or the miscellaneous poems. Aided by another subsidy from the admiral, it was published in April 1865, with a dedication to Landor, who had recently died and who was acclaimed in a three-page Greek elegy prefacing the volume.

Though Atalanta occupies the title role in the drama, the principal tragic figure is Althaea, the mother of Meleager, who causes his death because in his infatuation for Atalanta he has slain his uncles in a quarrel over the carcass of the wild boar. To this extent she is another example of the arrogant woman; but, unlike Queens Eleanor, Catherine, and Mary Stuart in his previous plays, she is not impelled by jealousy, lust, or cruelty, but is helplessly entrapped in the malign fate that Artemis has decreed for her family. Thus the doomed dignity of Greek tragedy replaces the self-generated passions of the Renaissance type. The protagonists are doubly tormented by being aware of their destiny but unable to prevent it.

Purists have objected that *Atalanta* is too romantic in tone to be acceptable as authentic Greek tragedy; but Swinburne was not producing a marmoreal reconstruction like Arnold's *Merope*. As with his previous plays, he had breathed his own life into an

archaic model. Later he confessed that "*Atalanta* was perhaps too exuberant and effusive in its dialogue, as it certainly was too irregular in the licence of its choral verse, to accomplish the design or achieve the success which its author aimed at;"[26] but this unwonted apology is a mere concession to the carping pedants. Like Shelley's *Prometheus Unbound* the play employs the Greek structure of dialogue and choruses to embody the poet's own transcendental vision. As in that play, the characters become universal: Meleager, the mighty huntsman, represents the human predicament, passive and helpless against destiny; Atalanta embodies the woeful power of love; Althaea is the eternal mother, giver of life and death.

The chief importance of *Atalanta* in Swinburne's intellectual development was that it resolved his dilemma about religion. The basic elements of his temperament were profoundly religious—his humanitarian sympathies, his worship of beauty, his awareness of a creative force in the universe. For this very reason he loathed the Christian faith as he saw it practiced in the modern world. In his view, it was allied with political autocracy, it poisoned personal relations with a hypocritical moral code, and it denied the deepest impulses of human nature by insisting upon an impossible asceticism. Furthermore, he came to maturity just when Darwinism exploded in the public consciousness and fortified the growing rationalistic challenge to the authority of the Bible. The older poets—Tennyson, Browning, Arnold, Clough—tried desperately to reconcile the new dispensation with the former one, but Swinburne suffered from no such divided loyalty. To him, the essence of Darwinism was man's identity with the primitive natural forces and instincts. As a basis for their modernized faith, both Tennyson and Browning emphasized love, but it was strictly *agape*, with scrupulous avoidance of *eros*. As an alternative to the defeated stoicism of Empedocles, the melancholy hedonism of Omar Khayyám, the tentative groping of *In Memoriam*, Swinburne hymned unqualified paganism.

As a creed suitable for the new era he turned back to the pantheism of the ancient Greeks, which accepted sensuality and—in spite of its implicit fatalism—permitted joy in man's relationship

with nature and with his kind. The readers of *Atalanta* were disturbed by an uncomfortable suspicion that the poet was not simply reconstructing an obsolete world view for literary effect, but was proclaiming it as his own genuine creed and worshiping the ancient gods as living presences. At the same time, however, the attitude toward the gods expressed through the choruses is the least Greek element in the play, for Swinburne follows Shelley in representing the Olympian powers as the very incarnation of tyranny. In a letter he remarked that his grief over Landor's death had "a little deepened the natural colours of Greek fatalism here and there, so as to have already incurred a charge of 'rebellious antagonism' and such like things."[27] The choruses indeed rise to a crescendo of blasphemy against

> The Lord of love and loathing and of strife
> Who gives a star and takes a sun away . . .
> Who, seeing the light and shadow for the same,
> Bids day waste night as fire devours a brand,
> Smites without sword, and scourges without rod;
> The supreme evil, God.

Christina Rossetti, recognizing that these lines assailed the Christian Jehovah rather than the Greek Zeus, pasted a strip of paper over them in her copy of the book.

Swinburne's vision of this sadistic deity probably owed a good deal to Blake's Urizen, "mistaken Demon of heaven." Also, however, there was a more sinister source for his diatribe. When Milnes, writing about *Atalanta* in the *Edinburgh Review*, described its satanism as "Byron with a difference,"[28] Swinburne told him that he should have said, "De Sade with a difference," declaring that "the poet, thinker, and man of the world from whom the theology of my poem is derived was a greater than Byron. *He* indeed, fatalist or not, saw to the bottom of gods and men."[29] The unhappy marquis, after having first attracted Swinburne's attention by his psychological perversion, had now become for him the exponent of a black gospel of suffering such as had never hitherto appeared in English literature, though it was soon to be discovered by other poets, such as Thomson and

Hardy, in the more ponderous writings of Schopenhauer and von Hartmann.

The blank verse of the play captures much of the Swinburnian melody through lavish use of alliteration and shifted stresses; but the choruses are its particular glory. For the first time the reading public was introduced to the poet's intoxicating rhythms. The opening chorus fully displays his whole array of devices—assonance, alliteration, antithesis, internal rhyme, verbal repetition, contrapuntal meter—in eight-line stanzas that sustain a haunting rhyme by echoing the first two lines in the last two, with a unique effect of springtime vitality:

> For winter's rains and ruins are over,
> And all the season of snows and sins;
> The days dividing lover and lover,
> The light that loses, the night that wins;
> And time remembered is grief forgotten,
> And frosts are slain and flowers begotten,
> And in green underwood and cover
> Blossom by blossom the spring begins.

The second chorus is in total contrast, shifting from youthful elation to taciturn fatalism largely by the typographical device of printing the lines as trimeter quatrains instead of running them together in hexameter couplets. Thus constrained, the phrases become grimly epigrammatic, stripped of ornament. Swinburne's verbal sleight of hand is apparent, for instance, in a trick of reversing the expected order of words: the customary emblems are inverted in "Time, with a gift of tears; / Grief, with a glass that ran;" similarly, in "Night, the shadow of light, / And life, the shadow of death," life would ordinarily be equated with light, and death with night. Swinburne thus injects new vigor into jaded metaphors. Throughout this austere survey of man's destiny the language is modeled closely on that of the Old Testament.

The third chorus, a paean to the ruthless power of Aphrodite, begins with ten lines of Swinburne's typical "disguised quatrains":

> We have seen thee, O Love, thou art fair; thou art goodly,
> O Love;
> Thy wings make light in the air as the wings of a dove. . . .

The rest of the long chorus is in extended stanza-patterns with complicated rhyme-schemes. The subsequent five choruses display further varieties of metrical forms; the final lament, chanted antiphonally between the choral group and the major characters, employs stanzas consisting of four lines in anapestic dimeter followed by one in hexameter:

> For the dead man no home is;
> Ah, better to be
> What the flower of the foam is
> In fields of the sea
> That the sea-waves might be as my raiment, the gulf-stream
> a garment for me.

The device causes each stanza to begin in a restrained tone and end with a wail of uncontrollable emotion.

The choruses tend to grow longer as the drama proceeds. As was later to prove so often, Swinburne is his own most formidable rival: he begins at such a high rhetorical pitch that he is unable to surpass it, and by remaining merely consistent he leaves the reader with an illusion of anticlimax.

Milnes (recently created Lord Houghton) exerted his wide influence to obtain attention for the book, and Rossetti also solicited favorable reviews. The result was a gratifying burst of acclaim. The *Athenaeum* said that "we yet know not to what poet since Keats we would turn for a representation at once so large and so graphic."[30] The *Sunday Times* ventured a prediction that "he is permanently enrolled among our great English poets: he possesses great tragic power."[31] The *Saturday Review* even defended Swinburne's fidelity to his Greek originals: "He almost beguiles us into imagining that we are listening to one of the great contemporaries of Euripides."[32] Ruskin was moved to term *Atalanta* "the greatest thing ever done by a youth—though he is a Demoniac youth! Whether ever he will be clothed and in his right mind, heaven only knows. His foam at the mouth is fine, meantime."[33]

With so much favorable publicity the book sold well, and a second edition was brought out within four months, followed before the end of the year by *Chastelard*, admiringly dedicated to

Victor Hugo. Swinburne was commissioned to write a critical introduction to a selection of Byron's poetry, and was tentatively offered the editorship of a new magazine.

Success promptly went to his head. His naïve self-confidence expanded into assertiveness, and he inveighed vituperatively against any critic who found fault with his work. He incurred a reproof from Lord Houghton for alleged discourtesy to Tennyson: after reading *Atalanta* the Laureate had written to Swinburne expressing envy of his gifts in rhyme and rhythm, but when he came to a party arranged by the publisher to enhance Swinburne's prestige the younger poet retreated into a back room and held forth stridently about Blake. William Bell Scott, who was apt to be motivated by jealousy, reported on "all his boasting of himself and all his belongings. . . . Of late he has been very much excited, and certainly drinking. Gabriel and William Rossetti think he will not live long if he goes on as lately without stopping."[34]

Chastelard was not as well received as *Atalanta*. The reviewers felt uneasily that its sultry passion implied perversion. The *Spectator* found "a radical deformity of his poetry" in "the want of moral and intellectual relief for the coarseness of passion;" the critic disliked "the oppressive atmosphere in that forcing-house of sensual appetite."[35] The *Athenaeum* could feel no sympathy for any of the leading characters: "Besides being inherently vicious, their language will offend not only those who have reverence, but those who have taste. We decline to show by quotation how often the Divine Name is sported with in scenes which are essentially voluptuous."[36] Even Lord Houghton, in the *Fortnightly*, chided the poet for "excluding from his speculation the great world of moral impression."[37]

All the reviewers, however, acknowledge Swinburne's dramatic power, imaginative "grandeur," and richness of language, and the publisher felt encouraged enough to undertake the issue of the long-delayed collection of Swinburne's shorter poems. Rossetti was well aware of probable public disfavor. When *Atalanta* came out, he told Swinburne that "I really believe on the whole that this is the best thing to bring out first. It is calculated to put people in better humour for the others, which when they do come will

still make a few not even over-particular hairs to stand on end."[38] Meredith sent an anxious warning: "Do be careful of getting your reputation firmly grounded: for I have heard 'low mutterings' already from the Lion of British Prudery; and I, who love your verse, would play savagely with a knife among the proofs for the sake of your fame; and I want to see you take the first place, as you may if you will."[39]

To test the moral impact of the poems, Swinburne read most of the manuscript one evening to Ruskin, and was "sincerely surprised by the enjoyment he seemed to derive from my work, and the frankness with which he accepted it."[40] The next day, however, Ruskin wrote anxiously to Swinburne's most trusted woman friend, Lady Trevelyan: "I . . . heard some of the wickedest and splendidest verse ever written by a human creature. He drank three bottles of porter while I was there. I don't know what to do with him or for him, but he mustn't publish these things."[41] Lady Trevelyan sent him an earnest plea: "Do let it be a book that can be really loved and read and learned by heart, and become part and parcel of the English language. . . . Don't give people a handle against you now."[42] Well aware that any such censorship would eliminate the very essence of his poetry, Swinburne defended himself stoutly: "Any poem which all my friends for whose opinions I care had advised me to omit, should be omitted. But I never have written such an one. . . . I cannot but see that whatever I do will be assailed and misconstrued by those who can do nothing and who detest their betters."[43] To prove his good faith, he did reluctantly cancel two poems on the "strong and unanimous advice" of friends.[44]

As usual, his supporters launched a campaign of propaganda. Through Lord Houghton's influence, he was incongruously yoked with Charles Kingsley to respond to the toast to "Historical and Imaginative Literature" at the banquet of the Royal Literary Fund. When introduced as "the representative of the future in English poetry" he delivered his sole public speech, which he had painfully memorized, and which proved to be an ardent tribute to Baudelaire, Hugo, and Villon, with Chaucer the only English poet ranked near them.

When, after delays over proofreading, *Poems and Ballads* was ready for publication in August 1866, it evoked torrents of abuse. The review in the *Athenaeum*, by Robert Buchanan, was embittered by personal spite, for Swinburne's publisher had just canceled a contract with Buchanan for an edition of Keats and had offered it to Swinburne instead. Buchanan condemned Swinburne for being not immoral but insincere, "unclean for the mere sake of uncleanness," even taking his religious blasphemies at second hand without original thought. The poems are too artificial and puerile to be morally harmful: "this young gentleman . . . is quite the Absalom of modern bards,—long-ringleted, flippant-lipped, down-cheeked, amorous-lidded."[45]

More devastating, because less scornful, was John Morley's article in the *Saturday Review*. Swinburne, he declared, "has revealed to the world a mind all aflame with the feverish carnality of a schoolboy over the dirtiest passages in Lemprière." He was "an unclean fiery imp from the pit . . . the libidinous laureate of a pack of satyrs. . . . Never have such bountifulness of imagination, such mastery of the music of verse, been yoked with such thinness of contemplation and such poverty of genuinely impassioned thought." Even the poet's technical skill is vitiated by exaggeration: "Mr. Swinburne riots in the profusion of colour of the most garish and heated kind. He is like a composer who should fill his orchestra with trumpets, or a painter who should exclude every colour but a blaring red and a green as of sour fruit. . . . We are in the midst of fire and serpents, wine and ashes, blood and foam, and a hundred lurid horrors. Unsparing use of the most violent colours and the most intoxicated ideas and images is Mr. Swinburne's prime characteristic."[46]

The publisher was disturbed by such attacks in the most influential journals, and his anxiety turned to terror when he received word that the magisterial *Times* was about to print an equally hostile review by its principal critic, E. S. Dallas, demanding prosecution for both poet and publisher. *Poems and Ballads* was precipitately withdrawn from the market before a single copy reached the booksellers. After irate negotiations and threats of legal proceedings, the edition was transferred to a less reputable

publisher, who specialized in pornography and who was happy to take advantage of the scandal that the reviews and the supression had propagated.

Other critics rallied to the poet's defense, and William Michael Rossetti even published an eighty-page book in favor of his work. Buchanan reentered the fray with a satirical poem in the *Spectator*, "The Session of the Poets." In the midst of a genteel conversation among the most eminent poets of the day,

> Up jumped, with his neck stretching out like a gander,
> Master Swinburne, and squeal'd, glaring out thro' his hair,
> "All virtue is bosh! Hallelujah for Landor!
> I disbelieve wholly in everything!—There!"

Chaos ensues. Jean Ingelow faints in Tennyson's arms. Arnold rushes out of the room.

> Till Tennyson, flaming and red as a gipsy,
> Struck his fist on the table and utter'd a shout:
> "To the door with the boy! Call a cab! He is tipsy!"
> And they carried the naughty young gentleman out.

The uproar soon spread across the Atlantic. Condemned violently in some reviews, defended in others, the American edition sold so fast that the presses could not keep up with the demand. A freethinking friend of Swinburne's, Winwood Reade, who was visiting the United States, reported jubilantly "to Algernon Swinburne, Pagan, suffering persecution from the Christians": "Your book is making a furore on this continent. No new volume of Tennyson has ever made more talk. The publisher has sold 6000 & is now printing the seventh. Mr Emerson to whom I was introduced yesterday asked me a great many questions about you. He had read yr/ Madonna Mia detached & instantly got the book. Lowell, he said, being a linguist, was especially interested in that department of your brain his curiosity having been excited about yr/ Greek verses and French songs."[47] Lowell was less benign, however, in a letter to a friend: "I am too old to have a painted *hetaira* palmed off on me for a Muse, and I hold unchastity of mind to be worse than that of body. . . . The true Church of poetry is founded on a rock, and I have no fear that these smutchy backdoors of hell shall prevail against her."[48]

Though in the face of abuse Swinburne maintained an attitude of shocked surprise and injured innocence, he must have been inwardly gratified by his success in flouting what he termed "the abject and faithless and blasphemous timidity of our wretched English literary society; a drunken clerical club dominated by the spurious spawn of the press."[49] As the self-elected laureate of emancipation, he was fulfilling the gloomiest forebodings of the orthodox that the new evangel of a scientific age would be total depravity, without moral control or religious faith.

A further reason why critics and readers automatically took offense was his subversion of the current Hellenistic revival. Arnold's "Hellenism," representing dignity, restraint, and "sweetness," was utterly unlike Swinburne's celebration of ancient Greece's fleshly indulgence, sexual deviances, and primitive fertility rites. Arnold represented the stoic tradition, Swinburne the hedonistic; and like all hedonism his was inherently gloomy, since self-indulgence inevitably falls victim to satiety as well as to age, disease, and death. The Greek paganism that he preached was only superficially a paean to the joys of living; essentially it was an invocation of dying as the only anodyne.

The book seemed all the more offensive because its scandalous themes were couched in such seductively luxuriant melodies. Ignoring the emphasis upon frustration and anguish, the respectable public assumed that the beautiful language constituted an incitement to perversion and vice.

The range of Swinburne's personal experience was so narrow, and indeed so conventional, that he had to depend almost wholly on literature and art to provide his imaginative stimulus. His emotional reactions, however, were so abnormally intense that a poem or a statue could stir him as profoundly as a love affair or a disaster for an ordinary person. Apart from its tone of sour malice, then, Buchanan's charge of insincerity was remarkably valid. In a sense, all the poems were "make-believe." Elsewhere in the review, Buchanan perceptively described Swinburne as "parroting" Browning. Like Browning, Swinburne had tried persistently to be a dramatist, and when he turned from plays to short poems he retained the habit of wearing fictitious masks. In a score of poems Browning had displayed a morbid interest in murderers and other

aberrant types—Sebald and Ottima, Porphyria's lover, the Duke of Ferrara—and Swinburne extended this psychological impersonation into the region of sexual perversion. The difference was basically stylistic. Swinburne's melodious fluency produced a less clearly objective impression than Browning's gnarled colloquialism, and so readers were more apt to identify the persona with the poet.

The fundamentally dramatic quality was asserted by Swinburne in a pamphlet which he published in rebuttal of his critics: "The book is dramatic, many-faced, multifarious; and no utterance of enjoyment or despair, belief or unbelief, can properly be assumed as the assertion of its author's personal feeling or faith. Were each poem to be accepted as the deliberate outcome and result of the writer's conviction, not mine alone but most other men's verses would leave nothing behind them but a sense of cloudy chaos and suicidal contradiction."[50] When considered as a group of dramatic monologues, the poems fall into several distinct groups. The most obvious are those in which the speaker can be readily identified. In "Laus Veneris" it is the knight Tannhäuser of the well-known legend; in "Itylus" it is Philomela in an equally familiar myth; in "Hymn to Proserpine" the subtitle is enough to indicate that it is a Roman pagan in the days of Constantine; in "The Leper" it is unmistakably a medieval scribe, who depicts himself in the opening stanzas. As Swinburne pointed out scornfully in his pamphlet, the much-vilified "Anactoria" was simply a paraphrase of Sappho's most famous ode to a beloved girl; "I have striven," he said, "to cast my spirit into the mould of hers."[51] Similarly, "Fragoletta" dealt with the bisexual heroine of a novel by Henri de Latouche.

The second group of poems are those which lack a specific context and clearly individualized speaker, particularly those about passionate women. These were explicitly described as imaginary in Swinburne's introductory poem dedicating the volume to Burne-Jones:

> O daughters of dreams and of stories
> That life is not wearied of yet,
> Faustine, Fragoletta, Dolores,

Félise and Yolande and Juliette,
　Shall I find you not still, shall I miss you,
　　When sleep, that is true or that seems,
　Comes back to me hopeless to kiss you
　　O daughters of dreams?

Later in the poem he equates his "songs" with the formal and traditional scenes in Burne-Jones's paintings:

Is there place in the land of your labour,
　Is there room in your world of delight,
Where change has not sorrow for neighbour,
　And day has not night? . . .
In a land of clear colours and stories,
　In a region of shadowless hours,
Where earth has a garment of glories
　And a murmur of musical flowers. . . .

Though the world of your hands be more gracious
　And lovelier in lordship of things
Clothed round by sweet art with the spacious
　Warm heaven of her imminent wings,
Let them enter, unfledged and nigh fainting,
　For the love of old loves and lost times;
And receive in your palace of painting
　This revel of rhymes.

Thus overtly linking himself with Rossetti's principal disciple in visual art, Swinburne claims to be a Pre-Raphaelite maker of decorative beauty. The first two poems that follow are the most conspicuously Rossettian: even the rhythms have his peculiar melancholy cadence produced by rhyming on normally unstressed syllables, and in "A Ballad of Life" the picture of a queenly beauty with her seven-stringed cithern and her three attendants is elaborated with Rossetti's sort of visual detail and explicit symbolism. "A Ballad of Death" employs identical techniques, and the two titles are enough to indicate that the poems form a balanced diptych in a purely medieval form, suggested by Rossetti's *Early Italian Poets.*

In "Notes on Poems and Reviews" Swinburne offered an exhaustive explication of the most abused poem in the group about

femmes fatales, "Dolores," to prove its psychological validity as a dramatic monologue: "I have striven here to express that transient state of spirit through which a man may be supposed to pass, foiled in love and weary of loving, but not yet in sight of rest. . . . The spirit, bowed and discoloured by suffering and by passion (which indeed are the same thing and the same word), plays for awhile with its pleasures and its pains, mixes and distorts them with a sense half-humorous and half-mournful, exults in bitter and doubtful emotions. . . ."[52] He goes on to call "Hesperia" "the next act in this lyrical monodrama of passion."[53] The solemn claim to artistic integrity must be regarded with some skepticism, however, when one learns from Swinburne's letters that he had been so enchanted with the melody and lubricity of "Dolores" that he had kept expanding it: "I have added yet four more jets of boiling and gushing infamy to the perennial and poisonous fountain of Dolores;" and then, "I have added ten verses to D—— très infâmes et très bien tournés."[54]

The third group of poems is the one that is regarded by recent biographical critics as genuinely autobiographical. Centering upon "The Triumph of Time," it includes also "A Leave-Taking" and perhaps others. Though interspersed among the poems on other themes, these seem to provide a consistent picture of a would-be suitor who has realized that his love is unrequited and who resolves to face a life of loneliness, concealing all signs of his secret devotion and seeking solace in the power and beauty of nature. It is a much more conventional theme: the proper Victorian hero who respects the happiness of an innocent girl. To consider these poems as revealing the personal story of Swinburne's attachment to Mary Gordon is to argue in a circle, for the biographers derive their evidence for the affair mainly from the same poems. A tenable hypothesis can be that "The Triumph of Time" is just as fictitious as the other poems, and that Swinburne was simply expanding his studies of amatory psychology by shifting to a persona of another type. Admittedly, the more identifiable scenery, as well as the intangible note of sincerity, reinforces the possibility of actual experience. The same setting and theme, however, occur in two poems that must be fictitious: "The Sun-

dew," written before the episode with Mary Gordon began, and "Félise," written after it ended. The latter poem depicts a rejected lover discovering a year later that the woman now desires him, whereas his ardor has cooled: "My heart will never ache or break / For your heart's sake." It is unlikely, though not impossible, that Mary rued her marriage and sought to recapture Swinburne's devotion. If, in spite of discrepancies, we continue to accept the poems as autobiographical, they are consistent with Swinburne's upbringing as a patrician Englishman, schooled in the code of good taste and self-control—very different from the public image of a rampant sensualist and lecher.

Swinburne's virtuosity in metrical forms is abundantly displayed throughout. The range of line lengths and stanza patterns is astonishing. Many of the poems conform to standard traditions. "To Victor Hugo" is a formal ode modeled on Milton's "Hymn on the Morning of Christ's Nativity." "Hermaphroditus," which looks like a Keatsian ode, is actually a sequence of four sonnets. Two lyrics are in the French fixed form of the rondel, and "A Ballad of Burdens" is to be classified as what shortly afterward came to be termed the "ballade" (to distinguish it from the folk ballad), though Swinburne did not yet attempt the special difficulty of using the same rhyme sounds in every stanza. "Anactoria" is in the run-on pentameter couplets of Keats's *Endymion*, whereas "Erotion" uses the same meter with the couplets end-stopped. "At Eleusis" is in normal blank verse; "The Leper" uses a simple ballad stanza. Adapting FitzGerald's quatrains for "Laus Veneris" Swinburne added complexity by rhyming the third lines in each pair of stanzas, instead of leaving them unrhymed. Apart from typography, therefore, the poem is in eight-line stanzas rather than quatrains.

The poems that chiefly caught the public ear were those in which Swinburne departed from the norms of English prosody in order to achieve his two distinctive effects—speed and emphasis. For speed he used triple feet—anapests and dactyls—and lines far longer than pentameter, though on occasion he could also trip along in exceptionally short lines, as in "Anima Anceps" and "Love at Sea." Emphasis was contributed by constant manipula-

tion of all the available devices—repetition, alliteration, internal rhyme, parallelism and antithesis, and many more.

The techniques were varied to be appropriate to the subject and mood. In "Hesperia" the sixteen-syllable lines, rhyming in quatrains and expanded still further rhetorically by long complex (often periodic) sentences, convey the vastness and surging power of the sea, while in "Hymn to Proserpine" lines of the same length, but arranged in closed couplets, sustain the flood of bitter rhetoric in which the aged pagan denounces the pallid new cult of Christianity. The narcotic monotony of "Faustine" is enhanced by the interminable continuation of a single rhyme sound, and thus the speaker is revealed as the mesmerized victim of the woman's avid lust. In "Dolores" the blasphemous identification of the goddess of fleshly desire with the Virgin Mary is intensified by the liturgical refrain line concluding every second stanza. The steady regularity of the *Rubáiyát* stanza retards the narrative of "Laus Veneris" to the deliberate pace of fate. The peculiar horror of "The Leper," combining a Poe-like necrophilic obsession with the medieval grotesqueness of the Dance of Death, gains its power from the almost casual simplicity of form and language. "A Match" moves with the dainty yet formal steps of a minuet in a Watteau painting. Probably the most widely admired of the poems, "The Garden of Proserpine," achieved an unwonted effect of limpid clarity by borrowing both landscape and stanza form from Christina Rossetti's "Dream Land."

Within Swinburne's idiosyncratic techniques of prosodic pattern inheres his unique handling of the currency of poetic communication—words and metaphors. His recurrent figures of speech occupy a narrow range: birds, serpents, roses, lips, and always his dominating image of the sea. Their appearance in poem after poem lends uniformity to the strange world in which his imagination exists. More often his words are actually abstractions, evoking no precise image at all. The resultant impression is peculiarly like that of dreams, which seem to be vivid and coherent but which become evanescent upon any attempt to specify their signification. T. S. Eliot provides the best analysis: "In Swinburne the meaning and the sound are one thing. . . . He uses the general word, because

his emotion is never particular, never in direct line of vision, never focused; it is emotion reinforced, not by intensification, but by expansion. . . . When you take to pieces any verse of Swinburne, you find always that the object was not there—only the word."

Eliot makes it clear that he is not speaking in disparagement: "The poetry is not morbid, it is not erotic, it is not destructive. These are adjectives which can be applied to the materials, to the human feelings, which in Swinburne's case do not exist. The morbidity is not of human feeling but of language. . . ." In a unique way, he says, Swinburne's poetry is aesthetically "healthy" . . . "because the object has ceased to exist, because the meaning is merely the hallucination of meaning, because language, uprooted, has adapted itself to an independent life of atmospheric nourishment. . . . Only a man of genius could dwell so exclusively and consistently among words as Swinburne. His language is not like the language of bad poetry, dead. It is very much alive, with this singular life of its own."[55]

This quality is related to another of his distinctive traits, his sheer proliferation. In each poem the melodious incantation flows through stanza after stanza with inexhaustible felicity, so that the mood and theme seem to move out of time into a sort of miniature eternity. It is easy to say that the poems would be better if they could be shortened; but it is seldom possible to select a particular stanza for elimination. If the poems had been shorter, they would simply not have been Swinburne's.

Ultimately, then, the uniqueness of his poetry is inseparable from his personal identity. His prosodic technique is highly susceptible to parody, but no imitator has ever seriously produced even a stanza that could be mistaken for Swinburne's. Similarly, in his use of language as an independent world of words he stands somewhere between Rossetti and the Symbolists, and yet he is not identifiable with either. His fecundity transports the reader into a hypnotic trance outside of actuality, beyond good and evil.

Within a few months of the publication of his book, Swinburne brought out three substantial prose works—the "Notes on Poems and Reviews," the Byron introduction, and the study of Blake— which established him as a critic of formidable ability. In all

three he excoriated his adversaries with savage wit, and his style displayed rhetorical qualities of emphasis and eloquence akin to those in his verse. At the same time, he tried to find a publisher for *A Year's Letters* and he was actively working on another intimately autobiographical novel, *Lesbia Brandon.*

While his literary stature increased, his behavior deteriorated. His closest intimates now were a homosexual young painter, Simeon Solomon, and a shady parasite of the Rossetti circle named Howell who catered to his fantasies about Sade. Under the influence of brandy his health grew steadily worse. His rejection of criticism approached paranoia: he flew into tantrums not only over adverse reviews but over harmless comments or suspected evasions by his friends.

Nevertheless, in spite of his rage and defiance, he was subconsciously affected by the pressure of disapproval. He began to wonder whether erotic passion and fatalistic pessimism could adequately sustain a poetic career. His profound need for a "father figure" as substitute for the well-intentioned but obtuse admiral always impelled him to accept the authority of older men, and at this juncture Ruskin made a valiant attempt to redirect his talent. After praising the art of his poetry, Ruskin went on:

> For the matter of it—I consent to much—I regret much—I blame or reject nothing. I should as soon think of finding fault with you as with a thundercloud or a nightshade blossom. All I can say of you, or them—is that God made you, and that you are very wonderful and beautiful. To me it may be dreadful or deadly—it may be in a deeper sense, or in certain relations, helpful and medicinal. There is assuredly something wrong with you—awful in proportion to the great power it affects and renders (nationally) at present useless.... I shall always rejoice in hearing that you are at work, and shall hope some day to see a change in the method and spirit of what you do.[56]

A month later Swinburne reported to William Rossetti:

> I have begun verse again after many months of enforced inaction through worry and weariness. I am writing a little song of gratulation to Venice with due reserves and anticipations.... If I do finish this poem at all to my satisfaction, there will be a bit of enthusiasm in verse for once—rather. After all, in spite of jokes and perversities... it is nice to have something to love and to believe in as I do in Italy.

It was only Gabriel and his followers in art (l'art pour l'art) who for a time frightened me from speaking out.[57]

The "little song" grew over the succeeding weeks into "A Song of Italy," a thousand-line paean to the cause of Italian freedom, much in the manner of Shelley. It was promptly followed by an "Ode on the Insurrection in Candia," a sustained Pindaric with echoes of "Hellas." Having at last consciously rejected the yoke of Pre-Raphaelitism and aestheticism, Swinburne was jubilantly assuming the role of crusader for international revolution.

The change had been foreshadowed in *Poems and Ballads* not only in the songs "In Time of Order" and "In Time of Revolution" but also in the ode to Victor Hugo:

> Thou art chief of us, and lord;
>> Thy song is as a sword
> Keen-edged and scented in the blade from flowers;
>> Thou art lord and king; but we
>> Lift younger eyes, and see
> Less of high hope, less light on wandering hours;
>> Hours that have borne men down so long
> Seen the right fail, and watched uplift the wrong.

Swinburne was extolling the sturdy political exile who denounced oppressors in *Les Châtiments* and *La Légende des Siècles*.

Another significant influence at this time was his enthusiasm for Walt Whitman. William Rossetti had been promoting Whitman's fame in England almost single-handed for ten years, and Swinburne in 1862 became enchanted with "Out of the Cradle Endlessly Rocking," which he called "the most lovely and wonderful thing I have read for years and years."[58] When he learned more about Whitman he saw an affinity between him and Blake in both outlook and poetic manner, and he was further drawn to him by a sense that he himself shared several of Walt's traits—love of the sea, political radicalism, frankness about sex, and victimization by prudish attempts at suppression. His admiration found utterance in "To Walt Whitman in America":

> Send but a song oversea for us,
>> Heart of their hearts who are free,

> Heart of their singer, to be for us
> More than our singing can be;
> Ours, in the tempest at error,
> With no light but the twilight of terror;
> Send us a song oversea! . . .
>
> God is buried and dead to us,
> Even the spirit of earth,
> Freedom; so have they said to us,
> Some with mocking and mirth,
> Some with heartbreak and tears;
> And a God without eyes, without ears,
> Who shall sing of him, dead in the birth?

Obviously, Swinburne was volunteering to perform as the bard resuscitating the moribund spirit of Liberty.

The most potent influence of all, however, was not literary but strictly political—Giuseppe Mazzini. In his undergraduate days Swinburne had chanted his ode to Mazzini with ritual genuflections before a portrait of the patriot, and now ten years later his revived fervor impelled him to seek a personal encounter. The aging refugee was chary of meeting such a disreputable admirer, until the publication of the Candia ode in the *Fortnightly* convinced him that Swinburne might be a useful recruit to his cause, and so he sent him a long and florid appeal:

I feel . . . hopeful that the power which is in you has found out its true direction and that, instead of compelling us merely to admire *you*, you will endeavour to transform *us*, to rouse the sleeping, to compel thought to embody itself into action. That is the mission of Art; and yours.

Whilst the immense heroic Titanic battle is fought, christened on every spot by the tears of the loving ones and the blood of the brave, between Right and Wrong, Freedom and Tyranny, Truth and a Lie, God and the devil—with a new conception of Life, a new Religious Synthesis, a new European World struggling to emerge from the graves of Rome, Athens, Byzantium, and Warsaw, kept back by a few crowned unbelievers and a handful of hired soldiers—the poet ought to be the apostle of a crusade, his word the watchword of the fighting nations and the dirge of the oppressors. Don't lull us to sleep with songs of egotistical love and idolatry of physical beauty: shake us, reproach, encourage, insult, brand the cowards, hail the Martyrs,

tell us all that we have a great duty to fulfill, and that, before it is fulfilled, Love is an undeserved blessing, Happiness a blasphemy, belief in God a lie. Give us a series of 'Lyrics for the Crusade.'[59]

Such words from his idol seemed to Swinburne like a fiat from heaven; and soon afterward his bliss was complete when Mazzini, hearing that "A Song of Italy" was about to be published, invited the poet to read the manuscript to him. When his hero greeted him, Swinburne could not resist the impulse to fall on his knees and kiss his hand. After the reading the exchange of flattery was fervent: Mazzini promised that when the revolution occurred he would take Swinburne to Rome and crown him with laurels in the capitol.

During subsequent months he summoned Swinburne to private interviews in which "he said things to me and told me stories I can't write about."[60] When the chief was abroad on secret missions, messages were transmitted to Swinburne through the London agents of the conspiracy. At long last Swinburne was able to enjoy the ecstatic illusion of being a participant in the affairs of the great world.

The typical intriguer, Mazzini was cold-bloodedly realistic about his disciple. Like most of Swinburne's friends, he believed that the poet was drinking himself to death: "He might be transformed but only by some man or woman—better a woman of course—who would like him very much and assert at the same time a moral superiority over him." Two years later, Mazzini expressed the opinion that "Swinburne will not last long. . . . I wish very much that he would, before vanishing, write something giving up, for the sake of the young people to come, the absurd, immoral French 'art for art's sake' system . . . but he will never do this." In 1870 Mazzini predicted gloomily that "he will not last more than one or two years."[61]

For a while Swinburne held out against his master's compulsion. "All Mazzini wants," he reassured his mother, "is that I should dedicate and consecrate my writing power to do good and serve others exclusively; which I can't. If I tried I should lose my faculty of verse even."[62] When *A Song of Italy* was issued as a brochure in April 1867, it received grudging reviews, with a

vicious attack in the *Saturday Review*, and few copies were sold. "A conspiracy of silence," Mazzini grumbled. Nevertheless, the Chief's pressure began to prevail, even in the matter of Swinburne's inveterate scorn for the "pale Galilean." Ever since meeting Mazzini, he told his sister in his old age, "I have been able to read the Gospels with such power of realizing and feeling the truth of the human character of Christ as I have never felt before."[63] The first evidence was in a poem on Siena, presenting a historical survey of Italy's woes and martyrs, in which Christ is mentioned sympathetically as the principal victim of perverted Christianity.

Garibaldi's campaign roused Swinburne to a high pitch of excitement, and he hastily wrote "The Halt before Rome," which came out in the *Fortnightly* inopportunely just when the Liberator suffered a serious setback. Turning his attention to English affairs, Swinburne composed "An Appeal to England" on behalf of three Fenian agitators who were about to be hanged for the shooting of a policeman; written in a simpler style than his usual magniloquence, it was peddled as a broadside in the streets of Manchester.

It is ironic—though perhaps psychologically plausible—that he relinquished erotic passion as a poetic theme just at the time when he was enjoying his only experience of sexual intercourse. His mistress was Adah Isaacs Menken, a flamboyant and buxom American circus performer, whose marital record rivaled the Wyf of Bathe's. A persistent legend has it that Rossetti bribed her to lure Swinburne into her toils, in the hope of therapeutic results. At any rate, she lauded his poems, begged him to help her with a volume of her own doggerel that she was about to publish, and impressed him with the fact that her original given name had been "Dolores." His letters to intimate friends mention her complacently as "my present possessor": "I enjoy ... the bonds of a somewhat riotous concubinage. I don't know many *husbands* who could expect from a *wife* such indulgences as are hourly laid at my feet." When she died some months later in Paris he reported that "it was a great shock to me and a real grief—I was ill for some days. She was most lovable as a friend as well as a

mistress."[64] About the same time, he was writing with similar self-satisfaction about a flagellant brothel to which he had been introduced, and so it seems that his masochistic obsession survived in his habits though not in his poetry.

His epileptiform seizures sometimes occurred painfully in public—one in the British Museum reading room, another at one of Lord Houghton's distinguished breakfast parties. Reports of these episodes, and newspaper gossip about his affair with Adah Menken, sustained the public identification of his private behavior with the themes of *Poems and Ballads*. His new poems, far from diminishing that illusion, merely added fresh grounds for obloquy: he was not only a lascivious sybarite but also a dangerous anarchist. On the other hand, the Reform League took him so seriously as a spokesman for the extreme Left that they invited him to stand as a candidate for Parliament. Though gratified by the attention, he was relieved when Mazzini advised him to conserve his energy for other uses.

Throughout 1868 Swinburne worked with ferocious intensity on his political poems, most of which came out in the *Fortnightly*. "A Watch in the Night" provided a panorama of the dolorous state of Europe, with its slaughtered patriots, venial statesmen, political prisoners and exiles, terrified leaders of church and state; England is dishonorably inert, France is in a dance of death, but Italy and Germany show symptoms of life and strength, and in the last stanza Liberty proclaims that "Night is over and done." "Super Flumina Babylonis" uses biblical language to declare the same faith. A group of four sonnets evoked outraged protests by gloating over a serious illness of Napoleon III.

The poems on religious topics showed Swinburne's change of attitude. He described "Before a Crucifix" as "a democratic poem addressed to the Galilean (Ben Joseph) in a tone of mild and modified hostility which I fear and hope will exasperate his sectaries more than any abuse." The major new pagan poem is not an invocation of a cruel Aphrodite or of a somber Queen of the Underworld, but is an affirmative oration by Hertha, the primitive Germanic Earth Mother, representing her as the Life Force immanent in all nature, which initiated and sustains the whole process

of evolution. The other principal religious poem, the "Hymn of Man," a retort to the Ecumenical Council in session in Rome, is in the same meter as Swinburne's earlier "Hymn to Proserpine," but as a sequel to that lament over the triumph of the "pale Galilean" he now chants a positivist religion of humanity, culminating in a blasphemous perversion of the angels' nativity song in "Glory to Man in the highest! for Man is the master of things." The poem was intended, Swinburne said, "to sing the human triumph over 'things'—the opposing forces of life and nature—and over the God of his own creation, till he attain truth, self-sufficience, and freedom."[65] The poet who had been the first unqualified voice of agony and dejection in Victorian poetry was becoming the most confident evangelist of physical, social, and spiritual progress.

The poet was uncomfortably aware of the change in his tone. He felt certain that "Hertha" was his masterpiece, terming it "the poem I think which if I were to die tonight I should choose to be represented and judged by. . . . It has the most in it of my deliberate thought and personal feeling or faith, and I think it as good in execution and impulse of expression as the best of my others." After pointing out that he had "made the All-Mother a good republican" who says, "I have need of you free / As your mouths of mine air: / That my heart may grow greater within me, beholding the fruits of me fair," he added anxiously, "This much I think may be reasonably supposed and said, without incurring the (to me) most hateful charge of optimism, a creed which I despise as much as ever did Voltaire."[66]

Alongside of "Hertha," the poem that he ranked highest was "The Eve of Revolution," a massive formal ode which he described as "the centre poem and mainspring" of his forthcoming volume: "I never worked so hard at perfecting a poem into which I had put so much heart."[67] Other important pieces included a choral "litany of Nations," which reiterated the international survey of "A Watch in the Night," and "Quia Multum Amavit," which damned the degradation of France on the eighteenth anniversary of the coup d'etat that established the Second Empire. A year later, in September 1870, the downfall of Napoleon III aroused Swinburne to such an ecstasy that he composed an elaborate Pindaric "Ode on the Proclamation of the French Republic,"

running to three hundred lines, which was completed within two days and sent off immediately to be printed as a pamphlet, since it was too topical to be held for the new book.

As a title for the volume, Mazzini's suggestion of "Songs of the Crusade" was discarded because of its Christian connotation, and "Songs of the Republic" seemed "presumptuous for any man but Hugo."[68] The title finally chosen, *Songs Before Sunrise*, was typical of Swinburne in its alliteration and symbolism. The forty poems were diatribes against monarchy and autocracy in government, priestcraft and theism in religion, often assailing both at once, since Swinburne regarded them as interchangeable phenomena. All the poems were intoned on an elevated level of ornate rhetoric and Old Testament solemnity. Swinburne actually felt faint stirrings of doubt about the style; he asked William Rossetti to read the manuscript and point out "any tendency (difficult to avoid where one wants and tries to be practical, but damnable to indulge) to the 'didactic-declamatory'—*the* stumbling block, in this way of work—to all men—even Hugo."[69]

When *Songs Before Sunrise* was published, early in 1871, while England was still horrified by the triumph of the French Communards, it evoked predictable accusations of blasphemy, atheism, and Red republicanism. Reviews in several influential periodicals, however, praised Swinburne's "pure poetic gift," sublimity, and devotion to the ideal of liberty. On a visit to Jowett at Oxford, he reported that he was "happy to note a steady progress in the University of sound and thorough Republican feeling.... Under these circumstances I find my position and influence properly recognized— 'which is also very soothing.' "[70]

Following the publication of *Songs Before Sunrise*, Swinburne's poetic vigor was seriously diminished; the harsh realities of history were nullifying his political idealism. Though Napoleon III had been deposed, the new French republic was not proving to be much of an improvement. The temporal power of the pope was terminated and Italy became a united nation, but under a monarchy that was far from liberal. Mazzini died in 1872, worn out and disillusioned. Little incentive remained for a poetic herald of liberty and pagan rationalism.

Nor could Swinburne resume his earlier dedication to aestheti-

cism and fleshly indulgence, since it had been nourished on the Pre-Raphaelite faith, and his association with his former comrades had virtually ended. He had seen little of Morris for several years, and after providing a eulogistic review of *The Life and Death of Jason* in 1867 he began to comment sarcastically on the bulk and stolidity of the subsequent poems. In spite of Rossetti's ill health and psychological withdrawal, Swinburne had continued to feel fond of him: he warmly encouraged the exhuming and printing of Rossetti's poems, and welcomed the volume with a long and worshipful review, which embarrassed the poet by its extravagance. Nevertheless, for some unexplained reason, after 1872 the two poets never saw each other or corresponded again. Buchanan's vicious essay on "The Fleshly School of Poetry" had been aimed as much at Swinburne as at Rossetti, and its devastating effect on Rossetti's psychoses may have induced a suspicion that Swinburne was becoming one of his enemies. On the other hand, Swinburne continued to depend on William Rossetti for literary and financial advice, and as recompense was lavish with meticulous scholarly suggestions for his editions of English poets.

His health and habits continued to deteriorate. On summer holidays he could still enjoy mountain climbing and long swims in cold water, but whenever he returned to his London lodgings he lapsed into dissipation. He was shocked and infuriated when —after several years of complaints and warnings—he was expelled from the Arts Club for disorderly behavior, such as damaging tableware and screaming curses at waiters. At intervals his worried father had to track him down in his haunts and take him away to their country house for recuperation.

Nothing, however, could curb his zeal for writing. In the almost forty years that remained of his life, he produced by far the larger bulk of his total literary output, including a number of his most beautiful poems. His mastery of technique in versification and language remained unimpaired, but the demonic fire had gone out, and he added nothing essentially fresh.

Before *Songs Before Sunrise* even went to press, Swinburne was projecting two ambitious poems. He explored all the medieval versions of the Tristram story in the hope of countering Tenny-

son's modernization: "I want my version to be based on notorious facts, and to be acceptable for its orthodoxy and fidelity to the dear old story: so that Tristram may not be mistaken for his late Royal Highness the Duke of Kent, or Iseult for Queen Charlotte, or Palomydes for Mr. Gladstone."[71] At the same time he was analyzing "all the events and situations of Mary Stuart's life from Rizzio's murder to her flight into England," and reported himself to be "choked and stifled with the excessive wealth of splendid subjects and dramatic effects. But something I must carve or weave out of them."[72]

Also he was becoming deeply committed to writing critical prose, both controversial and scholarly. Buchanan's attacks, along with the other abuse from reviewers, provoked him to publish *Under the Microscope* (1872), a piece of sustained invective unrivaled since the Marprelate controversy of Elizabethan times. In paragraphs that sometimes run for several pages without a stop for breath, he poured contempt and scurrility on all his adversaries. Ranging over recent critical controversies about Byron, Tennyson, and Whitman, he scattered exaggerated but often perceptive praise and blame in the intervals of tormenting Buchanan, Alfred Austin, and other "insects."

In 1872 a new acquaintance unobtrusively appeared in his ambience, and soon began to provide much-needed practical help. Walter Theodore Watts was a provincial solicitor whose bland and sensible demeanor masked a romantic longing to be a poet and a consuming eagerness for intimacy with famous authors. On a visit to London he became acquainted with Rossetti and proved to be a useful source of financial and legal advice. Before long he shifted his practice to London and devoted much of his time to helping his literary friends. After a while he took rooms a few doors from Swinburne's lodgings. Swinburne was morbidly suspicious of strangers and fiercely antagonistic toward anyone who seemed to be trying to control him; but Watts was discreet, and within a few months the poet was regarding him with trust and affection and depending on him in his entanglements with publishers.

In 1874 Swinburne brought out *Bothwell*, a mammoth drama

in sixty scenes, with sixty-two characters, which expanded the portrayal of Mary Queen of Scots as the archetypal femme fatale already established in *Chastelard*. Dedicating the book to Hugo with a sonnet in French, Swinburne described it as "Mon drame épique et plein de tumulte et de flamme." While he was in the midst of writing it he admitted that it would be "the biggest I fear in the language. But . . . I find that to cast into dramatic mould the events of those eighteen months it is necessary to omit no detail, drop no link in the chain, if the work is to be either dramatically coherent or historically intelligible."[73] Apparently the scholar was beginning to take precedence over the poet.

His Elizabethan studies bore fruit the next year in a monograph about George Chapman, an author whose massive tragedies and fluent epic translations had something in common with Swinburne's own work. A few months afterward a volume of *Essays and Studies* brought together a group of articles which demonstrated the breadth of his literary appreciation, the eloquence of his enthusiasm, and the mordancy of his scorn. In the same year, 1875, he published his second book of political poems, *Songs of Two Nations*. The two major poems, "A Song of Italy" and "Ode on the Proclamation of the French Republic," had first come out several years earlier. The rest of the book consisted of twenty-four sonnets, classified as "Dirae" (Curses); and though the poet's passionate concern is as intense as ever, the poems suffer from being too close to current events that no longer seem vital. The bitterest, "The Descent into Hell," jubilating over the death of Napoleon III and culminating with "The dog is dead," gives merely an impression of bad taste. Wrath, no matter how righteous, is a monotonous emotion for poetry.

The next year brought a second classical tragedy, *Erechtheus*. Written under the relentless eye of Benjamin Jowett, it is a reconstruction of a lost drama by Euripides, but conforming faithfully to the simple structural principles of Aeschylus. Being closer to the ancient models than *Atalanta*, it won praise from classical scholars for its dignity and restraint; but the subject is less familiar to the general reader, and the poetry lacks the color and energy and rebellious fatalism of the previous play. More in the tone of

Songs Before Sunrise, it celebrates heroic self-sacrifice in the cause of freedom.

One of Swinburne's idiosyncracies was an enthusiasm for contemporary novels; among literary scholars he was almost the first to regard them as worthy of serious critical attention, as represented by a book in 1877, *A Note on Charlotte Brontë*. In the same year his own novel, *A Year's Letters*, belatedly and pseudonymously ("by Mrs. Horace Manners") appeared in print as a serial in a fashionable magazine, the *Tatler*. Apparently no reader or critic perceived in it the element of sexual perversion that has been detected by some of Swinburne's recent biographers.

At this time the death of his father led to the dispersal of the family residence which had always been his refuge in extremities. Not long before, he had been barred from the privileges of the British Museum reading room, a serious handicap to his scholarly research. Under the inconspicuous influence of Watts he was beginning to question some of his radical tenets and to deplore the vagaries of such former intimates as Howell and Simeon Solomon; but his way of life was more debilitating than ever. He sometimes spent weeks at a time in bed in a state of torpor, incapable of looking after his affairs and beset by money troubles.

In these unpropitious circumstances, the second series of *Poems and Ballads* came out in 1878. Though it contains several poems that deservedly rank with his best, the overall impression betrays the decline of poetic power that had occurred during the decade since its predecessor. There are a number of charming scenic pieces that are as innocuous as anything by Wordsworth. Nostalgia for happy youthful days in the Isle of Wight lends a poignant charm to "A Forsaken Garden," but it has none of the passionate frustration of "The Triumph of Time." "At a Month's End," describing a belated last encounter between former lovers, seems to combine memories of that cryptic love story with details more pertinent to Swinburne's brief affair with Adah Menken, since the woman is addressed as "my sleek black pantheress," who leaves on the speaker "the wild-beast mark of panther fangs," while he identifies himself as "a light white sea-mew." This siren remains a dim wraith when contrasted with Faustine or Dolores.

"A Wasted Vigil" is in the same vein as "A Leave-Taking" in the first series of *Poems and Ballads*—serene acceptance of the fact that last year's love is irrevocably at an end. The tone of gentle melancholy, with natural predominating over human emotions, prevails in "Relics" and "The Year of the Rose." The most persistent and genuine theme in the volume is Swinburne's love of the ocean, as illustrated by "Ex Voto," which (in the meter of Christina Rossetti's "Dream Land") records his wish to be buried at sea.

One of Swinburne's own favorites was "In the Bay," an apotheosis of Marlowe, with subsidiary praise of Webster, Ford, Beaumont and Fletcher, set in a somewhat incongruous frame of a magnificent seascape. This poem indicates plainly the trend of the whole volume away from any pretense of dealing with real life and toward overt identification with literature. The book marks a stage in the process that later engulfed most poets of the last hundred years—abandonment of appealing to general readers and acceptance of an audience of scholarly specialists. "In the Bay" scrupulously avoids mentioning the lauded dramatists by name, and challenges the reader to identify them by the clues referring to their biographies and works.

Symbolic of the change of emphasis is "The Last Oracle," which obviously repeats the theme of "Hymn to Proserpine," being centered upon the same phrase, the Emperor Julian's "Vicisti, Galilaee;" but as an invocation of the God of Poetry, Apollo, it is less moving than the old pagan's mournful farewell to the ancient divinities. It is not a dramatic monologue but a modern writer's hopeful manifesto of a great new age of poetry that is to dawn with the collapse of gloomy Christian dogma. The poem has much in common also with "Hertha," but now the creating and sustaining power of all existence, rather than being a cosmic life force, is identified with poetic imagination and verbal magic.

Perhaps the finest poem in the volume is "Ave Atque Vale," a formal elegy on Baudelaire, in the grand manner of "Adonais." It had been written in 1866, when Swinburne heard a false report of the French poet's death, but of course was withheld from publication, and when Baudelaire did die the next year, the piece

was too late for inclusion in the first *Poems and Ballads*. Appearing now a dozen years afterward, it brought an outburst of the old organ tones into the muted atmosphere of the later poetry. A number of the other pieces are also literary tributes. "Memorial Verses on the Death of Théophile Gautier" is cast in one of Swinburne's elaborations of the *Rubáiyát* stanza; this time the third line of each quatrain provides the rhyme word for the next. Gautier is also the subject of an obituary poem in Latin and two in French. Barry Cornwall, last survivor of the original Romantic coterie, receives a tribute to his ripe old age, followed by a threnody on his death. "Inferiae" is a restrained but sincere elegy on Swinburne's father. A great man of an earlier epoch who is memorialized in Giordano Bruno. Swinburne was showing signs of becoming as exclusively elegiac as Arnold; but to offset the impression there is "A Birth Song" for William Rossetti's daughter.

A symptom of the increasing concern with literature per se is Swinburne's interest in the fixed verse forms of the medieval French and Provençal tradition. In the first series of *Poems and Ballads* there had been two rondels and one simplified imitation of a ballade ("A Ballad of Burdens"), which shirked the most exacting requirement of the form by using a new set of rhyme sounds in each stanza. Rossetti subsequently called attention to Villon by his adaptations of Villon's most famous poem, "The Ballad of Dead Ladies," "His Mother's Advice to Our Lady," and a rondeau, "To Death, of His Lady"; but he too avoided the strict rules. Swinburne now tried his hand at more rigorous conformity in a sestina, a double sestina ("The Complaint of Lisa"), a ballade ("A Ballad of Dreamland") and a laudatory one addressed to Villon himself, "our sad bad glad mad brother," whose blasphemous and antisocial candor was so congenial to Swinburne. He followed it with translations of ten of Villon's poems, which, except for the fact that prudence required the substitution of lines of asterisks for the more obscene passages, were transmitted with great skill.

The few and short new poems on political topics are clues to a mellowing in Swinburne's obsessions. "The Two Leaders," a pair of sonnets extolling John Henry Newman and Thomas

Carlyle, terms them "great and wise, clear-souled and high of heart," even though Swinburne deplores their being still captives "of gods and kings, of shrine and state." The old vituperation survives in "The White Czar," but the occasion of the poem was a contemptuous Russian comment on Queen Victoria's new rank as empress of India. In some embarrassment, Swinburne felt obliged to append a note to his poem, insisting that "the writer will scarcely be suspected of royalism or imperialism; but it seemed to him right that an insult leveled by Muscovite lips at the ruler of England might perhaps be less unfitly than unofficially resented by an Englishman who was also a republican."

The year after this volume was published, the discreet Watts perceived that the time had come for decisive action, if Swinburne's sanity and probably his life were to be salvaged. He took possession of a quiet suburban villa in Putney and, with the authority of Swinburne's mother, installed the poet as nominally his co-tenant but actually his willing captive. About the same time, another barrier supervened between him and the outside world. Deafness had been a hereditary affliction in his family, and within a few years his hearing degenerated to the point where he could not follow general conversation. For the remaining thirty years of his life, he surrendered all control of his affairs and his habits to his protector and devoted himself solely to the congenial activities of poetry and scholarship, shielded from any tension of practical problems.

Biographers and critics have debated acrimoniously over the ethical and aesthetic implications of the arrangement. Some insist that Watts's commonplace mind and orthodox social criteria stifled Swinburne's creative genius. A dispassionate look at the evidence indicates rather that the poet had already completed his span of original power. The vital period of Wordsworth and Coleridge had been even briefer, and one may venture heretically to suggest that Byron and Shelley and Keats might have lapsed into a similar anticlimax if they had lived to threescore-and-ten. Swinburne's volcanic energy had burned itself out in *Atalanta*, *Poems and Ballads I*, and *Songs Before Sunrise*. He had uttered all his infamous frankness about sexual passion, his subversive

doctrines of revolt against monarchies, creeds, and God Himself. The second series of *Poems and Ballads* showed him settling into middle-aged stability as lover of nature, laudator of great writers, and English patriot. Those who deplore Watts's intervention are almost openly conveying their ruthless wish that for Swinburne's reputation's sake it would have been better for him to die at forty, as miserable and psychotic as Rossetti. Thus he would have conformed to the image of *poète maudit* that came to dominate the fin de siècle.

The immediate result of his withdrawal to the placid atmosphere of "The Pines" was not only a prompt restoration of health but also a stupendous increase of publication. In the year 1880 alone he brought out four books. *A Study of Shakespeare* was his second substantial work on Elizabethan drama. *Songs of the Springtides* consisted of four extensive poems, two of which are among his outstanding work. "On the Cliffs" had been written on his final visit to the family's country house, and it is a complex amalgam of personal reminiscences and his sense of identification with Sappho. Recalling his favorite poem of Whitman, "Out of the Cradle Endlessly Rocking," the poem depicts him by the seashore, listening to the song of a nightingale and reviewing his unfulfilled life in a mood of remorseful resignation. As previously in "At a Month's End," he symbolizes himself as a sea-mew, flitting homelessly over the waves. His sense of desolation is pervasive:

> From no loved lips and on no loving breast
> Have I sought ever for such gifts as bring
> Comfort, to stay the secret soul with sleep,
> Rathe fruit of hopes and fears,
> I have made not mine; the best of all my days
> Have been as those fair fruitless summer strays,
> Those water-waifs that but the sea-wind steers,
> Flakes of glad foam or flowers on footless ways
> That take the wind in season and the sun,
> And when the wind wills is their season done.

There is less of bitter regret in "Thalassius," another autobiographical poem, which follows the model of Shelley's *Epipsy-*

chidion in giving a summary of the poet's life through a series of symbols. As usual, the dominant image is the ocean, and Swinburne, child of the sea, recounts his spiritual development during his youthful vacations in Northumberland. The mood of resignation implies that his submission to Watts has led him to recognize and accept the fading of his creative energy.

The third poem in the book, "The Garden of Cymodoce," records a summer holiday in the Island of Sark, and is more intricate in structure than the other two, following an elaborate pattern of interweaving two types of ode, the irregular and the Pindaric. Finally, there is yet another paean to Victor Hugo, this time an ode on the occasion of his seventy-eighth birthday. Perversely ingenious, Swinburne alluded to every one of Hugo's numerous books, without naming any, so that he felt obliged to append a bibliographical list of the forty-six titles.

At the end of the same year came *Studies in Song*, a title conveying an unwonted hint of modesty. Half of the volume is occupied with a gigantic "Song for the Centenary of Walter Savage Landor," again supplied with scholarly notes to identify the allusions. Carried away by his devotion to the defiant poet, he was unconscious of his prolixity, reporting to Edmund Gosse that "it sums up what I have to say of my great old friend on all accounts, whether critical or personal—and I know how much he would have preferred to have it said in verse. . . . But the limit of eight hundred lines is pitifully narrow for such a Titanic charge as the panegyric of such a Titan."[74] He seems to be half-consciously aware that he would have been wiser to write one of his eloquent prose essays. The book contained also three extended landscape poems, "Off Shore," "Evening on the Broads," and "By the North Sea," all displaying his usual rhetorical skill but none introducing anything new in either theme or meter. The shorter poems included a vituperative attack on the Czar of Russia, who by this time had replaced Louis Napoleon as Swinburne's most loathed tyrant. Though the book showed no decline in technical ability, critics and public alike were growing tired of his verbosity, and he was disappointed by its lack of success.

To modern tastes, probably the most attractive of the volumes

of 1880 is *The Heptalogia; or, The Seven against Sense.* One of his remarkable traits had always been his genius for parody; it was a concomitant of his linguistic gift and his verbal resourcefulness. Many of his wittiest burlesques were too lewd for submission to the Victorian public, but in *The Heptalogia* he collected seven of the most ingenious and yet printable that he had composed over the preceding years. The didactic solemnity of Tennyson, the cacophonies of Browning, the lush fluency of Mrs. Browning, the sentimental trivialities of Coventry Patmore, the flaccid platitudes of "Owen Meredith," the concentrated intensity of a Rossetti sonnet—each is magnified with diabolical accuracy; but distinctly the best is the seventh, "Nephelidia," in which Swinburne reproduces his own traits of theme, meter, and language with just the degree of exaggeration that renders them hilariously comic. The ability to laugh at himself was one of his most ingratiating characteristics.

Parody is a legitimate and often effective form of criticism, and a poet ought to be ready to endure the test or even to appreciate the attention. By publishing the book anonymously, however, Swinburne revealed his awareness that feelings might be hurt, and several of his victims were undoubtedly annoyed. In particular, the paranoiac Rossetti took this as the final evidence of Swinburne's malignity.

In 1881 Swinburne completed his dramatic trilogy on Scottish history with *Mary Stuart.* Less than half the length of *Bothwell,* it depicts the last months of the queen's life. Avoiding the familiar melodramatic confrontation between Mary and Elizabeth, Swinburne remains consistent with the previous plays in emphasizing her final love affair, with Anthony Babington, which motivated the conspiracy that led to her execution. To link this climax with the beginning of the trilogy, Swinburne invented an episode in which the lady-in-waiting, Mary Beaton, is so infuriated with the queen for forgetting Chastelard that she seals her doom by giving the English authorities a crucial document. Queen Mary dies as she lived, imperious, vengeful, and still sexually fascinating. Far from reprehending her for these ruthless traits, Swinburne characteristically sympathizes with her.

Within the next months he completed another ambitious work, "Tristram of Lyonesse," which had been started a dozen years before, when he wrote a prelude of 258 lines, only to leave it suspended during his periods of lethargy. The theme, in fact, had haunted him ever since his callow undergraduate effort, "Queen Yseult." Though the public was familiar with the story through the treatments by Arnold, Tennyson, and Wagner, Swinburne felt that none had done justice to the erotic intensity of the tragedy. Indeed, his immediate incentive for beginning to write it was contempt for *Idylls of the King.* As he reported to Rossetti at that time: "My first sustained attempt at a poetic narrative may not be as good as Gudrun [in Morris's *Earthly Paradise*]—but if it doesn't lick the Morte d'Albert I hope I may not die without extreme unction."[75] Both the prelude and the epilogue contain some of Swinburne's most moving poetry, and the nine cantos display other fine passages, but he was obliged to recognize that the narrative structure was not firmly sustained and that it was less an epic than "a succession of dramatic scenes and pictures with descriptive settings or backgrounds."[76]

As Watts feared that the explicit eroticism of the poem might revive old accusations of lasciviousness, he advised Swinburne not to publish it separately but to make up a stout volume by including twenty-one sonnets on Elizabethan dramatists, twelve mild ditties about children, and other miscellaneous pieces. Of this incongruous mixture, the poet wrote wryly to Lord Houghton: "*If* the British Matron can get over two Cantos (the 2nd and 4th) of my *Tristram*, I expect the Mothers of England to rally round a book containing forty-five 'songs of innocence'—lyrics on infancy and childhood."[77] The critics, however, were not mollified. Watts, who was now chief reviewer of poetry for the *Athenaeum*, loyally praised "the heroic splendour of the erotic passages,"[88] but the other journals condemned it as a tale of "low intrigue," full of "sensual appetite" and "eloquent blasphemy."

Two eminent poets expressed their opinions, less publicly and perhaps not without a trace of rivalry. William Morris, who had said twelve years earlier that his "soul yearned" to write a poem on this topic, observed in regard to Swinburne's book: "I have

made two or three attempts to read it, but have failed, not being in the mood, I suppose: nothing would lay hold of me at all. This is doubtless my own fault, since it certainly did seem very fine. But, to confess and be hanged, you know I never could really sympathize with Swinburne's work; it always seemed to me to be founded on literature, not on nature.... Now I believe that Swinburne's sympathy with literature is most genuine and complete; and it is a pleasure to hear him talk about it, which he does in the best vein possible."[79] Matthew Arnold's comment was more succinct: "Swinburne's fatal habit of using one hundred words where one would suffice always offends me, and I have not yet faced his poem, but I must try it soon."[80] When Arnold's letters were subsequently published, this remark served to crystallize Swinburne's previously ambivalent view of him; at the next opportunity he characterized Arnold as "a man whose main achievement in creative literature was to make himself by painful painstaking into a sort of pseudo-Wordsworth."[81]

Among the shorter poems in the *Tristram* volume there were inevitably a eulogy on Hugo, several invectives against Russia, the pope, and other autocrats, and a number of necrological or otherwise commemorative pieces. The most noteworthy, perhaps, is "A Death on Easter Day," in which, still loyal in spite of estrangement, Swinburne pays his final tribute to Rossetti:

> Albeit the bright sweet mothlike wings be furled,
> Hope sees, past all division and defection,
> And higher than swims the mist of human breath,
> The soul most radiant once in all the world
> Requickened to regenerate resurrection
> Out of the likeness of the shadow of death.

As Swinburne severed his personal ties he devoted himself more and more to scholarly studies. His literary articles in the *Fortnightly* and other periodicals were later assembled in various volumes. His penchant for controversy was satisfied by a prolonged and ludicrous verbal battle over technicalities in Shakespeare's prosody with F. J. Furnivall, whose temper was as intractable as Swinburne's own. The two pundits strove to outdo each other in

vituperation. A more respectable product of Swinburne's study was the sonnets on the dramatists, a series of vignette critical essays adeptly condensed into verse.

His preference for the sonnet form was enforcing a salutary discipline on his verbosity, and the restricted Old French forms were even more demanding. His next volume, *A Century of Roundels* (affectionately dedicated to Christina Rossetti), was a tour de force in this respect. Though he handles the nine lines and two refrains with unfailing charm and dexterity, the artificiality of the pattern is bound to become tedious when a hundred specimens are printed together. It may not be fanciful to suggest that Swinburne's submission to such restriction of form was a symptom of his new conventionality of mood.

A Midsummer Holiday and Other Poems (1884) covered the familiar ground again. Ecstatic descriptions of maritime scenery and fulsome praises of small children are mingled with sarcastic scorn for reactionary politicians and particularly for the House of Lords, which had just rejected a proposed reform bill.

Swinburne's next two poetical publications were dramas. *Marino Faliero* naturally challenges comparison with Byron's tragedy on the same subject. Swinburne's former admiration of Byron had changed to disfavor, and in his opinion the dramatic technique in Byron's play was gravely defective. Where Byron had condensed the whole action into the events of a single climactic day, Swinburne went more deeply into motivation. He presented the themes of freedom and human dignity with lyrical and rhetorical beauty, and manipulated them so as to forecast the future triumph of Italian nationalism. In the other tragedy, *Locrine*, based upon the same legend of ancient Britain that Milton used in *Comus*, he tried an experiment of abandoning blank verse in favor of a variety of rhymed meters; the ten scenes are in nine different stanza forms, with a result more ingenious than dramatic.

Swinburne's loss of enthusiasm for his former heroes was not confined to Byron. An essay of 1887, "Whitmania," is often unfairly cited as a horrifying instance of his apostasy, under Watts's control, to all his previous radical ideals. From the beginning, his delight in Whitman's best poetry had been mingled with repre-

hension of his disregard for form and his frequent prosiness. The admiration for his political independence and his candor about sex had been intensified by a crusading impulse to vindicate the American poet against unjust neglect and vilification. By the eighties, the situation was reversed: Whitman had become the vogue among the intelligentsia, and one of his devotees, ironically enough, was Robert Buchanan. Swinburne could not resist the opportunity to embarrass his old adversary by emphasizing the "fleshly" element in *Leaves of Grass.* The article was concerned with ridiculing the "Johnny-come-latelies" who were now Whitman's self-elected evangelists; but with his customary intemperance of language he included some vivid and richly comic metaphors to characterize Whitman's manifest defects. In another exaggerated article, "Mr. Whistler's Lecture on Art," he abjured the gospel of aestheticism.

A further instance of his modified attitude was his treatment of the English government. Always a devoted lover of his native scenery and history, he had vilified the royal family simply because he loathed all monarchies. Gradually, he came to share the public affection for Queen Victoria. In a sonnet of 1882, giving thanks for her escape from an assassin, he said that "No braver soul drew bright and queenly breath / Since England wept upon Elizabeth." By 1887, he was ready to celebrate her golden jubilee in a long poem, "The Commonweal," and the next year the tercentenary of the Spanish Armada inspired him to compose a major patriotic ode. In national affairs, he despised Gladstone's foreign policy and his proposal of Home Rule for Ireland (Swinburne's ideals of liberty were feebler than his anti-Catholicism). The Franco-Russian agreement and the growing power of Germany filled him with anxiety about foreign aggression. All these forces turned him into a vociferous imperialist just when his old comrade Morris became a violent revolutionary.

Most of the poems in the third series of *Poems and Ballads* (1889) were in the all too familiar styles, but one group represented a facet of Swinburne's talent that had not previously gained much notice. Ever since his childhood visits in Northumberland he had been fascinated by the folk ballads of the Border

region and had composed imitations of them. Rossetti and Morris shared this enthusiasm, and at the time of Meredith's brief intimacy with the group he too had been collecting specimens. While often using the technical devices of folk ballads, both Rossetti and Morris subjected them to sophisticated elaboration; paradoxically it was Swinburne, the most literary and mannered of the three, who proved able to reproduce with unique fidelity the stark simplicity and taciturn grimness of the authentic ballads. He included five of them in the first series of *Poems and Ballads*, but they were ignored in the furor over the erotic pieces. Two were adaptations of Continental ballads (one Breton, one Finnish); and of the other three, two showed something of the Rossetti-Morris artifices. "After Death," however, had the full gnomic impact of the primitive ballads. Now, in the third series of *Poems and Ballads*, of nine further examples of the genre only one ("The Weary Wedding") is tainted with echoes of "Sister Helen"; the others are probably the nearest approach to the genuine folk tone ever achieved by a modern poet. Swinburne's knack of parody was thus turned to serious effect.

His next play, *The Sisters*, was an ill-advised attempt to write poetic tragedy in a modern setting and with conversational diction; it is of some biographical interest because (as in *A Year's Letters* and *Lesbia Brandon*) the hero is an idealized self-portrait. His death at the hands of a jealous woman who loves him in vain might be read by psychoanalytic critics as symbolizing Swinburne's loss of poetic vitality.

In 1894 came *Astrophel and Other Poems*, dedicated to William Morris in a poem extolling his reconstructions of the heroic past:

> The wars and the woes and the glories
> That quicken and lighten and rain
> From the clouds of its chronicled stories,
> The passion, the pride, and the pain,
> Whose echoes were mute and the token
> Was lost of the spells that they spake
> Rise bright at your bidding, unbroken
> Of ages that break.

The principal poem in the book was an ode in praise of Sir Philip Sidney, and there were the customary elegies—on Tennyson,

Browning, William Bell Scott, Richard Burton, Philip Bourke Marston, and others. Several poems record dreams or trances: "An Autumn Vision," "A Swimmer's Dream," and particularly "A Nympholept," a strange and disturbing visionary experience of confrontation with elemental force as personified in the god Pan. With Titanic dignity reminiscent of Keats's *Hyperion*, the poem conveys the terror and fascination of man's attempt to comprehend the infinite power of nature. In this poem and two or three other late ones Swinburne showed signs of becoming a genuine philosophic poet, transmuting the rhetoric of "Hertha" and "Hymn of Man" into imaginative vision.

The *Astrophel* volume was acclaimed by the reviewers, who reluctantly admitted that since Tennyson's death Swinburne was the greatest living English poet. Only the surviving stigma of his former sexual and political perversities prevented his appointment as poet laureate.

In another Arthurian story, *The Tale of Balin* (1896), he continued to flaunt his rivalry with Tennyson, though he employed a tetrameter nine-line stanza form, adapted from the early "Lady of Shalott," rather than the pentameter of the *Idylls*. This type of "tail-rhyming" stanza reproduces the tempo of the medieval metrical romances instead of the epic movement of blank verse. William Morris had been exasperated by Tennyson's moralizing version of the tale and had thought of retelling it in his own more primitive manner, but he became absorbed in his Norse sagas, and now twenty years later Swinburne carried out the project. The setting is Northumberland, which was coming to figure more and more in Swinburne's poetry as his aging memory dwelt on the most vigorous interludes of his boyhood. Apart from the picturesque landscape passages, he followed Malory's version of the story with utmost fidelity, even to the extent of verbal borrowing. As in his folk ballads, his normally ornate style gave place to directness of action and an austere fatalism of attitude.

The attempt at stark vigor was repeated in a historical tragedy, *Rosamund, Queen of the Lombards*—not to be confused with his early *Rosamond*. He strives hard to convey the barbaric horror of the legend but does not quite achieve the requisite climax of savagery.

Swinburne's final volume of short poems, *A Channel Passage and Other Poems* (1904) was dedicated to the memory of Morris and Burne-Jones in another nostalgic poem about their youthful days "When seasons were lustrous as laughter / Of waves that are snowshine and gold." In old age he retained his capacity for hero-worship, and his Pre-Raphaelite comrades were assuming high rank in his pantheon as he realized that he was the last survivor. "A New Year's Eve," memorializing Christina Rossetti, not only records how her fresh, sweet poetry used to "uplift us, a spell-struck throng, / From dream to vision of life," but goes so far as to accept tentatively the possibility of the soul's survival after death. The title poem is also reminiscent, describing a stormy voyage that occurred half a century earlier. The longest poem in the book, "The Altar of Righteousness," is an ambitious survey of mankind's spiritual development, insisting on the eternal permanence of the moral order, whether its teaching be conveyed by religious leaders like Christ and Mahomet, or poets like Aeschylus and Shakespeare, or a mystical philosopher like his favorite Giordano Bruno. While still loyal to the Positivist "religion of humanity," he now accepts theism as one of its manifestations.

At this juncture a sense of finality in his career was conveyed by the issue of his *Collected Poems* in six volumes, with a long dedicatory essay that provides his retrospective explanations and judgments on his work. The next year his novel, *A Year's Letters*, finally came out in book form, retitled *Love's Cross Currents*. Even more symptomatic of an approaching end, his last dramatic piece, *The Duke of Gandia*, published in 1908, had been in manuscript since 1882, as it was only an episode for a proposed tragedy on Lucrezia Borgia, who had fascinated him for fifty years.

For many years Swinburne's life had been confined to an unchanging routine in his study and his daily two-hour walk on Putney Common. His last summer excursion to the seaside was in 1904. Scarcely any visitors were admitted to hear him discourse on literature and to see his precious quartos. After a bout of pneumonia in 1903 his health declined, and on 10 April 1909 he died of influenza. With a final display of his old defiance, he stipulated that the Christian burial service must not be read over his grave.

The last of his former associates, Meredith, wrote to Watts: "Song was his natural voice. He was the greatest of our lyric poets—of the world, I could say, considering what a language he had to wield. . . . I feel the loss of him as part of our life torn away."[82] Meredith himself died just a month later.

Swinburne's poetic record is a monument of contradictions. He was a radical by conviction but a traditionalist in methods .He wrote emotional lyrics but also intellectual versified essays. A highly subjective poet, he persistently preferred the objective genre of drama. He introduced the concept of "art for art's sake" into England, yet in most of his poetry art is the handmaid of doctrine. All this means that he was a product of his era, the high Victorian generation of conflicting impulses and diversified concerns.

If any consistent trait can be attributed to his poetry, it is the Pre-Raphaelite. This is not to say that he conformed to some abstract norm of "the Pre-Raphaelite poet." Nevertheless, it is obvious that his first undergraduate poetry was imitative of Morris, and that he resumed echoing Morris as late as *The Tale of Balin*. The permanently shaping influence, however, was Rossetti's, even though it came to be overlaid with others. Rossetti shaped Swinburne into a poet of erotic agony and ecstasy; Mazzini transformed him into the laureate of revolution; Watts finally remodeled him as a spokesman of patriotism, the beauty of nature, and the domestic virtues. Incompatible though they seem, the three identities were all inherent in Swinburne from the outset. Chameleon-like, he adopted the hue of his environment, but all the colors were his own.

As far as poetic technique was concerned, the first of the influences predominated. Swinburne's metrical and verbal methods changed scarcely at all during his career, and resemblances to Rossetti's poetry can be perceived throughout. Nevertheless, the total effect is profoundly different. Rossetti was intensive while Swinburne was extensive. Rossetti laboriously revised, condensed, and polished; Swinburne let the melodious words pour out in a gleaming torrent. The basic difference is that Rossetti was primarily a painter, seeing everything in precise pictorial detail,

whereas Swinburne's visual sense was rudimentary. Feeble physical coordination made it hard for him to write, let alone draw, and so the habit of observation was never developed. His descriptions of specific landscapes convey mood instead of picture.

VII. PERIPHERY

A center of energy as potent as the Pre-Raphaelite movement was bound to attract satellites into its magnetic field. Few poets in the second half of the nineteenth century were totally unaffected, as a cursory survey will suffice to indicate. The established seniors, Tennyson and Browning, grateful for the admiration that the young artists and poets bestowed on them, showed keen interest, and soon were on friendly terms with members of the group; but it would be hard to prove that their poetry was affected in any tangible way by the new influences. The most significant adherents can be considered in three categories: minor poets who found their identity solely through devoting themselves to the movement; poets of greater originality who were temporarily affiliated in some definable respect; and younger writers who inherited the influence and practiced or modified the Pre-Raphaelite traits in the next generation.

It will be convenient to begin with the Pre-Raphaelite Brotherhood itself. With the establishment of the *Germ*, Dante Gabriel Rossetti gave notice to his coterie that they were expected to wield the pen as well as the brush. Even Madox Brown contributed a sonnet. Since Rossetti's brother, William Michael (1829–1919), who showed little promise as a painter, had presumably

been recruited mainly to complete the mystic seven, he felt the poetic responsibility strongly. The cover of the *Germ* bore a sonnet of his, modestly emphasizing the priority of sincerity in poetry: "Be the theme a point or the whole earth, / Truth is a circle, perfect, great or small." Being the editor, he was obliged to fill up the pages with his own work when more temperamental contributors defaulted. For an illustration of *King Lear*, by Brown, he had to write a poem, "Cordelia." Eight of his brief pieces had originally been composed in the games of *bouts rimés* which were a family pastime of the young Rossettis. In the circumstances, it is astonishing that his contributions were as good as they were. A fairly extensive blank-verse poem, "To the Castle Ramparts," as well as shorter descriptive pieces shows precise observation, and his sonnets are neatly turned; but his diction lacks distinction and his lines move with none of the melody inherent in those of his brother and sister. Not published until twenty years later, his blank-verse poem, "Mrs. Holmes Gray," was his most ambitious effort to practice Pre-Raphaelite realism. Reporting a coroner's inquest, it aroused in Swinburne a mixture of fascination and disappointment. "That idea of yours," he told his friend, "beats everything but Balzac. I can't tell you—not what I think of the poem done— but what I think of the poem feasible. Do write something more in my line and I'll be the first to admit your superiority."[1]

Swinburne might have approved more strongly of one sonnet that came out in the *Germ*, "The Evil under the Sun," a bitter protest against the suppression of the Hungarian insurrection. Long afterward, in 1881, the poet planned to publish this and other expressions of political protest in a volume to be called *Democratic Sonnets*, but his brother took fright at the idea that such subversiveness might cost William his government post, and so the book did not appear until 1907, when the writer was a reverend senior.

With characteristic common sense, he accepted the evidence that his literary talent was not creative. "To be a quasi-poet," he remarked in his *Reminiscences*, "a pleasing poetaster, was never my ambition; I felt that in the long run I should stay outside the arena of verse altogether. And so, after making some few experi-

ments, I did."[2] For fifty years he earned his living in a routine civil service post, and functioned as balance wheel for the erratic family. He published inexhaustibly as an editor of literary texts, a reviewer, and a biographer. After his marriage to a daughter of Ford Madox Brown he was the chief contact point between the artistic and literary wings of the movement, and his industrious documentation provides almost all the basic information about it. After his death at the age of ninety, his daughter, Helen Rossetti Angeli, sustained his record, both in longevity and in literary productivity as chronicler of Pre-Raphaelitism, until 1969.

Among the other members of the Pre-Raphaelite Brotherhood, the one who emulated Dante Gabriel Rossetti in being both artist and poet was Thomas Woolner (1825–92), who was also its only sculptor. An opinionated radical and a devotee of Shelley, he constantly brooded on plans for heroic statuary, but his ambition exceeded his power of execution. Two poems by Woolner, "My Beautiful Lady" and "Of My Lady in Death," were the longest specimens of verse in the first issue of the *Germ*. Able pieces of Pre-Raphaelite decoration, they established the style of archaic naïveté, with short words, lines, and stanzas, that later was picked up in Morris's "Blanche" and Swinburne's "Queen Yseult." The awkward charm of Woolner's diction was apt to verge upon bathos:

> My lady's voice, altho' so very mild,
> Maketh me feel as strong wine would a child;
> My lady's touch, however slight,
> Moves all my senses with its might.
> Like a sudden fright. . . .
>
> Whene'er she moves there are fresh beauties stirred;
> As the sunned bosom of a humming-bird
> At each pant shows some fiery hue,
> Burns gold, intensest green or blue:
> The same, yet ever new. . . .

The use of unpoetical words was so frequent as to seem intentional. It pervades another of his *Germ* contributions, "Emblems":

... Where lay a rotting bird, whose plumes
 Had beat the air in soaring.
 On these things I was poring. ...

On swamps where moped the lonely stork,
 In the silent lapse of time
 Stands a city in its prime. ...

Coventry Patmore "praised Woolner's poems immensely, saying however that they were sometimes slightly over-passionate, and generally 'sculpturesque' in character" (meaning that each stanza was a separate unit).[3]

Woolner's failure to obtain commissions or to sell the statues he exhibited led him to despise the whole bourgeois taste and commercial orientation of his time, and in 1852 he emigrated to Australia, confident of making his fortune in the gold fields. When he found no nuggets he had to support himself meagerly by modeling portrait medallions of newly prosperous citizens, and after two years he returned ignominiously to England. Ironically, it turned out that he had discovered his métier. His medallion likenesses of literary friends became popular, and he began to receive orders for life-sized statues of celebrities. Within a few years, like his former comrade Millais, he was wealthy and was accorded the accolade of artistic respectability—election to the Royal Academy. With his rise in the social scale he abandoned the bohemian Pre-Raphaelites and attached himself to the more distinguished coterie of Tennyson. In 1863 he published a volume, *My Beautiful Lady*, in which his two *Germ* poems of that title, with their haunting echoes of "The Blessed Damozel," were expanded with a dozen other pieces about love and nature and encrusted in a tedious prelude and conclusion in didactic blank verse. Much later, completely under Tennyson's influence, he published several other books of poetry, mainly on mythological subjects: *Pygmalion* (1881), *Silenus* (1884), *Tiresias* (1886). They were as marmoreally lifeless as his statues.

Though never officially a member of the Pre-Raphaelite Brotherhood, the poet-painter who was closest akin to them was William Bell Scott (1811–90). In spite of his aggressive and

jealous disposition, he contrived to retain the affection of Rossetti, Morris, and Swinburne until the end of his life, long after they had drifted apart from each other.

The son of a Scottish artist, he was brought up to worship Blake and formed an ambition to emulate him in both arts. Overshadowed as a painter by a successful elder brother, he took to writing reflective poetry in the model of the eighteenth-century graveyard school until the literary dictators of Edinburgh, Christopher North and Sir Walter Scott, advised him to choose a less pretentious manner. Handsome in physique and dramatic in manner, he was popular in the Edinburgh artistic and literary circle, but made little headway with a career. His first book, *Hades; or, The Transit, and the Progress of Mind,* was published in 1838, shortly before Philip James Bailey's *Festus,* which somewhat resembled it in efforts to versify metaphysical speculation. He spent five years in London, making friends with various writers, and in 1842, when he was thirty-one, he finally had a picture accepted for exhibition at the Royal Academy. The next year he was appointed headmaster of an art school in the commercial city of Newcastle-on-Tyne, which doomed him to exile from intellectual stimulus.

Four years later the young Gabriel Rossetti, reading an obscure magazine, came across two poems by Scott, "A Dream of Love" and "Rosabel," the latter inspired by a prostitute he had known in his Edinburgh days. Perhaps struck by some resemblance to his own "Jenny," Rossetti decided in his usual precipitate way that the poem was the work of an important unrecognized author; and just at that time Scott's next book provided more of his work. *The Year of the World* was another of his tedious allegorical poems, "treating the different forms of religion underlying the periods of time occupied by the civilization of the world," and strongly resembling Shelley's *Prometheus Unbound.* Rossetti, who just at that time obtained a volume of Shelley and "surged through its pages like a flame,"[4] devoured Scott's book ecstatically and wrote him an incoherent letter asking where his other writings could be found. On receiving a guarded reply, he sent Scott a manuscript of his own poetry, and on Scott's next visit

to London he called at the Rossettis' home. The family, and soon
the whole Pre-Raphaelite circle, were impressed by his saturnine
good looks and his gloomy manner; if Lona Mosk Packer's hy-
pothesis is to be accepted, Christina Rossetti promptly fell in love
with him. He was asked to contribute to the *Germ*, and supplied
a long blank-verse poem entitled "Morning Sleep" and a sonnet,
"Early Aspirations." The next year he expressed his appreciation
for the new friendships in a sonnet "To the Artists Called P.R.B.":

> I thank you, brethren in Sincerity—
> One who, within the temperate climes of Art
> From the charmed circle humbly stands apart,
> Scornfully also, with a listless eye
> Watching old marionettes' vitality;
> For you have shown, with youth's brave confidence,
> The honesty of true speech and the sense
> Uniting life with "nature," earth with sky. . . .

This portrayal of himself, at the age of forty, as a disgruntled
outsider is confirmed in his autobiography: "Introspection was
my curse. Action was hated by me; I was an absentee, a somnam-
bule, and gave myself much to subjects no one else cared for. I
had thus a private interest apart from success, and was indeed
possessed of a mystery, as it were. Untiring industry I certainly
had, but it was only to meet the necessities of the hour. That
accomplished, I fell back upon my secret speculations in an ocean
of regrets and tobacco smoke; and on my poetry, which shared
in all the peculiarities of my nature."[5] Here clearly is the pose of
the artist as social exile, which emerged as one of the consequences
of Pre-Raphaelitism and kindred tendencies.

About this time he was producing a series of love poems to a
woman he called "Mignon," whom Mrs. Packer identifies as
Christina Rossetti; the lyrics move with a charming lightness that
contrasts with Scott's usual solemnity. They appeared in his 1854
volume, *Poems of a Painter*, which won some commendation. As
a painter, too, he was encouraged by a commission for a series of
murals depicting episodes in the history of Northumberland for
the castle of Sir Walter and Lady Trevelyan, and, like Ruskin be-
fore him and Swinburne a little later, he fell under Lady Trevel-

yan's spell. These murals, and similar ones illustrating *The King's Quair*, which he made for his later patroness, Alice Boyd, represent his principal work in the Pre-Raphaelite medieval style.

After 1864, when he gave up his art school position, he settled in London, where he saw much of the Rossettis and their circle. He also entertained them as guests during the summer months when he was with Miss Boyd at Penkill. In 1875, when he published his next volume of *Poems*, his dedicatory sonnet expressed his gratitude to Rossetti, Morris, and Swinburne for their encouragement:

> Now many years ago in life's midday,
> I laid the pen aside and rested still,
> Like one bare-footed on a shingly hill:
> Three poets then came past, each young as May,
>
> Year after year, upon their upward way,
> And each one reached his hand out as he passed,
> And over me his friendship's mantle cast,
> And went on singing, everyone his lay.

Scott's poetry is representative of the Pre-Raphaelite rank and file. His descriptive blank-verse pieces are precise and decorative, his ballads have a touch of eerie horror, his sonnets are always shapely, and his love lyrics often convey a real sense of passion. A series of sonnets called "Parted Love," written in 1868–69, though not published until he was in his seventies in *A Poet's Harvest Home* (1882), and possibly recording his feelings for Christina Rossetti, catches something of the Rossettian intensity:

> In vain I wish again within those arms
> To fold thee, once more feel there those shoulders soft
> And solid, but that is no more to be:
> Unless perchance—(*speak low*) beyond all harms
> I may walk with thee in God's other croft,
> When this world shall the darkling mirror be.

The hundred lyrics in the 1882 volume had almost all been written during the preceding few months, a remarkable achievement for a man of his age. He reported to Swinburne that "every one was produced with a spontaneity and energy, quite a new experience

to me. They (for the major part) record, or relate to actual incidents."[6] Mrs. Packer assumes that his impetus came from the publication of Christina Rossetti's *A Pageant and Other Poems*, and particularly from his response to her "Monna Innominata" sonnets. Certainly one of his lyrics, "Once a Rose," was an explicit reply to her "Summer Is Ended."

Quite apart from his putative romance with Christina, Scott played an ambiguous role in the Pre-Raphaelite drama. During the last decade of Rossetti's life he was a favorite whist partner, and the poet always enjoyed his holidays with Scott at Penkill, away from his depressing surroundings in Chelsea; it was on one such visit that Scott and Miss Boyd persuaded him to exhume and publish his poetry. On the other hand, even on these occasions Scott can be blamed for drinking brandy with Rossetti and for disturbing his morbid fancies with superstitious tales.

Scott's *Autobiographical Notes* are among the most candid and vivid sources of first-hand glimpses of the Pre-Raphaelite circle, but the book reveals his egoism, envy, and malice. His death in 1890 had been observed by Swinburne with affectionate "Memorial Verses":

> Poet and painter and friend, thrice dear
> For love of the suns long set, for love
> Of song that sets not with sunset here,
>
> For love of the fervent heart, above
> Their sense who saw not the swift light move
> That filled with sense of the loud sun's lyre
> The thoughts that passion was fain to prove
> In fervent labour of high desire. . . .

The posthumous publication of Scott's recollections, though edited by Swinburne's old friend John Nichol, changed the poet's devotion to fury, particularly because of his unflattering portrayal of Elizabeth Siddal. He branded Scott as "a man whose name would never have been heard, whose verse would never have been read, whose daubs would never have been seen, outside some aesthetic Lilliput of the North, but for his casual and parasitical association with the Trevelyans, the Rossettis, and myself."[7]

A poet of more substance than Scott, Coventry Patmore (1823–96), was another early recruit to the Pre-Raphaelite troop. The son of a minor figure in the "Cockney" literary circle that included Keats, Hunt, Lamb, and Hazlitt, Patmore was brought up in the Romantic tradition of uninhibited self-expression, and readily accepted his family's assumption that he was a genius. He had some thoughts of becoming a painter or a scientist, but his first love affair turned him into a poet. At the age of sixteen, while in Paris to learn French, he was captivated by a coquettish society beauty two years older, and when she ridiculed the youth's adoration he vented his despair in two long ballads which, though derivative, showed remarkable promise. Both are composed in the extended six-line ballad stanza later used memorably by Rossetti in "The Blessed Damozel" and "The Card Dealer." "The River" employs atmospheric suggestion to convey the suicide of a rejected lover who drowns himself on the night of his beloved's wedding to a rich rival. "The Woodman's Daughter," in the Wordsworthian tradition of rustic tragedy, again uses implication (somewhat like "The Thorn") to indicate that a seduced girl drowns her infant.

Two years later he encountered Tennyson's poems and was moved to emulation. In the mood and heptameter of "Locksley Hall" he composed "The Yewberry," a morbid young man's account of how he discovered his sweetheart's liaison with another lover. More closely identified with his disaster in Paris was "Lillian," in which a young woman rejects her suitor because she has been corrupted by reading French literature. He inveighs bitterly against "These literary panders / Of that mighty brothel, France." At this juncture Tennyson's publisher offered to bring out a book of Patmore's poems if he could supply enough material. He hastily terminated "Lillian" and set to work on a longer narrative poem in the same heptameter triplets as "The Yewberry." Based on a story by Boccaccio, it was first called "Sir Hubert" but in later editions became "The Falcon." It is an implausible tale of a baronet whose beloved marries another when he loses his wealth and becomes a farm laborer. He retains only his best falcon, because its eyes remind him of his lost Lady Mabel. After she is

widowed she visits his cottage, and to provide lunch for her he has to kill and broil the bird. Subsequently she convinces him that she now reciprocates his love, and so he acquires not only his longed-for bride but all her husband's property too. The solemn absurdity of the tale exerts a strange sort of guileless charm.

Eked out with a few competent sonnets, the poems sufficed for a slim volume, which was published before Patmore was twenty-one. His ecstatic father escorted him on a round of the literary salons and pleaded for favorable reviews. Browning reported that "a very interesting young poet has blushed into bloom this season,"[8] and Patmore was accorded the rare distinction of a visit to Elizabeth Barrett (before Browning was so privileged). The two-volume edition of her poems came out just at this time, and along with Tennyson she was the most obvious model of Patmore's poetry. Bulwer Lytton gave him both praise and advice: "I honestly ... think the promise you hold out to us is perfectly startling, both from the luxuriance of fancy, and the subtle and reflective inclinations of your intellect. ... As yet you seem to me to lean more towards that class of Poets who are Poets to Poets— not Poets to the Multitude."[9] The aged Leigh Hunt published a laudatory review, as did Dickens's dramatist friend, Thomas Noon Talfourd, who termed the book "a marvellous instance of genius anticipating time."[10] *Blackwood's Magazine*, still rampant after a quarter century of berating the Cockney school, distinguished the innocent little book with a ferocious blast: "This is the life into which the slime of the Keateses [*sic*] and Shelleys of former times has fecundated. ... Nothing is so tenacious as the spawn of frogs. ... His poetry (thank Heaven!) cannot corrupt into anything worse than itself."[11]

Within a year triumph gave place to catastrophe. Patmore's father lost all his money in railway speculation and decamped to France. Untrained in any vocation, the young poet had to set about supporting himself, and during a year of hack writing he barely avoided starvation. Then Monckton Milnes, describing his poetry as "of the highest genius and with the due amount of absurdity which youth demands and excuses,"[12] managed to have him appointed as a junior assistant in the British Museum Library.

On the strength of this meager income he married a penniless orphan girl who shared his literary tastes, and they were blissfully happy. Their tiny house became a meeting place for such paladins as Tennyson, Browning, Carlyle, and Ruskin. Meanwhile, Leigh Hunt's review had brought Patmore's book to the attention of the omnivorous Rossetti; he and his brother "read and re-read it . . . and delighted in it much."[13]

When his Cyclographic Society, precursor of the Pre-Raphaelite Brotherhood, in 1848 made a "List of Immortals," Patmore's name received one star, along with Tennyson and Mrs. Browning (her husband was honored with two, equaling Homer, Dante, and Chaucer). It was natural for Rossetti to be so moved by the lush romanticism of Patmore's poetry that he ignored its immaturity and extravagance. Especially it appealed to him by its insistence on the absolute priority of love before all other concerns. In one of the sonnets Patmore had declared, "At nine years old I was Love's willing Page; / Poets love earlier than other men." In "Sir Hubert" he said of "Love's brand":

> For ever and for ever we are lighted by the light:

> And ere there be extinguish'd one minutest flame, love-fann'd,
> The Pyramids of Egypt shall have no place in the land,
> But as a nameless portion of its ever-shifting sand.

Patmore's naïve sexuality was fully congenial to Rossetti. The specific detail in the poems' settings was also consistent with Pre-Raphaelite realism.

At one of the discussion sessions of the Pre-Raphaelite Brotherhood, Rossetti recited "The Woodman's Daughter" so movingly that Woolner was delegated to ask the author whether a copy of his book was available. When they met, Woolner showed Patmore some of his manuscripts, and a warm friendship ensued. Within a year Woolner was busy making medallions of the Patmore couple. Finally, late in 1849, Patmore attended a meeting of the brotherhood, and was gratified by their adulation. Soon they were assembling at his house as often as in their studios, and through him they first met some of the leading writers whom they most admired, notably Tennyson. To the *Germ* Patmore con-

tributed an essay on *Macbeth* and two short poems: a graceful lyric, "The Seasons," and a pleasant conversation piece, "Stars and Moon."

For the next year or two he seemed to be almost their literary mentor. Millais painted Mrs. Patmore's portrait and also a picture illustrating "The Woodman's Daughter," which he exhibited at the Royal Academy in 1851. When the *Times* virulently condemned Millais's canvases, it was Patmore who persuaded his friend Ruskin to come to the defense, and thus turned the critical tide in favor of the brethren. Looking back in old age, Patmore summed up those exciting days: "I was intimate with the Pre-Raphaelites when we were little more than boys together. They were all very simple, pure-minded, ignorant and confident." [14]

In his next book, *Tamerton Church Tower and Other Poems* (1853), the title piece is a strangely desultory performance. Written in the simplest ballad meter and the plainest of colloquial diction, it is mainly a leisurely account of rides back and forth across Cornwall and Devon, with extensive descriptions of summer weather. Imbedded in the middle of it is a concise page or two of action, in which the narrator falls in love, marries, and loses his bride by drowning when they are caught in a squall while rowing in the bay. Among the other poems, the most remarkable is "A London Fête," a chillingly callous depiction of a public execution. In view of Patmore's major concern, however, the significant pieces are "Honoria: Lady's Praise" and "Felix: Love's Apology," for they were brief samples extracted from a large project that he had been working on for several years.

During his engagement he had written to his fiancée, "I have been meditating a poem for you, but I am determined not to give you anything I write unless it is the best thing I have written." [15] After their marriage, he formulated a theory of Nuptial Love as a sublimation of erotic passion into aesthetic beauty, and he decided that no previous poet had done justice to the topic:

> I, meditating much and long
> What I should sing, how win a name,
> Considering well what theme unsung,
> What reason worth the cost of rhyme,

Remains to loose the poet's tongue
 In these last days, the dregs of time,
Learn that to me, though born so late,
 There does, beyond desert, befall
(May my great fortune make me great!)
 The first of themes, sung last of all.

In high excitement over his resolve, he hurried to tell his poet friend Aubrey de Vere about this great theme,

the more serious importance of which had been singularly missed by most poets of all countries, frequently as they had taken its name in vain. That theme was Love: not a mere caprice of fancy, or Love as, at best, a mere imaginative Passion—but Love in the deeper and softer sense of the word. The Syren woman had been much sung. . . . But that Love in which, as he affirmed, all the Loves centre, and that Woman who is the rightful sustainer of them all, the Inspiration of Youth, and the Consolation of Age—that Love and that Woman, he asserted, had seldom been sung sincerely and effectually.[16]

In March 1850, William Rossetti reported that Patmore "has been occupied the last month with his poem on Marriage, of which, however, he has not meanwhile written a line; but, having meditated the matter, is now about to do so. He expresses himself quite confident of being able to keep it up at the same pitch as the few astonishing lines he has yet written."[17]

The enthusiasm of his young friends gave him the needed stimulus. Lecturing them dogmatically, "he insists strongly on the necessity of never leaving a poem till the whole of it be brought to a pitch of excellence perfectly satisfactory; in this respect of general equality, and also in regard to metre, he finds much to object to in Woolner's poem of *My Lady*. . . . He himself spent about a year (from the age of sixteen to seventeen) on *The River*, with which, and *The Woodman's Daughter*, he is contented in point of finish. . . . Patmore holds the age of narrative poetry to be passed for ever, and thinks that probably none such will again appear. . . . He looks on the present race of poets as highly 'self-conscious' in comparison with their predecessors, but yet not sufficiently so for the only system now possible—the psychological."[18]

Holding these doctrines, he started to write his new poem in

alternately rhyming tetrameter and in subdued everyday speech, a form that proved so easy that, as he said later, "the first book ... took only six weeks in the writing, though I had thought of little else for several years before."[19] He confidently told Rossetti that the completed work would be bigger than *The Divine Comedy*. Under Tennyson's counsel, however, he paused for revisions, and so the first installment, *The Betrothal*, was not ready for publication until 1854. He sent the proof-sheets to Tennyson for final approval, and was told, "You have begun an immortal poem, and, if I am no false prophet, it will not be long in winning its way into the hearts of the people."[20] Book 2, *The Espousals*, came out in 1856, and thereupon the two parts were combined under the title that became famous, *The Angel in the House*.

The poem was an outstanding example of a genre that flourished briefly in the mid-Victorian years, the novel in verse. Its genre has been mentioned above in chapter 4, relative to Morris's *Pilgrims of Hope*. The first important examples were by Arthur Hugh Clough, *The Bothie of Tober-na-Vuolich* (1848) and *Amours de Voyage* (written in 1850, published in 1858). Tennyson's *Maud* (1855) was allied with the genre, and the two most popular specimens, along with Patmore's, were Mrs. Browning's *Aurora Leigh* (1857) and Owen Meredith's *Lucile* (1860). Clough's remain acceptable to modern taste because his ironic tone saves the commonplace details and diction from absurdity. Tennyson avoided the pitfalls by providing emotional intensity through the monodrama technique. This is true also of Meredith's *Modern Love*, a condensed variety of the genre. In the others, emotion lapses too often into sentimentality, and the use of meter and rhyme for trivial details and conversations is often ludicrous.

Insofar as the art of literature is concerned, the novel in verse is the reductio ad absurdum of Pre-Raphaelite realism. If absolute fidelity to observed experience is the primary requirement of art, then such tales of ordinary people in familiar surroundings, set forth in technically accurate meter, must be aesthetically valid. Yet somehow a more essential element of beauty is absent—what Ruskin or Arnold would have termed "the grand style." In revulsion against the platitudinous language and trivial domesticity

of *The Angel*, critics are apt to overlook Patmore's profoundly earnest spiritual purpose. As Osbert Burdett says, he believed that "marriage was not the end nor anti-climax of love, but its fulfillment; and he showed . . . that within its narrow circle, and because of its limitations, it was capable of delights, and discoveries, more wonderful than the extravagant adventures of Don Juan."[21] In the words of Frederick Page, "The Angel in the House, then, is conscious love, uniting its subject and object, Man, Woman, God."[22]

Patmore's version of love between the sexes was, as he himself insisted, totally unlike the two conventional aspects depicted by Rossetti and Swinburne—the unattainable saintly lady (derived from the chivalric tradition of Courtly Love) and the diabolical temptress (derived from the Christian equation of sex with sin). Nevertheless he was just as much an erotic poet as they were, and *The Angel* was another contribution to the deeply probing Victorian revaluation of woman's status.

Patmore's intimacy with the group diminished after the brotherhood broke up. In 1857 he went to Oxford to see the murals in the union, and wrote a vivid report of them for the *Saturday Review*, but he did not become a friend of Morris, Jones, and Swinburne, and his own career took a different direction. His adored wife died in 1862 after a long illness, leaving him with six young children. Two years afterward he joined the Church of Rome and married a well-to-do woman, also a convert. He could now afford to give up his librarian's work and settle in the country. His new prosperity, his orthodox religion, and his Tory politics all set up a barrier between him and the irresponsible Rossetti circle.

He published a sequel to *The Angel*, again in two parts, in 1860 and 1861, *Faithful for Ever* and *The Victories of Love*. Using the epistolary technique, he narrated the marital history of the man who had been the rejected rival in *The Angel*. Having thus exhausted the potentialities of domestic fiction, he spent several years in working on a sequence of irregular odes which expounded his amatory philosophy, no longer in realistic narrative but in mystical symbolism. Nine of them were privately printed in 1868, but Tennyson and his other friends did not appreciate

them, and so he burned most of the copies. Not until 1877 did a volume of the odes, now expanded to thirty-one, appear anonymously under the title *The Unknown Eros*. When reissued the next year, with the author's name, a number of others were added.

By coincidence, the privately printed edition of the first odes was at the same time as the first publication of *The House of Life*, and thus the contrast between the two major erotic poets of the Victorian age is brought into sharp focus. Both were proclaiming a religion of sexual love, but Rossetti's was persistently physical, whereas Patmore interpreted it as a transcendent spiritual experience, an analogue for mankind's communion with God. As in Rossetti's sonnets, some of the odes are profoundly melancholy— those which record the agony of the poet's grief for his first wife and reveal the complexity of his emotions toward his second marriage; but there is none of the morbidity that haunts *The House of Life*.

It was Patmore who introduced to Rossetti a young poet who proved to be one of his most loyal admirers. William Allingham (1824–89) was born in the tiny town of Ballyshannon, in the remote northwest of Ireland. His father was the local bank manager, and after elementary schooling Allingham went to work in the bank at the age of fourteen. Determined to become an author, he read widely, and when he was about twenty he began sending contributions to London periodicals. From 1846 he was an official in the customs service in Ireland, and managed to pay vacation visits to London. Leigh Hunt introduced him to Carlyle and other writers, and Patmore made him acquainted with Tennyson and Rossetti. Allingham, in turn, took Rossetti for the first time to meet Browning. The Pre-Raphaelite group were charmed with the Irish poet's ingenuous enthusiasm for poetry and with the simple, melodious melancholy of his own verse.

In 1850 he brought out a volume of poetry, dedicated to his original patron, Leigh Hunt, but he soon withdrew it from circulation in order to revise the poems extensively. A few of them reappeared in *Day and Night Songs* in 1854, and the success of this book led him the next year to combine it with a long narrative poem, "The Music Master," drastically revised from the 1850

book. This edition was provided with Pre-Raphaelite illustrations —one by Rossetti, one by Millais, and the rest by their protégé Arthur Hughes.

Allingham's songs and ballads had the unique advantage of possessing the authentic tone of folk poetry, which the Pre-Raphaelites strove to achieve by sheer will power. He explained in the preface to the 1854 volume: "Five of the songs or ballads . . . have already had an Irish circulation as 'ha'penny ballads.'" In fitting these to traditional tunes, following the example of Burns and Moore, he echoed the true lilt; but his language usually conformed to the faceless triteness of the peddlers' broadsides so closely that he only occasionally touched the inimitable hyperbole of peasant Irish rhetoric. A dim forecast of Synge may be detected in lines such as these from "lovely Mary Donnelly":

> When she stood up for dancing, her steps were so complete,
> The music nearly kill'd itself to listen to her feet;
> The fiddler moan'd his blindness, he heard her so much praised,
> But bless'd himself he wasn't deaf when once her voice she raised.

Allingham was handicapped by anxiety to avoid dialect; he remarked in his preface that "I found it not easy, in ballad-writing, to employ a diction that might hope to come home to the Irish peasant who speaks English (as most of them now do), using his customary phraseology, and also keeping within the laws of poetic taste and the rules of grammar."

The more literary poems are apt to contain traces of eighteenth-century formal language and moralizing, and only a handful achieve distinction. Allingham is usually represented in anthologies solely by "The Fairies," which with its tripping meter and touches of homely detail conveys the "natural magic" of Celtic legend:

> Down along the rocky shore
> Some make their home,
> They live on crispy pancakes
> Of yellow tide-foam;
> Some in the reeds
> Of the black mountain-lake,
> With frogs for their watch-dogs,
> All night awake.

The weird quality of the Irish imagination appears in "A Dream":

> I heard the dogs howl in the moonlight night,
> And I went to the window to see the sight;
> All the dead that ever I knew
> Going one by one and two by two.
>
> On they pass'd and on they pass'd;
> Townsfellows all from first to last;
> Born in the moonlight of the lane,
> And quench'd in the heavy shadow again.

An ornate ballad in the Morris style, "The Maids of Elfen-mere," with its decorative detail and its haunting refrain, was sufficiently Pre-Raphaelite to be chosen by Rossetti as the one to illustrate. An unexpected specimen of the comic-grotesque is "The Dirty Old Man" (which incidentally may have given Dickens a hint for Miss Havisham).

The narrative poem, "The Music Master," is a discursive, pathetic pastoral. The story is uneventful: the heroine is equipped with a malicious elder sister, who turns out to play no part whatsoever in the action; the hero emigrates to America for no adequate reason and leaves his sweetheart to pine away and die. The model is Goldsmith and Crabbe rather than Wordsworth, and the poem is redeemed from tediousness and sentimentality only intermittently by the loving portrayal of humble life in an Irish village.

In 1863 Allingham was transferred in the customs department from Ireland to England, and propinquity to the literary world stimulated his activity in writing. Following the fashion of the preceding decade, he composed a novel in verse, *Laurence Bloomfield in Ireland*, which came out as a serial in *Fraser's Magazine* before being issued in book form. The use of rhyming couplets lends a touch of aesthetic distance to the otherwise commonplace account of a philanthropic landlord who is trying to improve the condition of his tenants.

Allingham continued to see Rossetti for several years. We hear of them spending an evening together talking about Christina's poetry while they lay on the grass of Lincoln's Inn Fields. In his diary for 1866, mentioning a visit to the house in Cheyne Walk,

Allingham remarked, "My old regard for D.G.R. stirs within me, and would be as warm as ever *if he would let it.*"[23] A year later, when Rossetti was in a neurasthenic depression because of anxiety over his eyesight, he volunteered to visit Allingham at his home in Hampshire. For more than a week, the host made superhuman efforts to entertain and stimulate him, but to no avail; Rossetti was incurably lethargic and hypochondriac. After Allingham with difficulty arranged for a visit to Tennyson in the Isle of Wight, Rossetti balked at the last minute on the pretext that the five-mile crossing of the Solent might make him seasick. Discouraged by his failure to reestablish genuine communication with his former idol, Allingham confided to his diary that "it is plain that the simple, the natural, the naïve are merely insipid in his mouth; he must have strong savours, in art, in literature, and in life. Colours, forms, sensations are required to be pungent, mordant. In poetry he desires spasmodic passion and emphatic, partly archaic, diction."[24] Rossetti, however, dismayed by solitude after his return to London, begged Allingham to visit him. The days he spent in Cheyne Walk merely confirmed Allingham's disillusionment. The disorderly household, Fanny Cornforth's vulgarity, even Rossetti's profane language, got on the nerves of the precise and unsophisticated guest. The fact was that in his indiscriminate hero worship Allingham was more devoted to Tennyson and Browning than to Rossetti, and such eclecticism was not to Rossetti's taste. Summing up the uncomfortable visit, Allingham said that "in art, and still more in life, Rossetti and I have discords not to be resolved."[25]

In 1870 Allingham gave up his civil service position and settled in London as editor of *Fraser's Magazine*. He continued to revise his poems and to write new ones, but added nothing significant to his previous achievement. He dined a few times with Rossetti, but saw him seldom if ever after 1871, as the poet's alienation from old associates intensified.

Though Allingham's talent was slender, it was individual, and his early admiration for Pre-Raphaelite poetry never seduced him into sheer imitation. He had memorized Woolner's "My Beautiful Lady" when it came out in the *Germ*; rereading it thirteen years

later he still found it "tender and sweet," but added, "with the quaint guild-mark, so to speak, of the P.R.B. (I can't bear to be verbally quaint myself, yet often like it in another)."[26]

Another poet who moved for a while in the Pre-Raphaelite orbit before finding his own literary métier was Richard Watson Dixon (1833–1900). Having been at school with Edward Burne Jones in Birmingham, he remained his close friend at Oxford, and thus became intimate also with Morris. It was he who proposed to them the founding of the *Oxford and Cambridge Magazine*. A letter of Jones's depicts him at this time: "Dixon is another fine fellow, a most interesting man, as ladies would say—dark-haired and pale-faced, with a beautiful brow and a deep, melancholy voice. He is a poet also. I should be sorry to dash the romance of his character, but truth compels me to say he is an inveterate smoker."[27] Jones escorted him to Rossetti's studio in London, assuring him that "we shall see the greatest man in Europe," and Dixon was duly captivated. He took some lessons in painting, and was among the band of undergraduate novices who wielded brushes under Rossetti's direction on the murals for the union. For a while he shared the London studio of Jones and Morris in Red Lion Square, until he became convinced of his incompetence as a painter. Like them, he had been committed to a career in the church, but unlike them he did not relinquish his faith. Ordained in 1858, he went to work as a curate in a London slum. It was he who performed the marriage ceremony in 1859 for William Morris and Jane Burden.

His first book, *Christ's Company and Other Poems* (1861), was strongly Pre-Raphaelite in its pictorial precision, its formal verse patterns, and its melancholy cadences. The opening stanzas of "St. Mary Magdalene" suffice to display the Rossetti-Morris dominance:

> Kneeling before the altar step,
> Her white face stretched above her hands;
> In one great line her body thin
> Rose robed right upwards to her chin;
> Her hair rebelled in golden bands,
> And filled her hands;

> Which likewise held a casket rare
> Of alabaster at that tide;
> Simeon was there and looked at her,
> Trancedly kneeling, sick and fair;
> Three parts the light her features tried,
> The rest implied.

The poem goes on to recount her guilt-ridden hallucinations in gruesome detail.

The longest piece, "St. John," is a dramatic monologue of apocalyptic visions and mystical meditation, adorned with medieval details of emblems, heraldry, and general Pre-Raphaelite pictorialism:

> Came Gabriel, with his banner over him,
> White lilies, brass-bright flowers, and leaves of green;
> A lily, too, he carried seemed to brim
> With golden flames, which mounted pure and clean
> To touch his blessed mouth, and then would trim
> Themselves within the lily leaf again:
> Gabriel's fair head sank even with dream-pain.

Another long religious poem, "St. Paul, Part of an Epistle from Gallio," is a slavish imitation of Browning. An older model, Chaucer, was chosen for what was to have been a sequence of nine symbolic narratives of "The Crosses of Love," but only the prologue, "Love's Consolation," was written in time for inclusion in the book. The narrator is a garrulous old monk, and his word-pictures of lovely ladies and gallant knights, in the vein of "A Legend of Good Women," foreshadow the subsequent style of Morris in *The Earthly Paradise*.

Some of the shorter poems are notable for weird, elusive evocations of nightmare landscapes and moods of spiritual blackness.

> I mark a woman on the farther shore
> Walk ghost-like; her I shriek to with my might;
> Ghostlike she walketh ever more and more;
> Her face how white!
> How small between us seems the Infinite!

In spite of the obvious resemblances to Morris's work, the mixture of religious devotion and emotional gloom links Dixon with

Christina Rossetti rather than with the more secular-minded Pre-Raphaelites.

Dixon's promising start as a poet was not fulfilled. In 1861 he married a widow twelve years his senior, with three children, and gave up his curacy to become a schoolmaster, at which he persisted for six years, though he proved to be far too gentle and absent-minded to maintain discipline over unruly boys. His employment is chiefly memorable for setting up a fortuitous connection with the poetry of the next era. One of his first pupils was a seventeen-year-old youth named Gerard Manley Hopkins, who was greatly impressed by his teacher's recent book of poems. Seventeen years later, Hopkins sent Dixon a request for advice in his writing of poetry, and the outcome was a close friendship and a body of important correspondence. It was probably mainly through this intermediary that Hopkins acquired his contact with Pre-Raphaelite poetry.

Dixon's next book, *Historical Odes and Other Poems* (1864), added little to his achievement, though it showed clearer evidences of his religious mysticism. The four historical poems are pretentious, and two stories for the abortive "Crosses of Love" series are notable chiefly for their antagonism to carnality. The Pre-Raphaelite influence was diminishing in favor of Keats. Four philosophical odes are dignified and ornate, but a few of the short lyrics show something of Blake's engaging simplicity.

Thereafter Dixon vanished from the literary arena for twenty years. By 1866 he had material for another volume of short pieces and had almost finished a "Northern Epic" which he later destroyed because it was forestalled by Morris's saga poems. He asserted that "I stick to poetry and ever shall,"[28] but nothing got into print. In 1868 he resumed clerical duties as a minor canon of Carlisle Cathedral and began research on Anglican church history. In 1874 he published a biography of his father, who had been an eminent Methodist minister. Though he had faded into the obscurity of theological scholarship, he maintained some contacts with his old Pre-Raphaelite friends. Rossetti belatedly read his two books of verse in 1875 and wrote him a long and enthusiastic letter: "You are one of the most subtle as well as varied of

our poets, and . . . the neglect of such work as yours on all hands is an incomprehensible accident. . . . Surely there must be more in store by this time." Dixon replied ruefully: "My work has met with nearly absolute neglect, but along with this there has been some censure of a very ignorant sort. . . . I have several volumes of poems in MS, but no immediate prospect of publishing. I can hardly yet believe that I have received so much commendation from the author . . . whom I have always regarded as the greatest master of thought and art in the world."[29]

By this time he was settling down in a quiet country parish and working on his massive *History of the Church of England*, the six volumes of which came out at intervals over a quarter of a century. The unexpected tribute from Hopkins in 1878, leading to an introduction to Hopkins's friend Robert Bridges, restored a vital connection with poetry, and he felt encouraged to disinter and publish in 1883 an ambitious historical novel in verse, *Mano: A Poetical History*, which he had written several years before. Composed in terza rima, it deals with the exploits of a Norman knight at the close of the tenth century, when he is involved in the defense of Italy against the Saracens. The historical background is the apocalyptic expectation of the imminent millennium, and the narrator, an aged monk, shares the fatalistic and superstitious assumptions of the time. Hence a remarkable sense of immediacy emerges in spite of fantastic supernatural episodes and the whole Gothic tissue of imprisoned maidens, valiant knights, defiant outlaws, and mysterious parentage. Elements of Dante, the monastic chronicles, and the metrical romances contribute to the convincing medieval impression. Like Morris, Dixon was fully capable of identifying himself imaginatively with the Middle Ages.

Mano marked the end of Pre-Raphaelite influence in Dixon's work. The world-weary mood, the inevitable frustration and misery of earthly love, the word-pictures of the melancholy heroine nursing her secret passion, and the many other pictorial passages, all are in the Rossetti-Morris tradition. Thereafter, under the influence of Bridges, Dixon wrote in a simpler, more fastidious style. Though only 130 copies of *Mano* were sold in its first year, Bridges sponsored the private printing of three small

volumes of Dixon's subsequent verse in limited editions. *Odes and Eclogues* contained three narratives on mythological themes and three gravely gentle odes of personal meditation. *Lyrical Poems* (1887) displayed the Blakean element in his work, with its brief quatrains and monosyllabic language. In a final volume, *The Story of Eudocia and Her Brothers* (1888), the restrained manner proved inadequate for a tale from Byzantine history: the style is merely colorless and the narration is pedestrian. Dixon abandoned plans for a continuation and published no more poetry during the remaining twelve years of his life.

An anomalous position in any survey of Pre-Raphaelite poetry is occupied by George Meredith (1828–1909). On the basis of his poetic stature, he was the equal if not the superior of the two Rossettis, Morris, and Swinburne, all of whom occupy extensive chapters in the present study. For a crucial year or two of Pre-Raphaelite poetic activity, 1861-62, he was at the core of the inner group. Nevertheless, he has to be relegated to a few pages, on a par with Woolner and William Bell Scott. One reason is that, in spite of his lifelong insistence that he considered himself primarily as a poet, the literary histories persistently classify Meredith as a novelist. More important, however, he was too assertive and independent to subordinate either his personal attitudes or his creative functions to any outside influence. His temporary intimacy and subsequent coolness illustrate the paradox of attraction and repulsion exerted by any strongly dynamic center of energy.

Meredith was exactly three months older than Rossetti, but there is no evidence that either had more than barely heard of the other's existence until they were over thirty. The son of a tailor in Portsmouth, Meredith was physically handsome and mentally brilliant. His education was acquired in inferior schools but was topped off by a year and a half on the Continent, at a Moravian school on the Rhine, which gave him a touch of cosmopolitan assurance. Though humiliated by his inept father's bankruptcy and eventual emigration, he was ambitious for social and intellectual eminence, and chose literature as the most promising road to fame. After an abortive interlude as a law student, he followed the

normal procedure of seeking the patronage of an established author whom he admired. His choice fell upon Richard Hengist Horne, a picturesque adventurer who had written a high-flown classical epic, *Orion*, allegorizing the innate human urge toward strenuous progress and the ideal of love as a "combination of the mind with the senses which best helps the noble progress and happiness of certain beings." Horne was sufficiently impressed with Meredith's verses to give him advice about technique. On coming of age, the young poet married the daughter of the witty satirist Thomas Love Peacock, and in 1851 he published a small volume entitled *Poems*.

Many of them are undistinguished lyric, descriptive, and reflective pieces in the current Tennysonian style, but several are more noteworthy. "Daphne" and "The Shipwreck of Idomeneus" are agreeable classical exercises, and a series of "Pastorals" offer attractive rural landscapes in a variety of unrhymed stanzas. "South-West Wind in the Woodland" stands out as a vigorous evocation of the power of nature, insisting on the superlative joy inherent in even the harshest natural processes. Above all, "Love in the Valley" is an idyllic outpouring of a shy boy's first love, full of captivating glimpses of country life. The meter of alternating trochees and dactyls, virtually unprecedented in English verse, remained essentially unique until *Atalanta in Calydon* a decade later. Meredith was encouraged by a letter from Tennyson particularly praising this metrical innovation, which so haunted him, he said, that he walked about the house chanting the stanzas.

On the whole the book was favorably received, though several critics objected to its "sensuous warmth of image and expression" and the "studied and amplified voluptuousness" in "Daphne" and "The Rape of Aurora." Retrospectively it can be seen that the most significant review was in the *Critic*, since it was written by William Michael Rossetti. Characterizing Meredith as "a kind of limited Keats ... scarcely a perceptive, but rather a seeing or sensuous poet," he found in the poems "warmth of emotion, and, to a certain extent, of imagination."[30]

The next ten years were a hard time for Meredith. Obstinately determined to make his name as an author, he rejected his father-

in-law's efforts to find a secure salaried position for him at East India House. Poverty and disappointment caused increasing tension between Meredith and his wife; both were arrogant, satirically witty, and emotionally explosive. Ferociously proud, Meredith was humiliated by debt and by dependence on Peacock's bounty. For several years he produced reams of commonplace verse on popular topics, but sold only a few pieces to magazines. Meanwhile he was at work on an extended prose story, *The Shaving of Shagpat*, modeled on the *Arabian Nights*, a complicated mixture of fantastic adventures, satirical farce, and philosophical allegory, couched in rhythmic and highly metaphorical prose. The reviewers were baffled by the book when it came out at the end of 1855, and few copies were sold, but Meredith went on to write a second comic fantasy, *Farina* (1857), this time based on Rhenish folk-legends.

During these years Meredith made his first contact with Pre-Raphaelite art, and it proved disastrous by its effect on his doomed marriage. A close friend of the Meredith couple was Henry Wallis, a young painter who was exhibiting pictures in the Pre-Raphaelite style of bright colors, exact details, and literary subjects. By 1857 it was obvious that Wallis was in love with Mary Meredith, in spite of being nine years younger than she, and in 1858, already separated from her husband, she gave birth to a child by Wallis. Some months later the lovers went off to Capri. The bitter blow to Meredith's pride was compounded by a haunting sense of guilt for having somehow contributed to the matrimonial failure; yet, by the paradox of the creative imagination, this pathologically reticent man, who could scarcely bring himself to mention his personal problems even to his best friends, set about writing a novel that intimately revealed his disaster. *The Ordeal of Richard Feverel* (1859) was a subtle combination of irony and pathos, wit and serious psychology, written in a prose style that varied with the moods and was replete with allusion, implication, and symbolism. Such complexity had repelled readers enough in the two fantasies; it was still more obnoxious in a novel ostensibly dealing realistically with contemporary life. Condemned both for wilful obscurity and for laxity in morals, the book was commercially a failure.

Nevertheless, Meredith had at last found a foothold in his profession. His next novel was accepted as a serial in a popular journal, *Once a Week*, and he was appointed as an editorial adviser to an influential publishing firm, Chapman & Hall. Living a simple life in a cottage outside London, he began to establish friendships in the worlds of literature and society.

The maturing effect of his emotional crisis showed itself in the greater strength and originality of his poetry. He undertook to record with realistic detail the speech and mental attitudes of humble people; the most effective of these monologues, "Juggling Jerry," was followed by "The Beggar's Soliloquy," "The Patriot Engineer," "The Old Chartist," and "Grandfather Bridgman." At the same time, he was collecting folk ballads with some thought of publishing a book of them, and he tried his hand at three imitations, "The Song of Courtesy," "The Three Maidens," and "The Crown of Love." More idiosyncratic were two elusive, half-comic, half-symbolic pieces written in 1861, "By the Rosanna" and "Fantasy."

By this time his literary activities had finally made him acquainted with Rossetti, who saw in him a useful channel for publication. Early in 1861, Rossetti wrote to him praising his new novel, *Evan Harrington*, and proposing that Chapman & Hall should bring out a new edition of the forgotten play by Charles Jeremiah Wells, *Joseph and His Brethren*. In May, Meredith visited his studio and was given a copy of the newly printed *Early Italian Poets*; Meredith described the translation as "so good that he will rank as poet as well as an artist from the hour of its publication."[31] This opinion was reinforced when Rossetti showed Meredith the manuscript of his original poems, which he was dubiously thinking of publishing. Meredith told a friend that "he would please you more than I do, or can, for he deals with essential poetry, and is not wild, and bluff, and coarse; but rich, refined, royal-robed."[32] Rossetti offered to supply an illustration for Meredith's poem "Cassandra." Along with mutual literary admiration came social intimacy: Meredith was soon attending the uproarious evenings at the studio—"nothing but oysters and of course the seediest of clothes," or "short pipes and beer . . . being the order of the day."[33]

Friendship with Swinburne was a natural consequence, and Meredith recommended him to the editor of *Once a Week,* who accepted one of his stories. Meredith was entertained by Swinburne's reading of his burlesque "Fille du Policeman" but (as quoted earlier) felt uncertain as to his possessing "any internal centre."

The death of Meredith's estranged wife in October 1861 spurred him to write a poem about his maladjusted marriage, even more closely autobiographical than *Richard Feverel.* Its first ironical title was "A Love Match," which later became "Modern Love," perhaps an intentional suggestion of its bitter contrast with the idyllic "Love in the Valley" of ten years before. Both are episodic records of a lover's moods and experiences; but whereas the earlier speaker was a naïve country lad, this one is a disillusioned man of the world, miserably probing the psychological conflicts that are destroying his marriage. Instead of the fluent melody of the previous poem, "Modern Love" is in concentrated sixteen-line units that Meredith described as "sonnets." Like "The House of Life," it is a painfully intimate chronicle of frustrated love, but the novelist's ruthless realism is a world away from the poet painter's idealized symbolism. Rossetti assured Meredith, however, that it was his best work.

Modern Love, and Poems of the English Roadside, with Poems and Ballads, came out in May 1862, and the influential journals condemned it savagely. The *Spectator,* particularly, termed it prurient, flippant, meretricious, cynical, vulgar, and tawdry, "a very thick solution of mental mud." Significantly, the reviewer objected to the "confusion between a 'fast' taste and what Mr. Meredith mistakes for courageous realism, 'poetic Pre-Raphaelitism.' "[34] Swinburne with customary vigor defended his friend in a long epistle to the *Spectator,* terming "Modern Love"

a work of such subtle strength, such depth of delicate power, such passionate and various beauty . . . in some points, as it seems to me (and in this opinion I know that I have weightier judgments than my own to back me) a poem above the aim and beyond the reach of any but its author. Mr. Meredith is one of the three or four poets now alive whose work, perfect or imperfect, is always as noble in design as it is often faultless in result. . . . As to subject, it is too much to expect

that all schools of poetry are to be for ever subordinate to the one just now so much in request with us, whose scope of sight is bounded by the nursery walls; that all Muses are to bow down before her who babbles, with lips yet warm from their pristine pap, after the dangling delights of a child's coral; and jingles with flaccid fingers one knows not whether a jester's or a baby's bells.[35]

As well as being a notable document in the Pre-Raphaelite defiance of conventional prudery, the letter signalized Meredith's admission into the inmost Rossetti sanctum. A week after it was printed, Rossetti and Swinburne spent their notable weekend at Meredith's country cottage, when they announced their discovery of FitzGerald's *Rubáiyát* and when Swinburne composed "Laus Veneris." The purpose of the visit was to invite Meredith to participate in the project of communal living at Tudor House. Though he refused to give up his rural refuge, he agreed to rent a room that he could occupy on the day or two each week when his editorial duties brought him into town.

For a while he enjoyed the riotous interludes with the bohemian group, but the arrangement lasted for only half a year. Meredith was far too assertive a person to get along smoothly with two other equally positive poets. Fastidious about behavior, and a strenuous exponent of open-air exercise, he abominated Rossetti's slovenly habits of eating, sleeping, and working, and Swinburne's tipsy excesses. His sarcastic wit was not appreciated when applied to their work and conduct. Even the financial arrangements caused friction. William Michael Rossetti discreetly sums up the incompatibility between his brother and Meredith:

It would have been difficult for two men of the literary order of mind to be more decisively unlike. . . . Meredith had a far wider interest in life and society, the actual transactions of men and women in their relations ordinary or exceptional, the interaction of characters and motives, than either my brother or myself had. . . . He understood, and liked to understand, many things to which I was mainly indifferent—to some of them, as for instance everything connected with the ordinary politics of the day, my brother was much more indifferent than myself.[36]

Exaggerated stories were circulated about a melodramatic rupture, but in fact the separation seems to have been by mutual

agreement, and Meredith remained on friendly terms with his former housemates. After Rossetti's death he recorded his opinion temperately: "I liked him much, though I was often irritated by his prejudices, and his strong language against this or that person or subject. He was *borné*, too, somewhat, in his interests, both on canvas and in verse, and would not care for certain forms of literature and life which he admitted were worth caring for. However, his talk was always full of interest and rare knowledge; and he himself, his pictures, and his house, altogether, had I think an immense influence for good on us all."[37]

Meredith's relationship with Swinburne remained cordial for some years, surviving the portrayal of Swinburne as "Tracy Runningbrook," a character in Meredith's novel *Emilia in England* (1864). In 1867, after his second marriage, he wrote enthusiastically about the "Ode on the Insurrection in Candia": "The Ode is the most nobly sustained lyric in our language, worthy of its theme. Broader, fuller verse I do not know. I had a glance at the proofs, and my chief sentiment was envy. Now I can read without that affliction. For me there will never be time given even to try the rising to such a song."[38] In the autumn, Swinburne spent two days as a guest of the Merediths, but soon afterward, when Meredith was deputizing as editor of the *Fortnightly Review*, a dispute arose over the rate of payment for a contribution by Swinburne, and the old intimacy was never restored.

Deeply engrossed in writing his novels, Meredith did not publish another book of poetry until *Poems and Lyrics of the Joy of Earth* (1883). Developing in a direction forecast by "South-West Wind in the Woodland" in his first collection and "Ode to the Spirit of Earth in Autumn" in his second, his poetry was now devoted predominantly to philosophical exposition of man's relationship with nature, and his style was becoming more cryptic, a tendency that continued in subsequent volumes, along with equally opaque odes on international events in the vein that he had envied in Swinburne.

Any consideration of Pre-Raphaelite elements in Meredith's poetry must concentrate on the book published in 1862. Some of

the characteristic elements in it had already been foreshadowed in his previous work, written before he knew anything of Rossetti's movement; but certainly "Modern Love" and the "Poems of the English Roadside" show some affinity with Pre-Raphaelite doctrine in their precise depiction of recognizable experience and their disregard for Victorian prudery. As a concentrated novel in verse, "Modern Love" applies vivid poetic metaphor and symbolism to its realistic record of contemporary life. Such sections as 1, 11, 16, and 45 are pictorial vignettes with perceptible Pre-Raphaelite traits. The dominant irony, however, the essentially masculine energy, and the complex psychological analysis are remote from the Rossettian and Swinburnian preference for verbal melody and emotional rhetoric. The conclusion must be that Meredith was moving in his own orbit, which happened to encounter that of the Pre-Raphaelites at a juncture highly significant for both.

Perhaps the most remarkable of the recruits who enrolled under the Pre-Raphaelite banner was not a zealous young experimenter but a superannuated minor poet who received an infusion of energy under Rossetti's spell. Thomas Gordon Hake (1809–95) had published his first book of verse in the year Rossetti was born. Its nature is sufficiently indicated by the title, *Poetic Lucubrations: Containing the Misanthrope and Other Effusions*. A decade later he brought out *The Piromides: A Tragedy*, which dealt with the mysteries of Isis. His work belonged to the ambitious metaphysical Shelleyanism that flourished in the thirties, as represented by Bailey's *Festus* and Horne's *Orion*. In 1840 Hake published *Vates; or, The Philosophy of Madness: Being an Account of the Life, Actions, Passions, and Principles of a Tragic Writer*. It portrayed a would-be tragedian who set out to commit every sin and crime to provide authentic experience for his writings. This was reprinted ten years afterward in a magazine as *Valdarno; or, The Ordeal of Art Worship*, and thus it came to the omnivorous attention of the young Rossetti, who with customary ardor wrote the poet a fervent letter (which was not answered). William Michael Rossetti described the book as "a nebulous but

impressive romance" which "seethed in my brother's head."[39]

Handsome and socially affable, Hake had a successful professional career as a physician; in fact, in the same year as *The Piromides* he issued *A Treatise on Varicose Capillaries*. It was not until 1869 that he became personally acquainted with Rossetti as the result of a privately printed volume, *The World's Epitaph*, which reawakened Rossetti's admiration for his work. Thereafter, according to W. M. Rossetti, Dr. Hake was "the earthly providence of the Rossetti family."[40]

The poems that chiefly impressed Rossetti were far from the inflated rhetoric of Hake's early work. He was attempting to embody his religious and metaphysical ideas in simple narratives and familiar language, a form that he termed "parables." Rossetti was particularly impressed by "Old Souls," an assault on the hypocrisy and worldliness of modern religion through a description of Christ's ministry to the lowly in the guise of an itinerant tinker mending "old souls" like old pots. Two other tales that Rossetti admired were written with the same Wordsworthian simplicity of meter and diction: "The Lily of the Valley" was an idyllic picture of a little country girl, confronted for the first time with realization of death and the terror inherent in Nature; a companion poem, "The Deadly Nightshade," showed the horrors of slum life in a picture of a beggar boy and his drunken mother. In such poems Hake was certainly fulfilling the original Pre-Raphaelite objective of austerely recording truth. The series of short poems collectively entitled "The World's Epitaph" were more openly symbolic and transcendental, and in some of them the meaning remains obscure.

With Rossetti's advice and encouragement, Hake brought out in 1871 an enlarged edition of his book, as *Madeline: With Other Poems and Parables*. The principal addition was the title poem, a tortuously complicated narrative. Basically it tells about a betrayed village girl who while in a trance murders the overlord who seduced her, and dies with the birth of her infant; but the elementary story is heavily overlaid with supernatural visitants, and is conveyed antiphonally through a dialogue between a nature spirit and a group of nymphs. Hake's strong interest in hysteria, hallu-

cinations, and mesmerism contributes to the reader's bafflement.

Rossetti bestirred himself to write a long review of the book, mingling praise with judicious indication of faults. In summary, he said:

He is uninfluenced by any styles or mannerisms of the day to so absolute a degree as to tempt one to believe that the latest English singer he may have heard of is Wordsworth; while in some respects his ideas and points of view are newer than the newest in vogue; and the external affinity frequently traceable to elder poets only throws this essential independence into startling and at times almost whimsical relief. His style, at its most characteristic pitch, is a combination of extreme homeliness, as of Quarles or Bunyan, with a formality and even occasional courtliness of diction which recall Pope himself in his most artificial flights; while one is frequently reminded of Gray by sustained vigour of declamation.[41]

Probably as a result of Rossetti's criticism, Hake revised several of the "parables" and reissued them the next year, along with some new ones. This book also was reviewed by Rossetti (these being the only two reviews he ever published), and again he praised the poems for sympathy and simplicity, particularly "The Blind Boy": "There is hardly in Wordsworth himself any single poem of equal length which from so central a standpoint interpenetrates the seen with the unseen, bounded always in a familiar circle of ideas."[42]

Sustained by the warmly affectionate relationship with the Rossetti group, Hake continued to write copiously. Between the ages of sixty-two and eighty he brought out seven volumes of verse, continuing to strive for technical improvement. Perhaps his best level of achievement was in *New Symbols* (1876). Christina Rossetti said of "Ecce Homo" in that volume that its daring startled her and that it impressed her more profoundly than did any other poem of her own time. Among the longer poems, the Pre-Raphaelite interests are shown in "The Painter" and a companion poem on sculpture, "Michael Angelo." The latter particularly pleased Rossetti, who told Hake that it "may perhaps rank as the most masterly of your poems; some passages (as stanza three) having absolutely a new and valuable image in every couplet, and being as perfect in expression as words can make

them."[43] His last book of verse, *The New Day* (1890), consisted entirely of sonnets; some of them offer intimate glimpses of his literary friends, while others give the most effective expression to his moods of pantheistic ecstasy.

Hake's poetic methods were not those of the Pre-Raphaelites, and his addiction to religious topics separated him from all of them except Christina Rossetti. Nevertheless, his use of vivid dream scenes and of symbolic figures shows Pre-Raphaelite affinity; "The First Saved" (another favorite of Christina's) is a sort of orthodox mystical counterpart of "The Blessed Damozel." Though he continued to expand his range and to revise his earlier work, he could never overcome his innate limitations. His meters are too mechanically regular, his tempo is pedestrian, his language lacks imaginative suggestion, and his earnestness lapses too often into bathos. On the other hand, his palpable sincerity and his deep human sympathies entitle his poems to respect.

In the same way that Dr. Hake in the last twelve years of Rossetti's life served as the caretaker of his physical and mental health, another minor poet and practical man of affairs undertook the same function, less professionally but more extensively, for Swinburne. Theodore Watts-Dunton (1832–1914) has been caricatured so often and so unfairly as the fussy mentor who tamed the fiery poet into a sentimental reactionary that his own considerable literary ability has been forgotten. A contributing factor has been his tardy and limited publication in book form. He did not bring out his poems until he was sixty-five, but then they went through eight editions in ten years. His novel *Aylwin*, published in the next year, made a resounding success and soon came to be enshrined in "The World's Classics" series. His genuinely self-effacing character restrained him from issuing any collection of the immensely influential book reviews which appeared anonymously for many years and which were based on a more coherent critical theory than were those of rival men of letters such as Andrew Lang. Nonetheless, his critical principles, summed up in two encyclopedia articles, were hailed as the best exposition of the neo-romantic outlook that the Pre-Raphaelites had fostered.

Swinburne, with customary emphasis, described him as "the first critic of our time, perhaps the largest-minded and surest-sighted of any age."[44]

Walter Theodore Watts was born in Huntingdonshire, on the edge of the fen country, the son of a small-town solicitor who was also an amateur geologist and anthropologist of some standing in scientific associations. A brother of the solicitor was an eccentric polymath, expert in philology and occultism. Thus the boy lived in an atmosphere of ideas and became well informed in both science and philosophy. He was no mere bookworm, however, but rambled over the countryside and became acquainted with the gypsy bands that roamed eastern England. He qualified for the law and worked in his father's firm, meanwhile copiously writing poetry and at least two novels, which he could not bring himself to submit to publishers.

When he was nearing forty he set himself up in practice in London, where he soon met Dr. Hake and through him was introduced to the Rossetti circle. The vociferous writers began to listen respectfully to the graceful disquisitions on literary topics that could be heard from the quiet little solicitor, and he was soon asked to review books for the *Examiner*. By this time he was proving indispensable in handling Rossetti's complicated legal and financial affairs and also as an ever-reliable companion to the distraught poet. After Rossetti's disastrous breakdown in 1872, it was Watts as much as Hake who aided his recovery: he suggested topics for sonnets, and later proposed that Rossetti write objective narrative poems, the outcome being "The White Ship" and "The King's Tragedy." Rossetti eventually concocted a scheme for a joint volume of verse tales by Watts and himself.

From 1876 onward, Watts was the chief critic of poetry for the *Athenaeum*, and his reviews did much to ensure public appreciation for the volumes thereafter published by Rossetti, Swinburne, Morris, Meredith, and others of the circle. His friends were aware that he had forgone his ambition to be a creative writer in order to devote all his energy to the fostering of greater poets. Rossetti at the very end of his life described Watts as "a hero of friendship," and he died literally in Watts's arms.[45] At an

early stage of his residence in London Watts had written a novel which included portraits of some of his new artistic friends; but as he became more intimate with them he decided that publication of the book would be unkind and indiscreet, and so he withheld it for twenty-five years. Occasional sonnets in journals were his only indications of original work.

It was typical of Watts's diplomacy that he was able to remain on cordial terms with Morris and Swinburne after Rossetti was alienated from both those former friends. He continued to visit Kelmscott as long as Morris lived there, and in 1879 his patient helpfulness to Swinburne culminated when he acquired a comfortable house on Putney Hill and persuaded the poet to be his permanent co-tenant. "The Pines" was shared by Watts's sister and her little boy, and Swinburne became fanatically devoted to the child.

On reaching sixty-five Watts apparently decided that it was time for him to emerge as a creative writer. He made his name more euphonious by adding his mother's surname of "Dunton" and by dropping the preliminary "Walter." Some time before, Morris had arranged to issue a volume of Watts's poems from the Kelmscott Press, but with typical diffidence Watts delayed on the pretext that some of the manuscripts were mislaid. In 1897, however, he brought out *The Coming of Love, Rhona Boswell's Story, and Other Poems*.

The title poem is a disjointed series of soliloquies and dialogues recounting a love affair between a young squire and a passionate gypsy girl. The conversation of the gypsies, studded with Romany dialect, displays their genuine and realistic identification with Nature, in contrast with the cultivated man's more conventional and sentimental discourse. The girl saves him from a murderous attack by a jealous member of her band, and later he goes off to the South Seas for a year, but is haunted by memories of her love. Upon his return he witnesses a violent episode in which Rhona, defending herself from an attack by her gypsy suitor, pushes him into a river, where he drowns. Percy now weds Rhona and lives the Romany life, but their happiness is shadowed by their guilty secret, and when she disappears he realizes that she has been killed

by her vengeful tribe. After mourning for a year he goes to the Alps, where he lives in solitude and gloom, regarding Nature as a malign destructive power, until a sunrise on the montaintops gives him a vision of "Natura Benigna." In spite of its spasmodic construction, the poem—which Watts described as "an idyl of the open air"—has a fresh vigor and naïve lyricism which are surprisingly attractive.

The other long poem in the volume, "Christmas at the Mermaid," had been written soon after Watts and Swinburne became house-mates, and reflects their shared interest in Elizabethan drama. Except for Shakespeare, most of the playwrights participate in the conversation, and the author incidentally conveys his theory as to the identity of the mysterious friend in Shakespeare's sonnets: a modest minor poet who is proud to play Watts to Shakespeare's Swinburne. Most of the remaining poems, mainly sonnets, are on literary topics. "A Grave by the Sea" is a moving elegy on Rossetti, and there is also a memorial poem for Christina. More unexpected is a warm tribute to José Maria de Hérédia. To offset the surfeit of elegies and other worshipful exercises, the sonnet on "The Octopus of the Golden Isles" is a scathing denunciation of Robert Buchanan as Rossetti's destroyer.

Watts's admiration for Hérédia, the parnassian master of the French sonnet, was a natural consequence of his own addiction to that form. Preferring the Petrarchan pattern, he handled it always adeptly and sometimes eloquently, though his language tended to the florid. A good example, though far from rivaling Rossetti's flawless sonnet on the sonnet, is "The Sonnet's Voice":

> Yon silvery billows breaking on the beach
> Fall back in foam beneath the star-shine clear,
> The while my rhymes are murmuring in your ear
> A restless lore like that the billows teach;
> For on these sonnet-waves my soul would reach
> From its own depths and rest within you, dear,
> As through the billowy voices yearning here
> Great nature strives to find a human speech.
>
> A sonnet is a wave of melody:
> From billowing waters of the impassioned soul

A billow of tidal music one and whole
Flows in the octave; then, returning free
 Its ebbing surges in the sestet roll
Back to the depths of Life's tumultuous sea.

"The Coming of Love" had been written as a sequel to the still unpublished work of prose fiction, *Aylwin*, and the favorable reception of the book of poems emboldened Watts to bring out the novel in 1898. The hero, a sensitive nature-lover with a gypsy strain in his blood, is to some degree an idealized self-portrait. In childhood he forms a lifelong adoration for a high-spirited little Welsh girl, and later he comes to know her gypsy friends and learn their secret lore. Meanwhile his father, a spiritualist and student of Gnostic mysteries (modeled on Watts's scholarly uncle) initiates him into esoteric studies. Basically, then, the book is an outdoor romance in the tradition initiated by George Borrow (Watts's first literary friend) and maintained in such works as Meredith's *Harry Richmond* and tales and poems by Robert Louis Stevenson. Also the metaphysical element links it with the theosophical and cabalistic cults of the period, diversely represented by du Maurier's *Martian* and Stoker's *Dracula*, both of which came out within a year of *Aylwin*. Upon this substructure is superimposed, when Aylwin goes to London as a painter, a roman à clef about the Pre-Raphaelite artists, with Rossetti figuring as D'Arcy, his wily parasite Howell as De Castro, the neurotic James Smetham as Wilderspin, Kelmscott as Hurstcote Manor, and so forth.

While the descriptions of scenery are poetically lush, and the conversations of the hero and heroine implausibly eloquent, the novel has the charm of out-and-out romanticism, relieved with touches of humor. Though it went through twenty-two editions in six years, Watts made no move to publish another, and two remained in manuscript at the time of his death. In 1905 he married a young woman of less than half his age, who ministered assiduously to Swinburne's declining years. When Watts-Dunton died in his eighty-second year, he was the last survivor of the inner Rossetti circle, a voice from an earlier era.

The distinctive quality of his critical writings was described in 1898 by Arthur Symons:

He is the only contemporary critic who grapples with the essential problems of art. . . . His articles in the Athenaeum . . . are the interrupted confessions of a temperament whose whole activity seems to have passed into a continual brooding over art. They are not literary criticisms, they are meditations, counsels, discourses, upon that which is alone important in literature, that final quality in which it ceases to be 'literary' and becomes absolute, a spirit, an essence. He recognizes form as the interpretation, not as the message; an interpretation to be more jealously scrutinized, because the message is of infinite importance.[46]

The essence of Watts-Dunton's critical theory was expressed in his article on poetry for the *Encyclopaedia Britannica* and another on romanticism for *Chambers's Cyclopaedia of English Literature*; they were reissued posthumously, in a partly revised form, as *Poetry and the Renascence of Wonder*. An unregenerate romanticist, he had complained in one of his reviews that "with the world of pure literature, that unutilitarian world, people seem to have less and less of sympathy every day. Indeed, ignorance of this magic country—ignorance, positive and palpable, of that other world beyond 'Utilitaria'—is the characteristic of most contemporary criticism." Consistently Watts-Dunton asserted the priority of the imagination, "the wise vision of the artist," "the power of actually seeing the imagined object and flashing the picture upon the actual senses of the reader."[47] For him, the Coleridge of "Kubla Khan" and "Christabel" was at the apex of modern poetry. His definition of "absolute poetry" is "the concrete and artistic expression of the human mind in emotional and rhythmical language."[48] The reviews insisted that "pure art knows nothing of society and nothing of God." Again: "The poet, specially and professionally, should deal with the concrete, leaving abstractions to transcendentalist philosophers." The motive of poetic creation, in Watts-Dunton's view, is essentially self-expression: "All art is, if we search deep enough, an expression of an egoism stronger and more vital than common, an egoism 'too strong to die without sign.' " Condemning the intrusion of intellect into poetry, he sets up an antithesis between Poetry of Inspiration and Poetry of Ingenuity. The "power of thought in the artist is shown not in ratiocination but in the invention of motif."[49] From these few citations, it can be seen that in assuming the au-

tonomy of the imagination and the uniqueness of the artist, Watts-Dunton not only propagated the Pre-Raphaelite gospel but anticipated a prevalent attitude of the twentieth century.

During a few years of the eighteen-seventies, a new generation of Rossettian disciples came into view, closely united by personal ties and poetic practice, until a strange fatality put a premature end to their careers. The group centered in the homes of two proud parents who were themselves distinguished personages. On was Ford Madox Brown, whose son Oliver was the youngest and the most precocious of the three youths who showed such brilliant literary promise. The other host was John Westland Marston, father of a boy who in spite of having lost his eyesight at the age of three composed poetry of melodious charm. The elder Marston had started as one of the transcendentalist poets in the orbit of Philip James Bailey; but he soon turned to writing poetic plays, which were remarkably successful, and in mid-Victorian days he was regarded as the leading English dramatist. The third member of the young triumvirate, Arthur O'Shaughnessy, became allied with the group through marrying the blind poet's sister.

Arthur William Edgar O'Shaughnessy (1844–81), though of Irish descent, was born in London, and at the age of seventeen became an assistant in the British Museum, where he remained for the rest of his life, chiefly in the natural history department. He developed into something of an authority on fishes and reptiles, but his consuming interest was poetry, and in 1870 he published *An Epic of Women, and Other Poems*. The first section, consisting of poems on such familiar enchantresses as Helen of Troy, Cleopatra, and Salome, presented a modified version of Swinburne's eroticism. The opening piece, entitled "Creation," was regarded as particularly audacious, though Edmund Gosse protested that, "as some Catholic writers have been drawn through mysticism into sensuousness, O'Shaughnessy was led through sensuous reverie into mystical exaltation. His much maligned and misrepresented poem, 'Creation,' is, if we exclude the cynicism of the last stanza, pure Catholic doctrine."[50] There are echoes of both Rossetti and Browning in "A Troth for Eternity,"

a poem which gives a disturbing picture of psychotic jealousy. "The Fountain of Tears," with a compulsive Swinburnian melody, sets the keynote of morbid melancholy that haunts the book. "Exile" records the sense of alienation that was soon to become the standard poetic defiance of philistinism:

> A common folk I walk among;
> I speak dull things in their own tongue:
> But all the while within I hear
> A song I do not sing for fear—
> How sweet, how different a thing!
> And when I come when none are near
> I open all my heart and sing.

The most remarkable poem in the book, "Bisclaveret," is a gruesome monologue of a man who has become a werewolf and glories in his damnation.

The success of O'Shaughnessy's book brought him into the charmed circle that met at the Brown and Marston residences. The young ichthyologist was entranced by meeting Rossetti, Swinburne, and other idols. Rossetti's *Poems* had just appeared, soon followed by Swinburne's *Songs Before Sunrise;* it was the very heyday of Pre-Raphaelite poetry. In 1873 O'Shaughnessy married a daughter of the hospitable Marston.

O'Shaughnessy's second book, *Lays of France* (1872), consisted of metrical romances, derived from the *Lais* of Marie de France and distinctly reminiscent of Morris's early work, in both language and atmosphere. The best of them, "Chaitivel," tells about a woman whose three lovers have all died. To one of them, Pharamond, she had given a tress of her golden hair, which grew in his coffin until it formed a shroud. After mourning for her lost suitors, she falls in love with Chaitivel, and the knowledge of her infidelity penetrates to them in their graves. On her bridal day the three ghosts return to confront her. Her body is claimed by the one whose mistress she had been, but her soul remains with her new lover until the mighty Pharamond appears in full mail and fights Chaitivel to the death. The poem is weirdly effective in its mixture of morbid terror and lyrical sweetness.

His next book, *Music and Moonlight* (1874), opened with a

poem that has remained his best known, the ode beginning "We are the music makers." There is a clue to his artistic inadequacy, however, in the fact that the poem consisted of nine stanzas, and the anthologists have turned it into a masterpiece by the simple expedient of printing only the first three. Another successful piece is the "Song" which begins:

> I made another garden, yea,
> For my new love;
> I left the dead rose where it lay,
> And set the new above.
> Why did the summer not begin?
> Why did my heart not haste?
> My old love came and walked therein
> And laid the garden waste.

In contrast with the fragile grace of this lyric, the lines "To a Young Murderess" achieve something of Swinburne's voluptuous antithesis of love and hate.

Within the next few years O'Shaughnessy's personal life collapsed. His two children died in infancy; his adored wife died also after a hopeless illness; he burdened himself with hack writing in an effort to enhance his income, and his own death ensued at the age of thirty-seven. A posthumous volume, *Songs of a Worker*, was naturally saturated with more than his habitual melancholy, and his handicap of excessive fluency still persisted. He can be seen, however, as attempting greater philosophical depth in "Christ Will Return," a lamentation for human suffering, and "En Soph," a vision of the pathetic procession of newly created souls passing from the presence of God to endure the pain and frustration of earthly life. These two poems suggest that O'Shaughnessy might eventually have succeeded in moving beyond his narrow range of erotic dreams, melodious melancholy, and legendary terrors.

Philip Bourke Marston (1850–87) was six years younger than O'Shaughnessy, but his first book of poems was published only a few months later than *The Epic of Women*. His pathetic blindness, combined with his exceptional good looks and his precocious

talent, evoked excessive protective affection from his family and friends; they read to him constantly, and in early childhood he began dictating poetry to his mother. Between fifteen and twenty he produced a quantity of surprisingly good verse, and he was preparing for its publication in a book when he was devastated by his mother's death. He recovered happiness when he became engaged to a girl with a lovely voice, and in her praise he composed a sequence of fifty-seven sonnets, which were placed first in his book, *Song Tide*, when it was published in 1871. Of the other poems, the longest is "A Christmas Vigil," in which the Swinburnian morbidity and the Rossettian sensuousness are abundantly displayed. It is a monologue of a prostitute beside the dead body of the man who first seduced her:

> His was the snare in which my soul was caught;
> Oh, the sweet ways wherein for love he wrought!
> Yet God, not he, my wrath of soul shall bear,
> > God set the snare!
> God made him lustful, and God made me fair.
> O God! were not his kisses more to me
> Than Christians' hopes of immortality?
>
> O lovely, wasted fingers, lithe and long,
> > So kind and strong!
> O lips, wherein all laughter was a song,
> All song as laughter! Oh, the cold, calm face,
> The speechless, marble mouth, that had such ways
> Of singing, that for very joy of it
> > My heart would beat
> Almost as loud as when our lips would meet,
> And all love's passion, hotter for its shame,
> Set panting mouths and thirsting eyes on flame.

In full detail she recalls the ecstatic days of their love, and her despair and degradation after he deserted her. On hearing news of his mortal illness, she has come to his bedside, and in his delirium he mistakes her for the frigid woman with whom he has been hopelessly in love, and whose very Pre-Raphaelite portrait hangs above his bed. To soothe his last hours, the girl assumes the impersonation, and lavishes kisses on his dying (and dead) lips.

Just as the undertakers arrive with the coffin, she tears down the picture and flings it away. The shifting moods of sexuality and jealousy are conveyed with astonishing power by the sheltered, twenty-year-old poet.

The other poems are lyrics on the standard themes of love and loss, couched in the fluent meters and conventional images in which the originality of Rossetti and Swinburne had now crystallized. It was not solely sympathy for the poet's disability that led the reviewers to praise the book highly and for the major poets to wax enthusiastic. Rossetti wrote to him: "Only yesterday evening, I was reading your 'Garden Secrets' to William Bell Scott, who fully agreed with me that it is not too much to say of them that they are worthy of Shakespeare in his subtlest lyrical moods."[51] Later, in a sonnet "To Philip Bourke Marston, Inciting Me to Poetic Work," Rossetti conferred on him the apostolic succession:

> Gifted apart, thou goest to the great goal,
> A cloud-bound radiant spirit, strong to earn,
> Light reft, that prize for which fond myriads yearn
> Vainly light-blest,—the Seer's aureole.
>
> And doth thine ear, divinely dowered to catch
> All spheral sounds in thy song blent so well
> Still hearken for my voice's slumbering spell
> With wistful love? Ah, let the Muse now snatch
> My wreath for thy young brows, and bend to watch
> Thy veiled transfiguring sense's miracle.

No sooner was Marston encouraged by the success of his book than he was plunged back into despair by the death of his gentle fiancée. One of his sisters now gave up all her time and personal concerns to be his caretaker and amanuensis, even accompanying him on trips to France and a year in Italy. He formed a devoted friendship with Oliver Madox Brown, five years his junior, and they shared all their literary plans; but young Brown died in 1874. Inevitably, after his series of bereavements, Marston's second book, *All in All*, was darkened by grief. Again sonnets predominate, and move with the same somber dignity as Rossetti's, replete

with personifications of Love, Grief, and Death. The poems maintain a high level of technical skill and of beautiful imagery; but the obsessive mood of misery is bound to become monotonous.

Before long tragedy struck again, when his two sisters died within one year, and his much-loved brother-in-law not long after. By this time his father was in feeble health, and so the blind poet had to depend on outside friends for the attentions that he desperately needed. When he was little more than thirty his own health began to fail, and his financial circumstances, previously comfortable, became straitened. Nothing deterred him from composing poetry, and in the presence of friends he maintained his old charm and gaiety, but his thoughts dwelt more and more on death. Many of the poems in his third volume, *Wind Voices* (1883) are elegies—two on O'Shaughnessy, one each on Oliver Madox Brown, James Thomson (a heartfelt appreciation of "The City of Dreadful Night"), and Rossetti, whose loss was a final blow:

> What wreath have I above thy head to place,
> What worthy song-wreath, Friend,—nay, more than friend?
> For so thou didst all other men transcend
> That the pure, fiery worship of old days—
> That of the boy, content to hear, to gaze—
> Burned on most brightly, though as lamps none tend
> The lights on other shrines had made an end,
> And darkness reigned where was the festal blaze.
>
> Far from us now thou art; and never again
> Thy magic voice shall thrill me, as one thrills
> When noblest music storms his heart and brain.
> The sea remembers thee,—the woods, the hills,
> Sunlight and moonlight, and the hurrying rills,—
> And love saith, "Surely this man leads my train!"

After a stroke that left him speechless and helpless for a fortnight, Marston died in his thirty-seventh year. A posthumous volume of poems, *A Last Harvest*, came out in 1891.

Though Marston's scores of sonnets sound derivative of Rossetti's, his intense personal feeling smolders under the formal language. Apart from despair and the death wish, his most fre-

quent theme is sensual love, often combined with dreams. Naturally, in view of his restricted life, he seldom moved out of the prison of his own emotions. Naturally, too, his imagery is least vivid when it is visual, and the reader therefore gets an impression of familiar stereotypes. It is necessary to relinquish the customary primacy of things seen and to appreciate Marston's responsiveness to the other senses. Music is the overt subject of several poems and recurs in most of them; the sounds of the sea, of wind, of traffic, of voices, even the rustling of a garment, supply Marston's individual idiom.

Of the three young literary friends, the most versatile was Oliver Madox Brown (1855–74), the only son of the painter. In the aesthetic hothouse of Pre-Raphaelitism, it was taken for granted that he was a genius. He set out to be a painter, and during his earlier teens a half-dozen of his pictures, closely imitative of his father's work, were displayed at exhibitions. At the age of fourteen he shifted his ambition to literature and wrote a number of sonnets, most of which he destroyed in a fit of discouragement. He then turned his attention to prose fiction, on the ground that none of the Pre-Raphaelite authors had produced novels. His first, originally entitled *The Black Swan*, after extensive and reluctant revision under editorial pressure, to diminish the shocking and gruesome elements and to provide a happy ending, was published by a leading firm as *Gabriel Denver*, when he was eighteen. He was at work on two other long stories and several short ones when he died of blood poisoning the next year. All his drafts and fragments, along with fourteen poems, were published posthumously.

The affection felt toward him by the Pre-Raphaelite circle, and their sympathy for his father's pride and grief, produced an immediate legend of a lost prodigy, a second Chatterton. Rossetti, Swinburne, Marston, and others wrote the obligatory memorial poems. Privately, however, they admitted that the boy's work was too immature to allow any firm decision as to his merit; it showed remarkable promise rather than fully satisfactory achievement.

In the categories of Victorian fiction, *Gabriel Denver* has to

be classified as a sensational novel. It shows also distinct resemblances to *Jane Eyre* and *Wuthering Heights*. Its original version, *The Black Swan*, was a much more powerful piece of work. The suggestion of diabolic possession is reminiscent of Poe, and the symbolic element links it to Hawthorne. In spite of bombastic diatribes, it depicts adulterous love with passionate violence. The concentration of the action, with the man, his hated wife, and his mistress as castaways from a burned ship, lends both intensity and symbolic significance.

The two uncompleted novels are even more melodramatic. *The Dwale Bluth* includes a family curse, a half-gypsy child with an obsessive will to poison herself, and a blind poet clearly modeled on Philip Marston. *Hebditch's Legacy* centers upon a hidden will, an assumed identity, and an intricate set of love affairs. The hackneyed and implausible plots, however, are the vehicle for disturbingly powerful displays of primitive passions. The principal characters are monomaniacs, each controlled by a single urge—revenge, avarice, the death wish. The stories are full of psychotic dreams and weird superstitions, and the landscape settings (or, in *Hebditch's Legacy*, the swarming horror of London) are used to enhance the mood of each scene. All this is standard gothic practice, but Brown was unmistakably endeavoring, with inadequate technical mastery, to confront the basic problems of good and evil.

In spite of the conspicuous influence of Rossetti, Swinburne, and Morris on the work of the three young friends, Watts-Dunton protested against the assumption that they could be labeled as a new Pre-Raphaelite school. They were equally affected, he insisted, by the modern French poets, particularly Baudelaire and Gautier. While it is true that they were devoted admirers of the emerging French school of symbolism, this fact is merely another way of viewing the Pre-Raphaelite element. It was Swinburne who had introduced the enthusiasm for the French creed of art for art's sake; and conversely the French poets had been affected by such Pre-Raphaelite favorites as Poe.

With the untimely deaths of the three young authors, the charismal influence of Rossetti's personality came to an end. This

did not mean, however, that the movement had terminated; rather, it spread into a wider ambience. Probably the well-being of English poetry was benefited thereby, for O'Shaughnessy and Marston were so utterly enslaved by their adherence to Rossetti that they showed only tenuous indications of ever being able to write with originality.

One minor by-product of Pre-Raphaelite poetry was the vogue for the fixed French lyric forms. Introduced by Rossetti and Swinburne, ballades, rondeaux, and villanelles became the stock in trade of a swarm of minor poets in the eighties, such as Austin Dobson, Andrew Lang, and Edmund Gosse. These accomplished men of letters thus displayed their virtuosity in graceful witty verse without being obliged to contribute anything like originality or sincere feeling. The concept of poetry as a metrical artifact could go no further.

Much more important was the emergence of aestheticism, under the aegis of Walter Pater (1839–94). When he came up to Oxford in 1858 he was a year too late to be exposed to the Rossettian incursion that chained Morris and Swinburne to his chariot; but he inhaled the same mental atmosphere and inherited the same predilections. Oxford was ripe for aestheticism: the Tractarian incense still lingered in the air, Ruskin and Arnold maintained close ties with the university, and various student groups were discussing the arts. When Pater took root permanently in Oxford in 1864 as a Fellow of Brasenose, he became acquainted with Swinburne, and later he formed friendships with O'Shaughnessy, Solomon, and other satellites; but his shyness and his seclusion in Oxford prevented him from entering the intimate Rossetti circle. He had written poetry as an undergraduate, but destroyed it when he decided that his métier was critical prose. As an authority on Plato in philosophy and on the Renaissance in history and art, he lent academic prestige to the subversive new doctrine of beauty for its own sake. It was clearly perceptible in the essays that he wrote during the sixties, and his melodious prose style was the appropriate medium for the gospel of beauty. In an article on Morris's work, in 1868, he introduced the phrase "aesthetic poetry" and pointed out the "pagan spirit" that dis-

tinguished the Pre-Raphaelite group and Rossetti in particular—
"the continual suggestion, pensive or passionate, of the shortness
of life. This is contrasted with the bloom of the world, and gives
new seduction to it—the sense of death and the desire of beauty;
the desire of beauty quickened by the sense of death."[52] It was
in this essay that Pater first asserted that "to burn always with this
hard, gemlike flame, to maintain this ecstasy, is success in life"—
a credo that evoked a furor when it was incorporated into his
first book, *The Renaissance*, in 1873. By this time he had won
adherence from a small circle of admiring students, and the book
caused him to be recognized, by partisans and scoffers alike, as
the pontiff of a new creed.

Pater was one of the channels by which Pre-Raphaelite in-
fluence reached the most remarkable young poet of the time,
Gerard Manley Hopkins (1844–89). The apparent novelty of
Hopkins's style, when his work was tardily published in 1918,
blinded critics to the fact that he had been strongly affected by
the poetry of his own era; and his devout Catholicism was indeed
remote from the agnostic or atheistic views of the leading Pre-
Raphaelites. Nevertheless, the strongest traits of his poetic method
have much in common with theirs. As well as being intimate with
Pater, Hopkins had two associates of the Rossetti circle, Coventry
Patmore and Richard Watson Dixon, among his closest friends.
Gifted in music and painting as well as in poetry, Hopkins in his
undergraduate days was the very model of the modern aesthete.
His letters show that he was thoroughly familiar with the
poetry of the Pre-Raphaelites, though with characteristic self-
confidence he did not hesitate to point out their defects. At the
age of twenty, he offered the definition of Rossetti's "Olympian"
style that has been quoted in an earlier chapter. Just at this time he
met Christina Rossetti and her sister, and he reported that "I have
nearly finished an answer to Miss Rossetti's 'Convent Threshold,'
to be called 'A Voice from the World,' or something like that."[53]
In 1881, surveying the current types of poetry, he told Dixon: "I
hold that you and Morris belong to one school . . . I suppose the
same models, the same masters, the same tastes . . . the same keep-

ings, above all, make the school. . . . I used to call it the school of Rossetti: it is in literature the school of the Pre-Raphaelites. . . . This modern medieval school is descended from the Romantic school (Romantic is a bad word) of Keats, Leigh Hunt, Hood, indeed of Scott early in the century."[54] In 1886, he remarked perceptively that "some men exercise a deep influence on their own age in virtue of certain powers at that time original, new, and stimulating, which afterwards ceasing to stimulate their fame declines; because it was not supported by an execution, an achievement equal to the power. For nothing but fine execution survives long. This was something of Rossetti's case perhaps."[55]

It was natural that he admired Christina Rossetti, with her religious intensity, more than her brother. In 1872 he said, "she has been, I am afraid, thrown rather into the shade by her brother. I have not read his book. From the little I have seen and gathered of it I daresay he has more range, force, and interest, and then there is the difference between a man and a woman, but for pathos and pure beauty of art I do not think he is her equal: in fact the simple beauty of her work cannot be matched."[56] Hopkins's notebooks show that he paid close attention to her technical idiosyncracies such as assonances and eye-rhymes.

In Swinburne's poetry he objected first to lasciviousness "where the proportion of these subjects is great and secondly where the things themselves are the extreme cases in their own kind."[57] In 1877 he was comparing his own "sprung rhythm" with Swinburne's mingling of duple and triple feet: "Swinburne's dactyls and anapaests are halting to my ear."[58] Two years later he was much concerned with forming a critical estimate of the poet: "I do not think [the Swinburnian kind] goes far: it expresses passion but not feeling, much less character. . . . Swinburne's genius is astonishing, but it will, I think, only do one thing."[59] He admits that his friend Bridges does not have "such a volume of imagery as Tennyson, Swinburne, or Morris . . . but in point of character, of sincerity or earnestness, of manliness, of tenderness, of humour, melancholy, human feeling, you have what they have not and seem scarcely to think worth having."[60] In both Swinburne and Morris he repeatedly objected to archaisms ("I look on archaism as a blight").[61] By 1881 he was declaring: "Swinburne is a strange

phenomenon: his poetry seems a powerful effort at establishing a new standard of poetic diction, of the rhetoric of poetry; but to waive every other objection it is essentially archaic, biblical a good deal, and so on: now that is a thing that can never last; a perfect style must be of its age." [62] In 1883 the complaint was still that Swinburne and Tennyson are "weak ... in thought and insight." [63] Two years later he found fault with Swinburne's descriptions of scenery: "Either in fact he does not see nature at all or else he overlays the landscape with such phantasmata, secondary images, and what not of a delirium-tremendous imagination that the result is a kind of bloody broth. . . . At any rate, there is no picture." [64] In 1888 he was able to say of *Locrine*: "for music of words and the mastery and employment of a consistent and distinctive poetic diction, a style properly so called, it is extraordinary. . . . I shd. think it could only be in Persian or some other eastern language that a poetical dialect so ornate and continuously beautiful could be found. But words only are only words." [65]

In spite of his ambivalent view of the Pre-Raphaelite poets, Hopkins was deeply affected by their work. The poems surviving from his early period have the sort of mellifluous smoothness of language and meter, the pictorial elaboration, that was being produced by O'Shaughnessy and Marston. The longest, "A Vision of Mermaids," is wholly Pre-Raphaelite in its sensuous detail and lavish use of color. The three sonnets called "The Beginning of the End" are in the Rossettian manner. "Rosa Mystica" is a formal symbolic picture:

> What was the colour of that Blossom bright?
> White to begin with, immaculate white.
> But what a wild flush on the flakes of it stood,
> When the Rose ran in crimsonings down the Cross-wood.
> In the Gardens of God, in the daylight divine
> I shall worship the Wounds with thee, Mother of mine.
>
> How many leaves had it? Five they were then,
> Five like the senses, and members of men;
> Five is the number by nature, but now
> They multiply, multiply, who can tell how.
> In the Gardens of God, in the daylight divine
> Make me a leaf in thee, Mother of mine.

After the abrupt change in Hopkins's poetic style when he felt permitted to resume writing poetry, the Pre-Raphaelite decorative fluency gave place to the rugged intensity of his new manner; but his apparently innovative technique, with its emphatic repetitions, its excessive dependence on alliteration, and its mixing of duple and triple feet, was mainly a concentrated version of Swinburne. Some stanzas of "The Wreck of the Deutschland" could almost be inserted into "Hertha":

> The frown of his face
> Before me, the hurtle of hell
> Behind, where, where was a, where was a place?
> I whirled out wings that spell
> And fled with a fling of the heart to the heart of the Host.
> My heart, but you were dovewinged, I can tell,
> Carrier-witted, I am bold to boast,
> To flash from the flame to the flame then, tower from the
> grace to the grace.

While the rigorous compression of phrase in Hopkins's subsequent poems is the very antithesis of Swinburne's verbosity, the alliterations and sprung rhythm are simply a freer development of what in Swinburne was often a too mechanical pattern.

If the Pre-Raphaelite element in Hopkins has been obscured by his verbal and rhythmic experiments, it is all too obvious in the large group of poets who came to be classified as the Aesthetes and the Decadents. Every discussion of their work has indicated how faithfully they accepted and exaggerated the doctrines of Pater. Several of them—Oscar Wilde, Ernest Dowson, Lionel Johnson—had come directly within his orbit at Oxford, and others caught their enthusiasm at the Rhymers' Club. Yeats had a direct affiliation with the original Pre-Raphaelites through his father's artistic activities; he says in his *Autobiographies* that in his early London days he was "in all things Pre-Raphaelite." His devotion to Blake was another manifestation of the Rossetti-Swinburne influence. Of the whole fin-de-siècle group he declared, "we were all Pre-Raphaelites then," and more specifically in "The Tragic Generation" he explained, "If Rossetti was a sub-

conscious influence, and perhaps the most powerful of all, we looked consciously to Pater for our philosophy."[66]

To this indigenous source was joined the kindred influence of the French symbolists, promoted particularly by Arthur Symons. The concept of the alienated poet, writing solely to express his inward vision of beauty and despising the philistine standards of the everyday world, was carried over into the writers' personal behavior, as they indulged in alcohol or narcotics or sexual aberrations and usually declined into an early and miserable death. For this stereotype, Rossetti and Swinburne were models as conspicuous as Verlaine and Rimbaud. Even nonmembers of the Aesthetic group, such as Francis Thompson, conformed to the pattern. Not only in attitude, in subject matter, and in conduct, but also in the techniques of imagery, vocabulary, and versification, the poets of the eighties and nineties were the heirs of their Pre-Raphaelite predecessors.

In all essentials, then, the movement initiated by Rossetti proved to be the most potent force in mid-Victorian poetry. Shaping themselves on the great Romantics—Coleridge, Byron, Shelley, and Keats—they flouted the Victorian compromise with gentility and social consciousness. They revitalized English poetry by an injection of foreign hormones, and they determined not only the whole theory and practice of the so-called Last Romantics of the next generation but also to a large extent the poetic assumptions of such twentieth-century writers as the imagists. The dynamic energy of Pre-Raphaelite poetry had been generated by the electrical interplay among a half-dozen highly individual personalities during the crucial years from 1850 to 1870. Their stubborn rejection of materialistic values and a mechanistic society remains vitally important a century later.

NOTES

CHAPTER I

1. Review of *Virginia's Hand* by Marguerite A. Power, *Athenaeum*, 12 May 1860, p. 647.

2. Peter Bayne, *Essays in Biography and Criticism*, ser. 1 (Boston, 1857), p. 392.

3. Review of *Lays of Judah* by Robert Frame, *Athenaeum*, 20 August 1859, p. 242.

4. John Skelton, "Mr. Swinburne and His Critics," *Fraser's Magazine* 74 (1866):641.

CHAPTER II

1. Matthew Arnold, "The Function of Criticism at the Present Time," in *Essays in Criticism* (London, 1865), pp. 1–48.

2. John Ruskin, *The Works of John Ruskin*, ed. E. T. Cook and A. D. O. Wedderburn, Library Edition (London, 1903), vol. 3, *Modern Painters*, 1:111.

3. Ibid., p. 87.

CHAPTER III

1. Dante Gabriel Rossetti, *Dante Gabriel Rossetti: His Family-Letters*, ed. William Michael Rossetti (London, 1895), 1:83 (hereafter cited as *Family-Letters*).

2. Ibid., p. 123.

3. T. Hall Caine, *Recollections of Dante Gabriel Rossetti* (London, 1882), p. 284.

4. Dante Gabriel Rossetti, *Letters of Dante Gabriel Rossetti*, ed. Oswald Doughty and J. R. Wahl (Oxford, 1965–67), 3:1233 (hereafter cited as *Letters of Rossetti*).

5. Ibid., 1:384, 2:783, 850.

6. Algernon Charles Swinburne, *The Swinburne Letters*, ed. Cecil Y. Lang (New Haven, Conn., 1959–62), 2:64 (hereafter cited as *Swinburne Letters*).

7. *Letters of Rossetti*, 2:838.

8. Graham Hough, *The Last Romantics* (London, 1949), p. 53.

9. J. W. Mackail, *The Life of William Morris* (London, 1899), 1:110.

10. *Letters of Rossetti*, 1:214.

11. Ibid., 1:335.

12. Dante Gabriel Rossetti, *Letters of Dante Gabriel Rossetti to William Allingham*, ed. George Birkbeck Hill (London, 1897), p. 247.

13. George Meredith, *The Letters of George Meredith*, ed. C. L. Cline (Oxford, 1970), 1:106 (hereafter cited as *Letters of Meredith*).

14. Rosalie Glynn Grylls, *Portrait of Rossetti* (London, 1964), p. 131.

15. Henry James, *The Letters of Henry James*, ed. Percy Lubbock (New York, 1920), pp. 17–18.

16. William James Stillman, *The Autobiography of a Journalist* (Boston, 1901), 2:476.

17. Grylls, *Portrait of Rossetti*, p. 135.

18. Ibid., p. 136.

19. Thomas Maitland [pseud.], "The Fleshly School of Poetry," *Contemporary Review* 18 (1871):336–39.

20. Review of *Poems* by Dante Gabriel Rossetti, *Quarterly Review* 132 (1872):73–74.

21. Browning had, indeed, taken Buchanan's side in the controversy, and probably his portrayal of Juan and Fifine was influenced by "Jenny" (see W. C. DeVane, *A Browning Handbook* [New York, 1955], pp. 365–67).

22. Robert Browning, *Dearest Isa: Robert Browning's Letters to Isa Blagdon*, ed. Edward C. McAleer (Austin, Texas, 1951), pp. 336–37.

23. Maitland, "Fleshly School of Poetry," pp. 336–39.

24. Walter Pater, *Appreciations: With an Essay on Style* (London, 1889), pp. 229–30.

25. Oscar Wilde, *The Collected Works of Oscar Wilde*, ed. Robert Ross (London, 1908), 1:253–54.

26. Lord David Cecil, "Dante Charles Gabriel Rossetti" in *The Great Victorians*, ed. H. J. Massingham and Hugh Massingham (London, 1932), p. 443.

27. Dante Gabriel Rossetti, *The House of Life*, ed. Paull F. Baum (Cambridge, Mass., 1928), pp. 8–10.

28. Hough, *Last Romantics*, pp. 67–70, 77.

29. Cecil, "Rossetti," p. 444.

30. D. G. Rossetti, *House of Life*, pp. 25–26.

31. Hough, *Last Romantics*, pp. 68–69, 82.

32. John Heath-Stubbs, *The Darkling Plain* (London, 1950), pp. 154–58.

33. W. W. Robson, "Pre-Raphaelite Poetry," in *The Pelican Guide to English Literature*, ed. Boris Ford, vol. 6. *From Dickens to Hardy* (London, 1968), pp. 358–63.

34. Gerard Manley Hopkins, *Further Letters of Gerard Manley Hopkins*, ed. C. C. Abbott (London, 1938), p. 73.

35. *Letters of Rossetti*, 2:850.

36. William E. Fredeman, "Rossetti's *In Memoriam*," *Bulletin of the John Rylands Library* 47 (1965):298–341.

37. Dante Gabriel Rossetti, *The Collected Works of Dante Gabriel Rossetti*, ed. William Michael Rossetti (London, 1886), 1:xxxiv (hereafter cited as *Collected Works of Dante Gabriel Rossetti*).

38. Caine, *Recollections of Rossetti*, p. 220.

39. *Family-Letters*, 1:420–21.

CHAPTER IV

1. Christina Rossetti, *The Poetical Works of Christina Georgina Rossetti*, ed. William Michael Rossetti (London, 1904), p. xlix (hereafter cited as *Poetical Works*).

2. Rosalie Glynn Grylls, *Portrait of Rossetti* (London, 1964), p. 24.

3. Lona Mosk Packer, *Christina Rossetti* (Berkeley, Calif., 1963), *passim*.

4. *Poetical Works*, p. liv.

5. Packer, *Christina Rossetti*, p. 56.

6. *Poetical Works*, p. li.

7. *Letters of Rossetti*, 1:162.

8. Packer, *Christina Rossetti*, p. 204.

9. Violet Hunt, *The Wife of Rossetti: Her Life and Death* (London, 1932), p. xiii.

10. William Michael Rossetti, ed., *Ruskin, Rossetti, Preraphaelitism* (London, 1899), pp. 258–59.

11. *Poetical Works*, p. 462.

12. Maurice Bowra, *The Romantic Imagination* (Cambridge, Mass., 1949), pp. 254–55.

13. *Poetical Works*, p. 462.

14. *Letters of Rossetti*, 2:797.

15. Gerard Manley Hopkins and Richard Watson Dixon, *The Correspondence of Gerard Manley Hopkins and Richard Watson Dixon*, ed. C. C. Abbott (London, 1935), pp. 62, 77 (hereafter cited as *Hopkins-Dixon Correspondence*).

16. Packer, *Christina Rossetti*, p. 341.

17. Christina Rossetti, *The Family Letters of Christina Georgina Rossetti*, ed. William Michael Rossetti (London, 1908), pp. 176–77.

18. Bowra, *Romantic Imagination*, pp. 246–49.

CHAPTER V

1. William Morris, "The Aims of Art," in *The Collected Works of William Morris*, ed. May Morris (London, 1915), 23:85 (hereafter cited as *Collected Works of William Morris*).

2. Georgiana Burne-Jones, *Memorials of Edward Burne-Jones* (London, 1904), 1:99.

3. J. W. Mackail, *The Life of William Morris* (London, 1899), 1:52.

4. Burne-Jones, *Memorials of Edward Burne-Jones*, 1:109.

5. Mackail, *Life of William Morris*, 1:77.

6. Ibid., p. 81.

7. Ibid., p. 100.

8. Ibid., pp. 106–7.

9. Ibid., p. 108.

10. Ibid., p. 111.

11. Ibid., p. 126.

12. Edmund Gosse, *The Life of Algernon Charles Swinburne* (London, 1917), p. 43.

13. Burne-Jones, *Memorials of Edward Burne-Jones*, 1:162.

14. Mackail, *Life of William Morris*, 1:132.

15. Ibid., p. 133.

16. Walter Pater, *Appreciations: With an Essay on Style* (London, 1889), pp. 215–18.

17. Algernon Charles Swinburne, *The Complete Works of Algernon Charles Swinburne*, ed. Edmund Gosse and T. J. Wise, Bonchurch Edition (London, 1926), 15:51–52 (hereafter cited as *Complete Works of Swinburne*).

18. Matthew Arnold, "On Translating Homer," in *The Complete Prose Works of Matthew Arnold*, ed. R. H. Super (Ann Arbor, Mich., 1960), 1:127.

19. [Henry James], review of *The Life and Death of Jason* by William Morris, *North American Review* 105 (1867):689.

20. Mackail, *Life of William Morris*, 1:186.

21. May Morris, *William Morris: Artist, Writer, Socialist* (Oxford, 1936), 1:402.

22. William Morris, review of *Poems* by Dante Gabriel Rossetti, *Academy* 1 (1870):200–201.

23. *Swinburne Letters*, 2:68.

24. *Letters of Rossetti*, 2:773.

25. William Morris, *The Letters of William Morris to His Family and Friends*, ed. Philip Henderson (London, 1950), p. 30.

26. Ibid., pp. 50–51.

27. May Morris, *William Morris*, 2:xxxvii.

28. *Collected Works of William Morris*, 12:xxiii.

29. Ibid., 7:286.

30. Mackail, *Life of William Morris*, 1:302–3.

31. Ibid., 1:305.

32. *Collected Works of William Morris*, 22:164.

33. Mackail, *Life of William Morris*, 2:74–75.

34. *Swinburne Letters*, 4:307.

35. Mackail, *Life of William Morris*, 2:1.

36. Oscar Wilde, *The Collected Works of Oscar Wilde*, ed. Robert Ross (London, 1908), 3:154–55.

37. Philip Henderson, *William Morris: His Life, Work, and Friends* (London, 1967), p. 218.

CHAPTER VI

1. George Birkbeck Hill, *Letters of George Birkbeck Hill*, ed. Lucy Crump (London, 1906), p. 66.

2. John Keats, *The Poetical Works of John Keats*, ed. H. W. Garrod (Oxford, 1939), p. 64.

3. *Swinburne Letters*, 1:13.

4. Hallam Lord Tennyson, *Alfred Lord Tennyson: A Memoir* (London, 1897), 1:425.

5. *Swinburne Letters*, 1:16.

6. William Stubbs, *The Letters of William Stubbs*, ed. William Holden Hutton (London, 1904), p. 50.

7. *Swinburne Letters*, 1:25.

8. Georgiana Burne-Jones, *Memorials of Edward Burne-Jones* (London, 1904), 1:215.

9. Review of *The Queen Mother and Rosamond* by Algernon Charles Swinburne, *Spectator* 34 (1861):42.

10. Review of *The Queen Mother and Rosamond* by Algernon Charles Swinburne, *Athenaeum*, 4 May 1861, p. 595.

11. *Swinburne Letters*, 1:41.

12. Ibid., p. 38.

13. Samuel Taylor Coleridge, "Preface to *Christabel*," in *The Poetical Works of Samuel Taylor Coleridge*, ed. James Dykes Campbell (London, 1893), p. 601.

14. *Letters of Meredith*, 1:106.

15. *Swinburne Letters*, 6:94.

16. Edmund Gosse, *The Life of Algernon Charles Swinburne* (London, 1917), p. 85.

17. Elizabeth R. Pennell and Joseph Pennell, eds., *The Whistler Journal* (Philadelphia, 1921), p. 24.

18. Henry Adams, *The Education of Henry Adams* (Boston, 1918), pp. 139–41.

19. *Complete Works of Swinburne*, 13:419, 423.

20. Robert Browning, *New Letters of Robert Browning*, ed. W. C. DeVane and K. J. Knickerbocker (New Haven, Conn., 1950), p. 150.

21. T. J. Wise, ed., *A Swinburne Library* (London, 1925), p. 261.

22. John S. Mayfield, *Swinburne's Boo* (Bethesda, Md., 1953).

23. Cecil Y. Lang, "Swinburne's Lost Love," *Publications of the Modern Language Association* 74 (1959):123 30; Jean Overton Fuller, *Swinburne: A Critical Biography* (London, 1968), *passim*; F. A. C. Wilson, "Swinburne's 'Dearest Cousin': The Character of Mary Gordon," *Literature and Psychology* 19 (1969):89–99.

24. *Complete Works of Swinburne*, 16:133, 147.

25. Simon Nowell-Smith, ed., *Letters to Macmillan* (London, 1967), pp. 95–96.

26. Algernon Charles Swinburne, *The Collected Poems of Algernon Charles Swinburne* (London, 1904), 1:xiii.

27. *Swinburne Letters*, 1:115.

28. [Lord Houghton], review of *Atalanta in Calydon* by Algernon Charles Swinburne, *Edinburgh Review* 120 (1865):202.

29. *Swinburne Letters*, 1:125.

30. Review of *Atalanta in Calydon* by Algernon Charles Swinburne, *Athenaeum*, 1 April 1865, p. 451.

31. Quoted in Georges Lafourcade, *Swinburne: A Literary Biography* (London, 1932), p. 125.

32. Review of *Atalanta in Calydon* by Algernon Charles Swinburne, *Saturday Review* 19 (1865):541.

33. John Ruskin, *Letters of John Ruskin to Charles Eliot Norton*, ed. C. E. Norton (Boston, 1904), 1:157.

34. *Swinburne Letters*, 1:136.

35. Review of *Chastelard* by Algernon Charles Swinburne, *Spectator* 28 (1865):1342–44.

36. Review of *Chastelard* by Algernon Charles Swinburne, *Athenaeum*, 23 December 1865, pp. 880–81.

37. Lord Houghton, "Mr. Swinburne's *Chastelard*," *Fortnightly Review* 4 (1866):535.

38. *Letters of Rossetti*, 2:529.

39. *Letters of Meredith*. 1:330.

40. *Swinburne Letters*, p. 141.

41. Ibid.

42. Ibid., pp. 139–40.

43. Ibid.

44. Ibid., p. 173.

45. [Robert Buchanan], review of *Poems and Ballads* by Algernon Charles Swinburne, *Athenaeum*, 4 August 1866, pp. 137–38.

46. [John Morley], review of *Poems and Ballads* by A. C. Swinburne, *Saturday Review* 22 (1866):145–47.

47. Winwood Reade to Algernon Charles Swinburne, 2 December 1866, private collection of J. N. L. O'Loughlin, Esq., London, England.

48. James Russell Lowell, *Letters of James Russell Lowell*, ed. C. E. Norton (New York, 1893), 1:377.

49. *Swinburne Letters*, 1:208–9.

50. *Complete Works of Swinburne*, 16:354.

51. Ibid., p. 359.

52. Ibid., p. 360.

53. Ibid., p. 361.

54. *Swinburne Letters*, 1:122, 123.

55. T. S. Eliot, *The Sacred Wood* (London, 1920), pp. 135–36.

56. *Swinburne Letters*, 1:182.

57. Ibid., p. 195.

58. Ibid., p. 58.

59. Georges Lafourcade, *La Jeunesse de Swinburne* (Paris, 1928), 1:253–54.

60. *Swinburne Letters*, 1:242.

61. Giuseppe Mazzini, *Mazzini's Letters to an English Family, 1861–1872*, ed. E. F. Richards (London, 1922), pp. 154, 207, 239.

62. *Swinburne Letters*, 1:242.

63. Ibid., 6:168.

64. Ibid., 1:286, 281, 307.

65. Ibid., 2:37.

66. Ibid., pp. 80, 85.

67. Ibid., p. 95.

68. Ibid., p. 62.

69. Ibid., p. 95.

70. Ibid., p. 173.

71. Ibid., p. 51.

72. Ibid., p. 59.

73. Ibid., pp. 211–12.

74. Ibid., 4:158.

75. Ibid., 2:73.

76. Swinburne, *Collected Poems*, 1:xviii.

77. *Swinburne Letters*, 4:275.

78. [Walter Theodore Watts], review of *Tristram of Lyonesse* by Algernon Charles Swinburne, *Athenaeum*, 22 July 1882, p. 105. In 1897, Watts added his mother's surname and dropped the preliminary "Walter." He is hereafter cited as Theodore Watts-Dunton.

79. J. W. Mackail, *The Life of William Morris* (London, 1899), 2:74.

80. Matthew Arnold, *Letters of Matthew Arnold*, ed. George W. E. Russell (New York, 1895), 2:232.

81. *Complete Works of Swinburne*, 14:83.

82. *Letters of Meredith*, 3:1691.

CHAPTER VII

1. *Swinburne Letters*, 1:289.

2. William Michael Rossetti, *Some Reminiscences* (London, 1906), 1:78.

3. William Michael Rossetti, ed., *Pre-Raphaelite Diaries and Letters* (London, 1906), p. 222.

4. *Family-Letters*, 1:100.

5. William Bell Scott, *Autobiographical Notes* (London, 1892), 1:3.

6. Lona Mosk Packer, *Christina Rossetti* (Berkeley, Calif., 1963), pp. 341–42.

7. *Complete Works of Swinburne*, 16:14.

8. Derek Patmore, *The Life and Times of Coventry Patmore* (London, 1949), p. 46.

9. Ibid., p. 49.

10. Ibid., p. 46.

11. Review of *Poems* by Coventry Patmore, *Blackwood's Magazine* 56 (1844):342.

12. Patmore. *Coventry Patmore*, p. 68.

13. Rossetti, *Some Reminiscences*, 1:83.

14. Patmore, *Coventry Patmore*, pp. 74–75.

15. Ibid., p. 60.

16. Basil Champneys, *Memoirs and Correspondence of Coventry Patmore* (London, 1900), 1:159.

17. Rossetti, *Pre-Raphaelite Diaries and Letters*, p. 267.

18. Ibid., pp. 228–29, 233.

19. Champneys, *Coventry Patmore*, 1:160.

20. Ibid., 1:167.

21. Osbert Burdett, *The Idea of Coventry Patmore* (London, 1921), p. 13.

22. Frederick H. Page, *Patmore: A Study in Poetry* (Oxford, 1933), p. 101.

23. William Allingham, *William Allingham: A Diary*, ed. H. Allingham and D. Radford (London, 1907), p. 137.

24. Ibid., p. 162.

25. Ibid., p. 166.

26. Ibid., p. 91.

27. James Sambrook, *A Poet Hidden: The Life of Richard Watson Dixon* (London, 1962), p. 26.

28. Ibid., p. 55.

29. Ibid.

30. W[illiam] M[ichael] R[ossetti], review of *Poems* by George Meredith, *Critic* 10 (1851):539–40.

31. *Letters of Meredith*, 1:85.

32. Ibid., p. 106.

33. *Letters of Rossetti*, 2:424; S. M. Ellis, ed., *A Mid-Victorian Pepys* (London, 1928), p. 77.

34. Review of *Modern Love* by George Meredith, *Spectator* 35 (1862):580–81.

35. A[lgernon] C[harles] Swinburne, "Mr. George Meredith's *Modern Love*." *Spectator* 35 (1862):632–33.

36. Rossetti, *Some Reminiscences*, 1:287.

37. Joseph Knight, *Life of Dante Gabriel Rossetti* (London, 1887), p. 180.

38. *Letters of Meredith*, 1:353.

39. Rossetti, *Some Reminiscences*, 1:100, 281.

40. *Family-Letters*, 1:310.

41. *Collected Works of Dante Gabriel Rossetti*, 1:498–99.

42. Ibid., p. 501.

43. Thomas Gordon Hake, *Memoirs of Eighty Years* (London, 1892), pp. 249–50.

44. *Complete Works of Swinburne*, 15:313.

45. T. S. Hake and A. Compton-Rickett, *The Life and Letters of Theodore Watts-Dunton* (London, 1916), 1:229.

46. Arthur Symons, review of *The Coming of Love* by Theodore Watts-Dunton, *Saturday Review* 85 (1898):82.

47. Theodore Watts-Dunton, review of *Thomas de Quincey* by H. A. Page, *Athenaeum*, 2 June 1877, p. 697; review of *La Légende des Siècles* by Victor Hugo, *Athenaeum*, 17 March 1877, p. 348; review of *A Note on Charlotte Brontë* by A. C. Swinburne, *Athenaeum*, 1 September 1877, p. 264.

48. Theodore Watts-Dunton, *Poetry and the Renascence of Wonder* (London, 1916), pp. 8–9.

49. Theodore Watts-Dunton, review of *Poems and Ballads*, ser. 2 by A. C. Swinburne, *Athenaeum*, 6 July 1878, p. 1878, p. 8; review of *Poems and Lyrics of the Joy of Earth* by George Meredith, *Athenaeum*, 26 July 1883, p. 103; review of *La Saisiaz* by Robert Browning, *Athenaeum*, 25 May 1878, p. 611; review of *La Légende des Siècles* by Victor Hugo, *Athenaeum*, 17 March 1877, p. 348.

50. Edmund Gosse, "Arthur O'Shaughnessy," *Academy* 19 (1881):99.

51. Philip Bourke Marston, *The Collected Poems of Philip Bourke Marston*, ed. Louise Chandler Moulton (Boston, 1892), p. xxiii.

52. Walter Pater, "Aesthetic Poetry," in *Appreciations: With an Essay on Style* (London, 1889), pp. 213–27. This essay was written in 1868.

53. Gerard Manley Hopkins, *Further Letters of Gerard Manley Hopkins*, ed. C. C. Abbott (London, 1938), p. 66.

54. *Hopkins-Dixon Correspondence*, p. 98.

55. Ibid., p. 134.

56. Hopkins, *Further Letters*, p. 119.

57. Ibid., p. 82.

58. Gerard Manley Hopkins, *The Letters of Gerard Manley Hopkins to Robert Bridges*. ed. C. C. Abbott (Oxford, 1935), p. 44.

59. Ibid., p. 79.

60. Ibid., p. 96.

61. Hopkins, *Further Letters*, p. 148.

62. *Hopkins-Dixon Correspondence*, p. 99.

63. Hopkins, *Further Letters*, p. 189.

64. Hopkins, *Letters to Bridges*, p. 202.

65. *Hopkins-Dixon Correspondence*, pp. 156–57.

66. William Butler Yeats, *The Autobiography of William Butler Yeats* (New York, 1938), pp. 100, 147, 257.

BIBLIOGRAPHY

CHAPTER II

Angeli, Helen Rossetti. *Dante Gabriel Rossetti: His Friends and Enemies.* London, 1949.

————. *Pre-Raphaelite Twilight: The Story of Charles Augustus Howell.* London, 1954.

Bickley, Francis. *The Pre-Raphaelite Comedy.* London, 1932.

Bowra, C. M. *The Romantic Imagination.* Cambridge, Mass., 1949.

Fleming, G. H. *Rossetti and the Pre-Raphaelite Brotherhood.* London, 1966.

————. *That Ne'er Shall Meet Again.* London, 1971.

Fredeman, William E. "A Pre-Raphaelite Gazette: The Penkill Letters of Arthur Hughes." *Bulletin of the John Rylands Library* 49 (1967):323-62; 50 (1967):34–82.

————. "The Pre-Raphaelites." In *The Victorian Poets: A Guide to Research,* ed. F. E. Faverty, pp. 251–316. 2d ed. Cambridge, Mass., 1968.

————. *Pre-Raphaelitism: A Bibliocritical Study.* Cambridge, Mass., 1965.

Gaunt, William. *The Pre-Raphaelite Tragedy.* London, 1942.

Heath-Stubbs, John. "Pre-Raphaelitism and the Aesthetic Withdrawal." In *The Darkling Plain,* pp. 148–78. London, 1950.

Hilton, Timothy. *The Pre-Raphaelites.* London, 1970 .

Hough, Graham. *The Last Romantics.* London, 1949.

House, Humphry. "Pre-Raphaelite Poetry." In *All in Due Time: The Collected Essays and Broadcast Talks of Humphry House*, pp. 151–58. London, 1955.

Housman, Laurence. "Pre-Raphaelitism in Art and Poetry." *Essays by Divers Hands* 12 (1933):1–29.

Hueffer, Ford Madox. *The Pre-Raphaelite Brotherhood*. London, 1907.

Hunt, William Holman. *Pre-Raphaelitism and the Pre-Raphaelite Brotherhood*. 2 vols. 1905–6. 2d ed., rev. London, 1913.

Nicol, John. *The Pre-Raphaelites*. London, 1970.

Rossetti, William Michael. *Ruskin, Rossetti, Preraphaelitism*. London, 1899.

———, ed. *Preraphaelite Diaries and Letters*. London, 1900.

———, ed. *Rossetti Papers, 1862–1870*. London, 1903.

Ruskin, John. *Pre-Raphaelitism*. London, 1851.

Spender, Stephen. "The Pre-Raphaelite Literary Painters." *New Writing and Daylight* 6 (1945):123–31.

Waller, R. D. *The Rossetti Family, 1824–1854*. Manchester, 1932.

Watkinson, Raymond. *Pre-Raphaelite Art and Design*. London, 1970.

Welby, T. Earle. *The Victorian Romantics, 1850–1870*. London, 1929.

Wilde, Oscar. *The Collected Works of Oscar Wilde*. Edited by Robert Ross. Vol. 3, *Reviews*. London, 1908.

CHAPTER III

Baker, Houston A. "The Poet's Progress: Rossetti's *The House of Life*." *Victorian Poetry* 8 (1970):1–14.

Baum, Paull F. *The Blessed Damozel*. Chapel Hill, N.C., 1937.

Cooper, Robert M. *Lost on Both Sides: Dante Gabriel Rossetti, Critic and Poet*. Athens, Ohio, 1970.

Culler, A. Dwight. " 'The Windy Stair': An Aspect of Rossetti's Poetic Symbolism." *Ventures* 9 (1969):65–75.

Doughty, Oswald. "Rossetti's Conception of the 'Poetic' in Poetry and Painting." *Essays by Divers Hands* 26 (1953):89–102.

———. *A Victorian Romantic: Dante Gabriel Rossetti*. London, 1949.

Fredeman, William E. "Rossetti's 'In Memoriam': An Elegiac Reading of *The House of Life*." *Bulletin of the John Rylands Library* 47 (1965):298–341.

Grylls, R. Glynn. *Portrait of Rossetti*. London, 1964.

Harris, Wendell V. "A Reading of Rossetti's Lyrics." *Victorian Poetry* 7 (1969):299–308.

Holberg, Stanley M. "Rossetti and the Trance." *Victorian Poetry* 8 (1970):299–314.

Howard, Ronnalie Roper. *The Dark Glass: Vision and Technique in the Poetry of Dante Gabriel Rossetti.* Athens, Ohio, 1972.

————. "Rossetti's 'A Last Confession': A Dramatic Monologue." *Victorian Poetry* 5 (1967):21–29.

Hume, Robert D. "Inorganic Structure in *The House of Life.*" *Papers on Language and Literature* 5 (1969):282–95.

Hyder, Clyde K. "Rossetti's *Rose Mary*: A Study in the Occult." *Victorian Poetry* 1 (1963), 197–207.

Johnson, Wendell Stacy. "D. G. Rossetti as Painter and Poet." *Victorian Poetry* 3 (1965):9–18.

McGann, Jerome J. "Rossetti's Significant Details." *Victorian Poetry* 7 (1969):41–54.

Marillier, H. C. *Dante Gabriel Rossetti: An Illustrated Memorial of His Art and Life.* London, 1899.

Nelson, James J. "Aesthetic Experience and Rossetti's 'My Sister's Sleep,'" *Victorian Poetry* 7 (1969):154–58.

Packer, Lona Mosk, ed. *The Rossetti-Macmillan Letters.* Berkeley, Calif., 1963.

Pater, Walter. "Dante Gabriel Rossetti." In *Appreciations: With an Essay on Style*, pp. 228–42. London, 1889.

Pedrick, Gale. *Life with Rossetti: Or, No Peacocks Allowed.* London, 1964.

Rossetti, Dante Gabriel. *The House of Life.* Edited by Paull F. Baum. Cambridge, Mass., 1928.

————. *Letters of Dante Gabriel Rossetti.* Edited by Oswald Doughty and John Robert Wahl. 4 vols. Oxford, 1965–67.

Ryals, Clyde de L. "The Narrative Unity of *The House of Life.*" *Journal of English and Germanic Philology* 69 (1970):241–57.

Seigel, Jules Paul. " 'Jenny': The Divided Sensibility of a Young and Thoughtful Man of the World." *Studies in English Literature* 9 (1969):677–93.

Sonstroem, David. *Rossetti and the Fair Lady.* Middletown, Conn., 1970.

Stein, Richard L. "Dante Gabriel Rossetti's Painting and the Problem of Poetic Form." *Studies in English Literature* 10 (1970):775–92.

Talon, Henri A. *D. G. Rossetti: "The House of Life"*: *Quelques aspects de l'art, des thèmes, et du symbolisme.* Paris, 1966.
Vogel, Joseph F. *Dante Gabriel Rossetti's Versecraft.* Gainesville, Fla., 1971.
Weatherby, Harold L. "Problems of Form and Content in the Poetry of Dante Gabriel Rossetti." *Victorian Poetry* 2 (1964):11–19.

CHAPTER IV

Bell, Mackenzie. *Christina Rossetti: A Critical and Biographical Study.* London, 1898.
De la Mare, Walter. "Christina Rossetti." *Essays by Divers Hands* 6 (1926):79–116.
Packer, Lona Mosk. *Christina Rossetti.* Berkeley, Calif., 1963.
Rossetti, Christina Georgina. *The Family Letters of Christina Georgina Rossetti.* Edited by William Michael Rossetti. London, 1908.
Stuart, Dorothy M. *Christina Rossetti.* London, 1930.
Weathers, Winston D. "Christina Rossetti: The Sisterhood of Self." *Victorian Poetry* 3 (1965):81–90.

CHAPTER V

Arnot, R. Page. *William Morris: The Man and the Myth.* London, 1964.
Blench, J. W. "William Morris's *Sigurd the Volsung*: A Reappraisal." *Durham University Journal* 61 (1968):1–17.
Fleissner, R. F. "Percute Hic: Morris's Terrestrial Paradise." *Victorian Poetry* 3 (1965):171–77.
Grennan, Margaret R. *William Morris: Medievalist and Revolutionary.* New York, 1945.
Henderson, Philip. *William Morris: His Life, Work, and Friends.* London, 1967.
Hollow, John. "William Morris and the Judgment of God." *Publications of the Modern Language Association* 87 (1971):446–51.
James, Henry. "The Poetry of William Morris." In *Views and Reviews*, pp. 63–80. Boston, 1908.
Kermode, H. Sybil. "The Classical Sources of Morris's *Life and Death of Jason.*" In *Primitiae: Essays in English Literature*, pp. 158–82. London, 1912.
Mackail, J. W. *The Life of William Morris.* 2 vols. London, 1899.
Morris, William. *The Letters of William Morris to His Family and Friends.* Edited by Philip Henderson. London, 1950.

Raymond, Meredith B. "The Arthurian Group in *The Defence of Guenevere and Other Poems.*" *Victorian Poetry* 4 (1966):213–18.

Scott, Dixon. "The First Morris." In *Primitiae: Essays in English Literature*, pp. 183–236. London, 1912.

Stallman, Robert L. " 'Rapunzel' Unraveled." *Victorian Poetry* 7 (1969):221–32.

Thompson, E. P. *William Morris: Romantic to Revolutionary*. London, 1955.

Thomson, Paul R. *The Work of William Morris*. London, 1967.

Wahl, John Robert. *No Idle Singer: "The Lovers of Gudrun" and "Sigurd the Volsung."* Cape Town, 1964.

Yeats, William Butler. "The Happiest of the Poets." In *Ideas of Good and Evil*, pp. 70–89. London, 1903.

CHAPTER VI

Chew, Samuel C. *Swinburne*. London, 1931.

Connolly, Thomas E. *Swinburne's Theory of Poetry*. Albany, N.Y., 1964.

Coulling, Sidney M.B. "Swinburne and Arnold." *Philological Quarterly* 49 (1970):211–33.

Dahl, Curtis. "Autobiographical Elements in Swinburne's Trilogy on Mary Stuart." *Victorian Poetry* 3 (1965):91–100.

———. "The Composition of Swinburne's Trilogy on Mary Queen of Scots." *Tennessee Studies in Literature* 12 (1967):103–10.

Eliot, T. S. "Swinburne as Critic," "Swinburne as Poet." In *The Sacred Wood*, pp. 15–21, 131–36. London, 1920.

Fuller, Jean Overton. *Swinburne: A Critical Biography*. London, 1968.

Gosse, Edmund. *The Life of Algernon Charles Swinburne*. London, 1917.

Greenberg, Robert A. "Swinburne's *Heptalogia* Improved." *Studies in Bibliography* 22 (1969):258–66.

Hare, Humphrey. *Swinburne: A Biographical Approach*. London, 1949.

Housman, A. E. "Swinburne." *American Scholar* 39 (1970):59–79.

Hughes, Randolph, ed. *Lesbia Brandon: With an Historical and Critical Commentary*. London, 1952.

Hyder, Clyde K. "Algernon Charles Swinburne." In *The Victorian Poets: A Guide to Research*, ed. F. E. Faverty, pp. 227–50. 2d ed. Cambridge, Mass., 1968.

————. *Swinburne's Literary Career and Fame*. Durham, N.C., 1933.

————, ed. *Swinburne: The Critical Heritage*. London, 1971.

Kinneavy, Gerald B. "Character and Action in Swinburne's *Chastelard*." *Victorian Poetry* 5 (1967):31–36.

Lafourcade, Georges. *La Jeunesse de Swinburne*. 2 vols. Paris, 1928.

————. *Swinburne: A Literary Biography*. London, 1932.

Lang, Cecil Y. "Swinburne's Lost Love." *Publications of the Modern Language Association* 74 (1959):123–30.

McGhee, Richard. " 'Thalassius': Swinburne's Poetic Myth." *Victorian Poetry* 5 (1967):127–36.

McSweeney, Kerry. "The Structure of Swinburne's *Tristram of Lyonesse*." *Queen's Quarterly* 75 (1968):690–702.

Nicolson, Harold. *Swinburne*. London, 1926.

Panter-Downes, Mollie. *At the Pines*. London, 1971.

Peters, Robert L. *The Crowns of Apollo: A Study in Victorian Criticism and Aesthetics*. Detroit, 1965.

Raymond, Meredith B. "Swinburne among the Nightingales." *Victorian Poetry* 6 (1968):125–41.

Reed, John R. "Swinburne's *Tristram of Lyonesse*: The Poet's Song of Love." *Victorian Poetry* 4 (1966):99–120.

Reul, Paul de. *L'Oeuvre de Swinburne*. Paris, 1922.

Rutland, William R. *Swinburne: A Nineteenth-Century Hellene*. Oxford, 1931.

Swinburne, Algernon Charles. *The Swinburne Letters*. Edited by Cecil Y. Lang. 6 vols. New Haven, Conn., 1959–62.

Victorian Poetry. Special Swinburne Number. Edited by Cecil Y. Lang. Vol. 9, 1971.

Welby, T. Earle. *A Study of Swinburne*. London, 1926.

Wilson, F. A. C. "Swinburne's 'Dearest Cousin': The Character of Mary Gordon." *Literature and Psychology* 19 (1969):89–99.

CHAPTER VII

Allingham, William. *William Allingham: A Diary*. Edited by Helen Allingham and D. Radford. London, 1907.

Arinshtein, Leonid M., and William E. Fredeman. "William Michael Rossetti's 'Democratic Sonnets.' " *Victorian Studies* 14 (1971): 241–74.

Burdett, Osbert. *The Idea of Coventry Patmore*. London, 1921.

Champneys, Basil. *Memoirs and Correspondence of Coventry Patmore*. 2 vols. London, 1900–1901.

Charlesworth, Barbara. *Dark Passages: The Decadent Consciousness in Victorian Literature*. Madison, Wis., 1965.

Douglas, James. *Theodore Watts-Dunton: Poet, Critic, Novelist*. London, 1904.

Fredeman, William E. "Pre-Raphaelite Poet Manqué: Oliver Madox Brown." *Bulletin of the John Rylands Library* 51 (1968):27–72.

Gosse, Edmund. "A Blind Poet." In *Leaves and Fruit*, pp. 303–11. London, 1927.

Hake, T. S., and A. Compton-Rickett. *The Life and Letters of Theodore Watts-Dunton*. 2 vols. London, 1916.

Hake, Thomas Gordon. *Memoirs of Eighty Years*. London, 1892.

Hopkins, Gerard Manley. *The Correspondence of Gerard Manley Hopkins and Richard Watson Dixon*. Edited by Claude Colleer Abbott. Oxford, 1935.

―――. *Further Letters of Gerard Manley Hopkins*. Edited by Claude Colleer Abbott. 1938. Rev. ed. Oxford, 1956.

―――. *The Journals and Papers of Gerard Manley Hopkins*. Edited by Humphry House and Graham Storey. 2 vols. Oxford, 1959.

―――. *The Letters of Gerard Manley Hopkins to Robert Bridges*. Edited by Claude Colleer Abbott. Oxford, 1935.

Hunt, John Dixon. *The Pre-Raphaelite Imagination, 1848–1900*. London, 1968.

Meredith, George. *The Letters of George Meredith*. Edited by C. L. Cline. 3 vols. Oxford, 1970.

Moulton, Louise Chandler. *Arthur O'Shaughnessy: His Life and Work*. London, 1894.

Oliver, E. J. *Coventry Patmore*. London, 1956.

Paden, W. D. "Arthur O'Shaughnessy: The Ancestry of a Victorian Poet." *Bulletin of the John Rylands Library* 46 (1964):429–47.

―――. "Arthur O'Shaughnessy in the British Museum." *Victorian Studies* 8 (1964):7–30.

Page, Frederick. *Coventry Patmore: A Study in Poetry*. Oxford, 1933.

Pater, Walter. "Aesthetic Poetry." In *Appreciations: With an Essay on Style*, pp. 213–27. London, 1889.

Patmore, Derek. *The Life and Times of Coventry Patmore*. London, 1949.

Reid, J. G. *The Mind and Art of Coventry Patmore*. London, 1957.

Rothenstein, Elizabeth. "The Pre-Raphaelites and Ourselves." *Month*, n.s. 1 (1949):180–98.

Sambrook, James. *A Poet Hidden: The Life of Richard Watson Dixon*. London, 1962.

Scott, William Bell. *Autobiographical Notes*. 2 vols. London, 1892.

Stevenson, Lionel. *The Ordeal of George Meredith*. New York, 1953.

Thale, Jerome. "The Third Rossetti." *Western Humanities Review* 10 (1956):277–84.

Woolner, Amy. *Thomas Woolner, R. A.: Sculptor and Poet*. London, 1917.

Yeats, William Butler. *Autobiographies*. London, 1956.

INDEX